P9-DUG-059

JANETTA REBOLD BENTON is the author of five previous books, including *Holy Terrors: Gargoyles on Medieval Buildings* and *The Medieval Menagerie: Animals in the Art of the Middle Ages*, as well as numerous scholarly articles. A former resident of Paris, where she taught courses in medieval and Renaissance art as the Art Historian at the American Embassy, she is currently Professor of Art History and Director of the Honors Program at Pace University, Pleasantville, New York. Dr. Benton lectures regularly at the Metropolitan Museum of Art, the Smithsonian Institution, and elsewhere. She took her Ph.D. in medieval art at Brown University.

Thames & Hudson world of art

This famous series provides the widest available range of illustrated books on art in all its aspects.

If you would like to receive a complete list of titles in print please write to:

THAMES & HUDSON
181A High Holborn
London WC1V 7QX

In the United States please write to:

THAMES & HUDSON INC.
500 Fifth Avenue
New York, New York 10110

Printed in Singapore

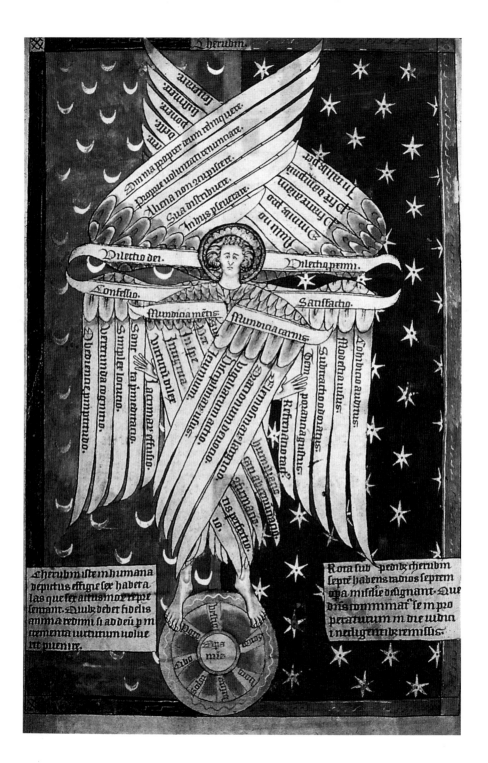

Janetta Rebold Benton

Art of the Middle Ages

250 illustrations, 90 in color

Thames & Hudson world of art

For Lillie Frankel Rebold (1912–2000) and Joseph Rebold (1909–2000).
The best parents.

Acknowledgments

I am fortunate to have wonderful friends who generously gave me their thoughts on the draft of this book. To Nona C. Flores, Lawrence Hundersmarck, and Elliot Benton I extend enormous gratitude.

© 2002 Thames & Hudson Ltd, London

First published in paperback in the United States of America in 2002 by Thames & Hudson Inc., 500 Fifth Avenue, New York, New York 10110

thamesandhudsonusa.com

Library of Congress Catalog Card Number 2001092917
ISBN 0-500-20350-4

Frontispiece. *The Cherub of Virtue*. Manuscript illumination from a 14th-century English psalter. Each of the cherub's six wings represents a virtue and each feather an aspect of virtue.

Printed and bound in Singapore by C. S. Graphics

Contents

Introduction

If you were an ordinary citizen during the Middle Ages – the period between the decline of the Roman Empire (*c.* 300) and the beginning of the Renaissance in Europe (*c.* 1400) – you would probably spend your entire life, from birth to death, in the same village, town, or city. The Church was the central authority on spiritual, moral, and intellectual matters. Wars and unrest were frequent, food might be scarce, and life was both insecure and short. Yet this was a period that produced some of the greatest art ever conceived; works of deep aesthetic and spiritual importance, not only to the people of the time, but to later ages, including our own.

Unlike the art of later eras, that of the Middle Ages is not focused on individual artists and personal styles. Instead, we are faced with a series of monuments and works defined by historical forces and geographic areas.

This book begins with a brief look at Early Christian art in the West and Byzantine art in the East. Next comes the Early Middle Ages (loosely considered to be the second half of the first millennium), which is divided into three main categories: 'Barbarian,' Carolingian, and Ottonian. We then reach the central theme of this book, the art of the High Middle Ages: the Romanesque and Gothic periods. The Romanesque begins in the year 1000, a symbolic millennium when many Westerners expected the end of the world. The Gothic is traditionally said to begin in the 1140s with the re-building of Saint-Denis by Abbot Suger.

The legacy of ancient Roman art was crucial to medieval culture. Christianity brought a shift in focus. Art and architecture now had new priorities: to create architectural spaces for worship, to enrich those spaces visually, and to teach the ideas and values of the new religion. But many Roman conventions were retained, and the political division of the Roman Empire into a Western Empire with its capital in Rome and an Eastern Empire with its capital in Constantinople (Byzantium) was paralleled by a division in artistic style. The West was more Roman, the Byzantine more open to Eastern influences.

Medieval art is thus characterized by a consistency of subject matter combined with a variety of styles, the former due to the

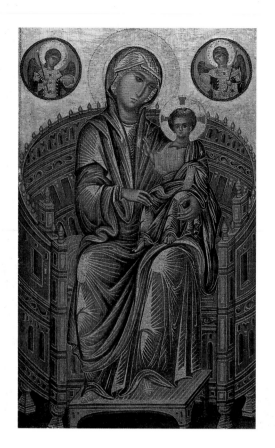

1. *Madonna and Child Enthroned*.
Byzantine, late 13th century.
Egg tempera on wooden panel,
81.6 x 49.2 (32⅛ x 19⅜)

power and patronage of the medieval Church, the latter due to the vast geographical and chronological span involved. One way of demonstrating this is to look at depictions of the same subject created in different eras, places, and artistic media. Consider the subject of Mary and her infant son Jesus – the Madonna and Child – probably the most universal of all medieval motifs.

A late thirteenth-century panel painting shows the distinctive Byzantine style – a style that remained consistent over several centuries. Mary's face, with its almond-shaped eyes, long thin nose, and tiny mouth, and the slender elongated proportions of her body, are typical; so too is the depiction of Jesus as a miniature man. The drapery is characterized by elaborate non-realistic folds that seem to have a life independent of the body beneath, the hard ornamental highlights contrasting with the soft skin. (Our current notions of 'realistic' and 'non-realistic' representation in art are largely based on early nineteenth-century conventions. Different formal conventions applied in much of the art of the

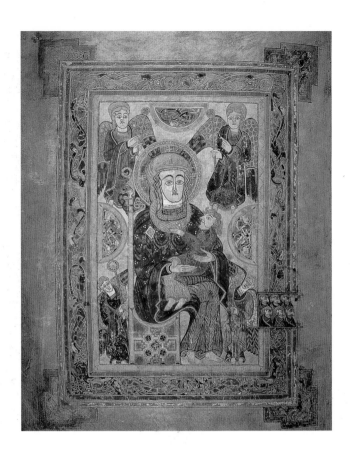

2. *Madonna and Child*.
'Dark Ages,' *c.* 800. Manuscript
illumination from the *Book of
Kells*, 33 x 24.1 (13 x 9½)

Middle Ages and care must be taken not to apply, anachronisti-
cally, ideas about realism as a value judgement.)

Compare the panel painting with a manuscript illumination
from the *Book of Kells*. Against a flat background with floating
figures, doll-like Mary and Jesus are treated as patterns of lines.
The curvilinear folds of Mary's drapery form a decorative design,
the transparent fabric revealing the non-anatomical shape of her
legs and pendulous breasts. We are now among the 'Dark Age'
Celts, a culture created by the migration of 'barbarian' peoples
from the east, whose art consists essentially of abstract pattern
without explicit reference to the natural world.

The disorder of the 'Dark Ages' was gradually replaced by a
semblance of political unity. The Carolingian era takes its name
from Charlemagne (742–814), King of the Franks, crowned
Emperor on Christmas Day 800 by Pope Leo III. Charlemagne
created an organized political structure, expanded the bound-
aries of Christendom by conquest, and encouraged education

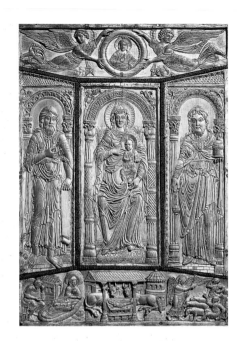

3. *Madonna and Child*.
Carolingian, early 9th century.
Ivory book cover, *Lorsch Gospels*,
38.4 x 26.7 (15⅛ x 10½)

and the revival of learning and the arts based on Roman classicism. Not surprisingly, since Charlemagne held sway over the area from the Pyrenees to the Danube, Carolingian art is a fusion of styles.

This combination of influences that went to form the 'Carolingian Revival' is demonstrated by an ivory relief of the Madonna and Child from the cover of the *Lorsch Gospels*. The Byzantine elongation makes seated Mary as tall as the standing figures of Zacharias and John the Baptist who flank her. Yet these Carolingian bodies are given greater roundness and their proportions are closer to Nature, the drapery clinging to the body and the folds softened, reflecting the Carolingian interest in the antique. The architectural setting with semi-circular arches and foliated column capitals is also antique in origin.

Such artistic amalgamation continued under Charlemagne's successors, leading, around the turn of the first millennium, to a new recognizable and definable style, known today as Romanesque. The style did not receive this name until 1818, and was used by M. de Gerville, an antiquary from Normandy, who viewed Norman churches as a debasement of ancient Roman architecture, and Latin as similarly so distorted as to be no longer Roman but only Roman*esque*. In fact, Romanesque architecture is literally 'like the Roman.'

Romanesque architecture is characterized by semi-circular arches (as opposed to the later pointed Gothic arches), solid construction, and thick walls. In painting and sculpture, the relative realism of Carolingian art gave way to increased abstraction as, once again, artists turned away from the material visible world and toward the spiritual world. A seated Madonna and Child, carved of oak and polychromed, represents a popular Romanesque type. The figures are stiff and formal. Jesus is depicted as a tiny adult, holding the scroll of law in one hand and blessing with the other. The draperies appear to be perfectly pressed and pleated into parallel ridges, only some of which obey the laws of gravity.

The years in which the Romanesque style was current were a time of stability and growth in Europe. Cities grew, the power of the popes increased, canon law developed greatly, the first universities were founded, and monasteries became centers of power.

In the mid-twelfth century a new style developed in the arts, known today as the Gothic. In its own time this was known as the 'French style' and referred to architecture – the dominant art of the time. Sixteenth-century Italians thought the style barbaric, preferring instead the classical. Because the best known of the barbarian tribes were the Goths, the style was called Gothic, i.e. barbaric, the implication of the term definitely derogatory.

If the Romanesque was the era of monasteries, the Gothic was the era of great cathedrals. These arose partly as the result of the continued rapid growth of cities and civic pride, combined with the available wealth that resulted from improved communication and expanded trade, and partly as a result of advances in building techniques founded upon the rib vault, the pointed arch, and the flying buttress.

The image of Mary and Jesus softened during the Gothic era. In the celebrated marble sculpture known as *Notre-Dame-de-Paris* (Our Lady of Paris), Mary has been humanized and transformed from an austere matron into a warm and appealing young mother. Artistic taste turned away from abstraction and back toward Nature; Gothic artists preferred slender, delicate, almost boneless figures. This animated Mary pulls her garment across her body, simultaneously revealing its shape and increasing the complexity of the pattern of broad sweeping folds. Like almost all Gothic Madonnas, she stands in the so-called 'hipshot' or *déhanchement* pose, with one hip supporting the baby, causing her body to sway gracefully, fluidly, forming an S-curve. Gradually artists came to depict Jesus as a baby. If medieval

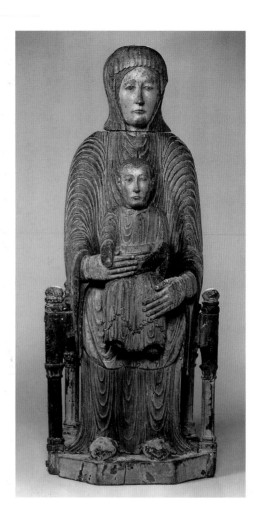

4. *Madonna and Child*.
Romanesque, 1150–1200.
Oak and polychromy, made
in the Auvergne region,
France, height 78.7 (31)

images of the infant Jesus are examined in chronological order, he can be found to grow younger as the years pass.

The aesthetic accomplishments of the Gothic era were made as conflicts continued between Church and State into the thirteenth century. The Church's role as primary transmitter of culture began to be taken over by secular institutions. Secular law improved. The fourteenth century saw problems within the Church – the exile of the papacy from Rome to Avignon between 1309 and 1377, and the Great Schism of 1378–1417, when two or more popes were elected simultaneously.

The instability of medieval life was exacerbated by a series of disasters in the fourteenth century. Famine was prevalent between 1315 and 1317. During the summer of 1348 between

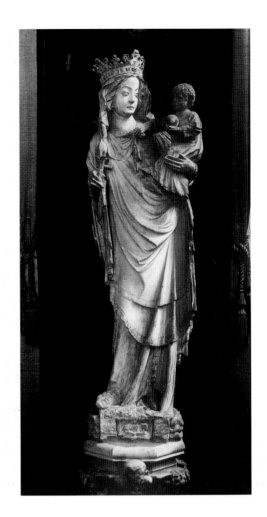

5. *Notre-Dame-de-Paris*,
Gothic, early 14th century.
Marble, French. Cathedral
of Notre-Dame, Paris

one-third and one-half of the inhabitants of Western Europe died from the Black Death (bubonic plague). This was carried by fleas on rats, brought to Europe from the Near East on merchant ships. Characterized by raised and darkened sores over the body, the plague usually dispatched its victims within days.

The Black Death, in conjunction with the Hundred Years' War between the emerging English and French nation states (1337–1453), led to a devastating depopulation of Western Europe and a major redistribution of wealth.

At the close of the Middle Ages, Western Europe differed significantly north and south of the Alps. Italy had already become quite separate from the rest of Europe, looking to her antique past rather than to France for artistic direction.

Every medieval town had its church, and a large city had many. Typically located in the geographical center of a medieval town, the church was the central focus and primary organizing force of daily life. One went to church to hear the sermon, to pray, to ask for the aid of God and the saints, or to offer thanks to them. Yet the Church did much more than serve spiritual needs. It was the location of meetings. Businesses functioned around and even inside the church. Goods were bought and sold here. Fairs were held on the surrounding property, often the only open area within a medieval town. And the church was the place to go if one were in need of employment or employees.

The Church offered a universal and unifying message in the Bible, which was available to the laity only through the Church. It was not necessary to understand Latin (and few did), for even though the mass was said in Latin, the sermon was preached to the public in the vernacular.

Another aspect of the organizing and unifying power of the medieval Church was its increasingly complex ecclesiastical structure. Pope Cornelius (251–253) writes of priests, deacons, sub-deacons, acolytes, clerics, exorcists, lectors, and porters. Further, during the Middle Ages, the Church became increasingly central-ized through the office of the bishops responsible to the pope for the activities within their dioceses. A pastor led each parish.

Throughout the medieval period, monasteries were impor-tant centers of religious activity. Monasticism, literally meaning 'dwelling alone,' was first practiced by fourth-century Christians and gradually developed thereafter, reaching a peak in the twelfth century. Monks took vows as members of a religious organization and lived apart from society, often under ascetic conditions imitating Jesus' simplicity. Based on poverty, chastity, and obedience, the life of a monk was one of self-deprivation of physical comforts. In certain orders, earthly pleasures, including ownership of all private property, were renounced.

The two main types of monasticism were the solitary (eremitical) type and the family (cenobitical) type living in reli-gious communities. Although prayer was the primary concern of monasticism, this spiritual occupation went hand in hand with physical labor. Thus, some orders practiced agriculture and were highly skilled farmers. Others were occupied with the copying of manuscripts, thereby preserving written culture, especially the ancient authors who would otherwise have been lost. Medieval monasteries might also be the site of work in the fine arts, includ-ing painting, sculpture, and metalwork. Later in the Middle Ages,

the mendicant (begging) orders, such as the Franciscans, devoted their lives entirely to preaching, education, and prayer, living on the charity of others. The various medieval monastic orders were distinguished not only by their specific teachings and beliefs, but also by their distinctive attire (see p. 282).

Pilgrimage – an activity that predates Christianity – was a special feature of medieval life. Undertaken by men and women from all segments of society, pilgrimages seem to have been especially popular in the eleventh century. Pilgrims traveled in groups, some numbering in the thousands. The journeys were undertaken to specific locations in order to venerate relics there and in the churches along the route, or to ask for divine help, or to discharge an obligation such as penance for a crime.

For pilgrims traveling to atone for particularly serious offenses, four sites in four different countries were especially popular: Canterbury for the relics of St. Thomas Becket (the tales told on the way to Canterbury were immortalized by Chaucer); Cologne for the relics of the three Magi; Rome for the tomb of the Apostles Peter and Paul; and Santiago de Compostela for the shrine of St. James. Guide books and local clergy provided pilgrims with information about the relics.

Pilgrim attire, as described in medieval literature and recorded by artists, was akin to monastic garb: a long loose gown and a separate hood. The pilgrim added a brimmed hat and a walking staff as well as 'pilgrim signs' – fabric badges sewn or pinned on the clothing or hat, or worn hanging at the neck. These were visible souvenirs indicating where the pilgrim had been. Because the many travelers required food, lodging, and other facilities, as well as guide books and souvenirs, pilgrimages, like tourism, created a lucrative industry during the Middle Ages.

The holiest pilgrimage site of all was Jerusalem, and it was a matter of the most profound distress that this lay outside Christendom. To regain it was the purpose of the Crusades, sporadic military expeditions that lasted for two centuries. As the Byzantine Empire shrank under the onslaught of the Muslims, help was sought from the West. Pope Urban II preached the First Crusade in 1095, encouraging an assembly in Clermont to rescue their Christian co-religionists in the East. Each crusader took a vow, was given a red cross to wear on his shoulder, and was made a soldier of the Church. In return for his participation, the crusader sought spiritual and material rewards. Eight crusades are generally recognized, the first beginning in 1095, the last in 1270, when the Holy Land was recovered by the Muslims.

If one of the dominant forces shaping daily life was the Church, the other was feudalism, a political structure based upon land tenure and involving specific rights and duties. Estates were given by a king to lords in return for an obligation to provide troops and military service as well as service at the king's court. The lord then let property parcels to vassals (who might be lesser lords) or serfs who were bound to the land by an oath of loyalty and who worked the land in service to the lord and gave him a share of their produce. In return, the lord protected his vassals and dispensed justice.

Property was granted to the Church in the same manner, with bishops having secular responsibilities to the king and ecclesiastical responsibilities to the pope and Church hierarchy. Much of the conflict between Church and State centered on the interpretation of the rights and responsibilities of the Church to the temporal powers.

By providing a means of political organization of territory, feudalism theoretically was a source of greatly needed stability. The structure imposed on society by feudal rights and responsibilities, however, fragmented society into many small, mostly self-sufficient, and often warring communities. Medieval society's pyramidal structure was characterized by an extreme contrast between the small number of wealthy land-owners at the top and the vast number of poor at the bottom. Not until the end of the era did a middle class of craftspeople and merchants develop in between.

By the close of the Middle Ages, Europe had achieved a more structured feudalism and a general increase in law and order. The concept of the nation state had begun to emerge with more effective central governments, and the fifteenth century saw the power of individual nations rise. Large military forces were now raised only when needed, for it had become excessively expensive to maintain a permanent standing army, and the soldiers were paid with money rather than with land.

The vast majority of people living in medieval Europe were illiterate. Although this included portions of the clergy, the Church was the major provider of education and most instruction was linked to religion. Monasteries were important intellectual centers that guarded and advanced culture, offering both education and a context for a life of prayer and work, thought to be an avenue to salvation. Many monasteries had libraries (several hundred volumes constituted a large library) and some had scribes who copied manuscripts in the scriptorium.

As society became progressively more urban, the intellectual centers gradually moved from the rural monasteries to the city cathedral schools, and then on to the universities. Established from the late eleventh century on, the earliest universities were those of Paris, Oxford, Bologna (law), and Salerno (medicine). By the early thirteenth century, Paris (founded 1215) and other universities had taken the lead in education from the cathedral schools.

Based upon the program of studies used in classical antiquity, the basic curriculum for the early clerics was established by the sixth century. It consisted of the Trivium (grammar, rhetoric, and logic) and the Quadrivium (geometry, arithmetic, astronomy, and music), which formed the seven liberal arts. The Trivium and Quadrivium served as the curriculum in the monasteries and cathedral schools and were refined by the universities.

During the Middle Ages, children customarily followed their parents' profession, a son often being trained from boyhood by his father and further instructed as an apprentice to a master in a guild. From the twelfth century on, artisans and artists practicing the same skills (such as masons, metalworkers, sculptors, or painters) were grouped into guilds. These corporations exercised significant control over not only the training but also the way of life of their members. At the time of King Louis IX (St. Louis) in the mid-thirteenth century, there were about 120 guilds in Paris. Along with standards of quality, the guilds maintained tradition. A medieval artist learned to use conventional methods and materials and to follow the accepted models, with skillful technical execution of traditional forms being the goal.

Only on exceptional occasions did a medieval artist have significant artistic liberty. Individuality was not valued in the medieval way of thinking, and an artist's personal style was neither cultivated nor encouraged. The quest for innovation, the desire to do something new, the belief that novelty is inherently good, are all ideas that had little place in medieval art and, in fact, were discouraged until the last years of the Middle Ages. The concept of an art school or art academy in which individuals are 'educated' (rather than 'trained') so that they might realize their potential by developing their own aesthetic was many years in the future.

Those people now referred to as artists, and admired as such because of the special talent they possess, were regarded as artisans or craftspeople until the end of the Middle Ages. Their relatively low status was linked to the medieval disdain for manual work as below the nobility and inferior to spiritual pursuits, and the active life as less desirable than the contemplative life – work of the hands

was less valued than that of the mind. Works of religious art were of value primarily in aiding the viewer to gain access to, and an understanding of, the invisible immaterial realm of God.

Such attitudes to the work of artists and the purpose of art are reflected in the scarcity of signatures on works of art, as well as the scarcity of portraits and self-portraits. (A parallel is seen in medieval literature in the rarity of biographies and auto-biographies.) Yet some artists certainly were considered more skilled at their craft than others and must have been in greater demand. In fact, there are many exceptions to the anonymity of the medieval artist: Unbertus (Saint-Benoît-sur-Loire, eleventh century), Engelram (Spain, late eleventh century), Gislebertus (Autun, early twelfth century), Hildebertus (Bohemian, mid-twelfth century), Imervard (Lower Saxony, mid-twelfth century), Nicholas of Verdun (Mosan, *c.* 1181), and Master Matthew (Santiago de Compostela, late twelfth century). There were no doubt other signed works, now lost. The situation is somewhat different in Italy: Wiligelmus is recorded in Modena in the early twelfth century, and the names of artists were routinely recorded from the time of Nicola Pisano just after the mid-thirteenth century in Pisa.

This is not to say, of course, that artists were not known by name in their own time. Clearly the architects of cathedrals, and the sculptors and painters who decorated them, were renowned and appreciated by their patrons. It is simply that such informa-tion was not normally thought worthy of being recorded. Their present anonymity is largely accidental.

The scarcity of documents written during the Middle Ages about art is consistent with the lack of interest in art as a subject worthy of analysis. Manuals providing instruction on how to paint a specific image or execute a certain technique occasionally survive, such as the treatise written by Theophilus, *De diversis artibus* (*On Divers Arts*), *c.* 1100 or in the early twelfth century, but there are no medieval art historical studies concerned with contemporary or earlier artists, or with aesthetics. Not until Leonardo da Vinci do we find an artist saying that he works with his head as well as his hands. And not until Giorgio Vasari wrote his *Lives of the Most Eminent Architects, Painters, and Sculptors* in 1550 was an historical approach taken to examine the develop-ment of the styles of specific artists.

The highest authority in medieval Europe – the Church – was also the major source of artistic patronage. Construction of churches, cathedrals, and monasteries as well as the acquisition of

manuscripts, ecclesiastical vestments, liturgical furnishings, and other items used in church ritual required significant wealth. This was acquired in many ways. Property, money, and valuable items were donated by wealthy members of the laity and by members of the religious hierarchy, given outright or promised in wills. Contributions were received from the local religious chapter. Indulgences were sold by the Church. Many small offerings were solicited from the faithful by various devices, including passing the plate and the omnipresent donation box. In return, the donor was promised that prayers would be said on his/her behalf, sins would be forgiven, and access to Heaven facilitated.

Lay patronage, like lay artists, grew ever more common as the years passed. At the close of the Middle Ages secular commissions came increasingly from kings and members of the nobility as well as from civic organizations and private individuals.

Medieval artists worked on commission: there was no 'art market' in today's sense. Artists did not paint a picture with the intention of selling it later, nor did they market their work through exhibitions in galleries and shops. Instead, a work of art was customarily created according to a contract – some examples survive from as early as the mid-thirteenth century. A contract for a painting, for example, might precisely stipulate the subject and iconography as well as matters such as the role of assistants in the work, or the amount of precious and semi-precious pigments or quantity of gold to be used.

Although in many ways harsh and insecure, medieval life placed high value on the visual beauty and appeal of one's environment. Even personal attire was treated as an art form, as evidenced by the vestments of the clergy during religious ceremonies, the armor worn by knights, and the secular clothing worn, particularly, by the wealthy. Similarly, medieval secular architecture emphasized visual appeal, often at the expense of comfort or convenience. This was true of dwellings ranging from modest half-timbered constructions to lavish manor houses. Castles and fortresses were built with an interest not only in defense but also in aesthetics. Artists provided yet another form of visual pleasure in medieval life – that of amusement, as evidenced by certain gargoyles, manuscripts, and carvings. These offer striking examples of what may appropriately be termed 'medieval mischief,' and go some way to showing us how the inhabitants of the Middle Ages came to terms with and enjoyed their world.

Chapter 1: Early Christian and Byzantine

Early Christian Art

The term 'Early Christian' is used to describe the art produced by Christian communities beginning in the mid-second century. Initially Christian artists were working in an atmosphere of persecution. They followed the conventions of late antique art but their subject matter was often without antique precedents. The Emperor Constantine officially encouraged Christian art. When he moved his capital to the shores of the Bosphorus, Christian art began to evolve into the sophisticated style known as 'Byzantine.'

The new religion was initially averse to representational art, in part because it was thought to serve the worship of idols. Yet Early Christians gradually came to use art to educate followers, perhaps illiterate, through pictorial representations of the Bible's teachings. What the faithful heard preached from the pulpit was illustrated and made memorable by what was seen in the artists' images. Art served as a means to worship and became an adjunct of theology, the images functioning as religious symbols. Art enabled the Church to attract worshippers and to transport them from their daily lives to the realm of the spiritual. Although conflict over the role of images in the Church would reappear periodically, most notably in the Byzantine Iconoclastic Controversy (see p. 32), the centrality of art to Christianity is of utmost importance.

In AD 313 the Emperor Constantine issued the Edict of Milan recognizing Christianity as one of the official religions of the Roman state, thereby permitting congregations to worship openly and to construct churches. One type of church, presumed to derive from the Roman law-court and known as the Early Christian basilica, was well established by the fourth century. The quintessential example, and one of many basilicas erected by Emperor Constantine, was Old Saint Peter's in Rome. This was built over the tomb of St. Peter, near the spot where he was crucified, but was destroyed in the early sixteenth century to make way for the present Saint Peter's.

The visitor to an Early Christian basilica such as Old Saint Peter's first entered the atrium, a rectangular forecourt used by

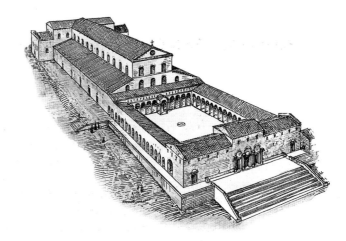

7. Reconstruction drawing of the exterior of Old Saint Peter's, Rome, begun c. AD 333, now destroyed

6. Plan of Old Saint Peter's, Rome, begun c. AD 333, now destroyed. This building, presumed to have been based on Roman prototypes for plan and structure, was to serve in turn as the model for a multitude of medieval churches. The longitudinal axis of the basilican plan focuses attention on the religious ritual performed at the altar in the apse which is directly before the visitor upon entering the nave.

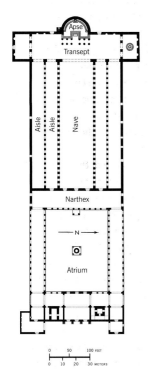

the unbaptized that was open to the sky and surrounded on all four sides by columnar arcades. Next, he or she passed through the narthex, an entrance hall or vestibule, and entered the nave, a large rectangular space designed to accommodate numerous people, flanked on either side by one or two aisles separated from the nave by colonnades. The nave ended with the transept, a section at right angles to the nave, offering additional space, beyond which was the semi-circular apse containing the altar. The plan is a Latin cross having one long arm (the nave) and three short arms (two transepts and the apse), as opposed to a Greek cross plan with four arms of equal length. The Latin cross resembles the shape of Jesus' cross, but there is no evidence that this was the original intent and the transept is omitted in many Christian churches.

The nave ceilings of Early Christian basilicas were made of wood. Lightweight and easily supported, a wooden ceiling permits construction of windows in the walls, allowing sunlight to enter; the reconstruction drawing of Old Saint Peter's shows the nave to have clerestory windows. Candles were the alternative source of light but the high flammability of the wooden ceiling resulted in the destruction of many structures.

Santa Maria Maggiore in Rome, originally built c. AD 430 but expanded and modified in later years, provides an extant example of an Early Christian basilica. A benefit of the basilican church structure, as Santa Maria Maggiore makes evident, is that upon entering the nave, the visitor's attention is focused naturally on the altar ahead by the simple, single, longitudinal axis of the plan. Although the exteriors of the Early Christian

8

basilicas were not intended to be admired and were unornamented, the interiors, where rituals and meetings took place, were decorated with patterned marble floors, marble columns, and mosaics of colored stone, glass, and gold covering the walls – as seen in Santa Maria Maggiore.

Other examples of Early Christian basilicas in Rome are San Giovanni in Laterano (later altered beyond recognition), Santa Maria in Cosmedin, Santi Nereo e Achilleo, San Paolo fuori le Mura (reconstructed after a disastrous fire), and Santa Sabina.

Round or polygonal central plan buildings with domed ceilings were also erected during the Early Christian era, the most significant surviving example being Santa Costanza in Rome. Built *c.* AD 350 as the mausoleum of Constantine's daughter Constantia, Santa Costanza is located close to the fourth-century church of Sant' Agnese fuori le Mura. The brick exterior is simple and plain, but the interior is embellished with composite capitals and the surrounding circular aisle (ambulatory) is covered by a barrel vault/tunnel vault ornamented with mosaics. Sunlight enters the clerestory windows above.

Ancient Roman mosaics were made with stone tesserae (small colored cubes) and the range of colors available was therefore limited. Glass and gold tesserae were introduced in the fourth century AD, but the mosaicists of Santa Costanza were still using the muted palette of antiquity. Later mosaics became brighter, the colors glowing, and their variety vast. Shimmering, glittering effects were achieved by intentionally setting the

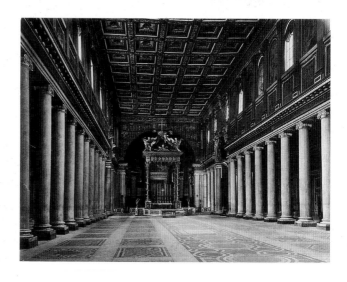

8. Nave looking toward altar, Santa Maria Maggiore, Rome, *c.* AD 430 and later.

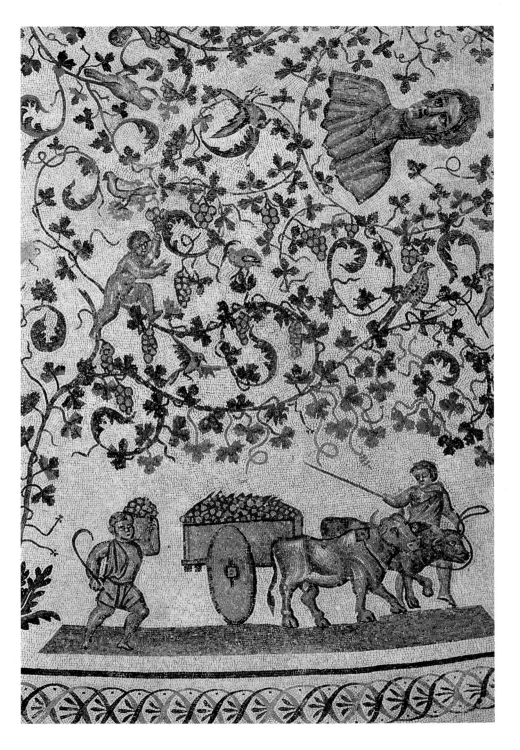

10. *Melchizedek Offering Bread and Wine to Abraham*. Mosaic in nave, Santa Maria Maggiore, Rome, *c.* AD 430

11. Marble sarcophagus of Junius Bassus, *c.* AD 359, 118.1 x 243.8 (46½ x 96)

tesserae into the plaster on slightly differing planes to reflect light coming from many angles, thus making solid walls and ceilings appear weightless and insubstantial.

Some of the mosaics in the ambulatory vault of Santa Costanza depict a vine pattern with small scenes of laborers gathering grapes, putting them into carts, transporting them to a press, and stomping on them. This subject was common for tavern floors, yet, because Jesus said, 'I am the true vine, you are the branches...' and because wine plays a part in the Christian ceremony, a secular subject was adopted and adapted to Christian symbolism.

Exemplifying the nave mosaics of Santa Maria Maggiore in Rome is the scene of Melchizedek offering bread and wine to Abraham, dated to *c.* AD 430. Following the classical style, the forms are modeled, the light and shade on the horses, figures, and amphora suggest dimensionality, and the three-quarter views imply movement. Taken as a whole, however, the mosaics of Santa Maria Maggiore were intended less to provide a factual portrayal of our world than an illustration of a Bible story. For this, genuine illusionism was neither required nor desired.

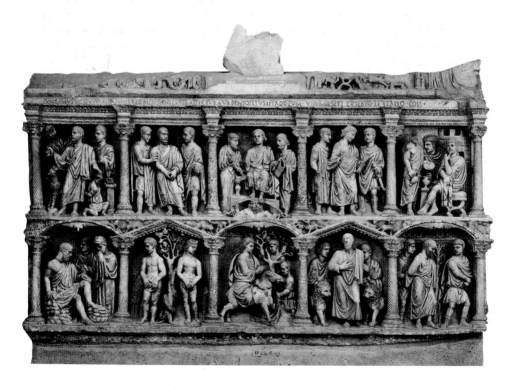

Therefore perspective may be inverted and shadows may fail to fall away from highlights: the amphora, for example, casts a shadow to the right in spite of the fact that the light comes directly from the front. A crowd of people can be shown in visual shorthand, abbreviated as a cluster of heads – an effective device to indicate a large number of bodies in a restricted space.

Because of Early Christianity's abhorrence of idol worship, sculpture was secondary to painting during the Early Christian era. Although the state continued to erect large statues of civic and military leaders in public places, large-scale free-standing sculpture was generally not favored. For the most part, sculptors turned to small-scale relief work on stone sarcophagi and ivory panels.

Sarcophagi with the front, and occasionally the lid, carved with small figures in high relief are among the earliest works of Christian sculpture that remain. There are extant examples dating from the early third century onward. Nearly all of them follow the conventions of pagan Roman sarcophagi very closely. Among the most notable is the sarcophagus of Junius Bassus, a prefect of Rome (a political position similar to a governor or high-ranking administrator) who converted to Christianity shortly before his death in AD 359. Two tiers of columns divide the front of his sarcophagus into ten sections. The subjects depicted derive from the Old and New Testaments. The upper row, left to right, portrays the sacrifice of Isaac, St. Peter taken prisoner, Jesus enthroned with Sts. Peter and Paul, and, in two sections, Jesus before Pontius Pilate. The lower row, left to right, shows the misery of Job, Adam and Eve after eating from the tree of knowledge, Jesus entering Jerusalem, Daniel in the lions' den, and St. Paul led to his martyrdom.

The proportions of the figures are far from the classical ideal; large heads are supported by clumsy doll-like bodies with formless arms and legs. The characters suggest no action or emotion in even the most dramatic situations. The background setting is almost eliminated in these crowded scenes. These comments are observations rather than criticisms, however, for realism was not the sculptor's goal. Thus the little vignettes on the sarcophagus need not provide all the details of every story – rather, they need only to bring to mind a story already familiar to their intended Christian audience.

Ancient pagan forms were sometimes reused for a Christian subject. In an early sixth-century ivory relief of the archangel Michael, carved on one leaf of a diptych (a pair of hinged panels), Michael derives from the winged victory figures of Greek and

12. *Archangel Michael*. Leaf of an ivory diptych, early 6th century AD, 43.2 x 14 (17 x 5½)

Roman art, and his drapery is rendered in the 'wet' clinging style of fifth-century BC Greek sculpture. If seen in isolation, the figure is convincing. But the treatment of space is far from scientific and, in spite of the architectural setting, there is no sense of depth: Michael's feet dangle over three steps and his hands are shown in front of the columns in spite of the fact that the columns' bases are in front of the stairs. Michael is on a precarious angle, even for an angel. Without acknowledging the basic spatial concepts, the artist carefully copied the superficial forms and carved them with technical perfection.

The oldest surviving Christian art is found in and around Rome in catacombs – underground cemeteries of the Early Christians. Some catacombs resemble towns of sepulchers and funeral chapels with miles of underground passageways cut into the rock. The walls and ceilings were often decorated with stucco or mural paintings and the subjects portrayed likely to relate to the Christian belief in the soul's afterlife.

A fourth-century ceiling in the catacomb of Santi Pietro e Marcellino (Sts. Peter and Marcellinus) in Rome provides an especially well preserved example. Jesus the Good Shepherd, the subject filling the center, was frequently depicted by painters and sculptors. Symbolically, Christians form Jesus' flock and, as the Good Shepherd, he watches over and cares for them. The entire painting forms a cross – a reference to the dome of heaven. The semi-circles contain the story of Jonah: according to the Bible, he is thrown overboard into the mouth of the waiting 'great fish,' shown here as a sort of curly serpent-dog; after three days he emerges from this creature; and finally he relaxes in safety under the vines. Jonah was a type for Jesus and his escape after three days an allusion to Jesus' resurrection. The figures between the semi-circles stand in a common early prayer pose – the *orant* pose. With hands raised to heaven, the *orans* figure asks for God's help.

In addition to Jesus the Good Shepherd and Jonah and the whale, popular Old Testament subjects for catacomb paintings were Noah and the ark, Moses, the three youths in the fiery furnace, Daniel in the lions' den, and Susanna. Popular New Testament subjects were taken from the life of Jesus, especially the miracles of healing, such as that of the paralytic or the raising of Lazarus. The subjects selected from the scriptures tend to be parables of salvation, illustrating the Christian belief that God is merciful and will intervene to save the faithful, thereby emphasizing the rewards of constant prayer. Catacomb paintings

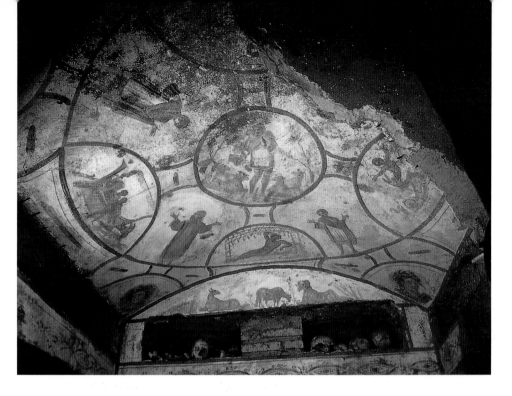

13. *Dome of Heaven*. Painted ceiling in catacomb of Santi Pietro e Marcellino, Rome, 4th century AD. The sketchy style of ancient Roman wall painting was perpetuated into the Early Christian period and used in catacombs to depict Christian subjects. These usually derived from the Bible and focused on the new religion's promise of God's protection, spiritual salvation, and a blissful afterlife.

ignore suffering and death, instead optimistically emphasizing life. Seemingly entirely omitted are depictions of Jesus' Passion (his suffering at the end of his physical life), for the earliest known representations are fifth-century carvings.

The catacomb paintings are intended to stimulate the viewer's thoughts by representing ideas and concepts. Their style, like that of the mosaics of Santa Maria Maggiore in Rome, recalls late Roman wall painting. In this abbreviated style neither perspective, nor a specific light source, nor cast shadows are used and the application of paint is sketchy and loose. Anything that does not relate directly to the story is eliminated.

Other Early Christian painted catacombs in Rome are those of St. Callistus, St. Domitilla, and Priscilla.

In AD 330 the Emperor Constantine established a second capital for the Roman Empire in the eastern Greek city of Byzantium, which was renamed Constantinople, and is known today as Istanbul, Turkey. Constantine's action split the Roman Empire in two. Although the western portion with its capital in Rome gradually declined, the eastern portion with its capital in Byzantium continued to thrive.

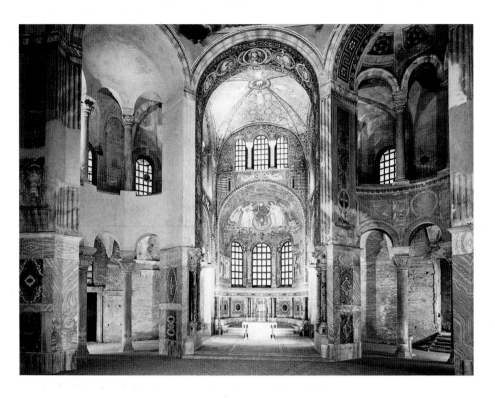

14. San Vitale, Ravenna, 526–547

Byzantine Art

The Byzantine Emperor Justinian (born 483, reigned 527–565) generously patronized the arts. His long and productive reign, referred to as the First Golden Age of Byzantine art, made Byzantium an artistic capital. Much art created during this First Golden Age survives today in the city of Ravenna on the east coast of Italy, once part of the Byzantine Empire.

The architecture and mosaics of the church of San Vitale in Ravenna, dated between 526 and 547, are an especially important accomplishment of the period. San Vitale is octagonal in plan, a type favored in the Byzantine East. Light creates a dramatic effect in the nave: the brightest light enters from above via the clerestory, whereas on the two lower levels light must filter through the two-story aisles. San Vitale is similar to Early Christian Santa Costanza in Rome in its central plan, but is much larger and more complex.

The domed ceilings of both buildings offer the advantage of a spacious interior unencumbered by supports. However, a dome tends to attract the visitor's eyes to the area directly beneath it, whereas the focus of the religious ritual is at the altar

– thus two focal points compete. In contrast, the longitudinal axis of the basilican plan, as of Old Saint Peter's or Santa Maria Maggiore in Rome, offers a single focus, although the interior space is interrupted by supports. The advantages of both types are combined in the church of Hagia Sophia in Constantinople, as will be seen.

6

8

The interior of San Vitale, in striking contrast to the drab exterior, is opulent in its ornament, made colorful by mosaics covering all the upper portions (the illusionistic angels on clouds are later additions), thin slabs of marble veneer, and marble columns with carved and painted capitals. Because columns, originally intended to support horizontal lintels, are here required to support arches, impost blocks are added, their purpose being to channel the weight of the arch down onto the column. Seemingly immaterial, the lacy delicacy of the surface decoration belies the underlying strength of the structure.

The celebrated mosaics of Justinian and Theodora, dated 16 c. 547, flank the altar – thus the emperor and empress are portrayed as ever-present worshippers in spite of the fact that neither ever actually visited Ravenna. Between them, in the apse, is an image of Jesus with St. Vitalis and Bishop Ecclesius, the former the patron saint of the church, the latter its founder, shown presenting a model of the church to Jesus. Similarly, Justinian offers a Eucharistic bread plate and Theodora a Eucharistic wine chalice. (On Theodora's gown, the three Magi are depicted bringing gifts

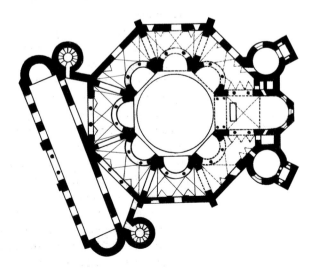

15. Plan of San Vitale, Ravenna, 526–547

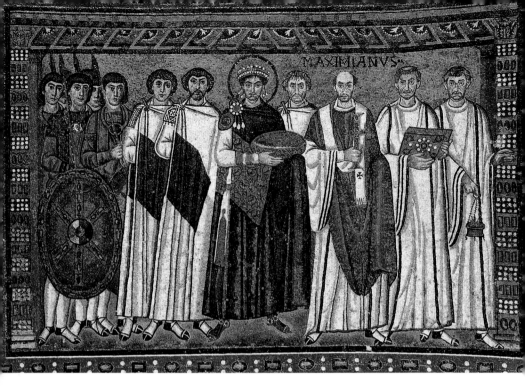

MAXIMIANVS

16. *Justinian and his Attendants*. Mosaic, San Vitale, Ravenna, c. 547. Departing from the relative naturalism of the ancient Roman tradition, the famous mosaics of Emperor Justinian and Empress Theodora use the inherent abstraction of both the medium and the Byzantine style to enhance the hieratic persona Byzantine royalty wished to convey.

to Jesus.) Justinian's companions bring a cross, gospel book, and censor: these items were carried ceremoniously into church and the congregation followed. Symbolic and spiritual, the mosaics convey divine presence in the form of the emperor and empress. The images are simplified for clarity and intelligibility, the abstraction implying timelessness.

Although Justinian, Theodora, and possibly others are specific individuals, everyone is made to look very similar, with large dark eyes, curved eyebrows, long nose, and small mouth – the characteristic Byzantine facial type. The drapery gives no hint of a body beneath and the elongated figures appear immaterial, ethereal, and weightless. Indeed, feet dangle and overlap, as if stepping on one another's toes. In contrast to the relative naturalism seen in Early Christian mosaics, sculptures, and paintings, the Byzantine figures are motionless, their gestures frozen. Flat frontal views are preferred to three-quarter views which would imply a degree of solidity and movement, the figures forming a rhythmic pattern across the surface. The antique Roman concern for realistic or consistent pictorial space has now disappeared. The very choice of mosaic in itself eliminates the possibility of naturalism. With its colorful surface

patterns, it is an ideal medium to enhance the image of divine power promoted by the Byzantine emperor and empress, while simultaneously increasing the sumptuous splendor of the building itself.

Hagia Sophia, the Church of the Holy Wisdom, in Constantinople, was built for Emperor Justinian between 532 and 537 by the architects Anthemius of Tralles and Isidorus of Miletus. There is little exterior decoration (the four minarets are later Turkish additions). Seen from the outside, Hagia Sophia appears to be a very solid structure that builds up in waves to the huge central dome. The plan makes clear that the central dome and two half-domes abutting on opposite sides form an oval nave, thus creating an axis. Hagia Sophia's ingenious plan amalgamates the desirable feature of the longitudinal basilican plan with that of the domed central plan in providing a single focus of attention as well as a vast open space.

While the dome of the second-century AD Pantheon in Rome was erected with relative simplicity on a circular base, that of Hagia Sophia rests on a square base formed by four huge piers. Transition from square to circle is achieved by the use of four pendentives, each shaped like a curved triangle; in effect, the

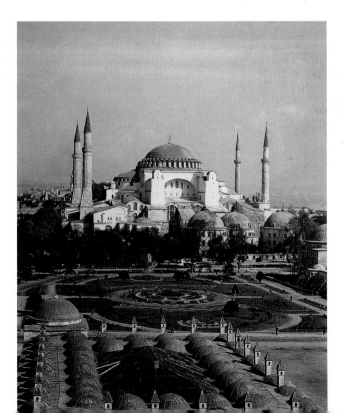

17. **Anthemius of Tralles and Isidorus of Miletus**, Hagia Sophia, Constantinople, 532–537

19. Interior of Hagia Sophia, Constantinople, 532–537. This unusual structure features a central dome with half domes on opposite sides, thereby combining the advantages of a longitudinal axis with those of a dome. The architects, Anthemius of Tralles and Isidorus of Miletus (the former described by Procopius as 'the most learned man in the skilled craft which is known as the art of building'), designed a church that was daringly experimental. Part of the central dome collapsed and had to be rebuilt.

dome rests on a larger dome from which segments have been removed. Hagia Sophia is one of the earliest examples of a dome on pendentives. This structural system produces an extremely lofty and uninterrupted interior space. From the inside, the dome seems to billow or to float as if it were suspended from above rather than supported from below. It is made of light-weight tiles, permitting the band of windows at its base. The light that streams through these windows is used as an artistic element, glittering in the mosaics and shining from the marbles. A polychromatic richness is created by the red and green por-phyry columns, the polished marble slabs on the lower walls, and the mosaics on the upper walls.

The First Golden Age of Byzantine art ended with the Iconoclastic Controversy or Iconoclastic Movement, a return to the Church's opposition to idols seen in the early years of Christianity. This was to be a long and acrimonious conflict, both religious and political. An imperial edict prohibiting reli-gious images was issued in 726. Four years later Emperor Leo III issued an edict calling for the destruction of all human repre-sentations of Jesus, Mary, saints, angels, and other religious personages, spawning important debate on the meaning of images – of icons (*ikons*).

Two opposing groups formed. The 'iconoclasts' interpreted the Bible's statement 'Thou shalt make no graven images' liter-ally. Because the iconoclasts believed the images themselves to

18. Plan of Hagia Sophia, Constantinople, 532–537

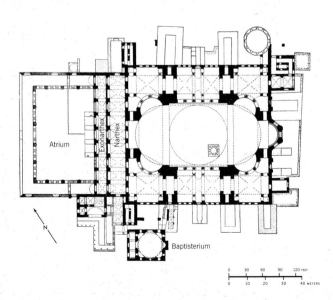

Atrium

Exonarthex

Narthex

N

Baptisterium

| 0 | 30 | 60 | 90 | 120 FEET |
| 0 | 10 | 20 | 30 | 40 METERS |

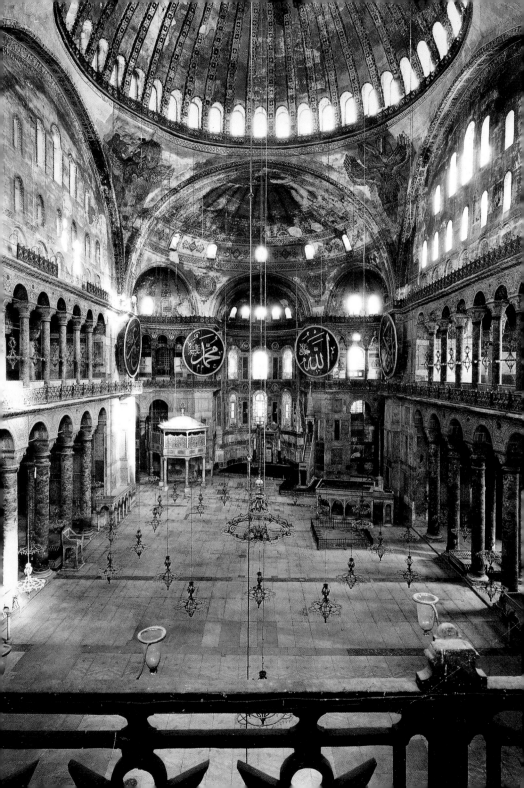

be the object of worship, art was seen to promote idolatry. Consequently, the iconoclasts thought religious art should be restricted to abstract symbols, plants, and animals. It should be noted that the iconoclastic emperors generously patronized the arts: they opposed only representational religious art (flora and fauna were considered suitable decoration for churches) but not other forms of representational art.

A very different position was taken by the 'iconophiles' ('icon-odules') – those who love images. The iconophiles accepted icons as objects of veneration in the belief that such objects served as windows onto the sacred and as avenues to the spiritual. The 'image' is different from the 'imaged.' Sacred images should be honored and respected, but not worshipped or viewed as magical.

The conflict ceased temporarily in 787 when, under the iconophile party, Empress Irene issued an edict at the Second Council of Nicea. In 815 Leo V reintroduced iconoclasm, although without the support of the general population. The dispute finally concluded in 843 with the triumph of the iconophiles under Empress-Regent Theodora and the reassertion of the iconophile position at the Council of Constantinople. With the iconoclasts defeated, a Second Golden Age of Byzantine art ensued. This was aided by an economy that had begun to improve by the mid-eighth century, the new prosperity evidenced by impressive church construction and redecoration of existing churches.

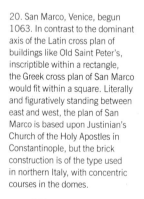

20. San Marco, Venice, begun 1063. In contrast to the dominant axis of the Latin cross plan of buildings like Old Saint Peter's, inscriptible within a rectangle, the Greek cross plan of San Marco would fit within a square. Literally and figuratively standing between east and west, the plan of San Marco is based upon Justinian's Church of the Holy Apostles in Constantinople, but the brick construction is of the type used in northern Italy, with concentric courses in the domes.

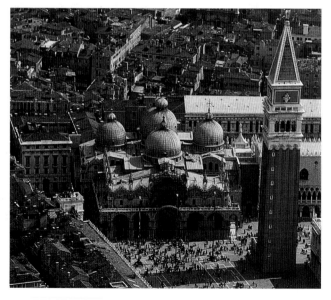

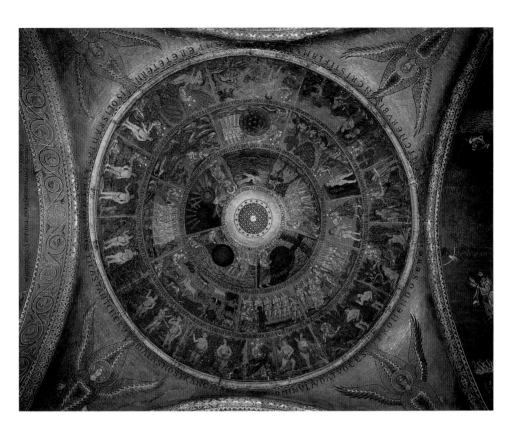

21. *Creation Dome*. Mosaic,
San Marco, Venice, c. 1200

The biggest and most elaborate church of the Second
Golden Age is San Marco (Saint Mark's) in Venice, a city built on
117 small islands that maintained long-standing commercial
ties to the Eastern Empire. Not surprisingly, San Marco, begun
in 1063, combines eastern and western qualities. The plan of the
church is a Greek cross and is based upon the plan of the Church
of the Holy Apostles in Constantinople: four arms of equal
length form a cross that can be inscribed within a square. A dome
rises above the crossing, with four other domes over each arm.
All five domes are covered with wood and gilt copper, giving San
Marco a tall, striking, and distinctive silhouette. The exteriors
of the domes, the original appearance of the facade, and other
portions of San Marco have been modified over the years.

The interior offers a visitor one of the ultimate experiences
in visual splendor. The vast space is quite dark, originally illumi-
nated only by small windows in the bases of the domes and by the
flickering light of countless candles. Yet all surfaces glitter, for
they are covered with mosaics made primarily of gold tesserae.

Among the many mosaics of San Marco, the most famous is the *Creation Dome* in the narthex, dated to *c.* 1200. This tells the story of Genesis in a sequence of scenes arranged in three concentric circles. The narrative begins in the innermost circle and includes the creation of heaven and earth; the separation of light from dark; the separation of water from earth; the creation of plants; the creation of the heavenly firmament; and the creation of fish, fowl, and animals. The story of Adam and Eve occupies a portion of the second circle and the outermost circle. Of particular interest is the scene in which God gives Adam his soul, usually represented as a tiny nude human with wings who enters Adam's mouth – like the breath of life that made man a living soul bestowed by God upon Adam in Genesis 2:7. These mosaics combine Byzantine and Early Christian styles; emphasis is on the decorative design and the didactic message rather than on realism and naturalism.

Additional notable examples of Byzantine architecture (and mosaics) in Ravenna are the Neon Baptistery, Sant' Apollinare in Classe, and Sant' Apollinare Nuovo. In Greece, Saint Eleutherion in Athens and the monastery church in Daphni (near Athens) deserve mention. In Sicily, Byzantine architecture and mosaics may be seen at Cefalù, Monreale, and Palermo.

Byzantine sculpture consists primarily of small-scale carvings in ivory or stone. The extraordinary technical skill of Byzantine carvers is demonstrated by the *Harbaville Triptych*, a late tenth-century ivory. A triptych consists of three hinged panels, the wings half the width of the central panel so that they can be closed over it to protect it or opened on an angle to enable the triptych to stand. (A diptych has only two panels; any work having more than three panels is simply referred to as a polyptych.) The *Harbaville Triptych* was made as a small portable altar for a wealthy person's private devotions at home or while traveling. The total dimensions, when fully open, are only 24.1 x 27.9 centimeters (9½ x 11 inches). Enthroned Jesus is flanked by St. John the Baptist and Mary who plead with him, asking God's mercy for humankind. Below, left to right, are five of the apostles: James, John, Peter, Paul, and Andrew. On the wings are warrior saints. In spite of the tiny size, the figures are graceful, the carving precise, and the details sharp. The original color added to the richness of the design and enhanced the clarity of the figures.

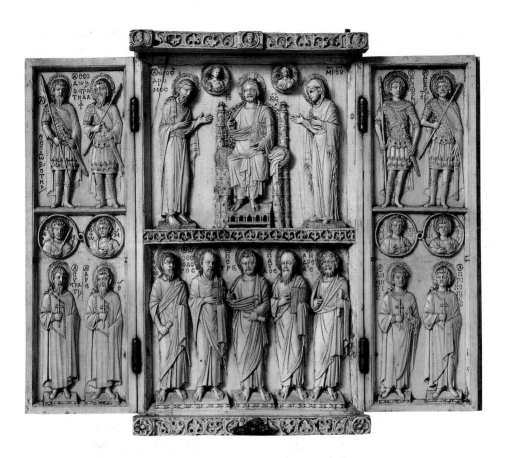

22. *Harbaville Triptych*. Ivory,
late 10th century, 24.1 x 27.9
(9½ x 11). Byzantine artists,
whether working in mosaic (Ill.
16), egg tempera (Ill. 1), or ivory,
as seen here, depicted the human
body in much the same manner –
attenuated and slender, often
with unnaturally small hands
and feet. Within those conventions,
the execution was technically
flawless.

A characteristic painting from the late Byzantine period
(the years following the Latin occupation, from *c.* 1250 until the
Turkish conquest in 1453) is the *Madonna and Child Enthroned*, a
late thirteenth-century work that represents a type long repeated
according to strict rules. It is an icon – a venerated image of a reli-
gious figure. The infant Jesus looks and acts like an adult, holding
the scroll of law in one hand and blessing with the other. Because
these figures serve as vehicles by which the pious encounter the
holy realm, no attempt is made to make them realistic. Thus Mary's
throne, which recalls the ancient Colosseum in Rome, is drawn so
that the interior and exterior do not correspond, the flat decora-
tive designs emphasizing spatial compression. Similarly, the foot-
stool does not obey the laws of perspective. Seemingly floating in
this golden realm are two roundels, each containing a half-length
angel carrying a staff, a symbol of Jesus' Passion, and an orb or
globe with a cross, a symbol of Jesus' domination over the world.

1

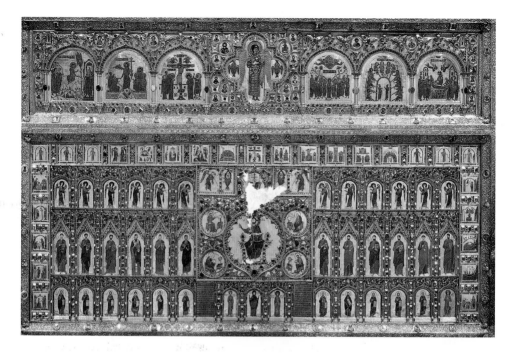

A particular Byzantine specialty was cloisonné enamel (see p. 134). By its nature, this medium is ideal for creating vividly colored two-dimensional patterns. The *Pala d'Oro* (Golden Altarpiece), in San Marco in Venice, is the largest extant Byzantine work in cloisonné enamel and among the most spectacular examples of enamel work ever created. It includes 137 enameled plaques made at different times and in different styles. The first *pala* was ordered from Constantinople and erected in 1105. It was renewed in 1209 and remodelled in 1345. Only one plaque can be firmly dated because it includes the name of the Empress Irene (1081–1118).

By the time Byzantium was conquered by Turkish forces in 1453, much of the Byzantine Empire had already been overrun.

20

23. *Pala d'Oro*, San Marco, Venice. Cloisonné enamel on gold plaques, late 11th century and later

24. *Empress Irene:* detail of the *Pala d'Oro*, San Marco, Venice. Cloisonné enamel on gold plaque, late 11th century and later, 17.4 x 11.3 (6⅞ x 4½)

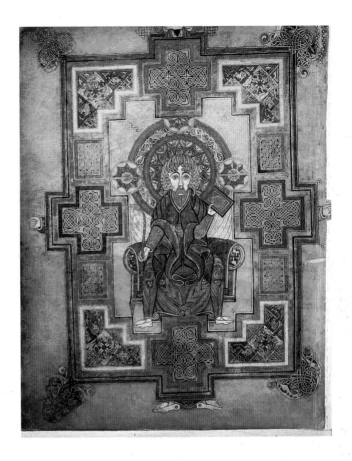

29. *St. John*. Manuscript illumination from St. John's Gospel, *Book of Kells*, c. 800, 33 x 24.1 (13 x 9½)

Carolingian Art

When Charlemagne (742–814) was crowned Emperor of the West by Pope Leo III in Rome on Christmas Day 800, it was a display of symbolic rather than actual authority. Charlemagne did nevertheless reorganize the political system, conquer territories, and expand the Empire as well as further the spread of Christianity. By his personal patronage he fostered the major achievements of the Carolingian Revival, encouraging classical studies and a renewed interest in learning and the arts, and making his court a focal point for these activities. His concern for the antique was perhaps partially motivated by its potential as political propaganda, for he sought to associate himself with the great rulers of antiquity. Indeed, a small bronze equestrian statuette, now in the Louvre in Paris, portrays Charlemagne in the guise of an ancient Roman emperor, recalling the large bronze equestrian statue of Marcus Aurelius on the Capitoline Hill in Rome.

31. Church of Saint-Riquier, Abbeville, consecrated 799, now destroyed. Engraving made in 1612 from an 11th-century manuscript illumination

32. Plan of a monastery. Modern version, with Latin inscriptions translated into English, of a drawing made in red ink on parchment, 820–830, 71.1 x 112.1 (28 x 44⅛). This plan, although never built, is invaluable for the quantity of information it offers on medieval monasteries and monastic life. The proximity of the infirmary and the cemetery suggests the insecurity and brevity of existence during the Middle Ages.

Charlemagne's capital was in Aachen, Germany, and his Palace Chapel was designed by Odo of Metz and built between 792 and 805. The Palace Chapel can be seen to be an adaptation of the octagonal plan of the Byzantine church of San Vitale in Ravenna. Like San Vitale, Charlemagne's chapel has an eight-sided interior, but the exterior is sixteen-sided. Echoes of ancient Roman architecture are evident in the massive masonry construction and semi-circular arches. In fact, the earliest surviving copy of the writings of the Roman architect Vitruvius, active in the time of Caesar and Augustus, is a ninth-century copy made by a Carolingian scribe.

Other than Charlemagne's Palace Chapel, little Carolingian architecture remains, yet Carolingian builders are known to have developed ideas that led to later medieval styles. An important example of this was the church of Centula, now called Saint-Riquier, near Abbeville, France. Consecrated in 799, it was the greatest basilican church of its time. Although Centula was destroyed, its appearance is known from an engraving that was made in 1612 from an eleventh-century manuscript illumination. Comparison between its plan and that of the Early Christian

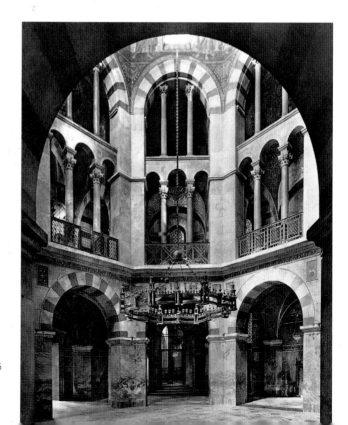

30. **Odo of Metz**, Charlemagne's Palace Chapel, Aachen, 792–805

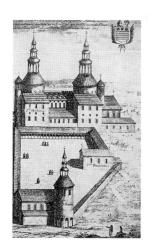

basilica of Saint Peter's in Rome, which also no longer survives, shows that the Early Christian basilica plan was modified during the Carolingian era to accommodate the changing needs of the congregation and of the Church. Innovations found at Saint-Riquier that would have future importance are: 1) a westwork (a monumental entryway) with two circular staircases; 2) a vaulted narthex that projects beyond the aisles, in effect forming a second transept; 3) a tower over the crossing of the nave and west transept, and a tower over the crossing of the nave and east transept; 4) two more circular staircases on the east; and 5) the addition of a square choir between the apse and nave. Finally, the multiple towers of Saint-Riquier foreshadow the complex and picturesque silhouettes characteristic of the churches of medieval Western Europe.

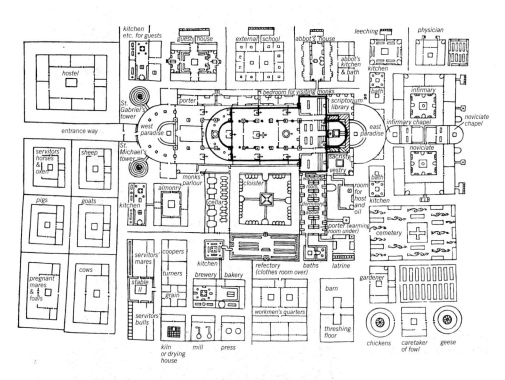

An important and highly instructive example of Carolingian architectural intentions is a monastery that was never more than a plan. Kept in the chapter library of Saint Gall, Switzerland, it is known as the plan of Saint Gall. A council met in Aachen in 816 and 817, decided upon a basic Benedictine monastery plan, made this drawing of it between 820 and 830, and sent it to the abbot of Saint Gall. The original plan is drawn in red ink on parchment and has Latin inscriptions explaining the function of each portion

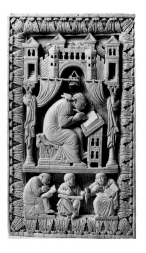

33. *St. Gregory Writing
the Canon of the Mass.*
Ivory plaque, 850–1000,
20.5 x 12.5 (8⅛ x 4⅞)

(it is shown here in a simplified form with modern translations). The plan was intended to serve as a model; each monastery that adopted it was expected to adapt it to that monastery's specific needs. Although no monastery was ever built in this exact form, the plan provides a good idea of what a medieval monastery included and how it was arranged. It was intended to be self-contained and self-sufficient: everything necessary for life is provided. The largest building is the church which, suited to the needs of monks rather than those of a congregation, has an apse and an altar at both ends, several entrances along the sides, and partitions dividing the nave. To the south of the church is the cloister, a rectangular space that is open to the sky, usually with a source of water in the center, and surrounded on all four sides by covered arcaded walkways. In the garth (the cloister garden) the monks could read, study, or meditate. On the south side of the cloister are the refectory (where meals were eaten); on the east the dormitory, baths, and latrines; and to the west are cellars. Further to the west are places for the animals. To the north, beyond the church, are the guest house, school, and abbot's house. To the east are the physician's quarters (with bloodletting specifically mentioned on the plan) and the infirmary, not so very distant from the cemetery. Several kitchens are located throughout the monastery. As to the degree of difficulty and hardship that came with life in such quarters, it may be worth noting that the plan includes more than one building for servants. However, little heating was included in the plan and winters must have been extremely difficult to endure.

Though physical comforts may have been ignored, aesthetic needs were not neglected. During the Carolingian period, sculpture generally was restricted to small pieces carved of ivory or made of precious metals and gems. Among the many surviving Carolingian ivory plaques is that of St. Gregory, dated between 850 and 1000. Gregory I, elected pope in 590, was one of the Latin fathers of the Church. He worked to abolish slavery and to prevent war but is perhaps best known today for having given his name to Gregorian chant. Between parted curtains, Gregory is shown writing the Canon of the Mass, inspired by the Holy Spirit in the form of a dove whispering in his ear. Below, three scribes are busy copying liturgical texts. Thus, this plaque, originally used to ornament the cover of a manuscript binding, depicts the actual working methods used in making the manuscript. Although the carving is technically exquisite and the manual dexterity displayed unsurpassed, the architectural background,

the disparity in the sizes of the figures, and their unnatural proportions are purely conventional.

A special category of small-scale sculpture consists of reliquaries, a reliquary being the container for a relic. A tangible item generally associated with a saint, a relic was usually a part of the revered person's physical body – skull, arm, foot, hair, even what was claimed, by more than one church, to be Mary's milk and Jesus' circumsized foreskin. It could also be an item owned by a saint or something with which he or she had contact. Some relics were believed to work miracles. Indicative of the importance attached to them, reliquaries were created in precious metals and set with gems. Highly valued stones were smoothed, rounded, and polished as cabochons, for during the Middle Ages stones were not cut in facets, as is customary today.

The purse reliquary of St. Stephen was made in the early ninth century of gold and silver gilt with precious and semi-precious stones over a wooden core. Several purse reliquaries exist, constructed in the shape of actual cloth purses but sparkling and shimmering with multi-colored gems. This purse reliquary is reputed to have contained earth bloodied by the first Christian martyr, St. Stephen, when he was stoned to death.

Gold and gems were also used to decorate manuscript covers, since the cover enclosing a sacred text was supposed to indicate the importance of the words. Among the most sumptuous of all book covers ever created is that of the *Lindau Gospels*, made *c*. 870 of gold, pearls, and semi-precious stones. Here the cabochons are

34. Purse reliquary of St. Stephen. Gold, silver gilt, precious and semi-precious stones over a wooden core, early 9th century, 12.6 x 32.1 x 9.5 (5 x 12⅝ x 3¾)

35. Cover of the *Lindau Gospels*. Gold, pearls, and semi-precious stones, *c*. 870, 34.9 x 26.7 (13¾ x 10½). The opulent incrustation of gems on this gold book cover reflects the reverence in which the words of the Gospel were held. Similarly, the care lavished on the illumination of manuscript folios indicates that neither expense nor time were to be spared on the embellishment of religious books during the Middle Ages.

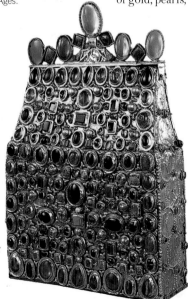

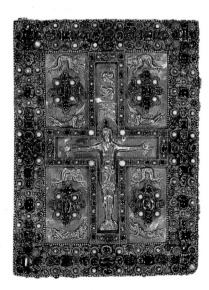

not set into the gold but raised up on little feet so that light can pass through, enhancing their glitter and brilliance. A rich variety of colors, shapes, and patterns is created by the cross, the heavily jeweled border, and the four jeweled medallions between the arms of the cross. Each of the eight figures around these medallions is different, posed to conform to the space available. All the raised figures are in *repoussé*, created by hammering from the back of the metal plaque. Although crucified, Jesus is not portrayed as dead for his body does not hang heavily from the cross; instead, he gestures as if speaking and appears weightless. He is shown triumphant over death, in striking contrast to later images which would portray him as suffering in death.

Interest in classical art was encouraged by Charlemagne, and the human figure became prominent in the visual arts once again. This is seen especially in the many manuscripts of the gospels and other sacred texts produced by Carolingian scribes and illuminators working in monastic and royal workshops.

One method of conveying information is seen in the *Utrecht Psalter*, dated 816–835, a French manuscript from the Reims school, made at Hautevillers or Reims. Here the ink drawings depict the Bible's words literally, even the metaphors and similes. Thus, in the bottom center, the illustration for Psalm 44:22, 'are we killed … as sheep for the slaughter,' actually depicts sheep. In the top center, for 44:23, 'Awake, why sleepest thou, O Lord?' God is shown in his bed, flanked by angels who extend their hands imploringly. And on the left is 44:25, 'our belly cleaveth unto the earth,' depicted by people literally lying on their bellies. These sophisticated little caricatures are rhythmic, energetic, forceful, and spontaneous, rendered in a rapid sketchy style with human gestures. The text of the *Utrecht Psalter* is in three columns, written in revived Roman capital lettering, which was centuries old by this time, and the figures, dress, and accessories are of a type current 400 years earlier.

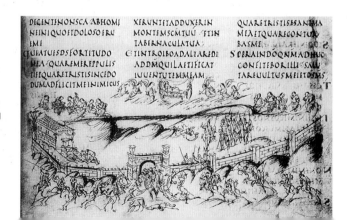

36. Psalm 44 from the *Utrecht Psalter*. 'You have let us be driven back by our foes; those who hated us plundered us at will.' Ink on vellum, made at Hautevillers or Reims, 816–835, approx. 33 x 25.1 (approx. 13 x 9⅞).

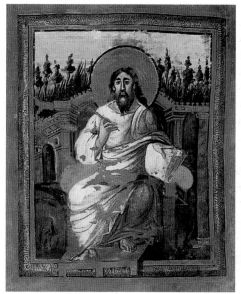

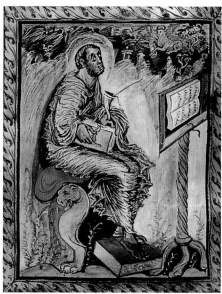

37. *St. John*. Manuscript illumination from the *Gospel Book of Charlemagne* (*Coronation Gospels*), c. 800–810, 32.4 x 25.1 (12¾ x 9⅞). Charlemagne's revival of the antique is evidenced in Carolingian manuscript illuminators' return to an art focused on the human figure depicted with a degree of naturalism and spatial illusionism. This is combined with abstract ornamental designs and overall decoration retained from the earlier Middle Ages.

38. *St. Luke*. Manuscript illumination from the *Gospel Book of Archbishop Ebbo*, 816–835, 26 x 19.7 (10¼ x 7¾)

The *Gospel Book of Charlemagne*, also known as the *Coronation Gospels*, dated c. 800–810, is connected with Charlemagne's court at Aachen and is said to have been found in his tomb. In this manuscript, St. John is portrayed in the Roman tradition, the style similar to that of wall paintings found in the ancient Roman cities of Pompeii and Herculaneum. John has normal body proportions and wears a garment much like a Roman toga. A frame has been painted on the vellum folio, creating the impression that the viewer looks through a window to see John outdoors, beyond the picture plane, the legs of his footstool overlapping the frame.

The depiction of St. Luke in the *Gospel Book of Archbishop Ebbo*, dated between 816 and 835, and illuminated for Archbishop Ebbo of Reims, departs from classical restraint in its motion and emotion. Around the figure are swirls of agitated drapery seemingly blown by a strong wind into flame-like nervous ripples. Even the landscape is oddly animated, for the hills sweep up. Everything appears to be moving in this energetic and dynamic style. Luke, too, is shown in the process of writing his gospel, for he holds an ink horn and a quill pen. He looks up to his symbol, the winged ox. The four Evangelists – Matthew, Mark, Luke, and John – are identified in medieval art by their symbols, known as the *animalia*: Matthew's symbol is the winged man; Mark's the winged lion; Luke's the winged ox; and John's the eagle.

Charlemagne's death in 814 was followed by a period of political instability that ended in 843 with the Treaty of Verdun. The Carolingian Empire thereby was divided into three parts under Charlemagne's grandsons: Charles the Bald controlled France; Louis the German controlled Germany; and Lothair controlled Lorraine. In 870 Lorraine was divided between Charles and Louis, whose domains roughly equalled today's France and Germany. In 911 the last Carolingian monarch died.

Ottonian Art

A new dynasty came to power when Otto I, known as Otto the Great, was crowned by the pope in 962. His empire, soon to be known as the Holy Roman Empire, was largely Germanic, and Germany led the world culturally. There was no abrupt change in art. Ottonian art is essentially a continuation of Carolingian.

This is demonstrated by Saint Michael's in Hildesheim, a Benedictine abbey church, built between 1001 and 1031, and initiated by Bishop Bernward, a patron of the arts. The plan of Saint Michael's recalls that of the Carolingian church of Saint-Riquier in the two transepts with towers, two apses, circular stair turrets, and side entrances. An alternating system of supports is used in the nave: two columns, one square pier, two columns, one square pier, and two columns, thereby creating an AABAABAA pattern

31

39. Abbey church of Saint Michael, Hildesheim, 1001–31. Built for Bishop Bernward of Hildesheim, damaged in World War II, and restored

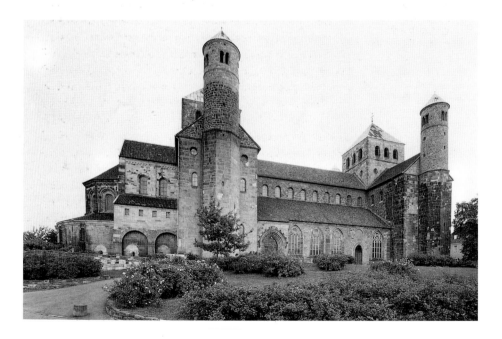

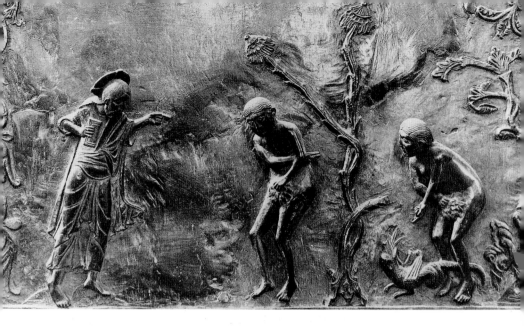

40. *Adam and Eve Reproached by the Lord*. Detail of bronze doors from Saint Michael's, Hildesheim, 1011–15. Doors 5.03 meters (16′ 6″) high, each panel approx. 55.9 x 106.7 (approx. 22 x 42). Cast for Bishop Bernward of Hildesheim, the doors were moved by his successor, Bishop Godehard, to Hildesheim Cathedral, where they stand today.

that effectively divides the interior into three spaces. The spaciousness of the interior is enhanced by a large unadorned area of wall surface between the nave arcade and the clerestory windows. The column capitals are twelfth-century work, and the painted wooden ceiling dates from the thirteenth century.

For Saint Michael's, Bishop Bernward had an enormous pair of bronze doors 5.03 meters (16 feet 6 inches) high made between 1011 and 1015. An impressive technical accomplishment, each door is a solid cast, as opposed to doors made of wood to which small bronze plaques are nailed. Within rectangular formats, the left door has eight scenes from Genesis and the right has eight from the Life of Jesus, thus paralleling the Old and New Testaments.

The scene of Adam and Eve reproached by the Lord may be singled out as one of the most memorable examples of visual story-telling ever created. God points his finger at Adam, accusing Adam of disobeying his sole commandment against eating the forbidden fruit in the garden of Eden. Adam, having succumbed to temptation and eaten the fruit of knowledge, is now aware of his nakedness and therefore covers himself with one hand. With the other hand, however, he points to Eve, thereby attempting to pass the blame. Eve, also having eaten the fruit, covers her nakedness with one hand, while pointing with the other to the serpent who tempted them to eat the forbidden fruit. Thus Eve, too, passes the blame. The gestures tell the story in a manner that is simple and direct, dramatic and emphatic. This is

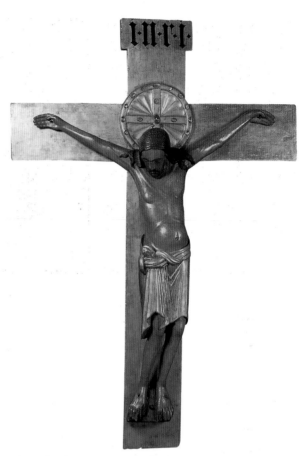

41. *Gero Crucifix*, Cologne Cathedral. Oak, *c.* 975–1000 (nimbus and stem of cross modern), height 1.88 meters (6' 2"). The profound drama seen here, although a departure from the usual emotional neutrality of art of the time, would later become a characteristic of Gothic art. A relic and the host (communion wafers) were contained in a cavity within the head.

genuine visual narrative: words are unnecessary. The background is almost blank, the setting reduced to the absolute minimum that will suffice to tell the story.

Ottonian sculpture was also capable of conveying profound emotion, as seen in the *Gero Crucifix*, which was given by Archbishop Gero of Cologne to that city's cathedral and remains there today. Dated between *c.* 975 and 1000, carved of oak, 1.88 meters (6 feet 2 inches) high, it is one of the oldest monumental wooden sculptures to survive from the Middle Ages. A century earlier, on the cover of the Carolingian *Lindau Gospels*, Jesus was shown alive, standing erect, and triumphant over death. But the *Gero Crucifix* offers a very different and far more emotional image of Jesus – one which renders him more human, for suffering is seen on his face, the sunken eyes revealing his agony. His head hangs to one side, his body sways to the other. The skin pulls across the shoulders, indicating the weight of his body hanging

35

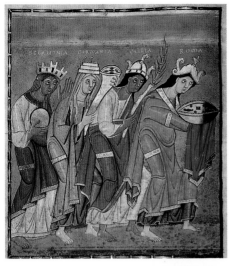

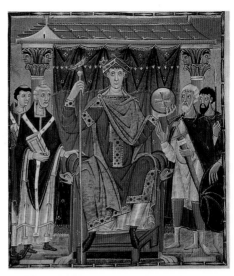

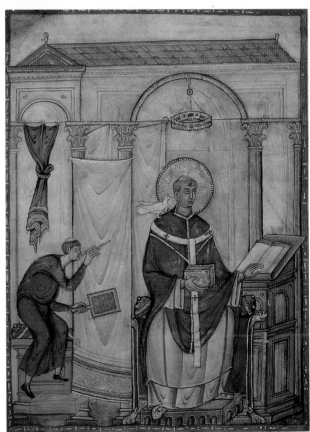

42. *The Four Provinces Pay Homage to Otto III*. Manuscript illumination from the *Gospel Book of Otto III*, late 10th century or *c*. 1000, 33 x 23.7 (13 x 9⅜)

43. *Otto III Surrounded by Ecclesiastics and Secular Dignitaries*. Manuscript illumination from the *Gospel Book of Otto III*, late 10th century or *c*. 1000, 33 x 23.7 (13 x 9⅜)

44. **Gregory Master**, *St. Gregory*. Manuscript illumination from the *Registrum Gregorii* (letters of St. Gregory), perhaps executed at Reichenau, 983, 27 x 20 (10⅝ x 7⅞)

from the nails, and his abdomen bulges. Realism is used here for expressive intensity. This portrayal is intentionally poignant and moving, evoking the viewer's sympathy. The image of Jesus as the suffering 'Man of Sorrows' begins.

The human figure continued to feature prominently in Ottonian manuscript illumination, with superb examples such as the depiction of St. Gregory in the *Registrum Gregorii* (the letters of St. Gregory), made perhaps at Reichenau. The manuscript was given by Archbishop Egbert to his cathedral at Trier in 983. This folio shows Gregory with his attributes: the dove on his right shoulder is a reference to the story that the Holy Ghost in the form of a dove dictated Gregory's writings to him, seen also in the Carolingian ivory plaque illustrated on p. 46. The illumination shows Gregory with a manuscript in each hand. The architectural background is, as usual, rendered without any form of perspective: both the side and the end are drawn parallel to the picture plane. Similarly, relative scale is disregarded and Gregory is drawn much bigger than his monk-secretary, thereby indicating Gregory's greater importance. The style of this manuscript is highly refined and its creator, known as the Gregory Master, is regarded as one of the finest Ottonian painters.

The *Gospel Book of Otto III*, illuminated in the late tenth century or around 1000, contains a depiction of the four provinces coming to pay homage to Otto III. Only rarely is there a relationship between facing folios, and this specific arrangement is a novelty in manuscript illumination. The provinces are personified by female figures, each bearing a gift and each wearing a different costume. Otto III is enthroned between pairs of dignitaries representing the secular and religious sectors of his realm.

The purpose of this image is to exult the emperor. Otto, conventionally represented larger than anybody else, stares straight ahead, stiffly erect and frontal, in contrast to the dignitaries who assume relaxed poses. The provinces, meant to display respect and reverence for their ruler, are shown by their bent poses to be humbled, much like Gregory's secretary: this is medieval 'body language.' Decoration, narration, and political glorification of Otto III are far more important than realism.

Chapter 3: Romanesque in Central France and Along the Pilgrimage Roads

So it was as though the very world had shaken herself and cast off her old age, and were clothing herself everywhere in a white garment of churches ... the faithful rebuilt and bettered almost all the cathedral churches ... monasteries ... and smaller parish churches ...

Thus wrote the monk Raoul Glaber in the early eleventh century at the church of Saint-Bénigne in Dijon when, contrary to popular expectation, the world did not end in the year 1000. In fact, Saint-Bénigne was started in 1001 as part of the spurt of building just after the year 1000. When the dreaded date passed safely, architects, artists, and artisans immediately went to work. A new style developed in France, spread over Western Europe, and became the dominant style in this area during the eleventh and twelfth centuries.

The term Romanesque was originally applied to architecture; sculpture, painting, and other arts created in the same area and era are also now referred to as Romanesque. Although once regarded by historians as merely a primitive stage of the Gothic, today the Romanesque era is recognized for its own highly distinctive characteristics. Because Romanesque art lacks the neat chronological development of the later Gothic, the discussion that follows is organized by geography as well as by chronology.

A very early and starkly simple example of Romanesque architecture is the monastery of Saint-Martin at Canigou, in the French Pyrenees. Arrival at Canigou is an uplifting experience – figuratively and literally. The former depends upon your faith and the latter upon your fitness, for the monastery occupies a splendid spot on a mountain top. The monastery is dedicated to Jesus and to St. Martin of Tours (*c.* 316–370). Great importance was accorded to St. Martin during the Middle Ages and the story of him cutting his cloak in two and giving half to a naked freezing beggar at Amiens was used as the model of charity.

Saint-Martin is a monastery of the Benedictine Order which emphasizes prayer and work. Benedict, founder of the Order, was born in central Italy around 480 and studied in Rome, but, seeking solitude, left his books and family fortune and went to Subiaco. He lived there and at Monte Cassino, where he built a

45

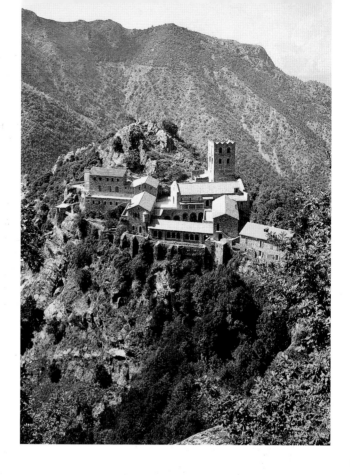

45. Monastery of Saint-Martin, Canigou, 1001–1126

monastery. Benedict's significance stems from his famous Rule, which created a pattern of living in communities for monks, whereas previously those seeking spiritual perfection did so in solitude as hermits. Benedict's twin sister, St. Scholastica, was the first Benedictine nun; when Benedict died in 547 he was buried with Scholastica on the top of Monte Cassino. His Rule was to serve as a model for numerous monastic communities throughout the Middle Ages.

As was customary in the construction of a medieval monastery, the church was the first building erected at Canigou. Begun in 1001, the extremely simple church consists of only a nave, flanking aisles, and a semi-circular apse. The rough stone interior, with a single-story elevation (without a clerestory) and a massive semi-circular vault, is stark, elemental, and primitive. Devoid of superfluous ornament, the simplest capitals are supported on the plainest cylindrical columns.

The cloister – a monastic feature noted in the Carolingian plan of Saint Gall – abuts the side of the church. As is typical, the cloister consists of covered arcaded walkways surrounding a garden with a source of water in the center. Although a medieval cloister is usually square or rectangular in plan, the cloister at Canigou is irregular due to the uneven sloping terrain.

32

Further north, in the Loire Valley, at Saint-Benoît-sur-Loire, are the Benedictine abbey church and porch tower of Saint-Benoît-de-Fleury. Although Lombard invasions between 577 and 580 destroyed the burial site of Benedict's remains at Monte Cassino, bones claimed to be his were brought in 672 or 673 to the abbey of Fleury, which was consequently renamed Saint-Benoît-de-Fleury. As already noted, relics were important for both religion and revenue: acquisition of these relics made Saint-Benoît a pilgrimage site and the abbey grew to be rich and famous.

Several churches preceded the one on this site today, the repeated rebuilding the result of fires in 865, 974, 1002, and 1026. The porch tower was unfinished at the time of the last fire. Today, all that remains of the abbey are the church and the porch tower: everything else was destroyed during the French Revolution. Fortunately, the church and porch tower are in

46. Nave looking toward apse, monastery of Saint-Martin, Canigou, 1001–1126

47. Porch tower, Saint-Benoît-de-Fleury, Saint-Benoît-sur-Loire, first half of 11th century

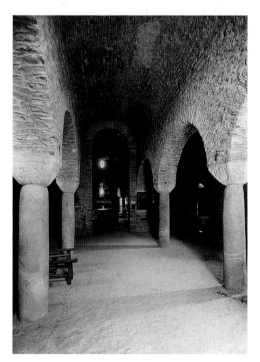

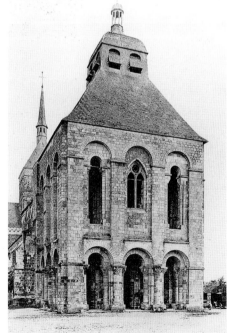

superb condition and are considered among the most beautiful and most important survivals of the Middle Ages. The upper part of the two-story porch tower, the wooden roof, and the bell turret, are, however, seventeenth-century work.

The porch tower of Saint-Benoît is unusual, if not unique, in Romanesque architecture for few Romanesque churches have large front porches and certainly not to this scale. One theory holds that the porch tower was originally isolated and free-standing, but its purpose remains a puzzle. Certainly it is impressive, a massive monument with the thick walls and round arches characteristic of Romanesque buildings. Saint-Benoît's masons used the local stone of the Loire Valley – an especially beautiful white or buff-colored limestone – to construct the ashlar masonry walls, each block of stone neatly shaped with right angles. A chronicle tells of cut stone brought down the Loire River from Nivernais (an old province in central France) by Abbot Gauzlin, who may have been responsible for the two-story porch.

The porch is squarish in plan with three openings on each side created by huge squat piers, each surrounded by engaged columns. Yet to walk on this porch is slightly dizzying, like wandering within a stone forest or labyrinth, because the plan is significantly askew, with the piers irregularly placed and unevenly spaced.

The form of the porch tower may have been symbolically associated with the heavenly city of Jerusalem, based upon John's vision in his Book of Revelation (Apocalypse), the last book of the Bible, written c. AD 95–100, perhaps on the island of Patmos, where John had been exiled by the Roman emperor Domitian. (An apocalypse is a revelation of God's secrets in regard to coming events, especially the end of time.) John described Jerusalem as square in plan (Rev 21:16), having 'on the east three gates; on the north three gates; on the south three gates; and on the west three gates' (Rev 21:13), and says that these gates are always open (Rev 21:25), much like the three openings on each side of Saint-Benoît's porch tower. Reinforcing this biblical association, the sculpture includes scenes from the Apocalypse and the Last Judgement. Thus the Bible appears to have served as a source for both the architectural structure and the sculptural themes. Romanesque artists, their patrons, and their audiences were thoroughly familiar with the biblical texts, although this was more often the result of hearing the stories rather than reading them; Romanesque sculpture was the equivalent of a picture book for the unlettered medieval populace.

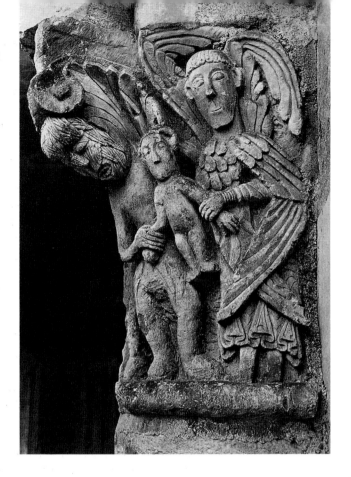

48. *A Soul between an Angel and a Devil*. Capital on lower level of porch tower, Saint-Benoît-de-Fleury, Saint-Benoît-sur-Loire, *c.* 1050

The column capitals on both levels of the porch tower are sculpted. Concentration of ornamentation on the capitals is a characteristic of the eleventh-century early Romanesque, whereas in the twelfth century the sculptor's territory expanded to include entire portals and cloisters. The fifty-four capitals on the lower level, dated to *c.* 1050, are generally considered to be of greater interest than the seventy-eight capitals on the upper level, dated to *c.* 1070–80. Prior to the eleventh century, column capitals tend to be decorated with foliage, a tradition that goes back to antiquity, whereas in the Romanesque era the vocabulary of subjects was enriched enormously. On one of these capitals on the lower level is a rare example of a signature of a Romanesque artist, which says UNBERTUS ME FECIT, Latin for 'Unbertus made me.'

A Soul between an Angel and a Devil on one of the capitals is a charming and literal rendering of the concept of good and evil forces trying to claim a human soul, depicted in medieval art as a

49. Plans of the five great
pilgrimage churches:
(a) Saint-Martin, Tours
(b) Saint-Martial, Limoges
(c) Sainte-Foy, Conques
(d) Saint-Sernin, Toulouse
(e) Santiago de Compostela

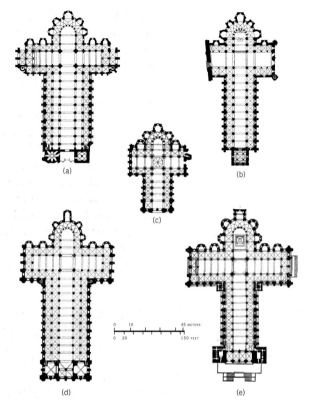

(a)

(b)

(c)

0 10 45 METERS
0 20 150 FEET

(d)

(e)

small person that enters one's mouth at birth (see San Marco's *Creation Dome*, p. 36) and emerges from the same orifice at death.[21] The angel wears a finely pleated gown whereas the devil's garment is coarse and crude, and the angel's face is in light whereas the devil's is in shadow – a subtle device found elsewhere. Saint-Benoît's capitals are still quite hesitant in style, experimental and naive, the bodies boneless and awkward – yet their message is clear.

Saint-Benoît was noted to be a pilgrimage site. Pilgrimages were an aspect of Christian life during the Middle Ages as well as an important source of artistic and intellectual exchange of ideas between people from different countries. The avowed purpose of undertaking a pilgrimage was to visit sacred sites and to worship relics (see pp. 15 and 133), especially those believed to have miraculous powers. A great many people traveled long distances along the pilgrimage roads. Facilities, some built specifically for pilgrims, were located every twenty or so miles – not a difficult distance to cover in a day. There were churches, abbeys, priories, monasteries, hospices in which people slept in large open halls,

and special chapels in which religious services were held. Charities aided the sick and the destitute, and buried the dead.

One of the major pilgrimage goals was the church of Santiago de Compostela (Saint James of Compostela) in north-western Spain. This church and those located on the roads leading to it are referred to as 'pilgrimage churches.' Of the original five great Romanesque pilgrimage churches, three remain – Saint-Sernin in Toulouse, Sainte-Foy in Conques, and Santiago de Compostela – and two are now gone – Saint-Martin in Tours and Saint-Martial in Limoges. These five churches had certain similarities. All had a Latin cross plan, a large nave with flanking aisles and a transept to accommodate the many pilgrims, a choir, ambulatory, and chapels on the transept and apse (radiating chapels). All five had a barrel vault above the nave and no clerestory. Even Sainte-Foy, the smallest of these churches, is quite large. So numerous were the pilgrims that many of the secondary pilgrimage churches were also of significant size.

99, 100

50. Saint-Sernin, Toulouse, begun c. 1070 or 1077

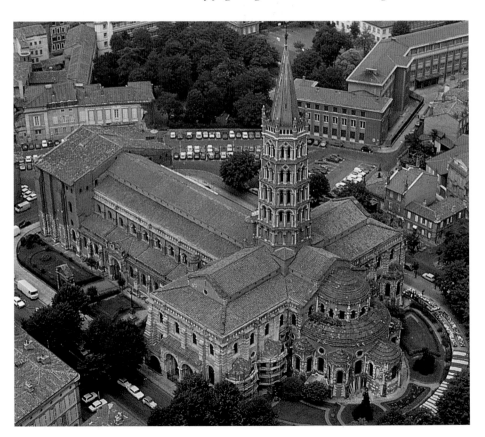

Construction of Saint-Sernin was started *c.* 1070 or 1077. The high altar was consecrated in 1096 and the apse end built by about 1098. It was customary to begin the construction of a church at the apse end, the most liturgically significant area, and then to build toward the entrance. With few exceptions medieval churches were built with the apse toward the east and the entrance toward the west.

Each space – nave, crossing, transepts, apse, ambulatory, chapels – is separate, neat, and discrete in Romanesque architecture, in contrast to Gothic churches in which one space flows freely into the next. The many different roof levels of Saint-Sernin clearly indicate the interior plan. Each chapel is a defined bulge, the ambulatory curves around the apse that rises above it, and these several levels build up to the crossing tower. This crossing tower/belfry was made higher in the Gothic era than the Romanesque builders intended, and was not finished until the nineteenth century. The original plan, in accordance with the Romanesque norm, called for two facade towers but they were never completed.

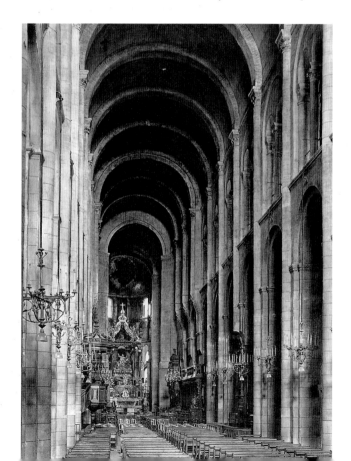

51. Nave looking toward apse, Saint-Sernin, Toulouse, begun *c.* 1070 or 1077. The quintessential example of the type known as the 'pilgrimage church,' Saint-Sernin's nave is characterized by a barrel vault, solid walls, and massive supporting piers. The readily apparent structural system produces a sense of security while the absence of windows, and therefore direct natural light into the nave, results in an atmosphere of mysterious darkness.

The proportions of Saint-Sernin were determined using mathematical ratios. The basic unit is the square bay of the aisles; the bays of the nave and transept are twice as large; the crossing tower is four times the basic unit; and the same is true of the bases of the intended facade towers. The use of mathematics to achieve pleasing proportions in architecture is hardly an innovation at Saint-Sernin, for the ancient Greeks had used numerical ratios in the construction of their temples.

The nave is typically Romanesque in its massive proportions, thick walls, semi-circular arches, closely spaced piers, engaged columns, and vaulted ceiling. Romanesque buildings are constructed mostly of cut stone and rubble, which have little cohesive quality and therefore limit the scale of the vaults. The enormous vaults constructed by the ancient Romans were of concrete, but the technique of mixing concrete did not continue into the Middle Ages. Instead, Saint-Sernin's nave is covered by a barrel vault of stone reinforced with semi-circular ribs. This form of nave vaulting – the most frequently used during the Romanesque era – provides several significant advantages over earlier flat wooden ceilings, such those of the Early Christian basilicas of Old Saint Peter's and Santa Maria Maggiore, both in Rome. Romanesque naves provide superb acoustics as the chants reverberate through the vaulted space, filling the church with music. Further, the stone vault is fire-resistant – of great importance during the Middle Ages when fire was a constant threat, especially to buildings illuminated by candles flickering below wooden ceilings. However, the fire hazard is not entirely eliminated because above the stone vault is a wooden roof, covered with tiles and steeply pitched to cause rain water to run off rapidly.

Because the stone barrel vault is an extension of the true arch principle, its dynamic structure exerts a constant lateral thrust that must be buttressed to prevent its collapse. In the Romanesque structural system, this buttressing is accomplished largely by the thickness and weight of the stone walls. In contrast, the introduction of flying buttresses in the Gothic era would eliminate the requirement for massive walls and would make possible an almost total elimination of weight-bearing walls.

Saint-Sernin's two-story nave elevation consists of the arcade and the galleries above. The decorative motif used repeatedly along the galleries of two small arches within a larger arch recurs frequently in the Romanesque and in later styles. However, the necessity of supporting the great weight of the

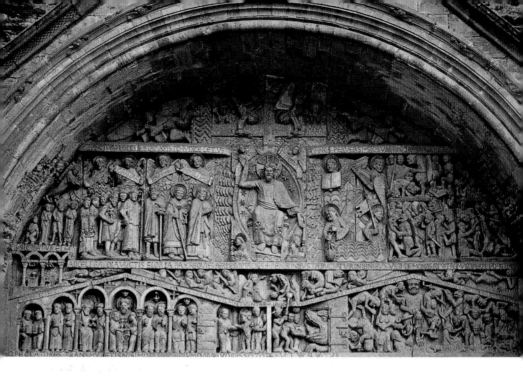

52. *Last Judgement.*
Tympanum, Sainte-Foy,
Conques, 12th century

stone vault does not allow for clerestory windows which would
weaken the structure and, although there are windows in the
aisle walls, the nave is quite dark.

A source of direct light is provided by the octagonal lantern
above the crossing of the nave and transept. The four corbeled
squinches provide the transition from the four corners of the
crossing below to the eight-sided lantern above. When the belfry
tower was added above, the four crossing piers had to be made
larger to support its weight, adversely affecting the interior view.
Still further to the east, the choir does have a clerestory.

The other major extant pilgrimage church located on the
roads leading to Santiago de Compostela is Sainte-Foy (Foi) in
Conques. Pilgrims traveled by donkey or on foot to reach this
impressive hillside location in a remote valley of the Auvergne
region. Today, Conques retains many of its medieval houses and
atmosphere and there is still only one access road on either side
of the tiny town.

Construction of Sainte-Foy was started about 1050 under
Abbot Odolric. Like Saint-Sernin, Sainte-Foy has all the typical
elements of a pilgrimage church plan: nave, aisles, transepts,
choir, apse, and radiating chapels off the ambulatory – but all
are on a smaller scale. Indeed, Sainte-Foy is basically a small

version of Saint-Sernin, for in both buildings the two-story nave elevation consists of the arcade and gallery, all arches are semi-circular, the nave is covered by a barrel vault, and the only source of direct light in the nave is the crossing belfry (early twelfth-century at Conques).

The main centers of Romanesque sculpture were in central, southern, and southwestern France, and in northern Spain. The sculpted twelfth-century tympanum (the semi-circular area above the doorway) on the facade of Sainte-Foy is a major monument of medieval art. This tympanum retains some of its original twelfth-century color – a rare survival on exterior medieval sculpture due to the protecting hood of the porch, favorable climate, and the absence of restorers with so-called good intentions. Romanesque tympana frequently feature a large central figure of Jesus within a mandorla, an almond-shaped glory of light, outside of which the subjects vary.

At Sainte-Foy, the subject of the tympanum is the Last Judgement, a popular medieval subject intended to show people the ultimate reward or punishment for their actions. If love of God did not deter people from sin, it was believed that perhaps fear of Hell would be more effective. To this end, medieval religious art employed what may be termed 'visual intimidation' to mold public behavior. In addition, at Sainte-Foy a verbal reminder is carved along the borders of the tympanum. This long rhymed inscription, presumably composed by monastery scholars, translates:

The assembled saints stand before Jesus their judge, full of joy. Thus are given to the chosen, united for the joys of heaven, glory, peace, rest and eternal light. The chaste, the peaceable, the gentle, the pious are thus filled with joy and assurance, fearing nothing. But the depraved be plunged into Hell. The wicked are tormented by their punishments, burnt by flames. Amongst the devils, they tremble and groan forever. Thieves, liars, deceivers, misers, ravishers, are all condemned with criminals. Sinners, if you do not reform your ways, know that you will have a dreadful fate.

The Sainte-Foy tympanum shows Jesus as the supreme judge, raising his right hand to welcome the saved to Heaven and lowering his left to banish the damned to Hell. According to medieval thought, whether one's soul went to Heaven or Hell was determined by weighing the soul which literally was shown to 'hang in the balance' in medieval art. At Sainte-Foy, the actual

weighing is performed by a competing angel and devil. Although only the pans remain from the scales, it is evident that the devil cheats – he pushes the pan down with his finger – but loses this soul nevertheless. Below, an angel welcomes the saved to the Gate to Heaven on the left and a devil forces the damned into the Mouth of Hell on the right.

In Hell, each person is punished according to his or her sin. Moreover, greatly encouraging the good behavior of the residents of twelfth-century Conques, specific sins are believed to have been represented by specific people who were guilty of them! For example, Pride, a neighbor of the abbey who coveted its wealth, is shown as an unsaddled horseman – one devil pulls him off his horse while another stabs him in the back. Lust is represented by a naked man and woman tied together, hands bound (the devil above asks Satan what their torture should be). Sloth is portrayed by a man lying idle under Satan's feet, burned by the flames of Hell. Avarice is shown as a miser, identified by a sack of coins around his neck – now he hangs by its cord. The tongue of the Slanderer is torn out by a devil. Just above is the Poacher who hunted in the abbey's woods, being cooked on a spit, like a rabbit, *by* a rabbit. Now chef, the rabbit has its revenge. This last image is among the many humorous examples of the medieval 'world turned upside down' in which the victim becomes victorious, a comic perversion by inversion of the natural order.

The visitor who passes beneath this tympanum enters a nave with a stone barrel vault for, as noted above, this was usual for Romanesque churches of significant size. Because this structural system does not permit direct sunlight in the nave, various inventive solutions were devised to alleviate the problem of interior darkness.

A clever system of nave vaulting can be seen, for example, in the church of Saint-Philibert in Tournus in Burgundy. An earlier church here was destroyed in 937 by an invasion and much was burned, emphasizing the advantage of fire-resistant stone vaulting. Another nave was built in 980 but burned in 1007 or 1008. Saint-Philibert was then roofed with wood between 1008 and 1028. It was given the nave vaulting seen today in the 1060s or at the end of the eleventh century, although it is possible that the diaphragm arches that divide the nave into bays are earlier. Each bay is covered by a transverse barrel vault, the axis of which runs perpendicular to the axis of the nave. The advantages of this structural system are that these vaults do not exert thrust on

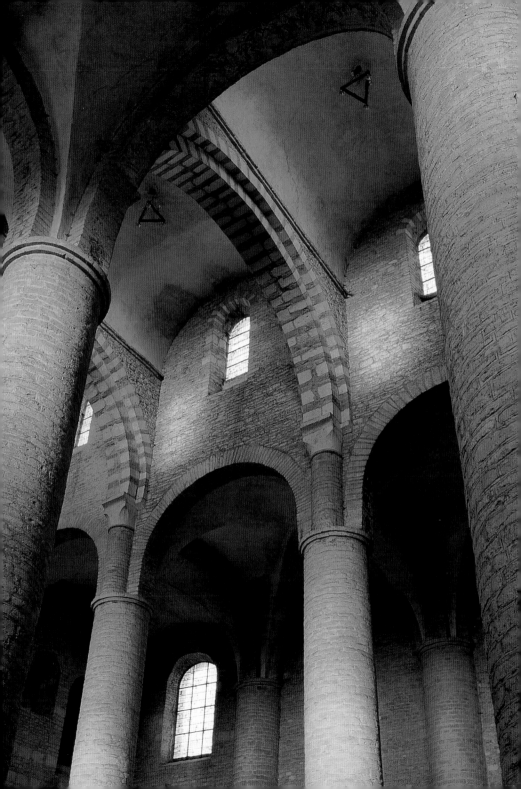

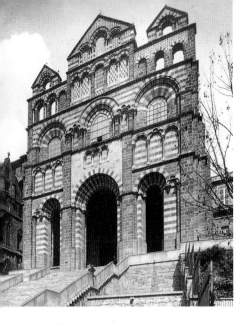

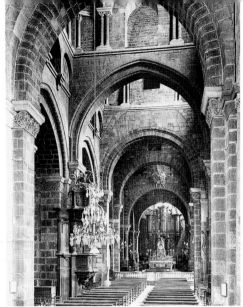

54. Cathedral of Notre-Dame, Le Puy, begun 11th century; facade, 12th century

55. Nave of Cathedral of Notre-Dame, Le Puy, begun 11th century. This nave demonstrates another of the several ways in which Romanesque churches were vaulted during this era of architectural experimentation. A series of domes, octagonal ovals in plan, provide the same advantage as the transverse vaults in Saint-Philibert (Ill. 53), for they permit the construction of windows in the nave.

the lateral walls and that flat spaces are left on these walls for windows. The severe grandeur of the nave is impressive, the great thickness of the walls creating an almost sculptural quality. The appeal of this bold style is based on large simple shapes rather than on decorative ornament.

Yet another type of nave is seen in the Cathedral of Le Puy in Auvergne, which occupies an impressive location on a steep slope rising above the city. Le Puy is on a pilgrimage road: the first recorded group of pilgrims (almost 200 monks) who traveled to Santiago de Compostela in 951 was led by Bishop Godescalc of Le Puy. Construction of the cathedral started in the eleventh century although the facade of multi-colored local granite is twelfth-century work.

Le Puy is the most important and obvious example of Moorish influence on French architecture during the Romanesque era. There had long been contacts between the city of Le Puy and the South, including Muslim Spain. Indeed, Muslim influences are seen in the picturesque silhouette created by the big towers with their stories of arches, polychrome stone patterns, cusped shapes on arches and doorways, and inscriptions written in Kufic (Arabic letters). Elsewhere, too, there was active trading of ideas between Spain and France – both exportation and importation of artistic inspiration. French masons and sculptors worked in Spain and returned home again, bringing Muslim influences into France.

The nave of Le Puy Cathedral is covered with a series of octagonal domes. This system was used for the six older bays of the nave constructed in the eleventh century. In the twelfth century the building was extended out over the slope on the west to form both a porch and a crypt, and the two smaller bays of this extension were also given octagonal domes. The transition from the octagon of each dome to the rectangle of its base is made by squinches, much like those found in Muslim architecture, and the bays are divided by diaphragm arches. Semicircular and pointed arches are used in combination. Other domed Romanesque churches are the Cathedral of Saint-Pierre in Angoulême (Charente); Fontevrault (Maine-et-Loire); Saint-Front in Périgueux (Dordogne); and Saint-Hilaire in Poitiers (Vienne).

Beside the Cathedral of Le Puy is an inviting cloister, constructed, as was customary, to a rectangular plan with a source of water in the center of the garth which is crossed by paths and bordered on all four sides by covered arcaded walkways. At Le Puy the patterned masonry has an Oriental quality, with Muslim echoes in the polychromy of the gallery arcade, adding spice and richness. Influences from Spain, North Africa, Sicily, and the Near East combine comfortably here.

Worthy of mention near Le Puy is the Chapel of Saint-Michel, a striking Romanesque remnant from the eleventh century situated on a rock so vertical and narrow that it is known as 'the needle.'

56. Cloister of Cathedral of Notre-Dame, Le Puy, 12th century

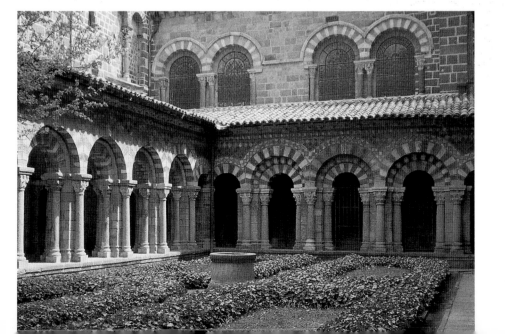

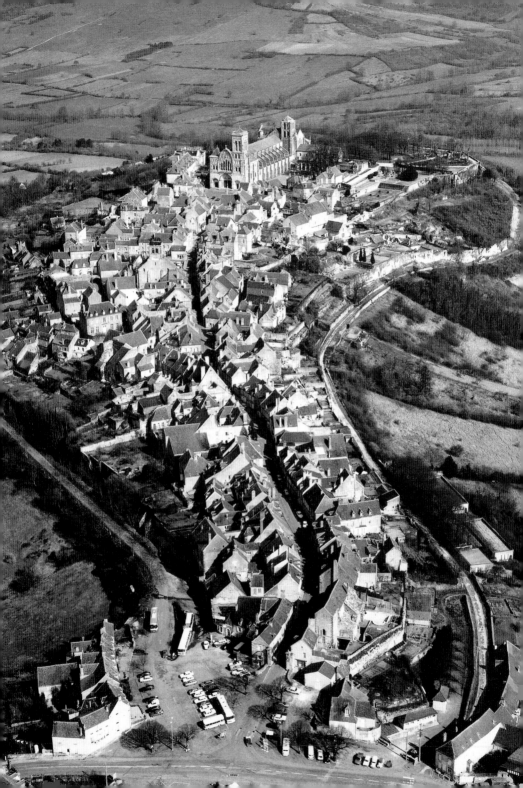

Sainte-Madeleine, located at the origin of one of the roads leading to Santiago de Compostela, occupies an elevated site at the top of the crooked streets of the small medieval town of Vézelay in Burgundy. It was the norm for medieval churches to be built on the highest point in town, with the specific orientation of the apse and altar to the east and the entrance to the west. A Carolingian church had been erected on this site and consecrated in 878. Vézelay began to rise in importance in the early eleventh century when the church claimed to possess the bones of St. Mary Magdalene (kept today in the crypt), thereby attracting many pilgrims. Romanesque Sainte-Madeleine was begun in 1096 and was dedicated in 1132. Gothic additions are the buttresses abutting the nave, as well as the east end begun in 1180. The entire church was finished by 1215. At its peak, Vézelay had 800 monks and lay brothers living in its monastery. Unfortunately, most of the monastery was torn down during the French Revolution, leaving only the church and a portion of the cloister. Today the facade is a combination of Romanesque and Gothic, plus nineteenth-century over-restoration. Two facade towers were planned: that on the south originally had a wood spire covered with lead but that on the north was never started.

The visitor enters Sainte-Madeleine through an unusually large narthex. Because of its size, this entrance hall was used for liturgical purposes, for those not baptized, for sinners temporarily forbidden from entering the church, and for the pardoning of repentants. It also provided lodging for pilgrims when other housing was full.

The nave, built 1120–32, is known for its harmony, achieved in part by proportions based upon simple mathematical ratios: 61 meters (200 feet) in length, 18.3 meters (60 feet) in height, and 12.2 meters (40 feet) in width. The bays are divided by heavy semi-circular ribs formed of light and dark voussoirs (the wedge-shaped stones that make up each arch). These stones are inconsistent in size, the result being irregular zebra stripes. As seen at Vézelay, Romanesque supports are characteristically massive in dimension and tend to vary in form: a simple pier or column may be elaborated by the addition of engaged columns. The supports may alternate in form, especially in later Romanesque buildings – a tendency that develops further during the Gothic period.

The unusual lightness – for a Romanesque church – of the nave of Sainte-Madeleine is achieved not only by the color of the stone but also by covering each bay with a cross vault (groin vault) formed by two barrel vaults intersecting at right angles.

58

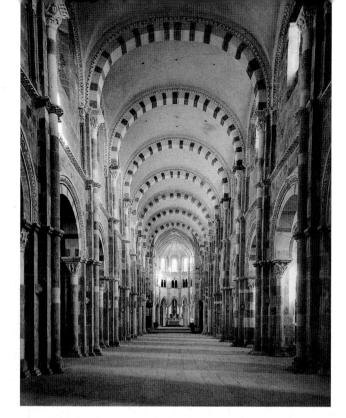

58. Nave of Sainte-Madeleine, Vézelay, 1120–32. A series of groin vaults – like the transverse barrel vaults at Tournus (Ill. 53) or the octagonal domes at Le Puy (Ill. 55) – permit construction of windows in the nave. The early cross vaults at Vézelay are without ribs; in the Gothic era ribs would be added and would take over the supporting function of the thick vaults and walls of the Romanesque.

Like many other Romanesque naves, Sainte-Madeleine is two stories high, but while other naves have galleries in the upper level, Sainte-Madeleine has windows. The cross vaults in Vézelay, like the transverse barrel vaults in Tournus, provide a flat space on the walls for clerestory windows. This is a successful solution to the lighting problem but at Vézelay the nave was not well-built nor was it adequately buttressed, the Romanesque masons having taken their ideas just a bit beyond their structural limits. Problems developed, the walls began to lean, and flying buttresses were added to stabilize the structure in the Gothic era and then rebuilt in the nineteenth century. The walls now lean out approximately 50.8 centimeters (20 inches).

Additional examples of French Romanesque architecture survive at Notre-Dame in Paray-le-Mondial (Saône-et-Loire); Saint-Croix-et-Sainte-Marie in Anzy-le-Duc (Saône-et-Loire); Notre-Dame-du-Port in Clermont-Ferrand (Puy-de-Dôme); Saint-Paul in Issoire (Puy-de-Dôme); Saint-Nectaire (Puy-de-Dôme); Sainte-Radegonde in Talmont (Charente-Maritime); and Saint-Juste-de-Valcabrère (Haute-Garonne).

53

Tympana received special attention in Romanesque Burgundy. The excellent condition of the famous tympanum at Sainte-Madeleine in Vézelay, carved 1120–32, is due to its protected location inside the narthex. The subject of the tympanum, taken from the Acts of the Apostles, is the Mission of the Apostles, also known as the Pentecost – the descent of the Holy Ghost upon Jesus' apostles, presented as an allegory and intended to encourage people to take the Mission of the Apostles as their own, to spread Christianity at all times of the year and to all the peoples of the earth. How could this idea be conveyed without words? Romanesque visual story-telling is simple and direct. Therefore, to show that ideas go from Jesus into the mind of each apostle,

59. *Mission of the Apostles*. Tympanum, Sainte-Madeleine, Vézelay, 1120–32

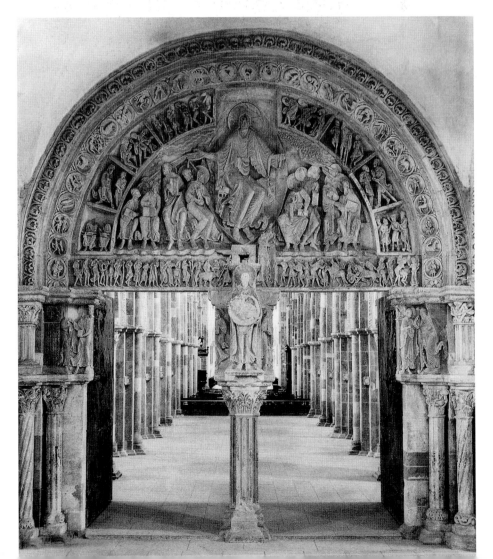

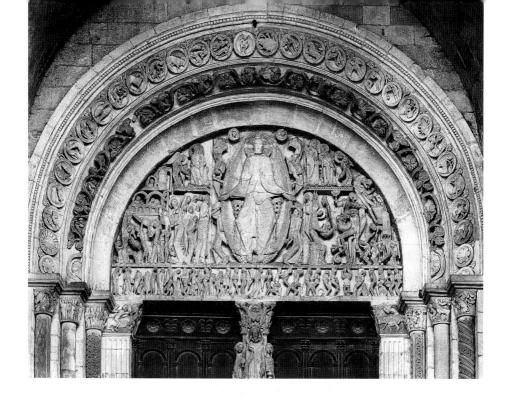

the sculptor carved rays emanating from Jesus' hands and touching the head of each apostle. To indicate their never-ending mission, the second archivolt (arch above the tympanum) depicts the signs of the zodiac and the labors of the months. To indicate the universality of their message, the innermost archivolt and the lintel (the horizontal beam at the bottom of the tympanum) depict the various races of people believed to inhabit the distant regions of the earth. Here are the Cynocephali from remotest India – people with dog heads who communicate by barking; the pig-snouted people from Ethiopia; and the Panotii with ears so large that they can be used to envelop the body like a blanket if the owner is cold, or to fly away if the owner is frightened. With greater fidelity to physical fact, the small size of pygmies is indicated by their use of ladders to mount their horses. Vézelay's tympanum provides the modern visitor with revealing insight into the twelfth-century view of the world, which was based largely upon ancient literary sources rather than upon travel and contact with other peoples.

The style in which this tympanum is carved accepts distortion as the norm. Jesus' elongated sticklike body is awkwardly

posed with the knees flattened to the side. The apostles vary in size according to the space available, appearing nervous, tense, even frantic with vitality. Drapery consists of fine parallel pleats falling to zigzag edges, the hems flipped up in fluttering folds. This is a visionary image representing spiritual characters rather than an illusion of real flesh and blood; although art was used as a bridge between earth and heaven, a visual distance and difference between the two realms was desired in the twelfth century. The Vézelay tympanum is simultaneously an exquisite abstract design and an effective symbolic illustration of church dogma.

Closely connected to Vézelay's sculpture is that at nearby Autun where the monumental tympanum on the west facade of the cathedral of Saint-Lazare was carved *c.* 1120/25–35. As at Sainte-Foy in Conques, the tympanum portrays the Last Judgement, noted to be a popular subject in Romanesque art and intended to give a clear image of what awaits on Judgement Day.

As at Conques, one's soul is shown to be weighed. On Autun's tympanum, an angel tugs at the basket on the left, and a devil actually hangs from the balance bar on the right. Thus, the angel and the devil, who represent good and bad deeds, each do their utmost to claim this soul. The angel wins and other saved souls cling to him. Another angel conducts the saved souls to the left side of the tympanum where they are boosted up into heaven by yet another angel. But what about the damned? Down on the lintel, they rise fearfully from the grave, the wicked cringing in agony. A serpent gnaws at the breasts of an unchaste woman, a gluttonous man scrapes an empty dish, and the claws of the devil close on the head of a sinner.

The Romanesque era was the golden age of monasticism. Life in a monastery provided not only assurance of salvation but also seclusion and an education. Due to the belief that salvation was more readily obtained if one made a donation to a monastery, monasteries grew wealthy. Some developed into huge complexes approaching self-sufficient communities that included crafts such as those of the mason, blacksmith, scribe, and artist, as well as the necessary livestock, crop fields, and gardens of a largely agrarian economy.

Monasteries, and the way of life experienced within, varied greatly according to the religious order to which they belonged. The powerful and worldly Cluniac Order was concerned with the soul, peace, charity for the poor, and protection for the weak, but also, and in particular, with beauty – in art and music – and

with fostering intellectual pursuits. For Cluny, to enhance the visual and auditory splendor of the Church was a form of praising God. Cluny was an active order, unconcerned with personal poverty, as were the later mendicant orders.

The Cluniac Order was based in Cluny, in southern Burgundy, originally an ancient Roman site named Cluniacum. The abbey here was founded in 910 by Guillaume (William), Duke of Aquitaine. Odo, Cluny's abbot from 927 to 942, was also a poet and musician who favored and encouraged the arts at Cluny and her dependent houses. Although Cluny was not located on a main pilgrimage road, it had many priories and associated buildings along the various routes and actively organized pilgrimages, thereby spreading the Cluniac ideal.

During the Romanesque era, the monastery of Cluny was of immense importance, and its buildings of enormous proportions. Although little of the monastery has survived, its history can be traced with some precision. Cluny I, the first monastic church, is thought to have been built between 915 and 927; it was dedicated in 927. The church of Cluny II, known as Saint-Pierre-le-Vieux, was built between 955 and 1000, and consecrated in 981. The east end was of the apse échelon type, in which the chapels are parallel to one another, as opposed to the radiating arrangement of chapels characteristic of pilgrimage churches. The adjoining monastery was rebuilt between approximately 981 and 1045. Cluny II served as the model at the abbey of Mont Saint-Michel (see p. 94) and elsewhere.

Cluny II was destroyed to permit the building of Cluny III, which was entirely walled and included the church of Saint Hugh, named for Hugh of Semur who was elected abbot in 1049 at the age of twenty-five and was to rule Cluny for sixty years. Hugh of

(see p. 94)

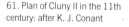

61. Plan of Cluny II in the 11th century: after K. J. Conant

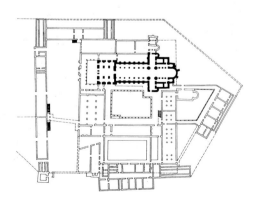

Semur was friendly, dignified, well-liked, and lived a long and productive life. Under his guidance, the number of monks at Cluny increased to approximately 300, the congregation grew, and a monastic empire was created, the Cluniac Order expanding beyond France into England, Germany, Portugal, Spain, Italy, and Poland, controlling 1,450 monasteries at its peak. Hugh personally visited many sites and approved many buildings, his ideas influencing architecture over a wide geographic area.

The church of Saint Hugh was extremely impressive and the interior famed for its luminosity and decoration. Its structure provided superb acoustics. Cluniac music was famous and the frequent chanting would have reverberated in the ribbed barrel-vaulted space of Cluny III. The nave measured 29.41 meters (96 feet 6 inches) high and the entire church 196.14 meters (643 feet 6 inches) long, making Cluny the tallest church of its time and the longest until the early sixteenth century. The architect of Cluny III was a monk there by the name of Gunzo who was a retired abbot and a musician. Gunzo seems to have planned the overall scheme, including radiating apse chapels and double transepts, working with Hézelon (d. 1123) who was a mathematician: the layout had a strictly mathematical basis using a

62. Plan of Cluny III in the 12th century: after K. J. Conant. The remnants of the church of Cluny II can be seen to the south of that of Cluny III.

module, much like Saint-Sernin in Toulouse. It is known that 50-1 Cluny's library contained a copy of the ancient Roman architect and author Vitruvius' *De architectura*, which was concerned with proportion and symmetry in architecture, and the use of simple mathematical ratios to determine proportions.

What remains today of Cluny, once a magnificent and massive monastery? Sadly, the answer is not much more than the south arm of the great transept of the church of Saint Hugh, constructed between 1088 and 1130, with the octagonal Holy Water Tower of the early twelfth century. The tremendous scale of these remnants is striking – as is the tremendous loss.

But perhaps some sense of life in the monastery of Cluny III is provided by the following statistics of what it once included: accommodation for 300 monks, 100 members of the service corps, 100 wayfarers in the hospice, 40 men and 30 women in the guest house, 32 sick and retired monks, over 30 novices, and 12 poor pensioners. In the twelfth century, the library had 570 books, then considered to be a large number. Pope Gregory VII said of Cluny, 'No other can equal it.'

Cluniac monasteries played an important role in politics and society, especially during the twelfth century. Cluny had vast resources and contacts with nearly everyone in a position of power. Three popes – Gregory VII, Urban II, and Paschal II – had been Cluniac monks.

In contrast to Cluny's encouragement of music and art, the Cistercian foundations were characterized by austerity. The order was founded in 1098 at Cîteaux by St. Robert of Molesme, Alberic, and Stephen Harding. The history of the order is linked with the name of St. Bernard of Clairvaux, its most famous member. Born around 1090 near Dijon, the well-educated son of a noble family, Bernard became a novice at the monastery of Clairvaux in 1112 and rose in the hierarchy to become abbot. Choosing a life of acute poverty for himself and his monks, Bernard's rigid and all-encompassing Rule was based on penitence, solitude, and deprivation, with daily life regulated down to the tiniest details and monasteries inspected for compliance. For example, according to the Rule, monks had to hold their bowls with two hands while drinking and salt had to be taken with a knife. Meals sometimes consisted of nothing more than barley bread and boiled beech leaves. After ongoing complaints about the menu, Bernard softened but continued to encourage prayer and observance. With this approach, Bernard was enormously influential on twelfth-century thought. At the time of his death

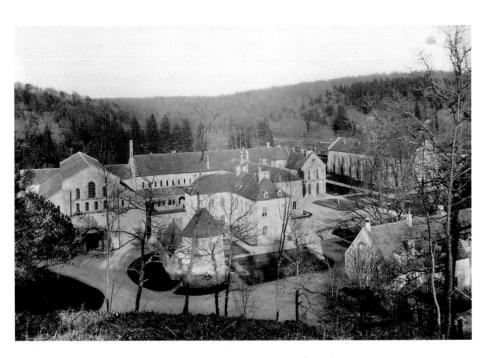

63. Monastery church of Fontenay, 1130/39–47. Both Cistercian architecture and Cistercian life were austere and severe, favoring various forms of renunciation and strict conformity. Fontenay, one of several surviving medieval Cistercian monasteries, shows the refined construction and solid proportions characteristic of the architecture of this Order. Indeed, even without the artistic ornament banned by St. Bernard of Clairvaux, Fontenay exerts strong visual appeal.

in 1153 Clairvaux had 700 monks and about 500 foundations had been established elsewhere – an amazing accomplishment. At the order's peak, there were 742 Cistercian monasteries.

For the chief representative of an order claiming to be devoted to seclusion and obscurity, Bernard of Clairvaux was very vocal, a witty and charismatic verbal fighter. In his eloquent objection to ornamental art, Bernard wrote, 'Oh vanity of vanities, but no more vain than insane! The church is radiant in its walls and destitute in its poor. It dresses its stones in gold and it abandons its children naked. It serves the eyes of the rich at the expense of the poor.' Bernard concluded his complaint with, 'If one is not ashamed of the absurdity, why is not one at least troubled by the expense?' Although the Cistercian Order was not intended to be opposed to Cluny, Bernard was critical of Cluny's worldly ways and encouragement of adornment rather than austerity.

Fontenay, the oldest remaining Cistercian monastery (Clairvaux was destroyed in the French Revolution), was built in Burgundy between 1130/39 and 1147. Like most Cistercian foundations, it occupies an isolated area, remote and secluded, with a source of water. Cistercian buildings were not intended for the public: the monks were deliberately cut off from the outside world and the monastery surrounded by a stone wall to

insure isolation. Women and children were never permitted into the monastery: a chapel and accommodation for them were provided at the gate. All the monks' needs were met from within the monastery and the Cistercians were known to be fine farmers who carefully tended their crops and livestock.

Just as Bernard required uniformity and austerity of his monks, so early Cistercian architecture was also standardized, repetitious, and built according to established norms. Decorative sculpture and the illumination of manuscripts were forbidden in 1124; decorative stone towers were forbidden in 1157; in 1182 it was proclaimed that all stained glass had to be removed within three years; and ornamental paving was discouraged.

The church, as specified in Bernard's Rule, had to be the first part of a monastery built. The facade of Fontenay's church is a demonstration of Cistercian aesthetics – simplicity intentionally taken to the point of severity. Monumental proportions, purity of line, equilibrium of mass, and fine ashlar masonry construction characterize Cistercian buildings. Light enters the nave through windows on the facade, at the crossing, and on the east wall, but there is no clerestory and the elevation is only one story high. Typically Cistercian, the vault is a peaked barrel, providing excellent acoustics. Although its pointed shape looks progressive and has been called 'half Gothic,' Cistercian architecture is fundamentally conservative.

In addition to the church, the portions of Fontenay that survive today include the cloister, located just beside the church and surrounded by walkways with substantial vaults having pointed arches inside. The square – rather than rectangular – bays are typically Cistercian.

The monks copied manuscripts – laboriously, tediously – in the monks' hall or scriptorium, also a standard part of a medieval monastery. The scriptorium was usually located off the cloister, which provided light.

The chapter house, another usual component of a monastery, has stone benches lining the walls. Here the monks met for meetings at which the practical decisions necessary for running the monastery were made. In addition, the religious chapters were read here – hence the name of the room.

The most extreme aspect of the austerity of daily life at Fontenay was the absence of heat in the buildings. All that could be hoped for in a Cistercian monastery was a small 'warming room,' primarily for sick monks, and the only room in which a fire could be lit. The monks of Fontenay slept communally in a

dormitory, typically a long rectangular room; only the abbot had his own private cell. The dormitory was reached by a staircase off the right transept of the church – direct indoor access was desirable, especially in winter. Although the dormitory at Fontenay was not heated, in some monasteries it was located over the kitchen and those fortunate monks benefitted from the rising warm air. This, however, was not the norm and at Fontenay and elsewhere there was more than just a religious reason to say prayers around the clock: this practice required the monks to be awakened every few hours, to move about and increase their blood circulation, so that they might be alive come morning. Nonetheless, deaths from cold occurred. Written warnings are known, such as a note that cautioned its recipient not to go to sleep that night, as it was expected to be unusually cold.

Additional notable Cistercian monasteries survive at Fontefroide (Aude); along the Côte d'Azur at Le Thoronet (Var); at Sénanque (Valcluse); and at Silvacane (Bouches-du-Rhône).

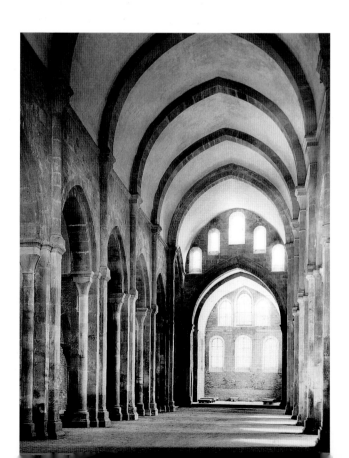

64. Nave looking toward apse, Fontenay, 1130/39–47

Chapter 4: Romanesque in Southern and Western France

In spite of centuries of neglect, many ancient Roman monuments are still to be found in the province of Provence in southern France: the most famous are the temple known as the Maison Carrée in Nîmes and the nearby aqueduct known as the Pont du Gard. Such ancient remains influenced medieval architects and sculptors working in this region to develop a more classical style that distinguishes Romanesque Provence.

This orientation toward the antique is apparent on the facade of the church of Saint-Gilles-du-Gard, which was begun 1116, although the west facade sculpture was probably made in the second quarter or middle of the twelfth century (the dating is contested) and the upper part of the facade is seventeenth-century. The antique influence is evident in the colonnade, classical fluted Corinthian columns, and pilasters. The sculpted figures flanking the doors are treated independently from the architecture, the carving of these bulky figures so deep that they are almost in the round. In Provence, the sculpted figures tend to be serene, with a spirit totally different from the frantic animation and abstract tendencies noted in Burgundy. Rather than the drapery with gravity-defying pleats falling to perfect zigzag hems, the figures at Saint-Gilles-du-

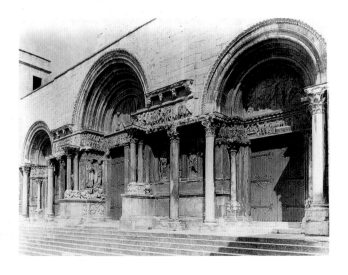

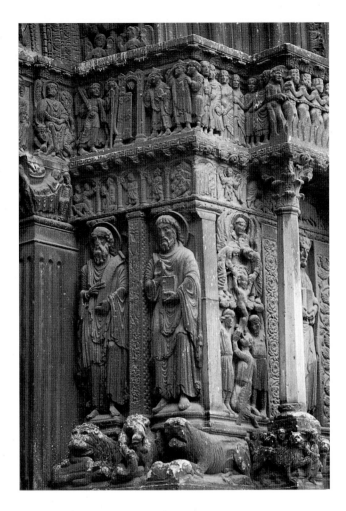

66. *Sts. Andrew and Paul*, Saint-Trophîme, Arles, late 12th century

65. Facade of Saint-Gilles-du-Gard, begun 1116, sculpture slightly later

Gard wear rich garments with complex folds that appear to have embroidered edges.

Nearby, at the start of one of the main pilgrimage routes leading to Santiago de Compostela, is the church of Saint-Trophîme in Arles, built in the late twelfth century, although here, too, there is a date debate. The porch of Saint-Trophîme, shaped like an ancient Roman triumphal arch supported on small columns, is similar to the central porch at Saint-Gilles. Antique influences are seen in the Corinthian capitals, fluted pilasters, moldings, and solid weighty figures with clothing similar to Roman togas. Flanking the doorway are figures of the Apostles John and Peter on the left, and Sts. Andrew and Paul on the right. The Romanesque sculpture of Provence is especially three-

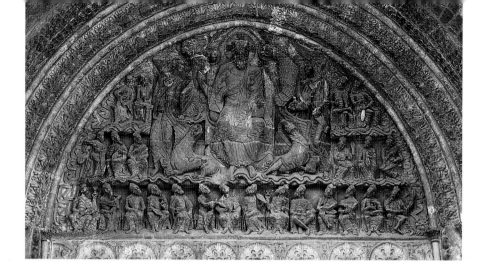

dimensional – the feet of these figures actually project over the edge. Medieval Provence never lost touch with its antique heritage.

Additional important Romanesque architecture and sculpture are found at the priory church of Notre-Dame in Serrabone (Western Pyrenees); the cathedral of Sainte-Eulalie in Elne (Western Pyrenees); the monastery of Saint-Michel-de-Cuxa (Eastern Pyrenees), although much of the cloister sculpture is now at The Cloisters, New York; and Saint-Guilhem in Saint-Guilhem-le-Désert (Hérault).

The church of Saint-Pierre in Moissac demonstrates the Romanesque tendency to encrust the portal elaborately with sculpture. Atypically, this portal is on the south side of the narthex to provide easy access from the town, rather than the more usual western location. The tympanum, carved between approximately 1125 and 1130, portrays Jesus of the Apocalypse. He is shown in Glory, with angels on either side, as well as the twenty-four Elders of the Apocalypse arranged in tiers. This is the second apocalyptic vision of St. John – Jesus between the four beasts used to symbolize the four Evangelists, Matthew, Mark, Luke, and John. The poses are contorted, proportions distorted, figures disfigured, and scale illogical. The drapery is pressed into perfect pleats and zigzag hems that stress the surface. Seemingly independent of the body beneath as well as of gravity, the fabric has taken on a life of its own.

On the trumeau – the central post supporting the lintel and tympanum, dated *c.* 1115–30 – are lions arranged in a criss-cross pattern that recalls the animal interlace of early medieval manuscripts (see p. 41). Similarities are the delicacy of the surface

67. *Jesus of the Apocalypse.* Tympanum, Saint-Pierre, Moissac, c. 1125–30

68. *Lions* and *Jeremiah*. Trumeau of south porch, Saint-Pierre, Moissac, c. 1115–30

69. Cloister arcade, Saint-Pierre, Moissac, c. 1100

treatment and love of flowing and undulating linear pattern. On the side of the trumeau the prophet Jeremiah has been made unnaturally long and thin to fit his assigned space, and his pose twisted to conform to the trumeau's scalloped profile. This dancing stance with legs crossed and feet dangling was used frequently for both sculpted and painted Romanesque figures. The hair, mustache, and beard falling into long, pointed, supple, serpentine strands have a calligraphic quality.

The church also has a charming cloister, with many capitals carved *c.* 1100. Over fifty with scenes and thirty with ornamental designs and foliage demonstrate the skill and ingenuity of Romanesque sculptors. The capitals also show the influence of the Moorish sculpture of Spain. The Moors were at their peak between the eighth and tenth centuries; Córdoba was one of the

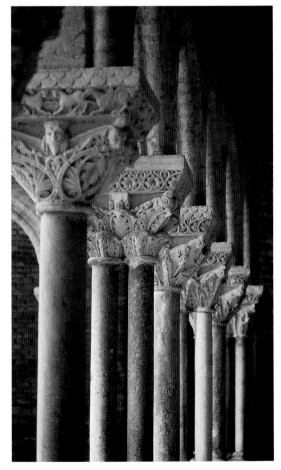

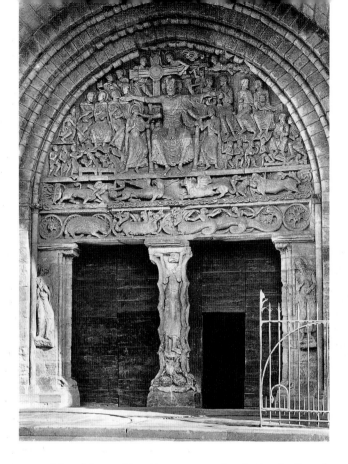

70. Porch, Saint-Pierre, Beaulieu-sur-Dordogne, *c.* 1125–50

great cities of the world and its mosque an inspiration for French builders. The style of art and architecture in northern Spain and southern France was much the same at this time, for the Pyrenees did not become a political boundary until the reign of Louis IX of France in the thirteenth century.

Another remarkable tympanum is found at the abbey church of Saint-Pierre in the town of Beaulieu-sur-Dordogne in Périgord. Upon visiting the region in 855, Raoul, Archbishop of Bourges, was so impressed by its natural beauty that he decided to found an abbey here. He called the area *bellus locus* ('beautiful place') – 'beau lieu' in French. The church of Saint-Pierre, built by Cluniac monks, has a projecting porch on the south side, dated to the second quarter of the twelfth century. As on Moissac's south portal, the sculptural program focuses on the tympanum and trumeau; the sculptors who worked at Beaulieu were from the same group as those who worked at Moissac, Souillac, and elsewhere in the region.

The subject in the Beaulieu tympanum is that Romanesque favorite, the Last Judgement. In the center Jesus dominates all other figures by his great size. He sits in majesty, arms outstretched to welcome the blessed, his pose creating a cross, and there is a cross behind him. Angels come, holding some of the Instruments of the Passion – that is, the instruments used to torture Jesus, here including the cross and nails. Flanking Jesus are angels blowing trumpets and, on both sides, apostles above and the dead rising from their tombs below. Perhaps more riveting, however, is the lintel further below, with two tiers of infernal monsters, a demonstration of Romanesque sculptors' ability to invent the most macabre creatures. Here are the beasts described in the Book of Daniel and in John's Revelation. One is endowed with multiple heads while a small monster pops out of the back of a larger one.

On the trumeau below, four attenuated prophets are obviously working very hard to hold up the lintel. The scalloped columns at the corners are, like those at Moissac, seemingly animated and certainly expressive, but non-structural.

Related sculpture is found at the abbey church at Souillac in Lot. The porch tower of this church was destroyed in the Wars of Religion, but the sculpture from its north facade was saved and placed on the interior west wall of the church in the seventeenth century. The figure of Isaiah, dated between c. 1130 and 1140, is considered Souillac's masterpiece, and is a perfect example of the spirit of the Romanesque. He seems to dance with his legs crossed, twirling and whirling, his garment swirling out in response to his dynamic undulating energy. This thin drapery is carved into sharp folds precisely indicated by double lines. His little head, with high-set eyes, is supported by a body elongated to the point of becoming tubular. In all of these characteristics, Isaiah is much like the figure of Jeremiah at Moissac. Isaiah's prophecy was painted on his scroll, to which he points, but the pigment no longer survives.

71. *Isaiah*, now on interior facade wall, abbey church of Souillac, c. 1130–40

Additional examples of notable Romanesque sculpture are at the priory church of Saint-Fortunat in Charlieu (Loire); Saint-Hilaire in Semur-en-Brionnais (Saône-et-Loire); and Saint-Julien in Saint-Julien-de-Jonzy (Saône-et-Loire).

Notre-Dame-la-Grande in Poitiers in the Poitou region of west central France, built in the second quarter of the twelfth century, is, in spite of its name, not very large. The city of Poitiers, however, located on one of the pilgrimage roads to Santiago de Compostela, was an intellectual center with a significant court in

68

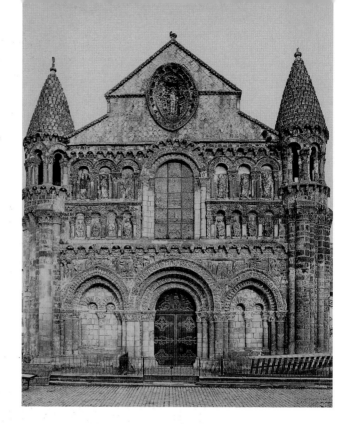

72. Facade of Notre-Dame-la-Grande, Poitiers, c. 1130–45. This church deserves its name not for its size, which is actually rather modest, but above all for the quantity of deeply carved and originally colorfully painted sculpture covering its facade. This sculpture incrusts the facade to the point that it obscures the underlying architectural structure rather than emphasizing it.

Romanesque times. The facade of the church is considered to be the ultimate Poitevin facade, and is one of the most famous in France for its harmonious proportions, equilibrium of lines, and, in particular, its abundant sculpture. Deeply carved, permitting a play of light and shadow, the exuberant sculpture spreads beyond its usual territory, totally covering the facade to create extreme richness, originally still richer when the sculpture retained its polychromatic paint (the exteriors and interiors of Romanesque churches were originally brightly painted). In this virtuoso display, the concern is for overall impact, for sumptuousness and splendor, rather than for fine details – quantity rather than quality seems to have been the goal. Intricate and varied, a certain Oriental character is probably to be connected with the Crusades, Muslim work in Spain, and trade with the Orient; in all, it is an eclectic style. Additional ornament is provided by large and small arcades and by bunches of columns clustered at the doorways and corners. Further, the tops of the spires at the corners and crossing are imbricated, that is, covered with many small curved stones that look like fish scales – a characteristic of the Poitou

region. Also typical is the fact that the entrance of Notre-Dame-la-Grande has neither a lintel nor a tympanum. Related examples of facade sculpture can be seen at the Cathedral of Saint-Pierre in Angoulême (Charante) and Saint-Nicholas in Civray (Vienne).

Notre-Dame-la-Grande is an example of a hall church. This is a type of construction, in which the vaults of the nave and aisles are almost equal in height, found especially in the area of Poitou. The basic structure of the hall church appears in early Roman crypts; it was also used above ground in Catalonia before the year 1000. At Notre-Dame-la-Grande the nave elevation, as is characteristic of hall churches, is only one story for there is no gallery or clerestory. The nave is covered by a ribbed barrel vault. Because the aisle vaults rise almost to the height of the nave vaults, they absorb much of the latter's lateral thrust, and buttresses on the exterior transfer the weight to the ground, thus achieving structural stability. The hall church is a handsome building, the space pleasing in its simplicity, readily understood and measured by the eye. The popularity of this type of church is due to its practicality as well as to its structural soundness. However, the nave is quite dark because light enters only through the aisle windows.

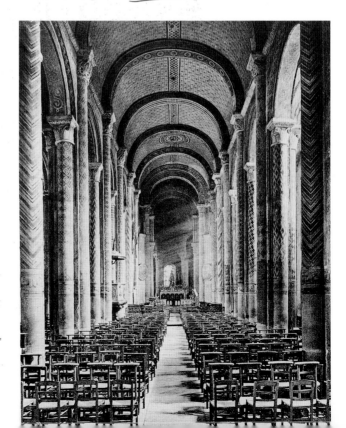

73. Nave looking toward apse, Notre-Dame-la-Grande, Poitiers, c. 1130–45. The hall church, characterized by relatively small scale and the structural simplicity of the barrel vault and single-story nave elevation, differs from other more complex Romanesque systems represented by Saint-Sernin in Toulouse (Ill. 51), Saint-Philibert in Tournus (Ill. 53), the Cathedral of Le Puy (Ill. 55), and Sainte-Madeleine in Vézelay (Ill. 58).

Not far from Poitiers is another Romanesque hall church, Saint-Pierre in Aulnay at the border of Poitou and Saintonge on the road to Santiago de Compostela. Its tall crossing tower was used as a landmark by pilgrims and other travelers. Considered a triumph of twelfth-century architecture, Saint-Pierre is often praised for its unity, the patina of its old stones, and its fine lines. The sculpted decoration of the three portals on the west facade is sumptuous, lush, and rich. The softness of the stone in the vicinity of Poitou and Saintonge made such abundant displays relatively easy to achieve.

Saint-Pierre's most important portal is not on the west facade but on the south transept. The tympanum is absent (noted above to be a regional characteristic); perhaps because of this the sculptors focused their efforts on the archivolts (the concentric arches above the portal) and their carving became highly developed there. Seen at a distance, the sculpture forms a pattern that radiates outward from the center. On the innermost archivolt are animals unknown to Nature, including centaurs and griffins – evidence of the medieval fascination with the fantastic and with animals born from the human imagination, many of which have distant ancestors in ancient mythology. These are entwined in rinceaux patterns – curling tendrils of Oriental inspiration. On the next archivolt are Jesus' disciples. On the third archivolt are the Elders of the Apocalypse, each holding a container and a musical instrument, normally numbering twenty-four but here increased to thirty-one because this is the number of voussoirs that make up the archivolt. On the fourth and outermost archivolt are fantastic people and animals, including a music-making donkey and his band of dancing donkeys, as well as fabulous creatures, again of antique origin, such as sirens, dragons, and griffins. The sculpture here is akin to that at the nearby church of Notre-Dame in Rioux (Charente-Maritime).

During the eleventh century, Romanesque sculptors had experimented, discovered, and enriched their art; during the twelfth, they achieved a certain stylistic stability. Although some critics have described twelfth-century sculpture as a decline, pointing to what they disparagingly call 'overabundance,' the same sculpture can be described as having great richness, and what has been dismissed as 'anecdotal,' marginal, or merely ornamental can be seen as admirable. Romanesque sculpture is characterized by deep undercutting, by love of pattern with preference for symmetry, and by distortion of

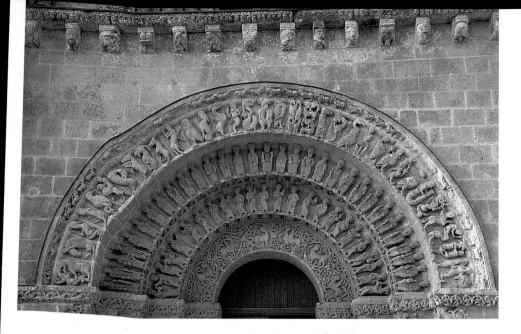

74. South portal of Saint-Pierre, Aulnay-de-Saintonge, 12th century

figures and space. In fact, Romanesque sculpture is actually highly disciplined and consistent – according to its own rules.

Not far from Aulnay is the abbey church of Saint-Savin-sur-Gartempe, on the banks of the Gartempe river. Much of its construction took place between *c.* 1060 and 1075, the oldest parts being the apse, ambulatory, chapels, and transept. The rest dates between *c.* 1095 and 1115, although Saint-Savin now has a very tall Gothic spire on the west that rises 95.1 meters (312 feet) above the tiny church. Saint-Savin, like Notre-Dame-la-Grande in Poitiers and Saint-Pierre in Aulnay, is a hall church; the nave is covered by a barrel vault that rests directly on tall arcade columns. But here, in contrast to other hall churches, there are no transverse ribs interrupting the vault surface and the vault is entirely painted, the famous murals referred to as 'the Bible of Saint-Savin.' Additional painted scenes adorn the narthex and crypt, and the nave columns themselves are painted to simulate marble. Taken as a whole, Saint-Savin is the most important site in all of Europe for the study of Romanesque murals.

This statement, however, requires clarification. Saint-Savin's status is due to the fact that a very small number of original Romanesque murals survive, perhaps only one or two percent, and these tend to be provincial or secondary work because the major works were painted in buildings that were likely to be redecorated frequently. Almost all extant Romanesque murals are in churches, for secular work has largely disappeared.

The nave vault at Saint-Savin was painted *c.* 1100 with the Old Testament cycle from Creation to Moses, the scenes arranged in four long fields. Although there are no precise divisions between the scenes, it is evident where one ends and the next begins. The sequence is irregular and the direction of the narrative changes repeatedly, perhaps the result of the absence of a comprehensive plan for the entire ceiling before work began, combined with a desire to avoid moving the scaffolding frequently. Four artists seem to have painted the vault, yet the style of the entire cycle is quite consistent.

Included are scenes illustrating Genesis 5:14-22 which explains that God decided to destroy mankind because of its wickedness, sparing only Noah and his family. God commanded Noah to 'build an ark and take on board two of every kind of living thing:' even the ark is shown to have an animal head. The two-dimensional figures look as if they have been cut from paper, their bodies divided into segments of flat color within hard outlines that form an almost abstract pattern that unifies the overall effect.

Technically, almost all Romanesque murals are painted by filling in areas with solid unmodeled color, adding dark lines, then highlights, and finally re-outlining the shapes in black or dark brown. The type of paint used is distemper, made of earth colors mixed with water and a variety of binders. Because the paint is transparent or translucent, several layers are applied. Rarely used in Romanesque murals was the *fresco buono* or true fresco technique (see p. 274), in which the painting is done directly on wet lime plaster; more common was *fresco secco*, in which the paint is applied after the plaster has dried.

Advice on Romanesque painting is offered by Theophilus Presbyter, a monk or priest who authored the Latin technical manual *De diversis artibus* (*On Divers Arts*), perhaps *c.* 1100 or in the early twelfth century. In this encyclopedic treatise of information on technique and training in the arts, Theophilus wrote, 'Fundamental to the art of painting is the composition of colors, then giving attention to their blending. Preoccupy yourself with that, and be exact to extreme limits, so that what you paint may be freely ornamented and spontaneously created. In following the practice of art you will be helped by the experience of many craftsmen of talent.' In other words, Theophilus advises the artist to make the colors carefully and to learn from the work of others.

Regarding the 'composition of colors,' Theophilus notes that different pigments are used for different painting techniques:

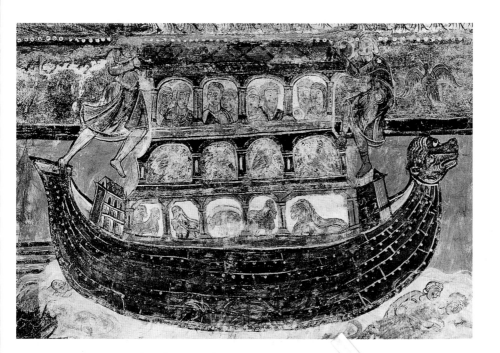

75. *Noah's Ark*. Fresco in nave vault of the abbey church of Saint-Savin-sur-Gartempe, *c*. 1100. The most extensive mural cycles and the best preserved Romanesque paintings are those in this church. Whether created by a painter's brush or a sculptor's chisel, the Romanesque style was extremely expressive and notably consistent – the figures flattened, their proportion distorted, the images easily seen at a distance, and their messages readily understood.

costly pigments are inappropriate for large scale murals; certain colors are chemically incompatible with the caustic quality of lime plaster; and others are sensitive to light and air. Medieval writers divided pigments into two categories: natural and artificial. The first category – natural pigments – consists of three types: 1) elements (substances that cannot be split into simpler substances) such as carbon, gold, silver, and tin; 2) minerals (inorganic substances that occur naturally and are mined): metallic salts such as iron oxide and copper carbonate, colored earth such as ochres, and ultramarine blue from lapis lazuli; and 3) vegetable extracts such as yellow saffron extracted from the crocus stigma and blue extracted from violets and cornflowers. The second category – artificial pigments – consists of manufactured salts, also of three types: 1) those made by the direct combination of elements, such as vermilion from mercury and sulfur; 2) those made by acid on metal, such as verdigris, an acetate of copper; and 3) those made by decomposition of salts in solution, such as the lakes.

If manufactured beauty was a source of pleasure in the Middle Ages, then so too was natural beauty. Unequaled in this regard is Mont Saint-Michel – a magnificent and mysterious island, referred to as 'the wonder of the Western world,' located

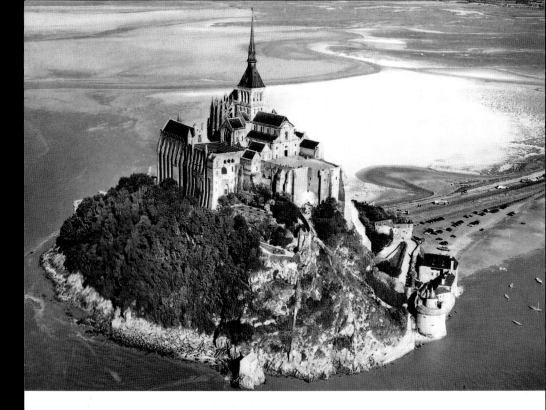

76. Mont Saint-Michel, 10th to 16th century. This architectural accomplishment is exceptional in location, impressive in conception, and daring in construction. The normally horizontal monastic plan, with buildings constructed side by side, has been adapted to an island mountain and made vertical, with buildings constructed in layers on various levels. That this monastery has endured the centuries with relatively little change is testimony to the skill of medieval masons.

where Normandy and Brittany meet. The enduring fascination of the monastery here is its spectacular site and the remarkable achievement of building upon it. Mont Saint-Michel is an architectural gem, an ingenious and audacious accomplishment, a monument to medieval engineering. The mountain is granite, 73.15 meters (240 feet) high and 822 meters (2,700 feet) in circumference. An isolated peak rising out of flat fields and water, it is both a mountain and an island. Victor Hugo called it the 'pyramid of the seas.'

A long history precedes the present form of Mont Saint-Michel. Around the end of the fifth century, Christian hermits lived on the mountain, which was then surrounded by forest and called Mont Tombe (tomb). In 708 St. Aubert, Bishop of Avranches, experienced a vision of St. Michael in which he was told to build a church in honor of the saint on the mountain. The first significant building here was an oratory constructed in association with St. Aubert's vision. It is said that the following year the sea swept in, ripped through the forest of Scissy, and made the mountain into an island. Geologists confirm that this took place in the eighth century.

On this extraordinary site are a retreat for monks, a sanctuary for relics, a church for pilgrims, and a fortress to withstand attacks by heretics and pillagers. What exists today was built between the tenth and sixteenth centuries in various architectural styles – Carolingian, Romanesque, and Gothic – in aesthetic and structural harmony and equilibrium.

Mont Saint-Michel offers a monastic plan built vertically. The east and west sides each have three major levels, one on top of the other. Construction was done in the tenth and eleventh centuries under the Benedictines and then the Cluniacs. The top of the mountain was leveled in the early eleventh century and construction of the church was started there in the first quarter of the century, although the interior was executed in the 1060s.

The nave has a rugged yet graceful quality. This is the Norman Romanesque style, with tall thin bays and a three-story elevation. The arcade has round arches, arch within arch, and the piers are massive, each with four engaged columns. The gallery has paired openings set within a larger arch – a popular Romanesque decorative motif. Continuing up the nave elevation, the clerestory windows are flanked by slender colonnettes. Ornamental carving is minimal. Instead, decoration consists of multiple elements, such as clusters of columns, large and small columns, and tall and short columns that play with variations in proportions. The columns that rise from the floor to the vault are without capitals:

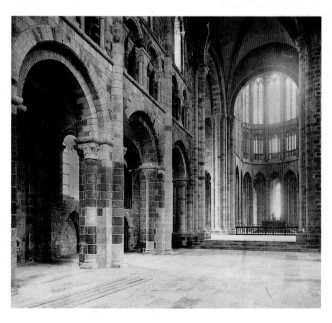

77. Nave looking toward apse, Mont Saint-Michel: church begun first quarter of 11th century, interior 1060s

nothing interrupts their vertical flow. Narrow string courses neatly divide the stories and create a horizontal accent – in the Romanesque, the horizontal dominates; in the Gothic, the vertical will dominate. The vault is a wooden barrel, restored in the nineteenth century. All Norman Romanesque naves originally had wooden roofs, until the end of the eleventh century in England and the early twelfth century in Normandy. The big clerestory, and hence the lightness of the interior, are possible because the wooden roof for the walls need not support an enormously heavy stone vault, as at Saint-Sernin in Toulouse and elsewhere.

Although the nave of Mont Saint-Michel's church is Romanesque, the east end is Gothic, constructed after the Romanesque chancel collapsed in 1421. The present east end was built between 1446 and 1521 in the late Gothic style with characteristic pointed arches, long verticals, slender proportions, minimal wall areas, and maximum window areas. The later history of this church includes the unfortunate shortening of the nave in 1780 when the three west bays and the facade fell down; now only four of the original seven nave bays remain and a new facade has been made.

Among the other Gothic portions of Mont Saint-Michel, the most celebrated is the cloister, built between 1225 and 1228 by Raoul de Villedieu, and already lauded in the thirteenth century.

The prosperity of Normandy during the Romanesque period is reflected in its important architectural accomplishments. Norman Romanesque masons are noted especially for their experiments in ceiling construction, including wooden vaults, stone groin vaults, and even pointed stone vaults, and Normandy was one of several areas in which the ribbed vault – a defining characteristic of Gothic architecture – was developed.

Two of the major monuments of Norman Romanesque architecture are in the city of Caen: the church of Saint-Etienne (Saint Stephen) from l'Abbaye-aux-Hommes (the Men's Abbey) and the church of La Trinité from l'Abbaye-aux-Dames (the Women's Abbey), both built by William of Normandy, later known as William the Conqueror, and his wife Matilda of Flanders. A curious history lies behind these two abbeys for they were built to expiate the pair's uncanonical marriage.

William and Mary were cousins, that is, 'within the forbidden degrees of affinity.' When William first asked Matilda to marry him, she responded, 'I would rather take the veil [i.e. join a nunnery] than be wed to a bastard.' In fact, William *was* a bastard: his father was Robert, Duke of Normandy, and his mother Arlette,

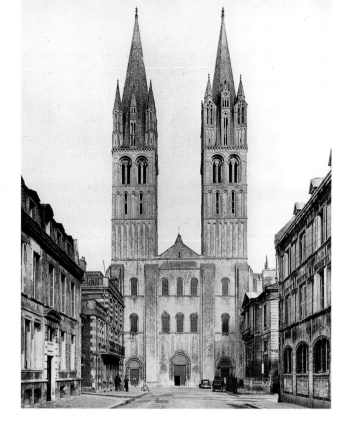

78. Facade of Saint-Etienne, Caen, 1064–77 (spires finished in the early 13th century). The stark simplicity of the two-dimensional facade, with the divisions of the surface stressing the structure, is in striking contrast to the luxuriant complexity of the three-dimensional facade of Notre-Dame-la-Grande in Poitiers (Ill. 72), seemingly overrun with carving. Saint-Etienne's facade, typical of Romanesque Normandy, can be compared to Cistercian facades, as at Fontenay (Ill. 63), in the absence of ornament as well as in the fine proportions.

the beautiful daughter of a rich tanner but not eligible for a noble marriage. William, although rejected by Matilda, refused to give up in his efforts to win her hand. He went to the palace of the Count of Flanders in Lille and (if the chroniclers are to be believed) treated Matilda very roughly, kicking her and pulling her hair. Curiously, in spite of this crude and uncourtly courting, Matilda agreed to marry William and the wedding took place around 1051. But this brought the pope's disapproval because such a marriage was a breach of canon law without papal approval. The pope excommunicated William and he was disgraced. However, when William and Matilda built Caen's two abbeys as penance, William apparently presiding personally over the buying of the land and the construction, the excommunication was lifted. Matilda and William also founded four hospitals in Caen. During the Middle Ages, building public structures was the norm for royalty and nobility as a means of atoning for their crimes as well as a way of expressing gratitude.

Active at Saint-Etienne was Lanfranco, confidant of William and famous doctor of letters from Pavia; the patron saint of Pavia is

Stephen and the men's abbey in Caen is dedicated to this saint. Saint-Etienne required only a few years to construct and was ready for dedication in 1077. The enormous building measures over 110 meters (361 feet) long outside and 107 meters (351 feet) long inside, yet never in its history did the abbey have more than a hundred monks. The explanation for its enormous scale is that William intended this to be his mausoleum. When he died on September 9, 1087, he was buried, according to his request, in the choir.

The Norman convention for church architecture was to stress the west facade and treat it as a rectangular volume topped by a pair of squared towers flanking a gable. Norman Romanesque exteriors have a fortified look, harsh and thick, powerful in their mass, the silhouettes clear and striking, majestic and commanding. As is typical of Normandy, Saint-Etienne's facade is simple, severe, and austere, essentially a solid block with a neat grid of horizontals and verticals, ten large windows and three portals with semi-circular arches. (The tympanum over the central portal is nineteenth-century work.) The exterior reveals the interior divisions, for the three stories correlate to the nave arcade, the galleries, and the clerestory, and the three vertical sections created by the four buttresses correspond with the interior division into nave and aisles. There is little ornament – indeed, this building has been described as 'nude.' The style is intellectual rather than emotional.

The use of two enormous towers on the west facade of a church first appeared around 1000 in the Rhineland, in Burgundy, and in Normandy. Saint-Etienne's towers do not grow up from the ground, but appear to sit on top of the big block of the facade. Above the block, each tower has a specific progression within the three stories of equal height: the first level has very thin blind arches; the second-story arches are open, wider, and fewer in number; and the third level has the biggest openings, the fewest units, and is decorated with the popular motif of two small arches within a larger arch. Decorative moldings divide the stories. The original spires must have been made of wood but the present stone spires were made in the early Gothic period and were finished in the early thirteenth century: that on the left, 82 meters (269 feet) high, is the older and the purer; that on the right, 80 meters (262 feet 6 inches) high, has an angled placement of the corner pinnacles. Romanesque and Gothic combine harmoniously.

The interior nave elevation consists of three stories: the nave arcade, the gallery, and the clerestory. The nave arcade has

characteristically Romanesque semi-circular arches. The gallery – a typical Norman feature – is covered by a half-barrel vault which functions much like flying buttresses would later in Gothic churches by resisting the lateral thrust of the nave vault. At Saint-Etienne the arcade and gallery are the same height, a feature found in later Anglo-Norman churches such as Lincoln, 1073–92; Canterbury, 1074–80; and Winchester, 1079 f. The clerestory, with a narrow passage between the arcade and the window wall, was to become a common feature in Normandy. Here there is an unusual arrangement of large and small arches that create asymmetrical bays. The nave combines vastness with simplicity, solemnity, serenity, and grace. A perfect balance is achieved between solid and void, between horizontal and vertical, all parts working together in harmony. Characteristic of the Norman Romanesque, sculpted ornament is minimal – indeed, decoration is almost ignored, consisting of no more than the typical fret moldings and geometric zigzag and chevron designs. Capitals are simple and there is no significant figure sculpture.

The nave of Saint-Etienne was originally covered with a wooden roof, the exact form of which is unknown; the present

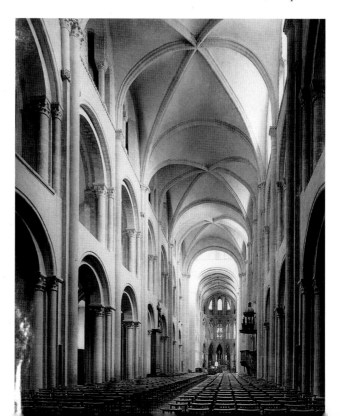

79. Nave of Saint-Etienne, Caen, vaulted early 12th century

stone vault is early twelfth century. It is believed that at some time between 1105 and 1120 the wooden roofs over the nave and transepts of both of Caen's abbey churches were replaced by stone vaults. Each bay is covered, not by a four-part cross/groin vault as at Vézelay, but by an unusual six-part groined vault. This system similarly provides spaces on the walls for clerestory windows and, in fact, doubles the number of clerestory windows possible per bay. When the new stone vault was built, it cut into the upper part of the nave walls and the clerestory was rebuilt to withstand the lateral thrusts of the masonry vault. In theory, the weight of the vault is supported by the ribs and is channeled down them to the corners of the vaults. Such a vault can be seen as transitional between Romanesque and Gothic. Saint-Etienne is still slightly awkward, still a somewhat uneasy design, yet its six-part vaults were repeated in important early Gothic buildings: Sens Cathedral (also dedicated to St. Stephen), mid-twelfth century; the Cathedral of Notre-Dame in Paris, second half of the twelfth century; Laon Cathedral, also second half of the twelfth century; and even into the thirteenth and fourteenth centuries, as at Bourges Cathedral.

In the thirteenth century the monks replaced the Romanesque choir of Saint-Etienne with a bigger Gothic choir. This had a large ambulatory, intended to facilitate processions, and radiating chapels. The proportions of the Gothic east end are more delicate than those of the earlier Romanesque portions of the church. The combination of a Romanesque nave and Gothic east end were noted also at Vézelay and Mont Saint-Michel.

Related notable Romanesque survivals are the church of Saint-Rémi in Reims (Marne); the monastery in Jumièges (Seine-Maritime); and the priory church of Saint-Vigor in Cerisy-la-Fôret (Manches).

William's invasion of England is documented by a unique and justifiably famous textile made between c. 1070 and 1080, known as the *Bayeux Tapestry*. It is located in Bayeux in Normandy, but it is not a tapestry (a textile technique in which the design is formed as the cloth is woven on a loom); instead, it is embroidery, in which the design is sewn onto a fabric background. Here the background consists of eight pieces of linen seamed together to measure approximately 70.41 meters (231 feet) long and 49.5 centimeters (19½ inches) high. Onto this surface a total of 58 scenes are embroidered in wool thread of eight colors: three shades of blue, two greens, a red, a yellow-buff, and a gray. The color range is restricted but harmonious. The figures are labeled and there are captions to relate the story clearly.

58

The story begins in 1064 when the childless king of England Edward the Confessor named his cousin William of Normandy as his heir and successor. Edward sent his brother-in-law and leader of the army Harold of Wessex to inform William of his selection. Edward is labeled REX – King. William and Harold are shown traveling on horseback to Bayeux, where Harold swears loyalty to William on the relics at Bayeux Cathedral.

However, when Edward died on January 6, 1066, it was not William but Harold who was crowned king of England. On his deathbed, Edward evidently named Harold heir, and the latter, in spite of his vow of loyalty to William, took the crown the day after Edward's death. William, not amused, sent an envoy to England to remind Harold of his promise of loyalty, which Harold, not surprisingly, chose to ignore. But then, as the embroidery depicts, a comet was seen in the sky at Easter time. Harold interpreted the comet as a sign of evil and terror – as would prove correct for him. In contrast, William's astrologer interpreted the comet as a good sign – which would prove correct for William. Clever and conniving, William appealed to the pope who sided with him and excommunicated Harold.

William's vessels landed at Pevensey on the southeast coast of England on September 28, 1066. William brought with him 12,000 knights and foot soldiers in 696 ships, plus smaller boats, his equipment and forces financed by the treasuries of the cities of Caen and Rouen. In the *Bayeux Tapestry* the colorfully striped boats float on wavy beige water as their sails are blown by the wind. In this excellent document of medieval life the banquet scene depicts which foods were eaten (including small fowl roasted on skewers) and how they were eaten. Soldiers are shown traveling, arming themselves, and fighting.

The climax of the story occurs at the Battle of Hastings on October 14, 1066. Harold had positioned himself on a landspur six miles northwest of Hastings. The English fought on foot, with the cavalry behind. The Normans fought on horseback, armed with swords and spears, with the archers behind. The Norman army is shown to be repulsed in an animated battle – a horse throws its rider. The dead are depicted in the border below. Harold was killed by an arrow in the eye during this battle, and William was crowned king of England in Westminster Abbey on Christmas Day 1066.

The entire *Bayeux Tapestry* is laid out like a medieval prototype for today's comic strips, with a series of scenes in chronological sequence. As is true also of the painted scenes on the

80. *Bayeux Tapestry* (detail depicting the Battle of Hastings and the death of Harold). Wool embroidery on linen, *c.* 1070–80

vault of Saint-Savin, although there are no firm divisions between the scenes the viewer can readily see where one ends and the next begins. Many shorthand devices are used to facilitate telling the tale: in this abbreviated form of narrative, an entire city can be reduced to a theater prop and settings are only as detailed as required to indicate where an event takes place. Figures are shown inside a building by removing a wall to allow visual access to the

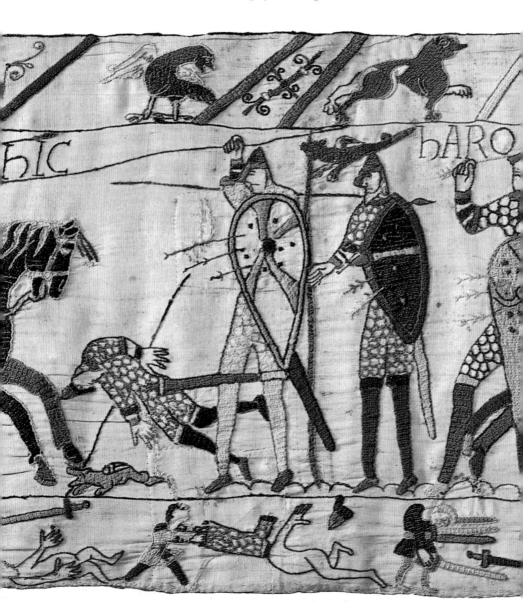

interior, which is drawn without benefit of perspective. The entire work is conceived as flat areas of color within firm dark outlines, much like contemporary murals.

William of Normandy's successful invasion of England in 1066 established his position as king as well as a political union between Normandy and England. Among the results of the conquest was the arrival of Norman Romanesque art in England.

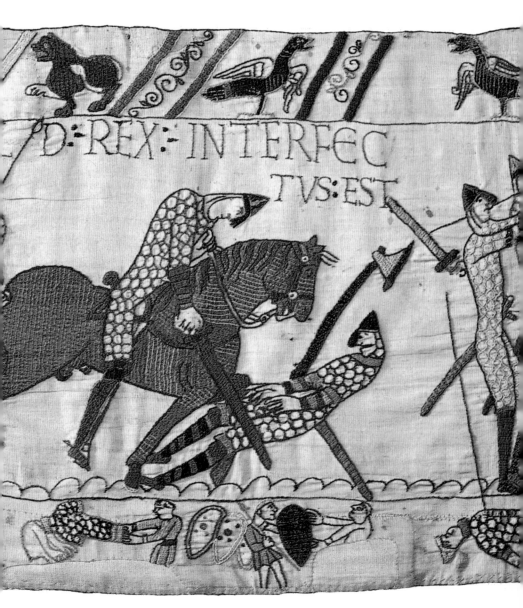

Chapter 5: Romanesque Outside France

England

The political union between Normandy and England estab-
lished in 1066 when William of Normandy became king of
England was to have a profound impact on the development of
England's social structure, government, ecclesiastical organiza-
tions, and art. The Romanesque style imported after the
Conquest was referred to in England as the Norman Style.
Opportunity combined with wealth resulted in grand Norman
churches in England.

The fully developed English Romanesque or Anglo-
Norman style is represented by Durham Cathedral, dated
1093–1133, impressively situated above the River Wear. The
history of Durham Cathedral goes back to St. Cuthbert of
Lindisfarne (*c.* 634–687), a shepherd who came to be consecrated
Bishop of Lindisfarne in 685. In 995 his body was moved to a
rocky outcropping that jutted into the river. A little wooden
church was built there, followed by the so-called White Church.
In 1080 William the Conqueror granted royal powers to
William of Saint Calais, Bishop of Durham. The White Church
was torn down in 1092 so the cathedral could be built, and on
August 11 of the following year William of Saint Calais and the
Benedictine monks began the foundations of the cathedral. The
new shrine of St. Cuthbert was finished in 1104 and soon became
a pilgrimage site. Men were permitted to approach the tomb but
women were not: Cuthbert was misogynistic. On December 31,
1540, when the monastery of Durham was taken by the Crown,
the shrine and its riches were confiscated. The shrine was
opened and Cuthbert's body was described as 'whole, incorrupt,
with his face bare and his beard as it had been, a fortnight's
growth....' The curious story of the saint is a reflection of
medieval religious fervor and faith.

Durham Cathedral is vast in its dimensions yet built to a
simple plan. The proportions are determined on the basis of
modular units: three double bays plus a single bay form the nave;
two double bays form the choir; and each transept arm consists
of a double bay plus a single bay. The plan of Durham was related

to that of Cluny II, with an apse échelon, in which the chapels 61
were parallel to one another rather than radiating. Some
Norman English cathedrals employed the French system with
an ambulatory and radiating chapels off the apse, as at
Winchester, Worcester, and Norwich; others had no radiating
chapels, as at Lincoln, Westminster, and here at Durham.

Durham's nave and choir have huge piers of two different 82
sizes and types that alternate. The main piers are reinforced by
attached columns rising from the floor to the vault without
interruption – a feature that will develop in the Gothic era when
the vertical definitely dominates the horizontal. The alternating
piers are fat cylinders, carved with geometric patterns. Durham's
nave is 22.3 meters (73 feet) high and 11.9 meters (39 feet)
wide. The proportions are thick, massive, powerful – like those
of any Romanesque nave. The elevation is three stories: the
nave arcade, the triforium gallery, and the clerestory. As in
Normandy, the capitals are simple and stark, nothing more than
a cubic or cushion shape with angles. Ornament consists only of
geometric zigzags, checkerboard patterns, chevrons, diagonal
lines, and diamonds carved into the piers and columns.

82. Nave looking toward choir, Durham Cathedral, 1093–1133; nave vaulted 1128–33. The style referred to as 'Romanesque' in France was known as 'Norman' in England, arriving there with the Norman Conquest. Durham Cathedral deserves comparison with Saint-Etienne in Caen (Ill. 79). Both have three-story nave elevations atypical for the period, decoration of geometric rather than the more frequent figurative carving, and unusual ribbed nave vaults (Caen's bays have six parts and Durham's four, omission of the transverse arches dividing the bays producing the impression of seven-part bays).

The ribbed vaulting of the choir aisles was erected 1093–*c.* 1095, and the choir vault was finished in 1104 although replaced in the early thirteenth century. The ribbed vault of the nave, erected 1128–33, is original. Rather than the usual four-part cross vault above each bay, here each rectangular double bay consists of two four-part vaults with the transverse arch between them omitted. A major accomplishment in the history of architecture is Norman Romanesque rib vaulting (see p. 89), which proved the feasibility of erecting a vault reinforced with ribs over a wide space. At Durham, however, this was done on the basis of mass for strength rather than careful calculation of thrusts and the placement of buttresses to counter these thrusts – as will be done in Gothic construction. In the early fifteenth century, Thomas Langley, Bishop of Durham, had huge buttresses built on the exterior of the west walls for reinforcement to avoid the cathedral's descent into the river, for no real foundations had been laid and the bases of the pillars went down only a foot or so into the earth.

A striking contrast to Durham's huge scale and dearth of decorative sculpture is offered by the tiny twelfth-century rural parish church of Saints Mary and David in Kilpeck in Herefordshire, where extraordinary Romanesque sculpture survives. There has been a church on this site since at least *c. 650*. After the Norman Conquest, William the Conqueror gave Kilpeck to a relative, William fitz Norman, whose grandson Hugh, now calling himself De Kilpeck, built the church. It is largely the work of twelfth-century Norman builders and is constructed of local limestone in a combination of rough rubble and ashlar masonry.

Kilpeck's sculpture is in very good condition and is the best example of the Herefordshire School. The subject portrayed on the south portal appears to be the Garden of Eden. On the tympanum is a curvilinear Tree of Life, the flora forced to conform to the shape of the tympanum. On the surrounding archivolts are various sorts of animals, identifiable and otherwise, variety evidently preferred over repetition. This is Creation, with all of God's creatures – and then some. The biting beasts recall the animal interlace of manuscripts illuminated in 27, 28 the British Isles during the Early Middle Ages. At the peak of the arch is an angel. The right jamb is thought to be carved with a

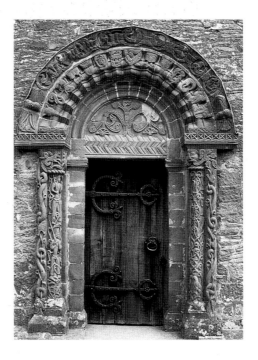

83. South portal of the Church of Saints Mary and David, Kilpeck, 12th century. Sculpture was certainly as expressively distorted in England as on the continent, combining geometric and curvilinear designs with plant and animal forms. This fascination with fantastic flora and fauna is characteristic of Romanesque sculpture, in contrast to the Gothic interest in accurately recording the real world, as evidenced by the identifiable plants carved in the chapter house of Southwell Minster (Ill. 165).

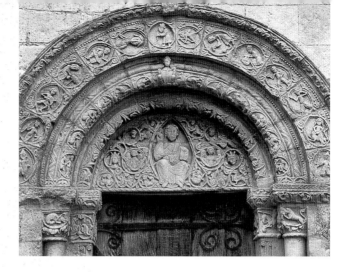

84. Tympanum, Church of Saint Nicholas, Barfreston, 1170s

representation of the Tree of Knowledge that will baffle even the best botanists. The twining sinuous serpents are shown with their heads up on the right jamb whereas, on the left, the equally acrobatic serpents have their heads down, as if defeated. The Romanesque sculptors of Kilpeck, like those elsewhere, display an unlimited imagination for inventing rich, profuse, dense, web-like patterns derived ultimately from Nature.

Another remarkable little church is that of Saint Nicholas in Barfreston, Kent, which was built in the 1170s. Its tympanum contains a depiction of Jesus surrounded by a mandorla, seen to be the standard Romanesque format in France. In the foliage to the left and right are the heads of a queen and a king – symbols of the moon and sun, Luna and Sol. The minute curling ornament recalls the interests of earlier metalworkers and manuscript illuminators. The archivolt is carved with the signs of the zodiac, labors of the months, and more. The music-making animals seen here appear with some frequency in medieval art and were already noted at Aulnay. On the right side, the rabbit riding a goat should not be overlooked.

Additional Romanesque sites in England include the cathedrals (not all of which were cathedrals in the Middle Ages) of Rochester, Saint Albans, Winchester, Hereford, Ely, Worcester, Gloucester, Norwich, Southwell, and Peterborough, as well as Saint John's Chapel, White Tower, London; the abbey of Bury Saint Edmunds; the abbey church of Tewkesbury; the monastery church at Pershore; the circular Holy Sepulchre, Cambridge; and Saint Kyneburgha, Castor. Worthy of mention in Ireland is Cormac's Chapel, Cashel, and in Scotland the abbey in Jedburgh.

74

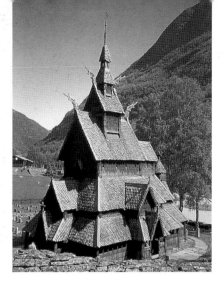

Norway

A novelty of medieval Norway are stave churches, built not of stone but of wood. Although wood-frame churches existed prior to the Romanesque era, stave construction is special to Norway. An excellent example from the village of Borgund in the area of Laerdal, dated *c.* 1150, has a striking silhouette reminiscent of an Asian pagoda and dragon heads on the gables that recall the prows of Viking ships. Careful construction enabled stave churches to survive the centuries. The timbers are placed vertically, in accordance with the tree's nature, which is unlike the log cabin type of construction found in Eastern Europe, Russia, and America, in which the timbers are placed horizontally, thereby allowing rain water to accumulate between them. Inside the Borgund church there are twelve wooden columns referred to as staves or masts – like those of boats. The rectangle of the church rises above the ambulatory that surrounds it on all four sides, utilizing the ambulatory with its sloping roof as a brace or buttress. Other notable stave churches in Norway are those at Gol, Urnes, and Lom.

Approximately 2,000 churches were built in Norway during the Middle Ages, of which about half were stave churches all dated within the two centuries between *c.* 1100 and *c.* 1300. This time period overlaps the Gothic: the stave church, like the Gothic church, is a type of skeletal construction. The stave system was not used exclusively for religious architecture, for homes were also built in this manner. Whether religious or secular in function, stave buildings tend to be small, as the system is not suitable for large-scale structures.

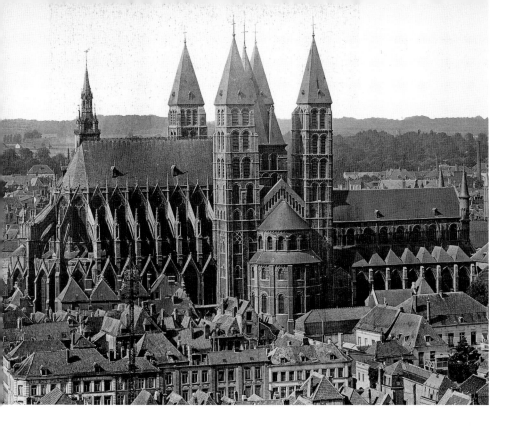

86. Tournai Cathedral, early 12th to 13th century

Low Countries

Tournai Cathedral, in present-day Belgium, is constructed of bluestone. The Romanesque nave was begun in 1110, with additional work done on the nave and towers between 1135 and 1200. The Gothic apse end was begun in 1165, with work continuing into the thirteenth century. The combination of a Romanesque nave and a Gothic east end recalls similar amalgamations noted at Sainte-Madeleine in Vézelay, Mont Saint-Michel, and Saint-Etienne in Caen.

58, 77
79

 The large scale of Tournai Cathedral reflects the wealth amassed in this area primarily through the textile trade; indeed, the cathedral is so large that it comfortably combines Norman, Rhenish, and Gothic aspects. French builders were to be influenced by Tournai's transept plan and unusual arrangement of towers: the square crossing tower is heavy and massive, topped by an octagonal spire. Its many stories and those of the other towers emphasize the vertical flow, moving smoothly heavenward, each tower a graceful composition in itself. The west facade was intended to have two

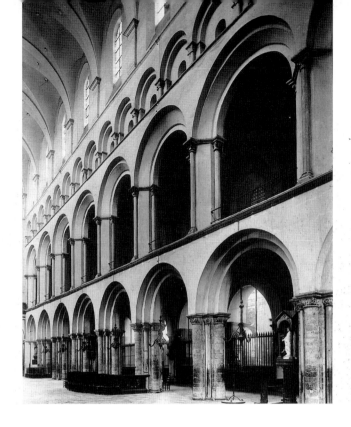

87. Nave looking toward apse, Tournai Cathedral, early 12th to 13th century

towers but received only pinnacles. The main apse is presumed to have had towers, but it was destroyed in 1242. Thus, Tournai Cathedral was intended to have a total of nine towers! Today, even without so very many, it presents a striking silhouette. The love of towers in this area is comparable to that in the Rhineland.

Tournai Cathedral's nave elevation is unusual in that it is four stories high, whereas the Romanesque norm is two or three stories. At Tournai the elevation consists of the arcade, the gallery, the triforium passage within the roof-space over the gallery, and the clerestory. Another oddity of the nave here is that each story is slightly recessed behind the story below – the space of the nave is actually wider at the top than at the bottom. The nave had a very conservative round-arched wooden roof made in 1110 but that seen today is modern; otherwise, the nave exists as it was originally.

The Romanesque is seen in Belgium also at the church of Sainte-Gertrude-et-Saint-Pierre in Nivelles, and elsewhere.

Germany

Germany is rich in Romanesque architecture, especially along the Rhine which was among the most civilized regions at the time. The Cathedral of Saint Maria and Saint Stephan in Speyer in the middle Rhine Valley was founded by Conrad II in 1030 and built in two campaigns of *c.* 1030–61 and *c.* 1080–1106. Speyer, with a dome and (originally) four towers, demonstrates the German preference for Romanesque churches with multiple towers. As the earliest and largest example of German Romanesque architecture, Speyer also demonstrates the preference for size, the overall design characteristically stout and simple. The walls of German Romanesque buildings are especially well-constructed and faced with carefully cut ashlar masonry. The walls of Speyer are massive: the west wall is about 6.1 meters (20 feet) thick, making it possible to construct spiral staircases within its thickness. The towers on the east end flanking the apse also contain spiral staircases. Italian influence is seen in a typical form of Romanesque architectural ornament known as Lombard bands – rows of small blind arches that create a pattern of light and shadow and are used for decoration rather than for structure. Lombard bands edge shapes such as the gable, stress contours of windows, and mark divisions between stories.

Speyer's huge nave is approximately 13.7 meters (45 feet) wide and twice as high. But the nave no longer retains its original appearance for between 1082 and 1106 the wooden ceiling was replaced by a series of domed unribbed groin vaults above square bays separated by transverse arches, the piers were strengthened, and the walls made higher. Thus Speyer was modified to look more like the domed nave bays of the Italian Lombard Romanesque, such as those of San Ambrogio in Milan. Political links between Germany and Lombardy at this time are reflected in the architecture. Speyer's nave was damaged in 1689 and rebuilt in the eighteenth and nineteenth centuries. Now significantly reconstructed, Speyer nevertheless retains some of the grandeur of the early Romanesque in Germany.

Praise for German Romanesque architecture's beautiful arrangement of volumes as well as its grand scale is justified by the Cathedral of Saint Martin and Saint Stephan in Mainz on the Rhine. With its multiple turrets and towers, both round and polygonal, Mainz Cathedral offers a particularly picturesque

92

88. Cathedral of Saint Maria and Saint Stephan, Speyer, 11th and early 12th centuries

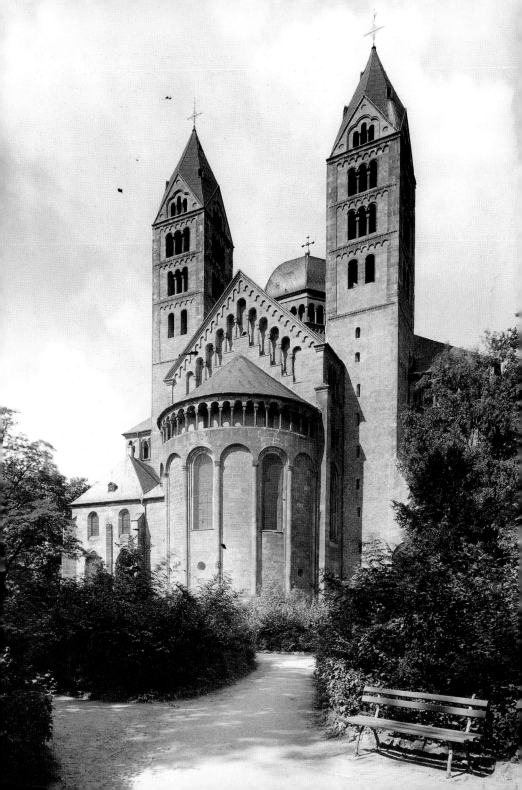

89. Cathedral of Saint Martin
and Saint Stephan, Mainz,
1081–1137

profile. The vast cathedral has one choir on the west and another on the east, creating a double-ended cathedral which is characteristically German Romanesque. The nave vaults, which were constructed prior to 1137, are of the domed type used in Speyer.

Perhaps the epitome of Rhineland Romanesque is the abbey church of Maria Laach. Once part of a monastery, Maria Laach occupies a beautiful site at the edge of a lake. Founded in 1093, work began in 1113 to replace the old monastery church with a new one. It was built rapidly, mostly between 1130 and 1156, and was consecrated on August 24 of that year, although the west towers are slightly later (1177–94) and the atrium was built in the early thirteenth century. Striking and typically Germanic, the multi-towered silhouette is created by towers that are round, square, and polygonal, all with pointed roofs, much like an enormous sculpture of simple geometric shapes. The church is constructed of contrasting colors of red and gray sandstone, yellow and white limestone, as well as columns of blue basalt. Decoration consists of Lombard bands, also seen at

Saint-Philibert in Tournus, Speyer Cathedral, San Ambrogio in 88, 91 Milan, and elsewhere.

Maria Laach is a big church with oblong bays in the nave and groined vaults in the aisles. The plan has transepts, apses, and choirs at both ends of the church, features found in other German Romanesque churches; at Maria Laach the choir on the west may have been used for parishioners and that on the east for monks and canons. The late eleventh-century crypt has the simplest columns and capitals supporting groin vaults.

There are numerous notable examples of German Romanesque churches. In Cologne are Saint Maria im Kapitol, the Holy Apostles, and Saint Martin the Great. In Alsace are Marmoutier (Maursmünster), the monastery church at Murbach, and Saint Peter and Saint Paul, Rosheim. Also of importance are the Cathedral of Saint Peter in Worms; Cathedral of Saint Peter and Saint George, Bamberg; Liebfrauenkirche, Halberstadt; Saint Servatius, Quedlinburg; Saint Peter and Saint Paul, Königslutter; Saint Klemens, Beuel-Schwarzrheindorf; Saint George and Saint Nicholas, Limbourg an der Lahn; Saint Martin Minster, Bonn; Saint Mary and Saint John the Evangelist, Ratzeburg; Saint Mary

90. Abbey church of Maria Laach, founded 1093, built mostly after 1130

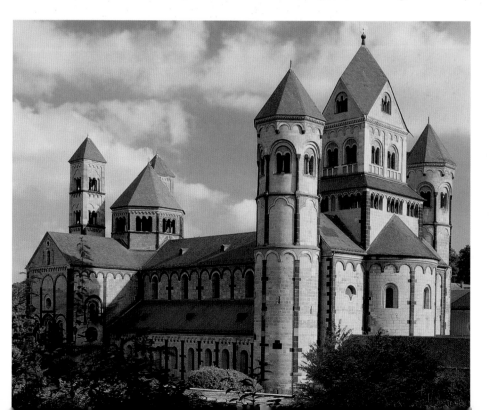

and Saint Nicholas, Jerichow; and the Cistercian abbey, Maulbronn. In nearby Switzerland, the Cathedral of Saint Maria in Basel deserves mention.

Italy

Italy developed distinct Romanesque styles in different geographic areas, in particular the Lombard Romanesque in northern Italy and the Tuscan Romanesque in central Italy.

The most important example of the Romanesque in Lombardy is San Ambrogio in Milan, built in the later eleventh and early twelfth century, although the dating is conjectural, contested, and complicated by the fact that there was an earlier church on the site. It is known that the smaller south tower was built in the tenth century; the taller north tower, known as the Canon's tower, was started in 1123; and the large rectangular atrium was built *c.* 1098. San Ambrogio is monochromatic and fairly simple, its appeal lying in its structural logic and its use of rhythmic geometric decoration of Lombard bands to edge the gable and mark the stories.

91. Atrium of San Ambrogio, Milan, later 11th and early 12th century

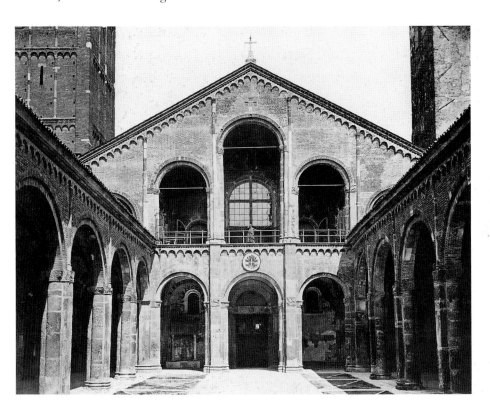

The nave is low and wide, the simple two-story elevation consisting of the arcade with an alternating system of supports and the galleries above. There is no clerestory and the interior is rather dark. Stuccoed vaults of stone rubble and brick may have been constructed after an earthquake damaged the church in 1117. The three nave bays are covered with quadripartite vaults. Here, atypically, all the arches are hemispherical and, therefore, the peak of each bay rises above the transverse arches, producing three domes. Although the date of these vaults is controversial, they may have been the first ribbed vaults in Europe.

In Tuscany there are two important locations for the Romanesque: Florence and Pisa. Tuscan Romanesque is characterized by an extraordinary use of stone arches for ornament rather than for support. This can be seen at the Baptistery in the center of Florence. This octagonal domed structure dated between approximately 1060 and 1150 is covered with this type of marble incrustation. The two-dimensional patterns make little use of light and shadow. Rather, they demonstrate the Tuscan love of multi-colored, simple, geometric designs.

93

92. Nave of San Ambrogio, Milan, vaulted after 1117. The history of Romanesque architecture appears to be a constant quest to innovate, with nave vaults the focus for new construction methods. San Ambrogio's series of domed, ribbed cross vaults evidence a willingness – in fact, a desire – to try inventive methods. These vaults might be regarded as a simplified variant on the octagonal domes above the nave at Le Puy (Ill. 55).

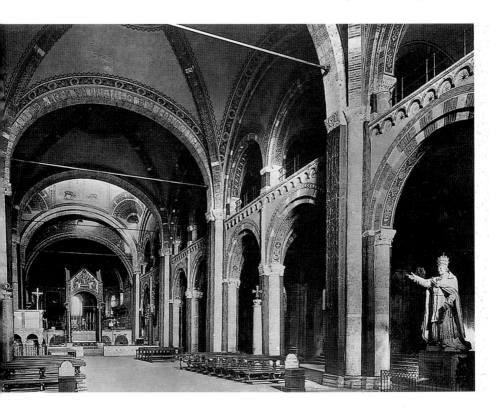

Across the Arno River, on the outskirts of Florence, is San Miniato al Monte, literally 'on the mountain.' The facade dates from 1062 to 1150, with the exception of the gable dated to *c.* 1200. San Miniato is part of a long Italian tradition of fine workmanship using Italy's abundant supply of variously colored and veined marble. This facade is veneered with marble in a pattern of applied arcades. The flatness of the surface is very different from the sculpted facades of France, exemplified by Notre-Dame-la-Grande in Poitiers.

72

The cathedral group in Pisa consists of the cathedral, begun in 1063; the baptistery, begun 1153; and the bell tower of 1174. All three buildings are covered with white marble inlaid with dark green marble, a technique used by the ancient Romans.

95

The cathedral is the work of the architect Buscheto (also spelled Busketos, Busketus, and Boschetto), although the facade was designed by Rainaldo. Blind arcades create a delicate and decorative lacy effect with animated light and shadow patterns. The five stories of arcades on the facade reflect the interior: the facade's lowest blind arcade corresponds to the nave arcade; the first open arcade reflects the galleries; the second open arcade the roof of the galleries; the third the clerestory; and the last the roof. Simple mathematical ratios determine the dimensions: the blind arcade is one-third the height of the facade and each open arcade is one-sixth the height.

The nave of Pisa Cathedral is constructed with a wooden ceiling permitting a fairly large clerestory and thin walls. This

96

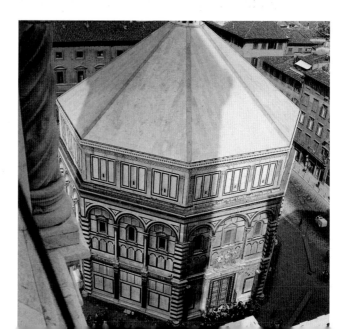

93. Baptistery, Florence, *c.* 1060–1150

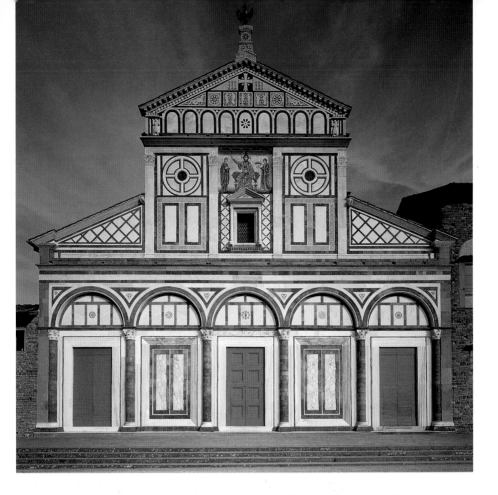

94. San Miniato al Monte, Florence; facade 1062–1150, gable *c.* 1200

ceiling, however, was rebuilt after a fire in 1596. The zebra stripes of alternating light and dark bands along the galleries continue the Tuscan love of color already encountered on the exterior.

The baptistery is circular and domed. The first two floors are Romanesque, with marble panels and arcades, whereas the pointy gables are fourteenth-century Gothic.

The bell tower (campanile), better known as the 'leaning tower of Pisa,' is the city's most famous monument. In Italy the bell tower is likely to be separate from the church, whereas in other countries the norm is two towers on the church's facade. The designer of the campanile was Bonanno Pisano, known also as a sculptor, and certainly the eight stories of arcades create a sculptural effect.

The fame of Pisa's campanile is due to a defect, for while most Italian towers of the Middle Ages tilt, rarely was this degree

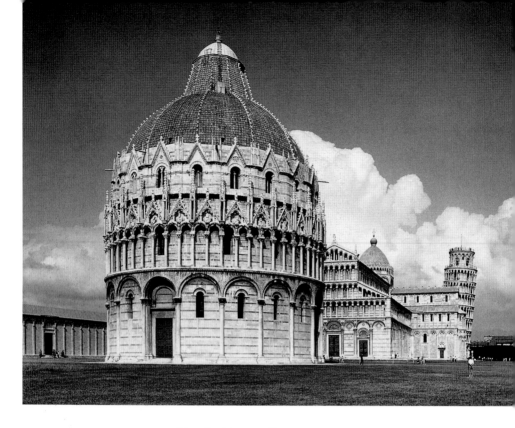

95. Cathedral group, Pisa: baptistery begun 1153; cathedral begun 1063; campanile 1174. The most famous of these three buildings is surely the last – Pisa's celebrated 'leaning tower,' designed by **Bonanno Pisano**. It deserves comparison with 'Giotto's tower' in Florence (Ill. 188). While Pisa's tower is circular in plan, that of Florence is square, and whereas the three-dimensional tiers of arcades are typical of Pisa, two-dimensional marble veneer is typical of Florence.

achieved without collapse. Pisa's campanile leans because the foundations were built poorly and provided uneven support. The tower began to settle unevenly while being constructed and the masons tried to correct the problem by making the tilt less extreme as the construction continued; therefore, the tower is both tilted off axis and curved in shape. It is 54.6 meters (179 feet) tall and is now approximately 4.9 meters (16 feet) out of plumb. Any additional increase to the incline has been prevented by a modern foundation and although now declared 'safe,' a 'keep off the grass' sign is hardly needed in the area of the tower's potential descent.

The center for Romanesque architecture in the region of Apulia in southeastern Italy was Bari and the prime example there is the church of San Nicola. The body of St. Nicholas, Bishop of Myra, was brought from Asia Minor to Bari by Normans in 1087, leading to an influx of pilgrims and the consequent need to build a church to accommodate them. Construction had started by 1089 and consecration took place in 1105 but work is known to have continued after 1132. In spite of deriving from many sources

97

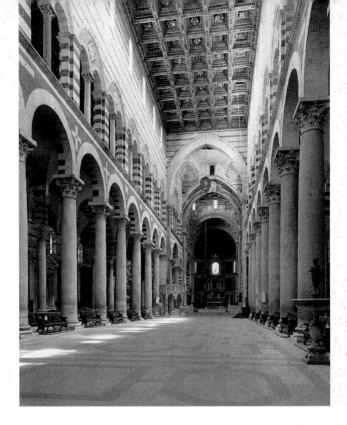

96. **Buscheto** (also spelled Busketos, Busketus, and Boschetto), nave looking toward apse, Pisa Cathedral, begun 1063

– Lombard, Norman, Tuscan, and local tradition – the style in which San Nicola is built is extremely harmonious due to the tan stone and the frequent repetition of arched shapes for structure and ornament. In the decorative use of blind arcades the exterior recalls the Lombard Romanesque, as seen at San Ambrogio in Milan. The massive mural quality recalls the Norman Romanesque, as seen at Saint-Etienne in Caen. The central portal is surrounded by rich carving and flanked by columns supported by cows on corbels.

 The massive nave of San Nicola, with a wooden ceiling flanked by groin-vaulted aisles, shows Tuscan influence – as at Pisa Cathedral. San Nicola's three-story nave elevation consists of the arcade, the tribune with three small arches surrounded by a larger arch in each bay, and the clerestory. With the later addition of the large transverse arches spanning the nave, the eastern one divided by three arches (through which the altar ciborium of *c.* 1139 is seen), the entire effect is that of a sculptural composition of arches in a variety of sizes and on all levels. The dome on squinches over the crossing is now hidden

by a wooden roof. San Nicola influenced several churches in Apulia, especially the cathedrals of Bari, Trani, and Bitonto.

Additional examples of Romanesque architecture in the area of Emilia Romagna are San Giovanni, Vignolo Marchese; the cathedral group of Parma; and the cathedral in Modena. In Lombardy are the circular church of San Tomaso in Limine, Almenno San Bartolomeo; Sant' Abbondio, Como; and San Michele, Pavia. In Tuscany are Collegiata Sant' Andrea, Empoli; Santa Maria della Pieve, Arezzo; San Michele in Foro, Lucca; and the Benedictine monastery in Sant' Antimo. In Umbria is Sant' Eufemia, Spoleto, and in the Veneto, San Zeno Maggiore, Verona. In Sicily, important Romanesque work remains at the cathedrals of Palermo, Cefalù, and Monreale, and the Palatine Chapel in Palermo, and in Sardinia at San Pietro del Crocifisso in Bulzi.

97. Facade and north side, San Nicola, Bari, 1089–after 1132

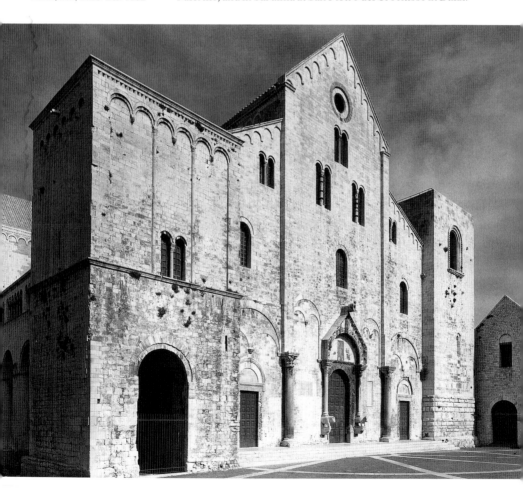

Spain

As intrepid Romanesque pilgrims, we have finally arrived at Santiago de Compostela in far northwestern Spain, considered the finest of the five major pilgrimage churches. During the Middle Ages the 'pilgrimage roads' leading to Santiago were among the most heavily traveled in Western Europe.

This site has been occupied since prehistoric times. In 813 it was claimed as the burial place of St. James the Apostle, whose body was said to have been brought here from Palestine. Legend embellished the story: glittering lights were seen and music heard at a spot in the woods – so said the keeper of the hermitage. He told Bishop Teodomiro of Iria (d. 847), who then claimed to have found the remains of James and two disciples at this spot. The city quickly expanded and encircling walls were built for

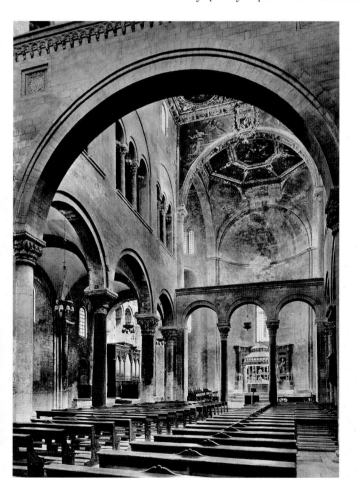

protection. In the ninth century there was a Benedictine church here and it was already a pilgrimage site. In 951, the Bishop of Le Puy, Godescalc, came to Santiago with almost two hundred monks. Around 1070 or 1075 the Bishop of Santiago, Diego Peláez, designed a new cathedral and this Romanesque building of golden Galician granite was almost complete by 1124 or 1128. Nine towers were planned – three big towers, two medium towers, and four small corner turrets – which would have produced a strikingly bold silhouette had they been completed. The huge staircase and the plaza in front of the cathedral were built during the Renaissance. The Romanesque facade was covered with Baroque decoration between 1658 and 1750, the abundance of exterior ornament forming a striking contrast to the austere, mostly Romanesque, interior behind it. The entire cathedral was not finished until the end of the eighteenth century. Today the cathedral of Santiago de Compostela and its towers dominate the city, but the cathedral hardly looks as it did in the peak period of the pilgrimages and, in fact, never looked as its architect intended.

The medieval pilgrim entered through the narthex, known as Master Matthew's vestibule, containing the Porch of Glory. 99 This triple doorway was heavily sculpted between 1168 and 1188 by Master Matthew (Mateo), who included an image of himself at the base of the median jamb, humbly kneeling and turned toward the altar in prayer. The Porch of Glory is a major work of art in terms of magnitude and iconographic complexity, and the original effect would have been even richer when the sculpture still had its bright colors. The central tympanum depicts Jesus in Glory with, as has already been noted to be standard in Romanesque tympana, an enormous figure of Jesus seated in the center. He displays his wounds, and is surrounded by the four Evangelists, each with his identifying symbol. Eight angels, four on either side of Jesus, bear several of the Instruments of his Passion. Carved on the archivolts are the twenty-four Elders of the Apocalypse, sitting and talking in pairs with their musical instruments. On the trumeau below is the seated figure of St. James the Apostle with his pilgrim's staff welcoming the visitor to his cathedral. At his feet is a diminutive feline looking much like a house cat, smiling and rubbing against his master.

The pilgrim who passed through Master Matthew's vestibule and into the nave, built of brown granite between 100 c. 1070/75 and 1120, would not have been disappointed. The interior is rhythmic, the proportions pleasing, elegant, harmonious,

and huge, for the interior vista stretches 76.2 meters (250 feet). The nave, which belongs to the type of pilgrimage church already described, has twenty typically thick Romanesque interior supports, each covering approximately 1.4 square meters (15 square feet). These supports are in the form of square piers with four attached shafts, the inner one continuing up the wall to carry the transverse arch that reinforces the barrel vault. The elevation is two stories, consisting of the arcade and the gallery with pairs of arches separated by a slender column and set into a larger arch. In this familiar Romanesque arrangement there is no clerestory – and hence no direct source of light into the nave.

Characteristic of the Catalan Romanesque is the church of San Clemente (Sant Climent) in Taüll, in the mountains of the province of Lérida, built entirely during the early twelfth century and consecrated December 10, 1123. The structure remains essentially unaltered. The east end is simple yet sophisticated, 101 the three apses ornamented with arches and engaged shafts. The campanile beside the church looks much like the tall bell towers of Lombardy, the six levels of open arches separated by Lombard bands. The interior has a nave covered by an open timberwork ceiling, flanking aisles, and round columns instead of the more customary piers.

The type of mural decoration that ornamented such churches is evidenced by a depiction from the neighboring church of Santa Maria in Taüll of David beheading the giant Goliath, painted *c.* 102 1123 and now in the Museu Nacional d'Art de Catalunya in Barcelona. The charming style is simultaneously sophisticated and naive. The story-telling is dramatically expressive with overtly theatrical gestures made by non-anatomical floating figures, with exaggeration for emphasis taken to the point of caricature. The style is that of the local Catalan tradition with the addition of other elements: Mozarabic, in which Arabic style is combined with Western subject matter, as well as Byzantine influences may be noted.

In the province of León, in the city of Salamanca, is the Old Cathedral, thus called to distinguish it from the New Cathedral built beside it in the sixteenth century. Exactly when construction of the Old Cathedral began is unknown. The earliest document in which it is mentioned dates to 1152 and construction was not completed until the thirteenth century. The nave 103 is presumed to have been constructed between some point prior to the mid-twelfth century and the early thirteenth century.

99 (overleaf) **Master Matthew (Mateo)**, *Jesus in Glory*. Tympanum of the Porch of Glory, Santiago de Compostela, 1168–88. This monumental and acclaimed accomplishment of Romanesque sculpture was still more striking and more readily seen in the shadows of the entrance vestibule when its original paint was intact. Comparison of this Spanish sculpture with the French *Jesus of the Apocalypse* in the tympanum of Saint-Pierre in Moissac (Ill. 67), carved several decades earlier, reveals iconographic similarities and stylistic differences.

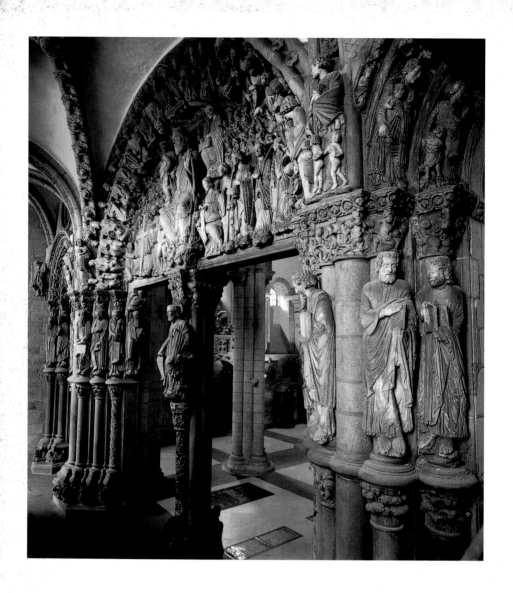

100 (opposite) Nave looking toward apse, Santiago de Compostela, c. 1070/75–1120. This church was the ultimate goal of enormous numbers of pilgrims, although the facade, now with a Baroque overlay, is very different from that seen in Romanesque times. The nave is an enlarged version of that of Saint-Sernin in Toulouse (Ill. 51) on one of the major roads to Santiago.

The ribbed vaults with pointed transverse arches covering the nave have similarities to early Gothic vaults, but the powerful robust proportions and thick walls are characteristic of the late Romanesque. So massive are the squat compound piers with engaged shafts and richly carved capitals that they seem almost to encroach on the space of the nave.

One accomplishment of late Romanesque architecture is the spectacular huge circular crossing tower – or cimborio – on the Old Cathedral; this is known as the Torre del Gallo (Tower of the

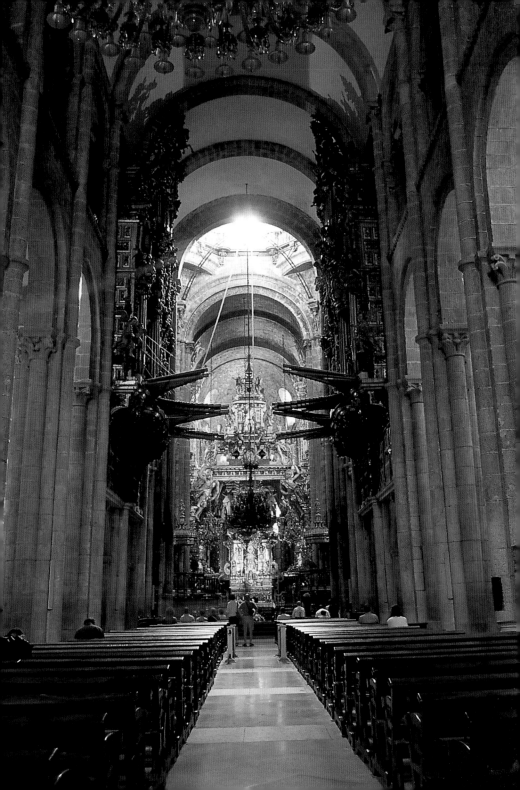

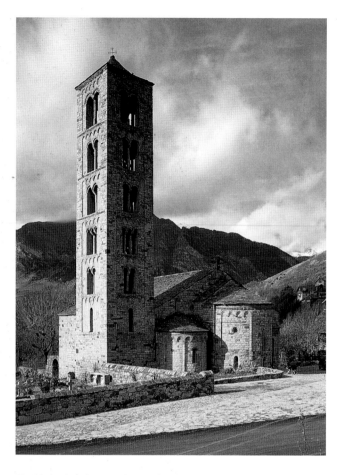

101. Apse end and bell tower,
San Clemente (Sant Climent), Taüll,
12th century, consecrated 1123

Cock) due to the weathercock on top. Seen from the inside, its
dome, constructed in the middle or second half of the twelfth 104
century, is the glory of the cathedral. The dome is supported on
pendentives, four spherical triangles that provide the transition
from the square crossing below to the circular dome above
(much as squinches provide the transition from a square cross-
ing below to an octagonal dome above). This lantern dome has
two tiers of windows at the base and is divided by ribs into
sixteen shallow segments; the effect created is a floating
architectural fantasy.

The Cathedral of Zamora, like the Old Cathedral of
Salamanca, also has a splendid cimborio above the crossing from
the middle or second half of the twelfth century. Zamora and
Salamanca are in the province of León, which had been held by
the Moors until just before the construction of these domes.

102. *David Beheading the Giant Goliath*. Mural from Santa Maria, Taüll, *c.* 1123

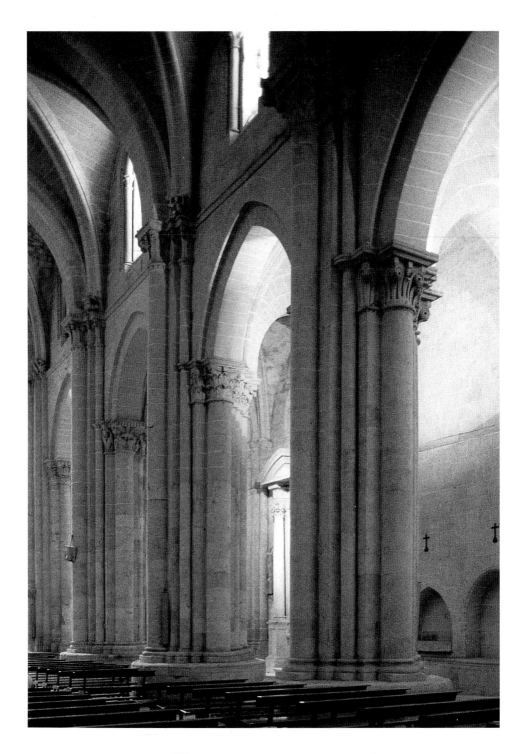

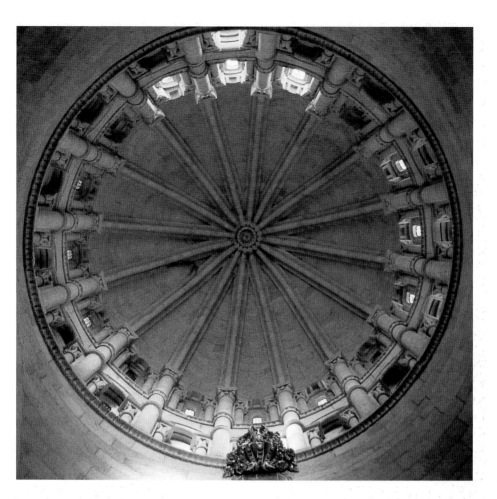

103. Nave of Old Cathedral, Salamanca, before mid-12th century–early 13th century

104. View up into crossing dome, Old Cathedral, Salamanca, middle or second half of 12th century

Indeed, the crossing domes and towers have a decidedly Eastern look and affinities with Moorish architecture, indicative of a successful merging of Eastern and Western aesthetics.

Further examples of the Romanesque in Spain are the abbey church of Santa Maria, Ripoll (Gerona); San Vicenc, Cardona (Barcelona); La Seu d'Urgell Cathedral (Lérida); Jaca Cathedral (Aragon); San Martin, Frómista (Palencia); San Isidoro (Panteón de los Reyes), León; San Lorenzo, Sahagún (León); Santa Maria la Mayor, Toro (Zamora); San Vincente, Avila; Santo Domingo, Soria; the circular Vera-Cruz, Segovia; the octagonal church of the Holy Sepulcher, Torres del Rio (Navarre); and the cathedral of Tarragona. In Portugal, noteworthy are the cathedrals of Coimbra and Lisbon, and the circular Templar church, Tomar.

Chapter 6: Romanesque Sculpture, Decorative Arts, and Manuscript Illumination

The decorative arts reached a new peak of opulent sumptuousness during the Romanesque era. Sculpture was polychromed and gilded, precious objects of gold and enamel glittered, ivory was carved into exquisite forms, and manuscripts were lavishly illuminated.

From the late eleventh century on, popular devotion to Mary increased. Many churches, cathedrals, religious orders, and brotherhoods were dedicated to Mary who was called 'Madonna,' 'Our Lady,' the 'Second Eve,' and the 'ideal woman.' Because all levels of society participated in the Cult of the Virgin, a wide variety of images of Mary were created, some for people who could barely afford a humble work and others for people who could commission a work in gold and gems from the finest artisan.

In addition to stone sculptures in situ on churches and cathedrals, many statues of Mary were carved of wood, the subject most often the enthroned Madonna and Child (see pp. 8-13). This type, which shows Mary seated with her infant son in her lap, was

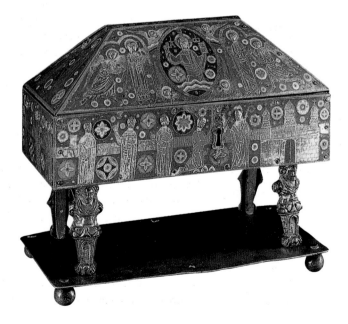

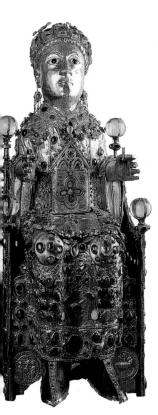

106. Reliquary image of Sainte Foy. Gold and jewels over wood, French, recorded 1010, height 85.1 (33½)

105. Reliquary coffer of the True Cross, Saint-Sernin, Toulouse. Champlevé enamel, made in Limoges, 12th century, 13 x 29 (5⅛ x 11⅜). The medieval cult of the relics focused especially on the veneration of items associated directly with Jesus and items believed to perform miracles. Relics had both religious and financial importance, resulting in the proliferation of objects of dubious authenticity: the wooden fragments claimed to come from Jesus' cross would suffice to construct an entire building.

repeated frequently during the twelfth century in all media and in all geographic areas in which the Romanesque flourished.

In addition to the Cult of the Virgin, there was a Cult of Relics that focused on tangible objects associated with important religious personages – Jesus, Mary, or one of the many saints (see p. 47). The most valued possessions of a church were its holy relics, often those of its name saint, and the many chapels in a Romanesque church contained altars, each dedicated to a different saint whose relics were kept there. The efficacy of a prayer was believed to be enhanced if the prayer was said when near a relic of the appropriate saint.

The enormous importance attached to the possession of relics was due not only to their spiritual value but also to their economic value. Because relics, especially those believed to perform miracles, attracted large numbers of generous pilgrims, a church's wealth might derive from their contributions, and the prosperity of the city might derive from the expenditures made by pilgrims. As a result, there was major trafficking in stolen and suspect relics throughout the Middle Ages. By the second half of the eleventh century, a great many – authentic and otherwise – had been collected in Western Europe.

The value of relics explains the lavishness of reliquaries such as the twelfth-century champlevé enamel reliquary coffer of the True Cross, a typical example made in Limoges. The wooden cross on which Jesus was crucified is one of the most important Christian relics. According to legend, Constantine's mother Helena found the True Cross, most of which was kept in the Church of the Holy Sepulcher in Jerusalem, although a portion was kept in Rome. In 614 Persians conquered Jerusalem and took the cross. In 630 it was retrieved by the Byzantine Emperor Heraclius, who then took it to Constantinople to protect it from the Arabs. The reliquary coffer illustrated here depicts the story of Raymond Botardel receiving a fragment of the True Cross from the abbey of Notre-Dame de Josaphat and bringing it to Saint-Sernin in Toulouse, where the coffer is kept. The figures are labeled to enhance the clarity of the narrative in the colorful scenes. Today, over 1,100 reliquaries of the True Cross are known.

Sparkling liturgical objects made of gold, silver, enamel, and precious and semi-precious stones enhanced the pilgrims' experience at Sainte-Foy in Conques, which retains what is probably the richest of all extant medieval church treasuries and includes the extraordinary reliquary image of Sainte Foy herself. Its original date is unknown though it was first described in 1010.

The belief that the head (or top of the head) of Sainte Foy contained within could perform miracles brought fame, money, and other offerings to the church. In fact, the reliquary is itself the result of contributions made by pilgrims, for if a jewel were given to the church it was added to the saint's attire: she wears agates, amethysts, crystals, carnelians, emeralds, garnets, hematite, jade, onyx, opals, pearls, rubies, sapphires, and topazes, as well as three antique cameos and thirty-one antique intaglios. Similar devotional images survive elsewhere and some are set with precious stones, but the sumptuous incrustation of Sainte Foy is exceptional.

Enamel, essentially colored glass fused to a metal surface by intense heat, was used for several millennia prior to the Middle Ages but became especially popular during the twelfth century. The basic material – glass – is not costly yet enamel is a highly valued luxury medium, its enduring appeal due to the jewel-like glitter of the colors that simulate the effect of gems. Items such as altarpieces, reliquaries, crowns, and vessels used in church rituals were often ornamented with enamel.

The ingredients needed to make enamel are flint or sand, red lead, and soda or potash. When heated, a clear flux results. While the enamel is hot and molten, a coloring agent is added in the form of a metallic oxide (for example, copper oxide produces green, cobalt oxide produces blue, and iron oxide produces red or brown). The enamel solidifies in slabs as it cools. To use a color, the slab must be ground to a fine powder and washed to remove dirt. The powder is applied to a metal surface and fired in a kiln at around 700-800 degrees centigrade (1300-1500 Fahrenheit); several applications and firings are required to build up thick enamel and to achieve a wide color range. After the enamel cools, the surface is polished to smooth out imperfections and to maximize the brilliance of the colors and the lustrous radiant sheen. Enamel is strong, hard, and durable.

This much of the process is the same for all enameling techniques. The differences between them have to do with the type of metal to which the enamel is applied and the way in which that metal surface is prepared to receive the enamel. Technically, medieval enamels fall into two categories: cloisonné, associated with the Byzantine East, and champlevé, associated with Western Europe.

Cloisonné enamel, probably invented by the Byzantines, is 23, 24 usually done on high-carat thin gold plaques. Gold is soft, pliable, takes high temperature, and does not tarnish. The enamel

colors are divided by uniformly thin strips of gold carefully placed to form the picture and soldered to the background. The term 'cloisonné' comes from the French word for 'partition' – the tiny metal fences are the 'cloisons.' Powdered colored glass is placed in the spaces formed between these fences and intense heat is applied to melt the glass and fuse it to the gold.

Champlevé, popular by the late eleventh or early twelfth century, differs from cloisonné in that it is done on thicker plaques of copper or bronze, gilded to look like solid gold. Less expensive than cloisonné, champlevé's use of base metals made possible the production of more and larger items to satisfy the enormous demand for liturgical objects created by the many new religious foundations. The metal ground must be of some thickness because the design is gouged into the surface with a kind of chisel, known as a burin; the term champlevé comes from the French for 'raised ground' or 'raised field.' The surface becomes a design of residual thin metal ridges. The bottoms of the troughs and channels are roughened – a process called 'keying' – to make the enamel adhere better. Champlevé does not have the multitude of uniformly thin gold wires of the cloisonné technique for, instead, the lines are fewer and vary in width, and the effect is less delicate.

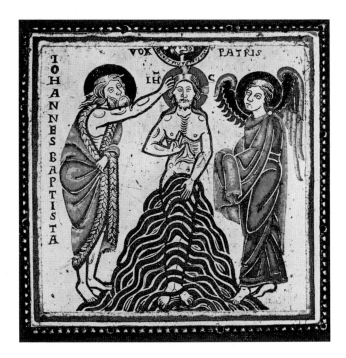

107. *Baptism of Jesus.*
Champlevé enamel, Mosan,
third quarter of the 12th century

The two major areas in which champlevé enamels were man-
ufactured in Western Europe were the Mosan area in the Meuse
River valley (part of today's Belgium) and the city of Limoges in
western France. An example of Mosan work is the *Baptism of* 107
Jesus, a plaque from the third quarter of the twelfth century.
In this non-naturalistic golden realm figures float and water is
signified by wiggly waves resembling hair. Lettering across the
background stresses the planar two-dimensional quality. Small
champlevé plaques were combined to make larger works by
riveting the plaques to a wooden core.

One Mosan enamel worker known by name is Nicholas of
Verdun. His masterpiece is the altarpiece at Klosterneuburg
Abbey, near Vienna. Signed and dated 1181 in an inscription, it is
the major extant program of enamel work of the century.
Originally, forty-five plaques adorned a pulpit, but after fire
damaged it, the plaques were used to create an altarpiece in the
form of a triptych in 1330–31. Each of the plaques contains a dif-
ferent scene, the figures engraved and gilded and the ground of
champlevé enamel. In the *Last Supper*, Jesus has just stated that

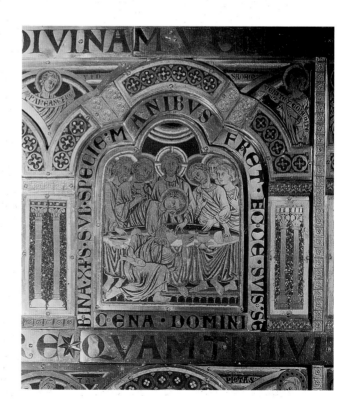

108. **Nicholas of Verdun**,
Last Supper. Champlevé enamel
plaque from the Klosterneuburg
Abbey altarpiece, Mosan, 1181,
height of individual plaque
14 (5½). The altarpiece is
a technically superb work
which shows that, at the end
of the Romanesque era, certain
artists were already leaving
behind the abstraction and
two-dimensionality typical of
this art in favor of greater fidelity
to the visible three-dimensional
world that would come to
characterize Gothic art.

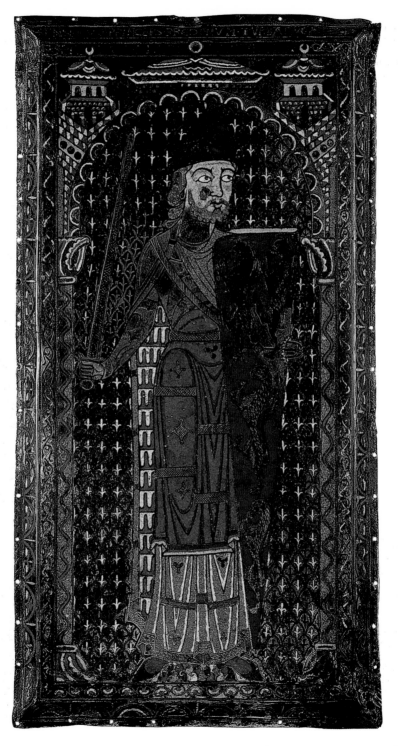

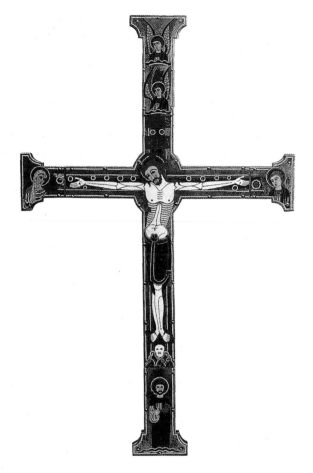

110. **Master of the Grandmont Altar**, *Crucifix*. Champlevé enamel processional cross, made in Limoges, *c.* 1190, height 67 (26⅜), length of arms 4.9 (1⅞), central plate 38.4 x 28.25 (15⅛ x 11⅛)

one of his twelve apostles will betray him (although only eight are indicated here). John, the apostle Jesus loved, is shown with his head on Jesus' chest. Judas, the betrayer, is shown stealing the fish, a symbol for Jesus from Early Christian times (the initial Greek letters of 'Jesus Christ, God's Son, Savior' spell out the word 'fish' in Greek – *ichthus*). The scene is crowded, all space filled in this condensed world. The apostles' feet appear below the tablecloth, although the table legs are not shown. The three-dimensional volume of the bodies is indicated beneath the drapery that clings as if it were wet – a return to the antique relationship between the figure and the fabric folds as determined by the body. This drapery is not used to create abstract linear patterns, as was characteristic of Byzantine and much of Romanesque art, for after the mid-twelfth century a change appears in art that is indicative of a growing interest in the

human figure, in Nature, and in the world in general. Nicholas of Verdun leaves behind the Romanesque era and moves into the Gothic.

A striking display of technical skill in champlevé enamel from Limoges is the funeral effigy of Geoffrey Plantagenet, made shortly after his death in 1151. The unusually large size of this plaque can be explained by the fact that it was the main part of the mausoleum of Geoffrey V Plantagenet, father of Henry II of England, the first Plantagenet king, and father-in-law of Eleanor of Aquitaine. Geoffrey is portrayed as a warrior in battle attire, a Christian knight standing sword in hand, eyes toward the sky. An inscription lauds his activities to achieve peace. 109

111. Griffin aquamanile. Gilt bronze, Mosan (or German), c. 1150, height 18.3 (7¼). The intrigue of animal imagery reached a highpoint during the Romanesque era. The extensive medieval menagerie of imaginary animals, often having antique lineages, included, with the griffin, the amphisbaena, centaur, dragon, manticore, mermaid/merman, siren, and a great many more that remain unnamed. Each of these 'composite creatures' is the result of combining parts of known animals (humans included) in ways unknown to Nature.

Another example of champlevé enamel from Limoges is the crucifix made as a processional cross c. 1190 by the so-called Master of the Grandmont Altar. A decorative linear pattern only distantly derived from human anatomy plays over the surface of Jesus' body in this highly stylized and highly sophisticated work. The Master of the Grandmont Altar avoids the physical horror of crucifixion, recalling the Carolingian *Lindau Gospels* cover, rather than the overt suffering seen in the Ottonian *Gero Crucifix*. Adam's skull is depicted at the base of the cross because tradition holds that Jesus' cross was placed on the spot where Adam and Eve were buried; thus the blood from Jesus' wounds symbolically redeems fallen humanity represented by Adam and Eve. Below the skull is St. Peter, suggesting that this crucifix may have been made for a church dedicated to Peter. On the horizontal terminals are busts of Jesus' mother Mary and the apostle John. 35 41

Precious and non-precious metals were used by medieval artisans to create a variety of objects. A charmingly fanciful example is offered by a griffin aquamanile, Mosan (or German), made c. 1150 of gilt bronze. Aquamanilia are water pitchers to be used for washing the hands at meals (forks being a rarity, one normally ate with one's fingers) and in church during mass. The term aquamanile derives from the Latin, 'aqua' (water) and 'manus' (hand). This cooperative creature raises his tail to form the handle so that the water will issue from his mouth when he is tipped.

Aquamanilia offered an opportunity for artistic invention and were frequently given the form of imaginary animals. The griffin has a lineage that goes back to antiquity: because it combined the nobility and strength of the lion with the mobility

112. **Master Hugo**, Bury Saint Edmunds Cross (back). Walrus ivory with paint, English, mid-12th century, height 57.5 (22⅝). Twenty prophets hold their prophecies, and a medallion enclosing the Agnus Dei (Lamb of God) proclaims that Jesus is the sacrificial lamb. The front of the cross originally showed Jesus crucified, prefigured by a tiny depiction of Moses and the brazen serpent within a medallion.

and visual acuity of the eagle, the valorous creature was used as a symbol of Jesus. But the griffin also had a negative interpretation: because it combined the lion's fierceness with the eagle's predatory nature, the destructive griffin was used as a symbol of the Antichrist.

Most aquamanilia are of bronze (copper combined with zinc forms brass; bronze is the result of the further addition of tin). Technically, a piece such as the griffin is cast and chased (the fine lines and details carefully crafted), and decorated with silver and niello. The early twelfth-century author Theophilus (mentioned on p. 92), in book three of his *De diversis artibus* (*On Divers Arts*), explained the techniques used in medieval metalwork. He described 'simple machines and specialized tools' but placed greatest emphasis on the skill of the person using the 'simplest tools.'

Ivory has long been a symbol of luxury: the ancient Greeks and Romans lauded its virtues. Strictly speaking, it is elephant tusk, which is dentine. This vascular material has a nerve canal at its center surrounded by a pulp cavity. The cavity is too soft to carve and the outermost husk too hard. In between is the only portion that can be used for fine sculpture – little more than half of the tusk. Ivory is readily affected by humidity, quickly absorbing moisture, salts, and substances in its environment, leading to brownish or greenish stains. It also tends to crack if permitted to dry out. On the positive side, ivory has a natural sheen due to its collagen content and can be highly polished. Although elephant ivory was praised and prized during the Middle Ages, walrus tusk was also used, especially in Northern Europe; during the Romanesque period, most ivories were not elephant but walrus tusk. And some so-called ivory is actually bone (usually horse, cow, or whale), which differs in structure and is spongy due to calcium phosphate deposits. Bone was used during the Middle Ages even where ivory was available, but considered a less luxurious substitute.

Among the most famous Romanesque ivories is the Bury Saint Edmunds Cross, associated with the abbey of Bury Saint Edmunds, England, and attributed to Master Hugo. This mid-twelfth-century walrus ivory retains traces of its original paint. Due to its delicacy, it was probably intended for use as an altar cross rather than as a processional cross. The complex iconography refers to salvation through Jesus' crucifixion. The corpus of Jesus is now missing from the front of the cross which looks like a tree with cut branches. The central medallion, held by angels,

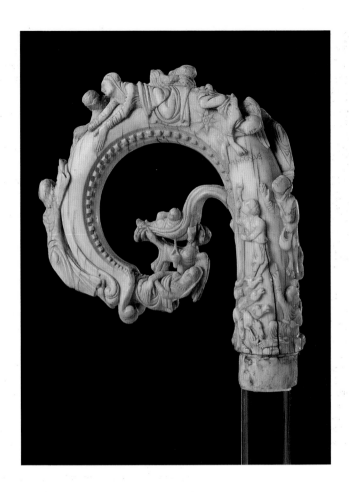

originally formed a halo behind Jesus' head. The portrayal of Moses and the brazen serpent contained within this halo is a typological prefiguration of the crucifixion. On the right terminal plaque is the descent from the cross and the lamentation over Jesus' body. On the left terminal plaque are the holy women at the sepulcher with the guards sleeping below and an angel gesturing toward Jesus on the top plaque. This plaque shows the ascension. The sculptor, evidently in an effort to create a composition that conforms to the square format, awkwardly abbreviated Jesus' body. At the foot of the cross, Adam and Eve rise from the grave as Jesus' sacrifice redeems humankind from original sin.

A fine example in elephant ivory is the Saint Nicholas Crozier, an English work of 1180, perhaps made in Winchester.

A staff with a curved crook at the top, the crozier is a symbol of authority carried especially by bishops, archbishops, abbots, and abbesses in their role as shepherds of the Christian flock. At the tip of the crozier, the infant Jesus lies on a tendril that grows from the stem and is supported by an angel. The annunciation to the shepherds and the birth of St. Nicholas are depicted on the shaft. Above, the infant Nicholas abstains from his mother's milk on fast days. On the outer curve of the crozier head, Nicholas provides dowries for three impoverished daughters of a nobleman of Myra. In this highly inventive use of the shape of the crozier head, figures seem to slip and slide through an entire environment carved in miniature.

Great importance was attached to the exquisitely delicate craftsmanship with which these objects were created, often on an almost microscopic scale. The conditions under which such items were produced make the accomplishment even more impressive. The medieval workday was usually restricted to the hours of sunlight, fingers stiff with cold could not be relieved by the artificial heating methods enjoyed today, and eyeglasses were not invented until *c.* 1285 in Padua.

The miniaturist's technique seen in ivory carving is equaled by that in manuscript illumination. In antiquity texts were written on papyrus, parchment, or cloth and rolled around a central core of wood, bone, or ivory and therefore referred to as a roll. During the Early Christian era, the roll was progressively replaced by the codex – a book formed by folding one or more sheets and sewing them together.

Every medieval monastery and church required Bibles, psalters, missals, and other books for religious study and moral instruction. Some monasteries had libraries. Books were copied slowly and tediously by hand. Often the Latin text to be copied was already filled with errors, to which the copyist added his own. Sometimes the lineage of a manuscript can be traced by its errors!

The word manuscript comes from the Latin 'manu' (by hand) and 'scriptus' (written). Most manuscripts were written not on paper but on animal skin known as parchment, the finest quality of which is vellum. The word 'parchment' derives from the name of the east Greek Hellenistic city of Pergamum. Pliny the Elder (d. AD 79) says King Eumenes II invented parchment in the second century BC when there was a trade blockade on papyrus: this material was called 'pergamenum' in medieval Latin. 'Vellum' comes from the French 'veau' or Latin 'vitellus' (calf). Strictly

speaking, parchment is made from the skin of a cow, while vellum comes from that of the youngest calves. The skin might also come from a sheep, goat, deer, hare, squirrel, or other animal. Due to the extensive preparation the skin undergoes before it is used in a manuscript, to determine just which animal was the source may require a skilled dermatologist with a magnifying glass. Each page is referred to as a folio, the front of which is the recto, and the back the verso.

Medieval manuals describe the various stages in the long and complicated procedures used to prepare parchment. The importance of selecting good skins is emphasized. First, the skin is washed in cold clear running water for a day and a night or, as one set of instructions puts it, until 'clean enough.' The skin is then soaked in a vat of lime and water for three to ten days and stirred several times each day with a wooden pole. The fur is pulled, rubbed, or scraped off and any remaining bits of flesh on the other side are removed. Two days of rinsing in fresh water are needed to remove the lime. Next, the skin is stretched taut on a wooden frame. Because the skin will shrink as it dries, it is kept wet with hot water. Both sides are scraped with a crescent-shaped lunellum, stretching the skin ever tighter, the goal being a smooth, even, thin skin, which is then moistened and rubbed with pumice to further smooth it. The parchment receives a final buffing with fine pumice and the surface is smoothed with chalk to remove any grease.

An 'illuminated manuscript' uses gold leaf to enrich the effect and to reflect the light. The gold is applied before the color for two reasons: so the gold will not adhere to the pigment and so the process of burnishing (polishing) the gold will not damage the surrounding color. Ink is kept in an inkhorn and the different colors are kept in small pots. A pen made from a quill or reed and held in the right hand is used to draw the image, while a knife held in the left hand is used to sharpen the pen and to erase mistakes. The binder most frequently used to make the paint is glair – egg white beaten until frothy or stiff, to which a little water is added and the mixture allowed to stand overnight until a colorless liquid forms (described as having a 'rank odor'). Glair is mixed with ground pigments derived from animal, vegetable, and mineral sources. The colors are painted on with a tiny brush.

During the Romanesque era, one person did the entire job just described. In the monastery scriptorium the monk prepared the parchment, cut it into rectangles, pricked and ruled the lines,

114. **Stephanus Garsia**, *The Flood*. Manuscript illumination from Beatus of Liébana's *Commentary on the Apocalypse*, 1028–72, 36.5 x 28 (14⅜ x 11), made for Saint-Sever Abbey in Gascony

copied the text, and painted the illuminations. During the Gothic era, however, the various tasks were likely to be done by different professional laymen in workshops according to a division of labor. Thus, the parchmenter prepared the parchment or vellum, which was sold in prepared sheets by the dozen or by the box; only the scraping remained to be done before it was used. The scribe who copied the text was a professional, or a cleric, or a student. The illuminator decorated the letters and borders. Working from written instructions, sketches, and model books, the illuminator painted the illuminations. Even the ink and gold leaf could be purchased ready-made, although artists continued to grind their own colors. Finally, the binder stitched the folios together.

Some medieval manuscripts are on paper rather than animal skin. Less costly than parchment, paper, invented in China probably in the second century AD, was used for books intended for students and clerics. Medieval paper was made from linen rags and was much stronger than that made today from wood pulp. Mills are recorded in Spain and Italy by the thirteenth century, in France by *c.* 1340, in Germany by 1390, and in England in the late fifteenth century. The invention of printing from movable type in the 1450s produced a sudden need for inexpensive paper. Parchment came to be used only for luxury books.

Included in a manuscript of the *Commentary on the Apocalypse* written by Beatus is an illumination of the Flood by Stephanus Garsia, dated between 1028 and 1072. Beatus, a Benedictine monk at the monastery of Santo Toribio in the Liébana Valley in the Asturias region of Spain, wrote his commentary on St. John's Book of Revelation around 776; it is preserved in a variety of manuscripts from the ninth to thirteenth century, some of which are illuminated. Stephanus Garsia illuminated this manuscript for the abbey of Saint-Sever in Gascony, then under Spanish rule. Mozarabic models would seem to account for the bands of flat solid color, absence of modeling, firm dark outlines, and expressive gestures – characteristics of Romanesque painting on any scale.

In the *Grimbald Gospels*, an early eleventh-century English manuscript from the Winchester School, St. Matthew is shown sitting at his desk, quill in hand, writing his gospel. He looks up to the winged man, his identifying symbol, as if seeking inspiration. The two-dimensionality of the flat surface is respected, with the heavy and highly decorative border stressing the picture plane.

115

115. *St. Matthew*. Manuscript illumination from the *Grimbald Gospels*, Winchester School, early 11th century, 32 x 24.5 (12⅝ x 9⅝)

116. *Initial R with St. George and the Dragon*. Manuscript illumination from the *Moralia in Job*, from Cîteaux, French or English, early 12th century, 34.9 x 23.5 (13¾ x 9¼)

117. *Lions*. Manuscript illumination from the *Bestiary*. English, *c.* 1200–10, page size 21.6 x 15.6 (8½ x 6⅛). The bestiary (*Book of Beasts*) derives from the late antique Greek *Physiologus* (*The Naturalist*), itself based on earlier texts. Bestiaries place the natural world in the service of religion, the characteristics of animals described as parallels for human behavior. Even the most implausible 'facts' (such as elephants' lack of knees) are presented without skepticism.

Initial letters might receive special decorative emphasis, as seen in a charmingly creative initial R formed by a depiction of 116 St. George and the Dragon in an early twelfth-century folio from a copy of Saint Gregory's *Moralia in Job*, illuminated in Cîteaux. Elegantly attired George stands on the shoulders of an assistant who spears the two-headed dragon in the belly. However fierce the monster may be, he cooperatively raises a wing and extends his tail to form the letter R.

Bestiaries – a special type of manuscript extremely popular during the Middle Ages – are encyclopedic compilations of animal lore and symbolism. Many illuminated bestiary manuscripts survive, especially from the twelfth and thirteenth centuries. The lion, king of beasts and the animal most frequently depicted in medieval art, is always the first animal described, as evidenced by an English manuscript of *c.* 1200–10. 117 According to the bestiary, lion cubs are born dead. Three days thereafter, they are brought to life by their father (how he accomplishes this depends on which version of the bestiary one reads: he either breathes on his cubs, licks them with his tongue, or roars at them). The bestiary compares this to the way in which Jesus was said to be resurrected by his father three days after his death. The inaccuracy of the story about the lion as well as of his picture in the bestiary may be explained by the lack of direct contact with lions in Western Europe as well as by the greater importance accorded to their symbolic/didactic value than to their zoologic characteristics.

Nothing more than observation, however, would have been required to resolve one debate recorded in the bestiary: weasels, some people claimed, conceive through the ear and give birth by the mouth, whereas skeptics denied this, arguing that weasels conceive by mouth and give birth by ear. Scientific experimentation, or even intelligent observation, had little to do with the information offered by the bestiary. Instead, the ideas of earlier authors were repeated, without verification of their 'facts.' This information was usually placed in the service of religious edification, the animals' lives and habits interpreted (even invented) to provide moral models for the reader either to emulate or to avoid.

Chapter 7: Earlier Gothic in France

'The acquisition of new assets ... the recovery of lost ones ... the multiplication of improved possessions ... construction of buildings ... accumulation of gold, silver, most precious gems and very good textiles,' wrote Abbot Suger (1081–1151) of the royal abbey of Saint-Denis, lauding his own accomplishments and patronage as he initiated a new style.

That style is known today as Gothic and refers to the arts and culture that developed from about 1140 onward in the Ile-de-France (the area around Paris) and in northern France. The Gothic style reached its peak in the thirteenth century. From the mid-thirteenth through the mid-fourteenth century, Paris was an important source of artistic inspiration for France, Germany, and England, whereas Italy remained quite separate artistically. By the middle of the sixteenth century, the Gothic style had come to an end in France, although aspects continued in Germany and England until the seventeenth century. By the eighteenth century and the Gothic Revival, the term no longer implied contempt (see p. 11).

Churches and cathedrals were embodiments of local civic pride, and cities vied with one another to create ever more beautifully built and embellished structures. Because these churches and cathedrals were built as houses of God and to honor God, there were no limits to the time, effort, and wealth lavished on them. The visitor was to be transported from the visible to the invisible, from the earthly to the spiritual. For the pious, the Church was a sanctuary, a haven that represented Heaven and the promise of eternal salvation.

The Gothic developed from the Romanesque, yet the two styles are opposites in many ways. Romanesque buildings, as represented by the nave of Saint-Sernin in Toulouse and the facade of Notre-Dame-la-Grande in Poitiers, are characterized by semi-circular arches, thick walls, and closely spaced supports that create a feeling of security. Massive and broad, Romanesque buildings seem to be bound to the earth. In contrast, Gothic buildings, airy and delicate, seem to be bound for the heavens. Characteristic are the nave of Chartres Cathedral and the facade of Reims Cathedral. With great height and very thin walls, the

verticals so incessantly accented, the buildings appear to soar upward. Small Romanesque windows give way to vast Gothic windows of stained glass. Such extraordinary architectural accomplishments evidence an era of confidence and daring, reflecting religious ideals and enthusiasm, inspiration and aspiration. The huge interiors created an emotional atmosphere of great spiritual value, particularly when chants reverberated from the high vaults.

The new Gothic style was made possible by structural innovations. Pointed arches exert less lateral thrust than semicircular arches, enabling the construction of vaults of great height. Ribs serve to reinforce the vault as well as to concentrate its weight at certain points, making it possible to minimize the structural role of the wall and to use glass instead of masonry between these points. Vault ribs were already seen in the late eleventh and early twelfth century in Norman architecture, as at Durham (1093–c. 1095) and Caen (early twelfth century). 82, 79 However, although the idea of the ribbed vault appeared prior to the Gothic era, it was only then that its potential was realized. Flying buttresses were a response to the problems created by the constant lateral thrust exerted by a true vault. The idea of a buttress – a solid mass of masonry used to reinforce a wall – was very old. But the 'flying' portion, that is the exterior arch, was new in the Gothic era.

The development of French Gothic architecture exhibits several phases:

1. Early Gothic, also known as the First, or Primitive, or Transitional Gothic, encompasses the years between the 1140s and 1190s. Important examples that will be examined here are the facade and east end of the royal abbey of Saint-Denis; the cathedral of Laon; and much of the cathedral of Notre-Dame in Paris.

2. High Gothic, also known as the Classic or Lancet Gothic, spans the period from the 1190s to 1230s. Key monuments include the cathedrals of Chartres, Reims, Amiens, Bourges, and Beauvais.

3. Rayonnant Gothic covers the period from the 1230s to 1350s. Included in this phase are the transepts and nave of Saint-Denis; the transepts of Notre-Dame in Paris; the Sainte-Chapelle in Paris; Saint-Urbain in Troyes; and much of Saint-Ouen in Rouen.

4. Flamboyant or Late Gothic is characteristic of the years from approximately 1350 to the early sixteenth century. A variety of buildings were constructed in this grand finale phase,

118. Facade of royal abbey of Saint-Denis, c. 1137–40

150

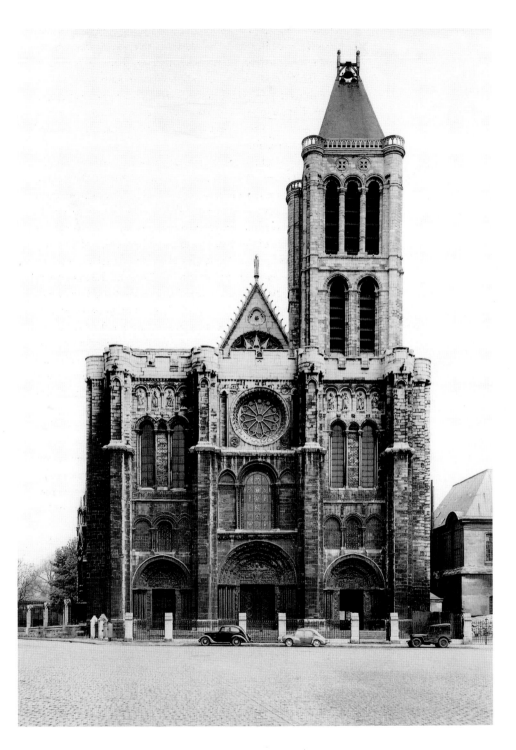

of which perhaps the purest is Saint-Maclou in Rouen. The terms Rayonnant and Flamboyant both relate to the characteristic tracery patterns of these styles.

There is little debate as to where the Gothic style begins: the royal abbey of Saint-Denis, just north of Paris, is referred to as the cradle of Gothic art. Denis, the patron saint of France, was the first of seven bishops sent to Lutetia (Paris) to convert the Gauls. Around AD 250, for his efforts, Denis was tortured on a hot grill and then decapitated in Montmartre on the northern edge of Paris. He is said to have picked up his head and walked northward to the site where the abbey was built. In fact, he may have been killed nearby and the abbey constructed over his grave.

Saint-Denis has a long architectural history. In 475 a large church was built on this site and other buildings followed. Around 750, the church was rebuilt by Pepin le Bref (Pepin the Younger – not Pepin the Short, as the name is sometimes incorrectly translated), the father of Charlemagne. Only fragments of the crypt remain.

The parts of Saint-Denis that herald the beginning of the Gothic were built under Abbot Suger: the west facade, the narthex, and the east end. Although Suger left the Carolingian church in between, it was later to be replaced in the Rayonnant Gothic style. Suger was a powerful politician and regent of France during the Second Crusade as well as abbot of Saint-Denis from 1122 until his death in 1151. A dynamic man with a taste for luxury, Suger provided the impetus for extraordinary artistic activity. Believing the Church to be a symbol of the Kingdom of God on earth, Suger made Saint-Denis as rich as possible, adorning it with a golden altar, jewelled crosses, chalices, vases, and ewers of precious materials. This richness was to serve not only God, but also France, and possibly Suger himself as well. He wrote about the abbey's development under his care,

118

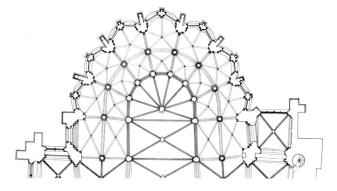

119. Plan of east end, royal abbey of Saint-Denis, 1140–44

recording his activities in his *Liber de consecratione ecclesiae*. He also had himself depicted in stained glass and sculpture, and had his name included in inscriptions at Saint-Denis.

Of great historical importance, Saint-Denis served as the prototype for other Gothic buildings. The facade, dated between *c.* 1137 and 1140, is the first example of monumental sculpture synthesized with architecture, the whole treated as an artistic composition with rhythm, clarity, and variety. Elements seen here that will become standard on Gothic facades are the three portals; two towers (only the south tower remains); one rose/wheel window (circular windows date back to ancient Roman times but reached their peak in the Gothic era); rows of figures representing Jesus' ancestors; and column figures on the jambs (now gone). Unfortunately, this facade was greatly damaged, much of the sculpture removed, and considerable restoration and recarving done.

Between 1140 and 1144, Suger removed the Carolingian apse and built a new choir. Today, only the ambulatory and chapels remain as they were in Suger's time. As the plan makes clear, the seven shallow chapels project only slightly: this may be perceived as a double ambulatory with curving exterior walls or a single ambulatory with deep chapels. A new concept of architectural space, of light and lightness, is inaugurated here. Spaces are not clearly divided by the solid walls and massive supports that characterize the Romanesque; instead, Gothic spaces flow freely and areas merge. Given that the arches exert a lateral thrust and the walls have largely been replaced by stained glass windows in each chapel, the visitor standing in the apse might wonder how this structure is able to stand. The answer is on the exterior and cannot be seen from the interior through the stained glass: buttresses project outward between the chapels. External buttressing was to develop greatly, ultimately evolving into the characteristically Gothic flying buttresses.

The Cathedral of Notre-Dame in Laon, famous for its towers, was reconstructed in the new Gothic style, work beginning in the second half of the twelfth century; the facade was finished in the early thirteenth century. Five of Laon's original seven towers remain – a multi-towered silhouette is characteristic of later Gothic churches. Surely the most eye-catching feature of the facade towers here are the enormous sculptures of bulls at the tops. These were intended to honor the bulls that hauled the building materials up to the construction site atop a ridge – a feat worthy of recognition since Gothic cathedrals were customarily constructed on the highest elevation available.

120

121

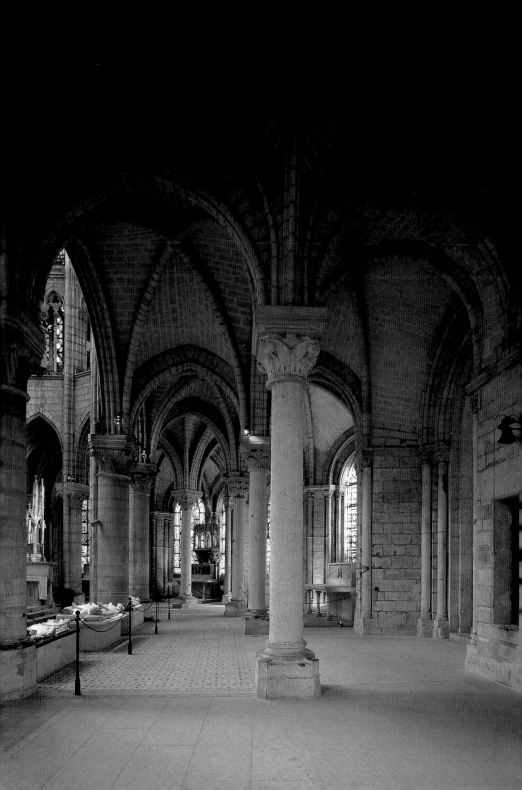

121. West facade, Cathedral of Notre-Dame, Laon, second half of 12th–early 13th century

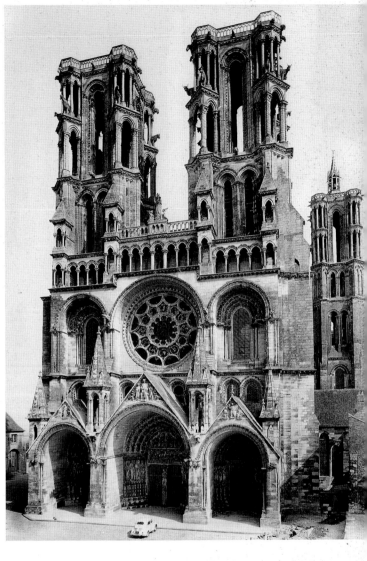

120. Choir ambulatory, royal abbey of Saint-Denis, 1140–44. Saint-Denis moves away from the Romanesque conception of architectural space as compartmentalized and segmented, and of architectural structure as based upon massive walls and semi-circular arches. The Gothic conception of space as open and fluid, and of structure as based upon delicate pointed arches, supporting ribs, and external buttresses begins here.

The interior of Laon Cathedral is light, the accents domi- 122 nantly vertical, and the proportions soaring. This nave, built for the most part in the last quarter of the twelfth century, is 24.08 meters (79 feet) high. The four-story elevation of the nave is indicative of the Early Gothic for the number of stories will gradually diminish to three and ultimately to two. The four stories of the nave elevation are: the nave arcade, the gallery, the triforium, and the clerestory. (The triforium was originally thus named due to the three openings per bay, but the name does not

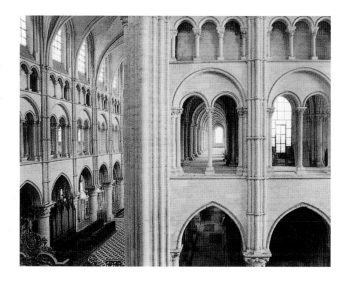

122. Interior seen from crossing, Cathedral of Notre-Dame, Laon, mostly last quarter of 12th century

change even if there are two, or four, or more openings per bay.) In the Early Gothic period support for the vault was still provided by thick walls. At Laon, the outward thrust of the six-part vaults is stabilized by arches under the roof and behind the triforium that form a type of hidden buttress. In the thirteenth century the whole cathedral was given flying buttresses: although they were not required structurally, they were added to 'modernize' Laon Cathedral.

The Cathedral of Notre-Dame-de-Paris (Our Lady of Paris), located in the center of Paris on the island in the River Seine known as the Ile-de-la-Cité, is among the most famous buildings ever erected. The spectacular site has long been appreciated: there were Gallo-Roman ramparts as well as Merovingian and Carolingian churches here. Bishop Maurice de Sully, founder of the present cathedral, had the earlier churches removed. Construction of Notre-Dame started in 1163 with the choir, noted above to be, liturgically, the most significant area and therefore normally the first built.

In the 1180s flying buttresses were used at Notre-Dame to stabilize its great height – one of the first uses of flying buttresses. They are in two parts, with the outer buttress exposed and the inner buttress hidden under the roof of the inner aisle. The flying buttresses counteract the lateral thrust of the vault, joining the wall at the critical point of thrust between the clerestory windows where there is minimum stone and maximum glass. By annuling the wall to the point of creating a web of

stone, buildings of tremendous height could be constructed. Further, the exterior of the building is animated by the cage – a sort of second volume – created around the building by the flying buttresses. From this time forward, they had an important structural and visual role in Gothic architecture.

The facade of Notre-Dame was built, for the most part, during the first half of the thirteenth century. The large amount of wall still evident is a holdover from the Romanesque. The composition of the facade is a masterpiece of balance achieved on an enormous scale through a subtle equilibrium of horizontals and verticals. In the previous Romanesque period the horizontals dominated; later in the Gothic period the verticals would dominate. Further, Notre-Dame's facade has an underlying geometric pattern based on a sequence of squares, one inside another. The entire facade is a square 43.3 meters (142 feet) on each side. The towers are half the height of the whole solid

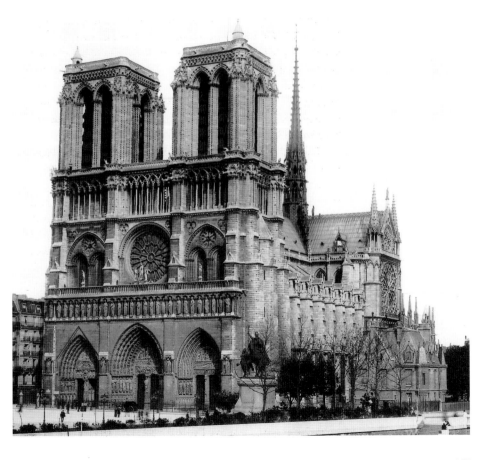

123. Cathedral of Notre-Dame, Paris, 1163 f. Notre-Dame is a major monument not only in Paris but also in the history of art, its appeal enhanced by a particularly picturesque location on an island in the River Seine. The west facade has pleasing proportions that are mathematically derived and, as is typical of Gothic facades, one rose window, two towers, and three portals.

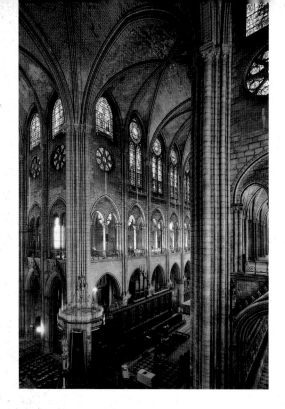

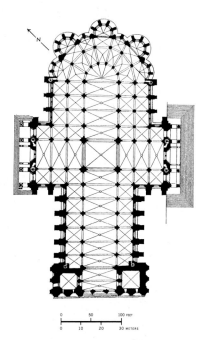

124. Interior seen from crossing,
Cathedral of Notre-Dame, Paris,
1180–1230

125. Plan of the Cathedral
of Notre-Dame, Chartres,
1194–1220

126. Cathedral of Notre-Dame,
Chartres: Royal Portals and
windows above 1145–55,
remainder of facade 1194 f.,
north steeple early 16th century

area – simple geometry. Abbot Suger expressed related ideas on the use of mathematics in architecture.

The facade sculpture program includes a row of thirty-eight statues, comparable to a horizontal Tree of Jesse, representing the kings of Judah and Israel. The facade rose window, 9.1 meters (30 feet) in diameter, forms an enormous halo for the sculpture of Mary (to whom the cathedral is dedicated) and her infant Jesus. Above, to their left and right, are Adam and Eve. Many of the statues here today are recent work but reproduce the originals. All were once painted brightly and generously gilded.

The interior, built between 1180 and 1220, measures 122.5 meters (402 feet) long and over 32.9 meters (108 feet) high, making it the highest cathedral at that time by almost 9.1 meters (30 feet). Originally constructed with a four-story elevation, the nave was 'modernized' between 1220 and 1230 – almost as soon as it was first finished – to a three-story elevation by eliminating the triforium which consisted of a row of circular windows. Thus, the third and fourth stories were combined and the enlarged clerestory windows extended down through the area

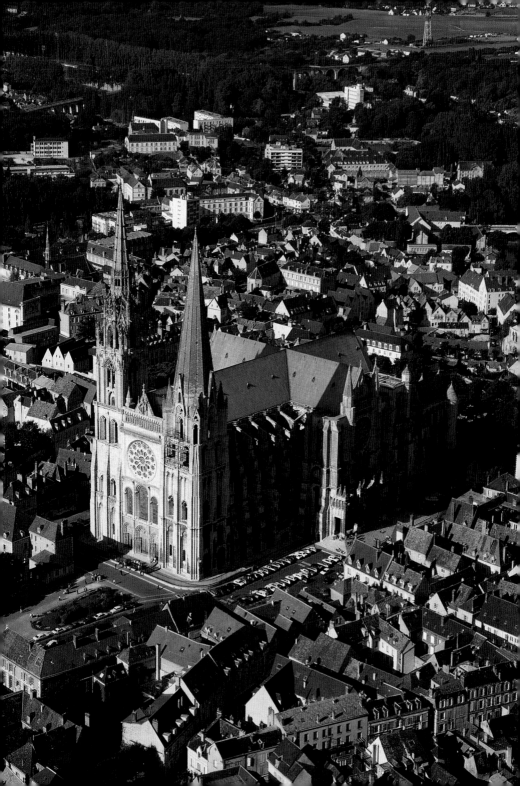

that had been the triforium. (Several four-story bays were re-created near the crossing and in the transepts by the French architect and master restorer Eugène-Emmanuel Viollet-le-Duc [1814–79].) In this Early Gothic nave, the wall still appears solid, strong, severe, broadly modeled and massive, and the interior is still quite dark.

Other portions of the cathedral were also remodeled, work taking several decades. The vaulting of the choir was rebuilt; the flying buttresses were doubled; the transepts were recon-structed; and work was done on over forty chapels.

Additional examples of Early Gothic architecture in France are the cathedrals of Angers, Noyen, Poitiers, Senlis, and Sens, as well as Saint-Yved, Braisne; Notre-Dame-en-Vaux, Châlons-sur-Marne; Saint-Jean, Lyon; collegiate church of Notre-Dame, Mantes; Saint-Germain-des-Prés, Paris; Saint-Quiriace, Provins; Saint-Rémi, Reims; and Saint-Leu-d'Esserent.

The Cathedral of Notre-Dame in Chartres, a spectacular structure with splendid sculpture and sparkling stained glass, is the first masterpiece of the High Gothic. It was the first cathe-dral to be planned with flying buttresses as an integral part of the structure. The trend in Gothic architecture was to progres-sively open the wall spaces between the buttresses, making the cathedrals ever lighter and airier. Earlier forms were refined, extended, and made increasingly more vertical.

Dedicated to the Virgin Mary and built on the highest eleva-tion in the city, Chartres Cathedral was intended to be a 'terrestrial palace' for Mary. The cathedral still possesses an important relic, known as the *sancta camisa* – a piece of cloth, possibly part of a tunic or veil, said to have been worn by Mary when Jesus was born. Because of this relic, Chartres was believed to be under Mary's protection and it became an extremely popu-lar pilgrimage site. Although many miracles were attributed to the treasured textile, it could not fend off fire, a chronic enemy during the Middle Ages and the cause of the cathedral's destruc-tion in 1020. Rebuilding of a new cathedral in the Romanesque style began immediately and by 1024 a new crypt was finished. Known as Fulbert's Crypt, it is still the largest crypt in France. However, in 1134 fire nearly destroyed the city and badly damaged this cathedral. Between 1145 and 1155 the Royal Portals and the stained glass windows above them, all extant today, were made. In 1194 the cathedral suffered great damage from yet another fire. Little more than Fulbert's Crypt, the Royal Portals, and the windows above survived.

126

129

That the *sancta camisa* survived the fire of 1194 safely in the crypt was taken as a sign to build Mary a more magnificent monument. The people of Chartres immediately and willingly gave money, muscle, and time. All social classes participated, from the high nobility to the humble peasantry. So enthusiastic were the efforts made in bringing the rough limestone for construction from five miles away in carts that people spoke of the 'cult of the carts.' By 1220 the main structure and the vaults were finished, built with great speed and in a very consistent style. The dedication took place in 1260.

The facade of Chartres, like that of Notre-Dame in Paris and many other Gothic cathedrals, has four buttresses, three portals, two towers, and one rose window. Chartres' facade towers are strikingly dissimilar: the south spire, built at the same time as the rest of the upper facade, is 101.8 meters (344 feet) high, whereas the north spire, built in the early sixteenth century in the Flamboyant Gothic style, rises 114.9 meters (377 feet). Given that each tower was built in the style popular at the time of its construction, neither symmetry nor consistency can be said to have been Gothic aesthetic goals. Chartres' towers are dissimilar, but not discordant. Indeed, it might be argued persuasively that they are twice as interesting as two identical towers.

The plan of Chartres uses the Royal Portals for an impressive entry on the west and Fulbert's Crypt for the foundation on the east. The unusually large choir is one-third the length of the building. Radiating chapels project from the double ambulatory around the apse. The buttresses protrude on the exterior like spiny bones, the plan making clear the extent to which the wall has been eliminated.

The nave measuring 128.6 meters (422 feet) long with a vault 36.9 meters (121 feet) high has a sense of openness, airiness, and soaring verticality: in comparison, the nave of Notre-Dame in Paris rises just over 32.9 meters (108 feet). Because it was built quickly and has undergone few modifications and only minor damage since 1260, Chartres displays great unity. The three-story elevation consists of a high arcade, the triforium, and the clerestory. A multiplicity of lines lead the visitor's eyes up the wall to the clerestory windows, which are almost the same height as the openings in the nave arcade – about 13.7 meters (45 feet). All the openings are tall and narrow, emphasizing the vertical. The nave is covered by simple four-part vaults. The springing of the vault ribs begins high in the clerestory, whereas earlier Gothic vault ribs rise from the bottom.

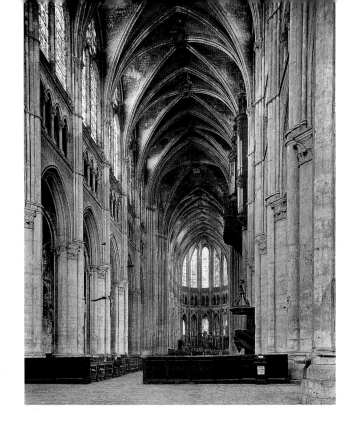

127. Nave looking toward apse, Cathedral of Notre-Dame, Chartres, 1194–1220. While Romanesque church architecture is characterized by experimentation in vaulting methods, Early and High Gothic church architecture is characterized by experimentation with proportions and a quest for ever greater height. Where Romanesque naves have small windows or none, Gothic naves have large windows – less to admit sunlight than to display stained glass. Unseen through these windows are the flying buttresses that support the stone walls.

The tremendous window area permitted by the exterior buttressing was not intended to produce a brightly lit interior because stained glass prevents much of the natural light from entering. Instead, stained glass provides colored light in the windows themselves and in the flickering dabs falling on the stone interior as the sunlight passes through the colored glass.

Chartres Cathedral was famous during the Middle Ages for reasons other than its religious role. The city was the site of four annual fairs at which a vast variety of goods were sold around and even in the cathedral (wine merchants were eventually forbidden from selling in the nave and were instead allotted an area in the crypt). Chartres was also an important intellectual center from the late tenth century until the early thirteenth century when the University of Paris was founded and drew some of the attention away.

Reims Cathedral, like the cathedrals of Paris, Chartres, and many other cities, is dedicated to Mary. At some point between 1210 and 1220, fire destroyed an old Carolingian building on this site; soon after, construction of the present cathedral began.

The west portals date from approximately 1230 to 1240 and are in the High Gothic style. Construction of the upper part of the facade continued until the end of the century, moving in to the Rayonnant phase. The towers were finished in 1445 and 1475, although more work was done on the towers after a fire in 1481.

The tall narrow facade is composed of a great many vertical elements emphasized by the shape of the tympana, the pointy gables, the plethora of pinnacles, and the clusters of slender colonnettes all pointing repeatedly to heaven. The facade is notably three-dimensional with portals so deep that they might more accurately be called porches. The portal gables rise very high, blending the lowest story into that above. An oddity of Reims, and perhaps the most distinguishing feature of the facade, is that rather than having the usual sculpted stone tympana Reims has stained glass tympana that further enhance the delicate lacy quality of the wall. Creation of such a spindly skeletal structure of stone is a feat of architectural daring, for thrusts must be carefully calculated and the spidery structure sustained by a multiplicity of external buttresses.

The nave of the cathedral, built mostly after 1241, measures 138.1 meters (453 feet) long and 37.8 meters (124 feet) high to the sharply pointed vaults, making evident the progressively

128. Cathedral of Notre-Dame, Reims: west facade c. 1230 f., towers largely 15th century

increasing height of Gothic cathedrals. Reims' architects achieved an effect of great unity and harmony, due in part to the fact that all the supporting piers are identical and the same basic elevation is used in the nave and choir. Each bay is covered by a four-part ribbed vault – in the nave, at the crossing, in the choir, as well as in the aisles. Thus the system is completely consistent. The nave elevations of the cathedrals of Reims, Amiens, and, to some extent, Beauvais, were meant to be enlarged variations on Chartres Cathedral. The three-story nave elevation at Reims imitates that at Chartres by employing a huge arcade, small triforium, and huge clerestory above. As at Chartres, the clerestory windows consist of double lancets with a rondel above, and there are four openings per bay in the triforium – a frequently employed arrangement. The walls are thin, interruptions to the verticals minor, and the effect soaring, light, and airy.

It may be noted that the chairs seen today in Chartres, Reims, and other medieval cathedrals and churches are modern additions: physical comfort was not a focus in medieval architecture. Only the bishop had a seat ('cathedra' is Latin for throne): it was the presence of the bishop's chair or throne that elevated a church to the status of cathedral. During the service the faithful stood or kneeled; if they wished to sit, they brought their own stool or chair.

129. Royal Portals. West facade, Cathedral of Notre-Dame, Chartres, 1145–55

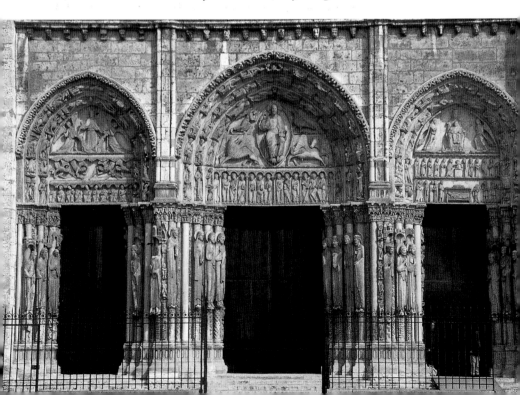

The logical place to seek the earliest Gothic sculpture would be Saint-Denis – if the work there were not so badly damaged. Fortunately however, the sculpture on Chartres Cathedral's three triple portals (on the west facade and the north and south transepts) survives intact, although the rich paint and gilding is now gone. From the Early Gothic era are the Royal Portals on the west facade, dated between 1145 and 1155. The tympanum of the central portal depicts Jesus surrounded by a mandorla of light and the four beasts representing the four Evangelists, Matthew, Mark, Luke, and John. This imagery persisted from the Romanesque era, as seen at Moissac, and maintained its popularity in the Gothic. Below, jamb figures flank the doorway. They are symmetrical, ordered, clear, and immediately intelligible, in contrast to the Romanesque tendency to complex compositions and figure poses. These jamb figures form a 'precursor portal' of Old Testament ancestors of Jesus – iconography used at Saint-Denis and perhaps started by Abbot Suger. Those without crowns are the prophets, priests, and patriarchs of the Old Testament – Jesus' spiritual ancestors. Those with crowns are the kings and queens of Judah – Jesus' physical ancestors. Medieval iconography was intentionally complex, with layered and overlapping meanings permitting multiple interpretations for these statues; thus, in addition to being the royal ancestors of Mary and Jesus, they may also be associated with the kings and queens of France, thereby combining religious and secular authority. Due to comparisons made between the Church and the Heavenly Jerusalem, these portals were regarded as the 'gates of heaven.'

The jamb figures are referred to as 'column figures' because they maintain the shape of the columns to which they are attached. Indeed, the sculpture is very closely linked to the architecture, with the columns carved to resemble the human form. These majestic figures project a noble dignity and a calm serenity. They are immobile: there is no twisting, turning, or bending; they do not interact with one another nor with the spectator. The drapery still consists of many tiny linear folds that fall to perfect zigzag hems, but this drapery obscures the body beneath and looks much like the fluting of a column, thereby stressing the architectural role of these figures. These are not substantial, earth-bound bodies, standing on solid ground; instead, their feet simply dangle.

After the fire of 1194, Chartres was rebuilt and the transepts given porches with triple doorways. The north transept portals

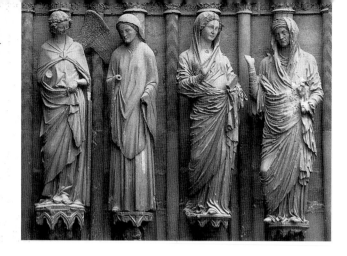

130. *Annunciation* and *Visitation*. West facade, Cathedral of Notre-Dame, Reims, 1230s. Gothic sculptors created ever more lifelike figures. Those from the Early Gothic period are columnar in shape and one with the architecture, as seen at the Cathedral of Notre-Dame, Chartres (Ill. 129). At Reims, the figures are freed from the architecture, have normal body proportions, and move in space to converse in pairs. This idea is taken still further in Ill. 131.

date approximately 1200 to 1215. The jamb figures here differ from those on the west facade in that their proportions are closer to Nature, their bodies bulkier rather than elongated, their feet more perpendicular to the ground. They thus appear to stand rather than to hover. The parallel linear drapery folds are replaced by softer curving folds. The relationship between figure and column changes as the figures expand beyond the confines of the columns. Some even turn their heads and their faces begin to show emotion. The style seen on the north portals is more elegant, more relaxed, more graceful than that on the west portals.

The south transept figures, carved slightly later than those on the north transept, date *c.* 1220. These figures are now much larger than the columns and their bodies more three-dimensional. The figure of Saint Theodore is slightly later in date (*c.* 1230–35) than the others on this portal. Rather than being rigidly erect like his predecessors, he strikes a swaying pose with his head turned to the side, his body forming a slight S-curve as he stands solidly on a horizontal platform.

Some of Chartres' sculptors seem to have worked later at Reims Cathedral. The High Gothic figures who act out the Annunciation and the Visitation on the west facade, dated to the 1230s, are descendants of the latest column figures at Chartres. But at Reims, rather than standing side by side, unaware of the next figure's presence, they interact. The columns from which they extend are hardly noticed. Now there is a figure on every other column and the columns are smaller and spaced further apart. The figures are no longer as united with the architecture as they had been at Chartres.

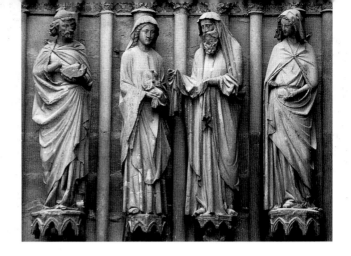

131. *Presentation of Jesus in the Temple*. West facade, Cathedral of Notre-Dame, Reims, 1230s–c. 1240. Here, four figures communicate and even exhibit emotion through facial expression and pose.

The two pairs of figures are carved in very different styles. The Annunciation depicts the moment when the angel Gabriel tells Mary she will give birth to Jesus. In view of the extraordinary nature of the news she has just received, Mary shows surprisingly little emotional response. She is severe, standing erect, her heavy drapery falling in broad sharp folds to completely obscure her legs. Graceful Gabriel, however, grasps his drapery so that it falls on diagonals, his slender body forming an S-curve with relaxed elegance. And he smiles a Gothic grin. The new interest in emotion is a characteristic of the Gothic era.

The Visitation depicts the meeting of Mary, now pregnant with Jesus, and her cousin Elizabeth, pregnant with John the Baptist, exchanging their news. According to the story, Elizabeth is older, and this is correctly shown by the sculptor. Both bodies form a pronounced S-curve – the contrapposto (counterpoise) pose of antiquity revived. They move in space, left and right, as well as front and back. Many small drapery folds run on diagonals and horizontals, the complicated crinkles following the outlines of the body.

Also on the facade of Reims Cathedral are four figures that interact through space as they portray the Presentation of Jesus in the Temple. Mary and old Simeon are in the center, while Joseph holds doves. Unlike at Chartres, the columns now are widely spaced, the figures further apart, no longer columnar in shape, and they stand firmly on little platforms. Their gestures are freer, looser, and more natural than in earlier works. Joseph, dated to *c.* 1240 and thus a bit later than the other figures here, is the work of the so-called Saint Joseph Master. The figure's expressive face reveals a new sense of life, movement, animation,

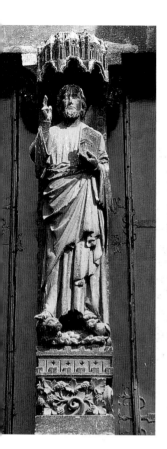

132. *Beau Dieu*. Trumeau of central portal of west facade, Cathedral of Notre-Dame, Amiens, first half of 13th century

and delicacy. A new style, known as the 'Reims style,' appears here during the thirteenth century and was maintained in many respects for the next 150 years. Although historians refer to this 'Reims style,' a variety of workshops were active in the city over many years, with the result that there are differing plastic qualities and differing emotional expressions found within the style.

At Amiens Cathedral, on the trumeau of the central portal of the west facade, is the famous *Beau Dieu*, carved in the first half of the thirteenth century and considered a masterpiece of Gothic art. No longer shown high above in the tympanum in judgement, Jesus has descended to the worshiper's level. Almost a statue in the round, he is portrayed holding the Gospels in his left hand while blessing with his right. The face is idealized and generalized, noble and serene – a kinder gentler concept of Jesus than in the Romanesque era. The drapery is treated as an aesthetic composition to be appreciated in its own right, falling into elaborate folds at the bottom but plain above the waist, serving to act as a foil and to set off the head: the costume does not distract or detract from Jesus.

The four animals below Jesus illustrate Psalm 91:13: 'Thou shalt walk upon the adder and the basilisk; the young lion and the dragon shalt thou trample under feet.' These pairs of animals are shown on the pedestal and, appropriately, under Jesus' feet. Medieval artists often portrayed figures standing on small symbolic animals, people, or objects. In the case of the *Beau Dieu*, the adder represents sin. The basilisk, a kind of lizard with a crest along the spine, represents death. The young lion, in this specific context, represents the Antichrist or devil: more often the lion serves as a symbol of Jesus. Finally, the dragon, which routinely carries negative connotations in Western art, also represents the devil. The implication of the whole composition is that Jesus is triumphant over all these evils.

Saint-Étienne in Bourges, a striking example of High Gothic architecture, was begun *c.* 1195 although the west facade dates to the end of the thirteenth century. Unlike the three-portal facades seen elsewhere, Bourges is unique in its broad facade of five arched portals that correspond to the nave and double aisles. The central portal is the largest but their sizes and shapes are otherwise notably irregular. Richly sculpted, they are an integral part of the facade composition, in which the arch motif is used in various clever ways. The two facade towers are not identical either, for the unfinished south tower is more sober than the higher late Flamboyant Gothic north tower. Bourges' portals

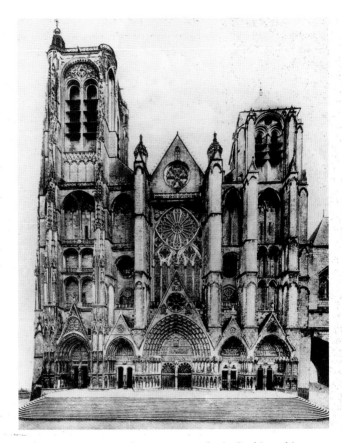

133. Cathedral of Saint-Etienne, Bourges, begun c. 1195; facade late 13th century

and towers are among the many examples in Gothic architecture that demonstrate less concern for symmetry and regularity than for an animated and picturesque effect. The ancient Greeks employed a similar aesthetic, referred to as 'unity and variety,' in which the elements of a composition are of sufficient similarity to create unity yet adequately varied to avoid monotony.

The plan of Bourges Cathedral is simple, the early thirteenth-century interior consisting of a nave flanked by double aisles, small radiating chapels around the apse, and no transepts. Bourges is 124 meters (407 feet) long with six-part vaults rising 37 meters (121 feet). The inner aisles are lower than the nave, and the outer aisles, also covered by four-part vaults, still lower but wider – a structural system that serves to buttress the nave as the lateral thrust exerted by the huge vault is gradually dissipated to the periphery. On the exterior the flying buttresses are in two rows over the inner and outer aisles, and are in three tiers – a daring skeletal structure in stone.

134

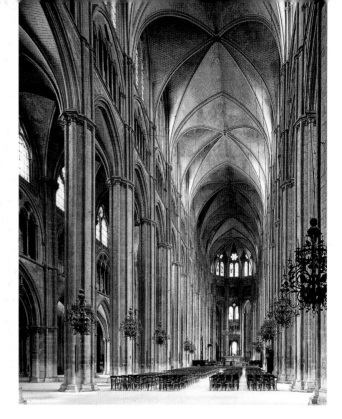

134. Nave looking toward apse, Cathedral of Saint-Etienne, Bourges, early 13th century. This interior is considered especially harmonious due to the fine proportions, the absence of transepts that would otherwise interrupt the arcade, and the unusual consistency of the elevation in the nave and choir. The gradual High Gothic tendency to ever more glass and ever less stone is seen in this graceful space, in which the visitor is surrounded by shimmering colored light.

The nave elevation is three stories: the unusually high arcade, the triforium, and the relatively small clerestory within the ceiling's curve (the springing starts at the bottom of the clerestory). There is also a clerestory in the inner aisle. Because the nave and choir are uninterrupted by a transept, the same elevation is used throughout the cathedral. All supporting piers are identical cylinders surrounded by slender colonnettes, adding to the unity. The proportions are wonderfully harmonious, unified, coherent, and clear, with all details highly refined.

In striking contrast to Bourges' unity, the Cathedral of Saint-Julien in Le Mans appears purely Gothic when seen from the apse end, but the huge plain facade, built in the eleventh and twelfth centuries, is Romanesque. Inside, the Romanesque nave is lower than the Gothic transepts and choir, the disparity diplomatically described by the people of Le Mans as 'somewhat unsightly.'

In the early thirteenth century, when the Romanesque structure was only about sixty years old, the canons of Saint-Julien were granted the right to build a new choir. The work here is associated with the master mason Simon of Le Mans. Construction

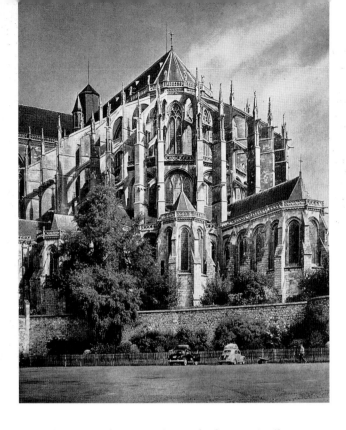

began in 1217 and consecration took place on April 24, 1254, when the relics of St. Julien were placed here, although the choir was not actually finished until c. 1273. Some time had been required to lay out the subterranean foundations of the characteristically complex Gothic space of the choir with seven unusually long radiating chapels (the central Lady Chapel being the largest) protruding from a double ambulatory. But the choir elevation is only two stories: the arcade, with compressed arches and multiple colonnettes, and the clerestory. The triforium, reduced to a passage behind a railing, is all but eliminated. The forms are slender and delicate, incessantly accenting the verticals that lead the visitor's eyes up to a vault 32 meters (103 feet) from the floor.

In the late thirteenth century it was decided that the old Romanesque transepts did not harmonize visually with the new Gothic chancel, but it was not until the late fourteenth century – a century after the work was planned – that the raising of the south transept actually got under way, under the foreman master Jehan le Maczon (the mason). When Charles VI of France visited Le Mans in 1392 the south transept was finished, but the king found

the discrepancy between the north and south transepts 'unbearable' and therefore founded a perpetual mass and contributed money to have the north transept raised to match the south. The north transept was started early in the fifteenth century, funded by indulgences granted by the pope to people who contributed to the cathedral's completion. Construction was almost finished around 1430 although work continued on the sculpture and stained glass. After the fifteenth century few changes were made to the cathedral, which appears today essentially as it did then.

The most impressive view of Le Mans Cathedral is from the east; when seen from what is now a car park, the cathedral's dramatic elevated location enhances its soaring verticality. In a complex spatial configuration, the skeletal structure of the cathedral is surrounded by that of the flying buttresses. But this external stone cage brought with it a new problem, for while the buttresses permitted the huge windows filled with stained glass, the buttresses cast shadows on the very windows which are meant to be seen with sunlight streaming through them. To solve the problem, a unique method was employed: at a distance from the wall, the arches of the buttresses split into inverted V shapes as they slope steeply downward so that they cast only the slightest shadow onto the choir glass. This display of daring, of thrust and counterthrust to achieve perfect balance, makes Le Mans's flying buttresses the most extraordinary and justifiably famous in Gothic architecture.

Comparison of the dimensions of the vaults of Gothic cathedrals makes evident the quest for ever greater height: the nave of Notre-Dame in Paris rises 35 meters (115 feet); that of Chartres

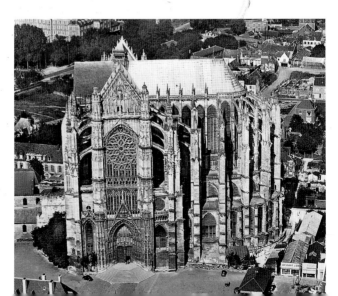

136. Cathedral of Saint-Pierre, Beauvais, begun 1225, seen from the south

36.9 meters (121 feet); Reims 37.8 meters (124 feet); and Amiens 42.4 meters (139 feet). But the choir of the Cathedral of Saint-Pierre in Beauvais reaches almost 48.2 meters (158 feet). The great height achieved by medieval masons was a matter of civic pride, each city trying to outdo the others.

Beauvais Cathedral, however, provides a demonstration of the limitation of the Gothic structural system. Here is the ultimate example of ultra-refinement, of the escalating tendency to replace solid with void, and to reduce the wall to a skeleton of arches and supports. Working with pointed ribbed vaults and flying buttresses there is, in theory, no limit to the height that can be achieved. In fact, however, concepts of Gothic construction could be taken too far – as the demise of Beauvais Cathedral dramatically demonstrated. Perhaps the most bizarre of Gothic cathedrals, Beauvais is notable for what it is not. The cathedral is a fragment, consisting of only the east end, crossing, and transepts. There is no nave!

The history of Beauvais begins with an old cathedral on the site that burned several times and was seriously damaged in 1225. Although there is some question as to when the present east end was begun, 1225 is likely, and the architect is believed to have come from Reims. The piers of the apse and choir are presumed to have been built by about 1238, as well as the foundations of the apse, radiating chapels, and outer aisle of the choir. The seven radiating chapels are fairly squat in proportion. The roofs of the chapels and that of the outer aisle are nearly flat, allowing light to enter the triforium and clerestory of the ambulatory. The upper parts of the ambulatory and the inner parts of the choir aisles were probably built between the late 1230s and c. 1245. The triforium and clerestory of the choir were probably built between 1250 and 1255. Support is provided by tall thin piers with flying buttresses in two flights and on three levels. The spider-like flying buttresses reinforced by metal ties, finished by 1272, seem to float far above the radiating chapels. The effect is fantastically fragile – in fact, too fragile. In 1284, only twelve years after completion, the choir vaults collapsed. The choir was reconstructed by 1322. The transepts of Beauvais Cathedral postdate the rest of the building and were built in the sixteenth-century Flamboyant Gothic style. Today the cathedral is approached from the south transept, built between 1500 and 1548.

Today, there remains a tiny building abutting the cathedral where the nave was intended to be. This building is a rare Carolingian survival, the former Notre-Dame de la Basse-Oeuvre, now believed to have been built in the eighth century.

137. Interior looking toward apse, Cathedral of Saint-Pierre, Beauvais, late 1230s–c. 1245 and 1250–55; collapsed 1284, rebuilt by 1322. In principle, the Gothic masons' pointed arch, supporting ribs, and flying buttresses remove all restrictions on the height that may be reached. In fact, Beauvais provided a practical demonstration of theory versus gravity – the latter prevailing. Beauvais' repeated collapse resulted in a cathedral that never received a nave and concluded attempts to build ever higher.

The two buildings, one Carolingian and one Gothic, form a striking contrast in style and scale: one is tiny and solid, the other is tremendous and skeletal.

Beauvais once had an enormous crossing tower, built between 1558 and 1569 by Jean Vaast/Vast, the spire reaching 151 meters (497 feet). Inside the tower, the highest vault rose an extraordinary 134.1 meters (440 feet) from the pavement. Constructed with three stories of stone and one story of wood, this was the tallest tower of its time, its height intended to impress, to amaze, to astound. The crossing tower, however, was soon recognized to be unstable and reinforcements were begun. Nevertheless, in 1573, only four years after its completion, the tower collapsed. Worse yet, the whole tower did not fall and workers were afraid to knock down the remaining portions. Finally, a criminal was told that if he would complete the demolition he would be set free. He did, and he was. Now Beauvais Cathedral has neither tower nor nave.

The interior of the cathedral is lit by windows on three stories and on three planes – in the radiating chapels, the outer walls of the aisles, the triforium, the clerestory of the apse, and the clerestory of the aisles' inner wall. The triforium and clerestory are linked together rather than clearly separated as areas increasingly merge in Gothic architecture. The walls – lacy screens rather than structural supporting elements – are of unprecedented thinness, and the vault is of unprecedented height. Beauvais has the highest medieval vault, dizzying in its dimensions. The choir is only about 15.5 meters (51 feet) wide but the height is more than three times the width.

Why the choir collapsed is not precisely known and may have to do with a combination of factors. Suggested explanations are: insufficiently solid foundations; improper construction of the triforium and clerestory; weakness in the aisle piers; or weak buttressing. Rebuilding involved the addition of six piers in the choir, which created a very pointed lower arcade. Four piers were added between the aisles. Supplementary transverse arches were added in the vaults, making the four-part vaults into six-part vaults. Reconstruction was done on the verticals of the flying buttresses. In all, rather than being structurally innovative, Beauvais is the extreme extension, the ultimate inflation, of existing ideas of Gothic construction. After the collapse of Beauvais, buildings became lower and smaller.

Other examples of High Gothic architecture are the cathedrals of Amiens, Auxerre, Bayeux, Coutances, Meaux, and Rouen, the abbey churches of Saint-Serge in Angers, Saint-Père in Chartres, and Longpont, and the collegiate church of Saint-Quentin.

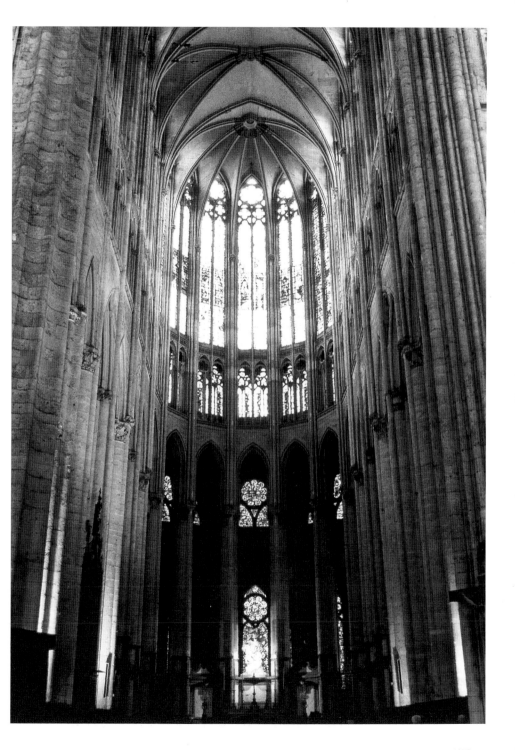

Chapter 8: Later Gothic in France

The Rayonnant is the third of the four phases of the French Gothic style, the name derived from the French *rayonner*, meaning 'to shine' or 'to radiate.' This refers to a new style of radiating window tracery in which the stone divisions between areas of glass were made progressively thinner and formed into ever more intricate patterns, but always symmetrical and based on geometry. A new aesthetic of harmonious ornament was achieved as the stone wall was gradually eliminated. The evolution from High Gothic to Rayonnant Gothic, however, does not involve revolutionary innovations in either structure or plan.

Paris was the center for the Rayonnant style under Louis IX (born 1214) who reigned as King of France from 1226 until 1270 – a very long reign for any era, but especially so during the Middle Ages. Known for keeping his word and being impartial, Louis IX was described as 'the model Christian king.' He played a key role in the evolving Gothic style, for under his guidance major cultural strides were made in France, especially in terms of cathedrals and universities (between 1255 and 1259 Robert de Sorbon, the king's confessor, founded the Sorbonne, which later became part of the University of Paris). Louis IX, often called St. Louis, was canonized in 1297.

Just a few minutes walk from the cathedral of Notre-Dame is the Sainte-Chapelle: the intriguing history behind this small building reveals much about the priorities and values of the Middle Ages. In 1239 Louis IX paid Emperor Baudouin (Baldwin) of Constantinople a great sum of money for what was believed to be a part of Jesus' crown of thorns. In 1241 he bought additional relics in Constantinople, including a piece of Jesus' cross, iron fragments of the Holy Spear that pierced Jesus' side, the Holy Sponge, a nail from the crucifixion, and the robe and shroud of Jesus. (Still later, the Sainte-Chapelle acquired the front part of the skull of St. John the Baptist – the back was in Amiens.) Louis IX had these relics placed in an ornate shrine and the Sainte-Chapelle was erected to house it. The cost of the shrine is known to have been at least 100,000 livres. While it is difficult to determine the equivalent expense in today's terms, some sense of its enormity may be gained by comparison: the Sainte-Chapelle cost

138. **Pierre de Montreuil (?)**, facade and south side, Sainte-Chapelle, Paris, 1241/43–48; rose window 1490–95

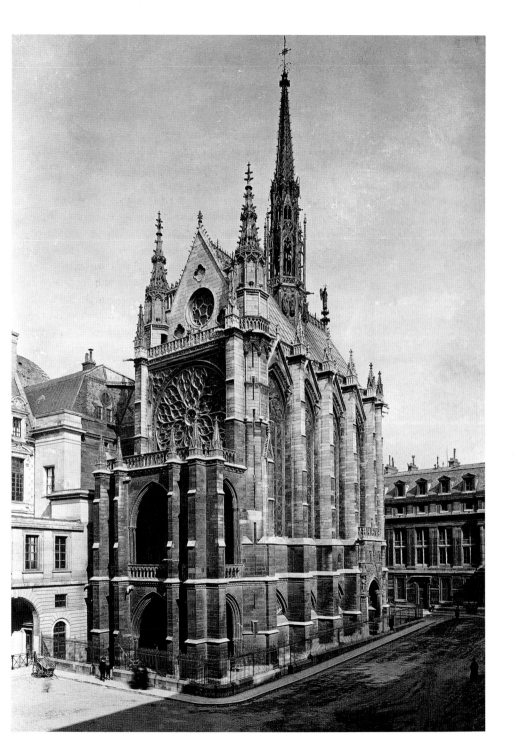

Louis IX about 40,000 livres, but the crown of thorns cost him 135,000 livres!

Resembling an enormous reliquary itself, the exquisite Sainte-Chapelle is the purest extant example of the Rayonnant style. Rich and refined, this display of architectural virtuosity was considered a masterpiece as soon as it was built and its reputation has remained undiminished. It does not dazzle by great size – indeed, when compared to other Gothic buildings, it is tiny. The interior is a mere 32.9 meters (108 feet) long and 10.7 meters (35 feet) wide. It is divided into a lower and an upper chapel, the lower measuring only 6.6 meters (21 feet 8 inches) high, and the upper all of 20.5 meters (67 feet 3 inches) high. The wooden spire covered with lead is almost 30.5 meters (100 feet) high, built in the nineteenth century but based on the original fifteenth-century wooden frame spire recorded in documents.

The exterior of the Sainte-Chapelle was built between 1241/43 and 1248 with great speed and great unity of style. The chapel remains essentially as it was when originally built, the most important exception being the west rose window which was remade between 1490 and 1495 in the Flamboyant Gothic style and now fills the entire surface whereas, originally, there was a smaller rose with four quatrefoils here. The porch terrace and several other features have been reconstructed.

The structure of the Sainte-Chapelle relies on the use of buttresses set against the sides of the chapel to resist the lateral thrust exerted by the vault. Because the building has a massive base and a much lighter superstructure, the buttresses are heavier at the bottom than at the top. However, all the buttresses project outward to the same extent, even on the apse where less resistance is needed.

The idea of a two-story church or chapel was not new. At the Sainte-Chapelle the two floors are unequal – in all respects. It was common during the Middle Ages for the king to have a private chapel in his palace or castle, with direct passage to it from the royal apartments. At the Sainte-Chapelle the upper chapel was therefore level with Louis IX's apartments, which explains, in part, the relatively low ceiling of the lower chapel, which was used by lower-ranking members of the court.

The lower chapel, dedicated to Mary, is dark and crypt-like. More complex in plan than the upper chapel, the lower includes aisles formed by rows of little columns. Because the aisles provide a structurally solid base for the upper chapel, they are very narrow and are covered by sharply pointed vaults that enable the nave

and aisles to reach the same height. An oddity of the Sainte-Chapelle is the flying buttresses attached to these columns – inside! The slender iron rods used to reinforce the structure are seen here in their first systematic application.

The upper chapel, dedicated to the Crown of Thorns and the Holy Cross, is the same width as the lower chapel but more than three times its height. The plan is extremely simple, consisting of only four rectangular bays and a seven-sided apse. The walls seem to disappear, replaced by windows that resemble soaring shafts of light and create a glass cage. Almost three-quarters of the height of the wall is stained glass: 15.2 meters (50 feet) high, the windows fill all the surface area up to the vault. The very thin piers of stone actually project inward approximately a meter (over three feet), but they are hardly noticeable because their bulk is masked by bundles of nine colonnettes. In an extraordinary achievement of architectural engineering, all other supports are external, leaving the interior a continuous uninterrupted space. In essence, the bearing 'wall' is outside in the form of buttresses, invisible from within through the stained glass. The result is an illusion of weightlessness, an ethereal environment that seems to disregard – if not to defy – the laws of gravity.

The impact of the upper chapel is oriented to the visitor inside. Indeed, to stand here on a sunny day with light streaming through the stained glass windows on all sides is as close as one can hope to come to standing inside a multi-colored, multi-faceted, sparkling jewel. A description of the Sainte-Chapelle, written in 1323 by Master Jean de Jandun, translates, '... on entering one would think oneself transported to heaven and one might with reason imagine oneself taken into one of the most beautiful mansions of paradise.'

The windows, although restored and incomplete, are among the most important monuments of medieval stained glass. Each bay on the north and south walls has four windows, grouped in two pairs, with quatrefoils and roses at the top. In the apse there are only two per bay, with three trefoils at the top. In all, the upper chapel has fifteen thirteenth-century windows and one fifteenth-century window (the west rose), for a total of 618 square meters (6,652 square feet) of glass. The fleur-de-lys (the arms of King Louis IX) and the castles of Castille (for the king's mother, Blanche of Castille) often appear among the various border patterns. Typical of mid-thirteenth-century glass, the dominant colors are red and blue. The stone tracery patterns differ from window to window.

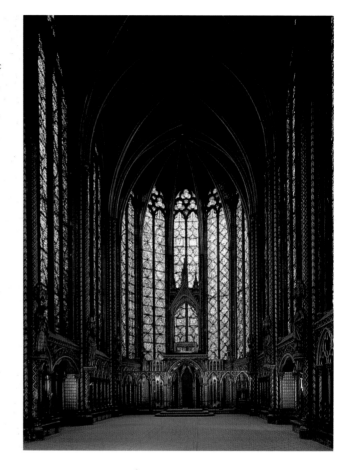

139 **Pierre de Montreuil (?)**, upper chapel looking toward apse, Sainte-Chapelle, Paris, 1241/43–48. The delicacy and elegance of the Rayonnant Gothic achieved its ultimate expression in this glittering gem. The interior is among the most affecting architectural spaces ever created. In this habitable reliquary, one is entirely surrounded by color and light, for all surfaces are ornamented and every available extravagance of the era is employed.

The entire program of the upper chapel windows is oriented to the revered relics once preserved here. The central window of the apse shows Jesus' Passion, introduced by Old Testament stories in the nave. The cycle begins on the north side with scenes from the Book of Genesis and concludes on the south with the story of the relics of the Passion, especially the crown of thorns, and their arrival in Paris. In these windows, the king of France is associated with kings David and Solomon, linking French royalty to biblical royalty. Many coronation scenes are portrayed (that of Jesus, plus twenty others), perhaps in an effort to connect the crown of France to Jesus' crown of thorns.

Pierre de Montreuil is thought to be the architect of the Sainte-Chapelle, but no document confirms this. He was, however, the most famous architect in Paris in the mid-thirteenth century and would go on to work at Saint-Denis and Notre-Dame.

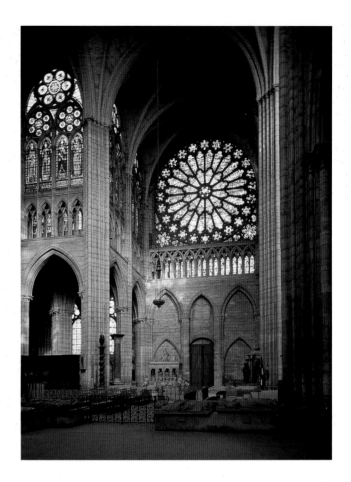

Under Louis IX, Rayonnant portions were added to buildings constructed in earlier styles. In 1247 Louis placed Pierre de Montreuil in charge of the royal abbey of Saint-Denis (see 118-20 pp. 151-3). The transepts, the upper portions of the choir, and the nave are among the earliest examples of Rayonnant Gothic. The tracery of the rose windows in the transepts radiates out from the centers, making clear the origin of the term 'rayonnant.' The north transept rose window, constructed c. 1250, is the first very large Rayonnant rose. Demonstrating the daring perforation of the wall characteristic of the Rayonnant style, the rose window, the spandrels (triangular sections at the corners), and the triforium level are all glass. The subject portrayed in the north rose is the Tree of Jesse. The south rose, of about 1260, shows the Gregorian calendar and the signs of the zodiac.

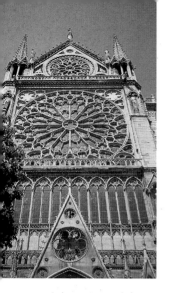

The Rayonnant transepts at Saint-Denis provided the model for those at the Cathedral of Notre-Dame in Paris which were to be copied in turn at other churches. Notre-Dame's transepts were extended and made nearly identical to one another as part of the 'modernization' that started in the mid-thirteenth century. An inscription on the south porch says it was begun in 1257 by Jean de Chelles; it is also associated with Pierre de Montreuil. Characteristic of the Rayonnant style, the transept facades are very flat, very delicate, and very open, with extremely slender proportions. A patterned effect is produced by the tracery in the windows, on the blank walls, on the arcades, and in the gables. The Rayonnant style is one of amazing grace: to achieve this aesthetic in stone and glass is an exceptional accomplishment.

Saint-Urbain in Troyes was built to mark the site where Pope Urban IV was born and to honor the saint and martyr

123-4

141. **Jean de Chelles and Pierre de Montreuil**, south transept rose window, 1257 f., Cathedral of Notre-Dame, Paris

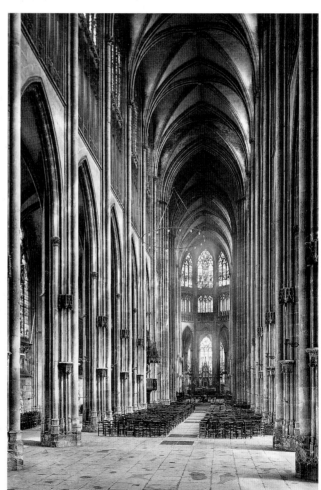

142. Nave looking toward apse, Saint-Ouen, Rouen: choir 1318 f., nave 15th and 16th centuries

143. Facade, Saint-Urbain,
Troyes, mostly *c.* 1262–*c.* 1286

Pope Urban I. It was partially constructed between *c.* 1262 and *c.* 1286 and more work was done in the fourteenth century, although it was completed only in 1905. This small delicate church is highly ornamented, embellished with elegant windows, lacy pinnacles, and slim columns. In fact, Viollet-le-Duc observed that, 'The construction of this church is really only composed of buttresses and vaults. The intervals between the buttresses are only lattices of stone.... It appears that the architect sought to economize as much as he could with the hewed stones.'

The interior of Saint-Urbain, designed by Jean Langlois, is especially harmonious, with a limited number of elements used repeatedly. The nave elevation is only two stories (the triforium is eliminated). So large are the openings in the walls that they can hardly be called walls; rather, they have become stone frames.

The church of Saint-Ouen in Rouen was constructed in the Rayonnant style, with the exception of the west facade which was rebuilt in the nineteenth century. The interior has a large choir of three bays, begun in 1318 and finished in 1339, as were the ambulatory, radiating chapels, and crossing piers. No real wall surfaces remain in the choir: the only solid areas are the spandrels of the arcade. The proportions are pure and highly refined, the linear elegance typical of the Rayonnant style. Stress is on delicacy and verticality rather than on surface.

The long nave of nine bays, flanked by a single aisle on each side, was built in the fifteenth and sixteenth centuries, the upper part not finished until after 1536. The nave is very bright – a Rayonnant characteristic created not only by the vast clerestory windows but also by the great size of the aisle windows and the narrowness of the aisles. With only minor changes, the style of the choir was maintained into the nave, creating a very unified interior. Above the arcade, it is unclear if this is a two-story clerestory or a glazed triforium plus a clerestory: is this a two-story or a three-story elevation? In earlier phases of the Gothic, each story was distinct, whereas overlapping or merging of stories is a Rayonnant feature. The only column capitals are just below the vault, creating minimal interruption to the long verticals. The tracery on the nave windows already begins to curve, moving toward the Flamboyant but, as yet, is restrained to harmonize with the earlier Rayonnant choir. The vaults in the choir and nave are the simplest system of four-part vaults, supported on slender ribs. The interior was originally painted but little color remains today.

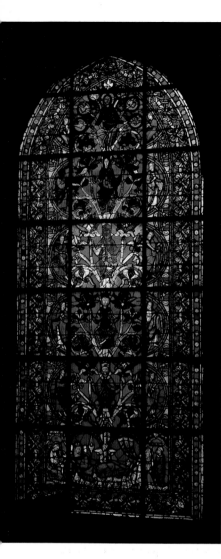

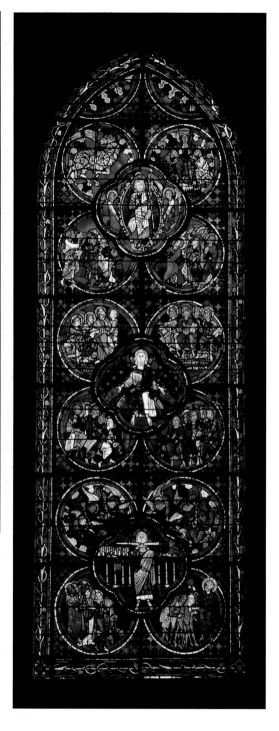

144 (above) *Tree of Jesse*.
Stained glass window, royal abbey
of Saint-Denis, *c.* 1140–*c.* 1144.
In no other era does stained glass
have the same importance as
during the Gothic, when stone
walls were replaced by glass
windows. Those in the choir of
Saint-Denis, like the choir itself,
stand at the beginning of the
new Gothic style.

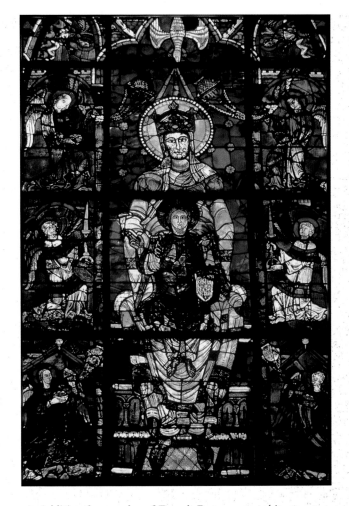

146 (right) *Notre-Dame de la Belle-Verrière*. Stained glass window, Cathedral of Notre-Dame, Chartres, c. 1170. The border panels with kneeling angels swinging censors and holding candles are early 13th-century additions.

Additional examples of French Rayonnant architecture are the cathedrals of Albi, Carcassonne, Clermont-Ferrand, Evreux, Metz, Narbonne, Rodez, Strasbourg, Toulouse, and Troyes, as well as the Church of the Jacobins, Toulouse.

The Gothic structural system offers the fullest possibilities for stained glass which, in turn, is an important component of the impact of Gothic interiors. Stained glass reached its zenith in Gothic France. The solid walls on which murals had been painted during the Romanesque period disappeared, their didactic and decorative roles assumed by stained glass.

145 (left) *Apocalypse*. Stained glass window, Cathedral of Saint-Etienne, Bourges, 1215–25.

From the exterior there is little to see in a stained glass window except the pattern of stone tracery: stained glass is interior decoration, intended to be seen with sunlight streaming

185

through from behind. The interior of a building is enlivened not only by the stained glass windows themselves but also by the countless touches of flickering colored light cast on the walls as sunlight passes through the glass, the patterns constantly changing at different times of the day and year and under different weather conditions.

The colored light flooding the interior of Gothic buildings had special significance during the Middle Ages. Light was regarded as an attribute of divinity and was believed in medieval philosophy to have mystical qualities. John the Evangelist saw Jesus as 'the true light,' and as 'the light of the world who came into the darkness.' St. Augustine called God light and distinguished between physical and spiritual light.

Colored glass has a long history. The ancient Egyptians made glass, and the technique was already highly developed in Roman times. Documents indicate that as early as the fourth century AD colored glass was used to decorate church windows. The oldest surviving fragments of stained and painted glass are from ninth-century France.

Theophilus Presbyter, author of the Romanesque technical manual *De diversis artibus* (see also p. 92 and p. 140), explains how glass was made during the Middle Ages. Theophilus' recipe calls for one part river sand for silica, plus two parts beech ash and carbonized fern (vegetable ashes or potash) for an alkali. This mixture is boiled in a clay pot until it melts, the alkali causing the silica to fuse. The result is a very impure glass containing organic residue and debris that render it readily attacked by the atmosphere. Theophilus' glass is greenish; he said it could be boiled longer to make it yellowish or reddish.

In the thirteenth century, a monk named Heraclius wrote *De artibus romanorum* which explains how to color glass by adding powdered metallic oxides – copper oxide for red, cobalt for blue, antimony for yellow, iron oxide for green, and manganese for violet. Twelfth- and thirteenth-century glass is thick and uneven. From the thirteenth century on, sodium was added to make a thinner, although softer, glass. After the fourteenth century, glass was made thinner still.

Construction of a stained glass window is a long and tedious process. First, the design is drawn to scale, allowing for the thickness of the lead strips that will join the pieces of glass. Early glass was cut with a hot iron; diamond cutters appear in the fourteenth century. The pieces of glass are assembled in a temporary frame. Details such as facial features, fingers, and fabric folds are painted

on with grisaille (the term derives from the French word for 'gray,' although the paint may also be brown or black). Grisaille is made of iron or copper oxide, plus gum arabic or wine; the oxide vitrifies when fired. After one day, the pieces of glass are fastened together with lead strips which are H-shaped in cross-section and soft enough to bend easily. The lead strips are then soldered together with tin. In addition to holding the small pieces of glass together, the lead also forms an important part of the design. The window may be strengthened with iron bars: in early windows, a grid was used, although gradually the bars were curved to correspond with the design. Finally, the window was sealed by putting putty in the cracks between the lead and the glass.

The development of Gothic stained glass begins with the windows at Saint-Denis dated between *c.* 1140 and *c.* 1144. Medieval windows are usually read from the bottom to the top. At the bottom of the *Tree of Jesse* window the patriarch sleeps as 144 the tree grows from his side; Jesse was the progenitor of a royal line that includes David. Jesus' noble ancestry is portrayed by the kings of Judah and their descendants in the branches. At the top is Mary and then Jesus with an aureole of seven doves of the Holy Ghost in gold medallions. However, at Jesse's feet, Abbot Suger, noted to be largely responsible for the introduction of the early Gothic style at Saint-Denis, had himself depicted holding this very window. The scenes at Saint-Denis (minus the figure of Abbot Suger who also appears at the feet of Mary in the Annunciation scene) were used as models and copied throughout Europe. Glass workers traveled from job to job in the twelfth century, repeating a repertoire of subjects; local glass workshops are not found until the fourteenth century.

Notre-Dame de la Belle-Verrière, a celebrated stained glass 146 window in the south ambulatory of the choir of Chartres Cathedral, created *c.* 1170, is also known as 'The Blue Virgin' for the pale blue of Mary's robe. Formal and frontal, regal and rigid, Mary is crowned and enthroned as queen of heaven with the infant Jesus on her lap. The dove above Mary with the three rays of light represents the Holy Spirit. The style of stained glass developed gradually: here the lines are sweeping and energetic.

Around 1200 a distinctly Gothic style of stained glass appeared and the first half of the thirteenth century is regarded as the golden age of stained glass. Bourges Cathedral is an important site for its study, for though the windows here date between the twelfth and seventh centuries, the most famous are those in the apse chapels dated 1215–25. Each window here is organized

147. *Annunciation and Visitation*.
Stained glass window, Sainte-
Chapelle, Paris, *c.* 1248

148 (opposite) Grisaille glass,
Saint-Urbain, Troyes,
c. 1260–80

by a different underlying geometric pattern. The subject of the *Apocalypse* window derives from St. John's Book of Revelation (see p. 58). The lowest of the three quatrefoils contains a striking image of Jesus as judge. With the two-edged sword between his teeth, the book with the seven seals in his right hand, and the seven stars in his left hand, Jesus is flanked by the seven golden candlesticks, symbols of the seven churches of Asia (Rev. 1). The colors are deep and rich, jewel-like in intensity. Flowing lines create softer drapery effects than in the twelfth century – the same distinction found between twelfth- and thirteenth-century sculpture.

The Sainte-Chapelle in Paris is also a major monument for the study of stained glass. The Annunciation and Visitation, dated to *c.* 1248, may be compared to the same subjects carved in stone at Reims Cathedral. At the Sainte-Chapelle the little

130

figures are supple and spontaneous, vigorous and vital. The stories are vividly told through overt gestures and poses such as Gabriel's wings overlapping the border or Mary's humbly bowed head as she receives Gabriel's news. The Sainte-Chapelle windows were to influence those at Tours, Le Mans, Soissons, and elsewhere.

Saint-Urbain in Troyes offers excellent examples of windows that combine colored glass with grisaille – a technique popular from the mid-thirteenth century and throughout the fourteenth. Windows were especially large at this time and grisaille windows, because they are made with large pieces of slightly greenish glass, were more economical to produce than windows constructed of a multitude of tiny pieces of multicolored stained glass. The style of ornament, in general, now becomes simpler and more geometric.

In addition to grisaille, another technique for painting on glass that began in fourteenth-century Europe and quickly gained in popularity is silver stain or jaune d'argent – literally, yellow of silver. A solution of silver salts is painted on the glass and then fired. Silver stain can be used on nearly clear glass to create a vivid yellow or in small areas to give luminous highlights to colors. It can be applied over other colors to expand the color range, for example over blue to create green or over red to create orange.

Another technique, known as Jean Cousin, popular in the fifteenth and sixteenth centuries, uses a trioxide of iron to create a red color on small areas of stained glass.

Yet a further possibility for painting on glass is enamel, a glaze made of ground glass and colored metallic oxides that is applied to white glass and then fired. The technique, developed in the sixteenth century, revolutionized stained glass by greatly expanding the range of colors and effects possible.

Some colors are so dark as to be almost opaque. These were therefore fused in very thin sheets to clear glass, or clear glass was dipped into the colored molten glass, producing flashed glass, used especially for reds, and popular from the fourteenth century on. The colored film of flashed glass can be scratched through to create designs – a technique known as *sgraffito*, rarely used prior to the fifteenth century. A related method is stippling, which involves applying a brown powder to clear glass and then scratching through it to make details which appear as transparent lines.

On the whole, the colors used in fifteenth- and sixteenth-century stained glass were more transparent, lighter, and less

149. **Ambroise Havel (?)**, facade, Saint-Maclou, Rouen, 1500–14. It would be difficult to describe the characteristics of this Flamboyant facade with exaggeration. The quantity of carving may be compared with that on the facade of Romanesque Notre-Dame-la-Grande in Poitiers (Ill. 72), although the purpose of the Romanesque facade is to instruct with narrative relief rather than to excite with flame-like ornament.

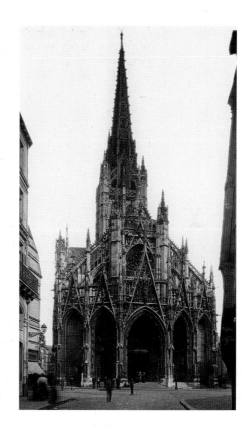

luminous than those of earlier centuries. Much use was made of grisaille. Windows were usually larger and were made of pieces of glass of a variety of sizes, whereas all were quite small in earlier windows. The virtuosity of individual artists came to be emphasized, in contrast to the anonymity of the medieval guild system.

While the Rayonnant phase of the Gothic is characterized by radiating patterns, the Flamboyant phase is characterized by curving patterns. They are literally flamboyant – that is to say, flame-like. Early Gothic, High Gothic, and Rayonnant Gothic architecture was originally based in, and disseminated from, the Ile-de-France. The origin of Flamboyant Gothic, however, is less clear. It did evolve from the Rayonnant, possibly with the aid of the English late Gothic.

Saint-Maclou in Rouen, a small parish church located behind the cathedral, is the paradigm of French Flamboyant Gothic. The church was designed in 1434 by Pierre Robin. The facade was probably designed by Ambroise Havel with an unusual porch faceted into three planes to bow outward, dated 1500–14. Saint-

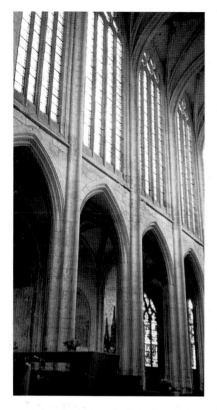

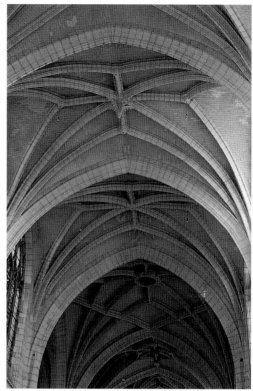

150. Choir elevation, Saint-Etienne, Beauvais, 1506–c. 1550

151. Nave vaulting, Saint-Nizier, Troyes, begun early 16th century

Maclou was consecrated in 1521 and construction seems to have been finished by this time. (Because a church need not be absolutely complete to be consecrated, consecration dates, which are often recorded, do not necessarily indicate the date when the final touches were put in place.) Saint-Maclou is notably homo-geneous in style, for only the crossing spire is modern.

The Flamboyant style, as evidenced by Saint-Maclou, is characterized by a delight in delicacy and a compulsion for complexity. Stone surfaces become luxurious, covered with a great profusion of lace-like ornament. The design can be described as exuberant, interlacing and undulating, with overlapping openwork planes. Virtuosity and dexterity are displayed, not without a degree of ostentation. No large flat wall areas remain, all surfaces are broken, all masses annihilated in this architectural extreme. The ornament almost obscures the actual structure beneath it: it is surely not intended to emphasize or clarify the structure. The steeply pitched openwork gables are filled with flame-like forms, created by countless curves and countercurves,

the surface tangle animated by light and shade as the sun moves. This new form of decoration is as dynamic as the underlying structure that makes it possible.

The plan of Saint-Maclou is unusual in that it lacks a chapel on the east end, which seems a mandatory feature elsewhere. Instead, there are four hexagonal chapels off the ambulatory that create diagonal movements comparable to those on the facade.

The nave and choir of Saint-Maclou, completed around 1470, were built in almost one campaign and are therefore highly homogeneous, the interior and exterior unified by the late Gothic aesthetic of animation. The absence of transepts, and the interruption they would cause, enhances the coherence. The reduction of the number of stories in the nave elevation to only two is characteristically Flamboyant. Early Gothic elevations, as at Laon Cathedral, have four stories; High Gothic Chartres Cathedral has three stories; and at Rayonnant Gothic Saint-Ouen in Rouen, the second and third stories merge. At Flamboyant Gothic Saint-Maclou, however, the nave arcade is almost as tall as the triforium and clerestory combined, and the triforium so minimized that this appears to be an elevation of only two stories. Elimination of divisions between stories and the absence of capitals on the nave arcade enhance the effect of overlapping areas and freely flowing forms.

122
127
142

The small parish church of Saint-Etienne in Beauvais, originally built in the Romanesque style between *c.* 1125 and 1140, retained its Romanesque facade and nave but acquired a Flamboyant Gothic east end. After a storm ruined the crossing tower in 1480, a new Flamboyant Gothic choir was built between 1506 and *c.* 1550, replacing the smaller Romanesque original. The old Romanesque nave remained, contrasting strongly with the new Gothic choir, the disparity tactfully described as 'ungainly' (worse was said of Le Mans). The vaulting of the nave is lower than that of the choir, yet the nave elevation is three stories while the choir elevation is only two because the triforium was entirely eliminated here, leaving only the arcade and large clerestory.

While the number of stories in the nave elevation decreased in the Flamboyant Gothic, the ribs of the vaulting multiplied, extremely complex rib patterns becoming a characteristic of the style. What were previously simple four- or six-part vaults were made progressively more ornate as the number of ribs proliferated. Among the many buildings in which this can be seen is Saint-Nizier in Troyes, begun in the early sixteenth century.

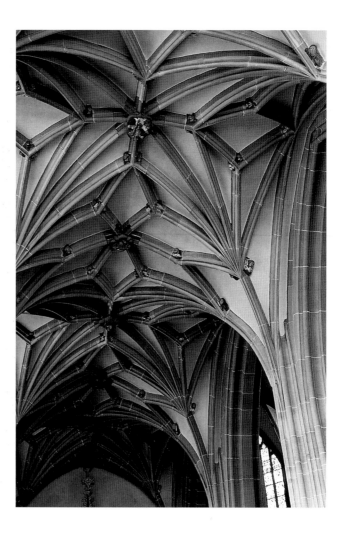

152. Vaulting in left aisle,
Saint-Thiébaut, Thann, 1492

Here the two-story nave is topped by a vault with complex star patterns. The original structural logic of the Gothic ribbed vault, in which the ribs served to reinforce and support the vault, is obscured by this animated tracery.

Flamboyant fantasies in vaulting were not restricted to the nave, as demonstrated at the collegiate church of Saint-Thiébaut in Thann. Although the two-story nave has complex rib vaulting, more striking are the aisle vaults, where the ribs form a decorative web that is further ornamented by carved and painted figures.

During the Gothic era, as earlier, abutting a church there was likely to be a cloister in the form of a square or rectangular

153. Cloister, Saint-Etienne, Toul, 13th and 14th centuries

154. Cloister, Saint-Dié, between the Church of Notre-Dame-de-Galilée and the Cathedral of Saint-Dié, 15th and 16th centuries

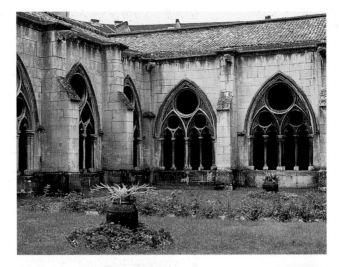

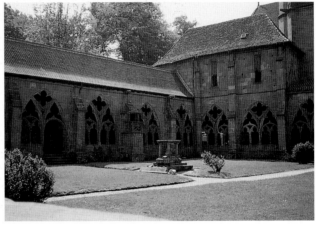

garden. The surrounding arcades reflect stylistic changes: the difference between Rayonnant and Flamboyant Gothic cloisters is made evident by comparing that in Toul with that in Saint-Dié. Just beside the church of Saint-Etienne in Toul stands a lovely little cloister, built in the Rayonnant style during the thirteenth and fourteenth centuries. Characteristic of the Rayonnant style, the tracery patterns in the arcade are delicate, the forms refined and slender. In contrast, the tracery is far more elaborate in the arches of the Flamboyant cloister at Saint-Dié, located between the church of Notre-Dame-de-Galilée and the Cathedral of Saint-Dié, built in the fifteenth and sixteenth centuries. Characteristic of the Flamboyant style, the tracery curves to

create complicated stone patterns that seem to undulate or flicker before the visitor's eyes.

Additional examples of the French Flamboyant Gothic are the church of Saint-Pierre, Caen; Notre-Dame, Cléry; Saint-Gervais, Paris; the church of Saint-Nicholas-de-Port; the abbey church of Saint-Riquier; Saint-Nicholas, Troyes; and the abbey church of La Trinité, Vendôme.

Architectural embellishment also appears in the form of gargoyles, an intriguing category of medieval architectural sculpture and a characteristic feature of Romanesque and especially Gothic buildings. Found along the rooflines, a multitude of gargoyles may glower down on the visitor, as seen at Reims Cathedral. Their location is explained by their function, for a true gargoyle is a water spout – a glorified gutter. Thus, in addition to keeping watch over people passing below, on a rainy day the gargoyles also spit and drool on them, as demonstrated by a lion gargoyle at Strasbourg Cathedral.

155. Row of gargoyles, Cathedral of Notre-Dame, Reims, 13th century f. Gargoyles are especially subject to erosion – from the water that flows through them and from their exposed position on exteriors. Consequently they are particularly likely to be restored, recarved, or replaced, making it difficult to date them with precision.

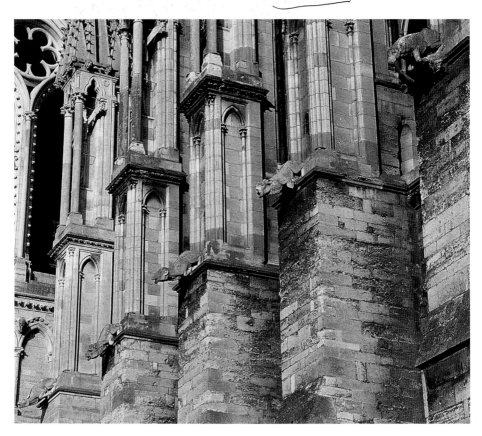

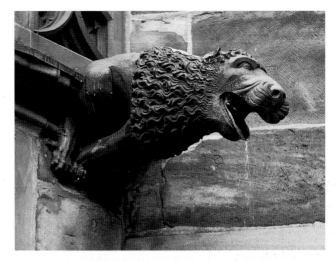

156. Lion gargoyle during rain shower, Cathedral of Notre-Dame, Strasbourg (the present cathedral built mostly in the 13th century). Gargoyles (as opposed to grotesques) function as gutters that remove rainwater from the roofs of buildings. In spite of their humble job, they were elaborately carved, most frequently in the form of animals. The vast majority are creatures of fantasy but, among representations of real animals, lions are especially pervasive: their popularity is also noted in the bestiary (Ill. 117).

157. Human gargoyle vomiting, Notre-Dame, L'Epine (the church built 1405–1527)

A great many medieval gargoyles survive, no two of which are identical. The majority are in the form of fantastic fauna invented by the fertile medieval imagination. Among real animals that were unfamiliar in Western Europe and regarded as exotic, the lion was most frequently carved. Among real animals that were familiar, dogs were most often represented. Only occasionally were people carved as gargoyles. When they are, in view of their location on churches and cathedrals, their behavior is striking, sometimes bordering on the bawdy, sometimes going far beyond. Water may pour from a barrel held by a person mischievously trying to douse the people below, as in the cloister at Toul. Elsewhere the person may appear to vomit, as at Notre-Dame in L'Epine, France. In other instances, as at Autun Cathedral or Freiburg Münster, another orifice is employed!

There is great debate over the meaning of gargoyles. Although they were common on churches and cathedrals, only occasionally do they represent obvious religious subjects. Perhaps they are pure fantasy, holdovers from the Romanesque fascination with monsters. It has also been suggested that they represent devils and evil spirits excluded from entering the church, or made to serve the church – as waterspouts. Alternatively, the gargoyles' frequently monstrous physiognomy and rude behavior may have been intended to scare devils away from the church, leaving the faithful in safety inside. In all, it is probable that gargoyles conveyed a multiplicity of meanings and were connected with the medieval preoccupation with the prevalence of sin, the need for protection against sin, and the inevitability of punishment for sins committed.

The sculptors who carved the gargoyles must have worked closely with the masons who erected the buildings that benefited from the gargoyles' work as gutters. During the Middle Ages, no one was referred to as an 'architect.' The term did not yet exist and no medieval job description equates to that of today's architect. Rather, a 'master mason' was likely to be in charge of the design and construction of a building. To attain this position (or that of master in another craft) one studied in a church or monastery school, served as an apprentice for five to seven years to be a journeyman, and then, to become a master, one had to create a master work.

Although written documentation of the methods used by medieval masons are scarce, manuscript illuminations provide valuable information. Most Gothic cathedrals are built of limestone or sandstone. A significant expense in cathedral

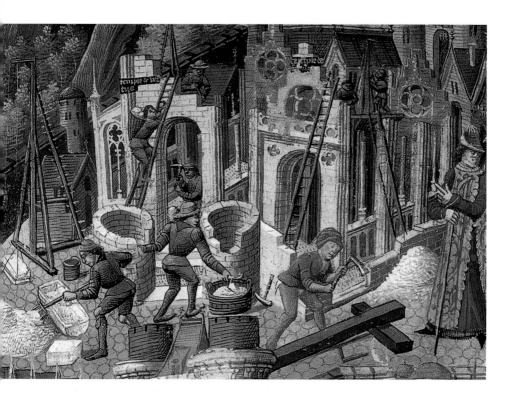

158. *Construction of the Temple of Virtue*. Detail of manuscript illumination from St. Augustine's *The City of God*, c. 1475, 45.5 x 31.5 (17⅞ x 12⅜)

construction was the transportation of the stone from the quarry to the building site, which was normally accomplished in carts pulled by oxen or horses. When possible, water transport was used as this was usually less costly.

Once the building materials were delivered to the construction site, human muscle, aided by some basic devices such as the block and tackle pulley, crane, hoist, and treadmill, powered the rest of the work. The stones, shaped with hammers and chisels, were carried up wooden ladders and scaffolding, perhaps in a hod on the worker's back. Cement was mixed, usually with water, though it is said that the mortar of the Flamboyant Gothic church of Saint-Thiébaut in Thann was made with wine. Many different skills were required to build a cathedral: masons made the stone walls and vaults; carpenters erected the wooden roofs above the stone vaults; plumbers made the sheets of soft lead that covered the roofs or ceramicists made tiles for this purpose.

Among the most difficult aspects of cathedral construction was the erection of the vaults, usually constructed one bay at a time. A scaffold was built, upon which a wooden centering frame

was mounted. Sections of the stone ribs were hoisted up and into place, a cage of ribs thus created in each bay, and the spaces between the ribs filled with web courses of thin stonework. When the vault was complete, the scaffolding and centering were removed and re-used to make the next bay, producing a degree of consistency.

A number of craftspeople and laborers worked simultaneously on a building: at minimum, a master, several masons, and several aides were present, and many more were likely to be on site and active. Workers engaged in such construction did not receive annual leave or vacation, but did not work Saturday afternoon or Sunday, and there were about thirty (unpaid) religious holidays during the year. Workers were paid by the day, receiving their wages every four or, more frequently, five days. The length of the workday varied with the season – long in the summer when there are many hours of light, but very short in the winter when the sun is already low by late afternoon.

Chapter 9: Gothic Outside France

The popularity of the 'French style,' as what is today called Gothic art was known during the Middle Ages, spread beyond France. Throughout Europe, rather than imitating this style precisely, each country that adopted it adapted it to suit local needs and tastes.

England

English Gothic architecture passed through several distinct phases which, like French Gothic, began with relative simplicity and concluded with great elaboration. Indeed, although English early Gothic is reticent, late Gothic reached extremes of eccentricity beyond anything found in France or anywhere else, but without the French emphasis on increasing height. The history of Gothic architecture in England is complicated by the fact that individual buildings, in spite of what initial intentions may have been, are unlikely to have been completed in a single style – even less so than in France. Although portions of some of the medieval cathedrals have been replaced by other styles, Salisbury, Lincoln, Exeter, and Lichfield are still consistently in one style.

The phases of English Gothic are:

1. Early English, characteristic of the late twelfth and much of the thirteenth century, displays relative restraint. This style is seen in the choir and Trinity Chapel of Canterbury Cathedral; the facade and nave of Wells Cathedral; and Salisbury Cathedral.

2. The Decorated Style encompasses roughly the last quarter of the thirteenth through the mid-fourteenth century. The Rayonnant Style nave of Westminster Abbey, London, may be included here. Key works of the Decorated Style are the so-called 'leaves' of Southwell Minster; the retro-choir of Wells Cathedral; and the unique octagonal crossing tower of Ely Cathedral.

3. The Perpendicular Style was in vogue from *c.* 1330 to *c.* 1530. Some examples are quite plain, economical, and standardized. Yet others are characterized by eccentricity and extremism. Included in this phase are the choir and cloister of Gloucester Cathedral; King's College Chapel in Cambridge; and the Chapel of Henry VII in Westminster Abbey, London.

One of the buildings that introduced the Gothic style to England was Canterbury Cathedral. This sprawling structure has two transepts and a single axial chapel on the east, unlike compact French cathedrals with one transept and several radiating chapels. These features were to be used repeatedly in England. Canterbury's monumental east portion creates the impression that two churches have been joined together. After a major fire damaged the cathedral, the choir was rebuilt in 1174 and 1175 by a Frenchman known as Master William or Guillaume de Sens, a skilled mason, carpenter, and engineer. The oddly crooked side walls of the choir seem to wave in and out rather than being parallel to one another. This effect is the result of the decision to preserve and accommodate two Romanesque towers from the old building. The color contrast of the crocket capitals of the arcade is created by dark Purbeck marble. On September 13, 1178, Guillaume de Sens was injured, in a fall from scaffolding 15.2 meters (50 feet) above the ground, and returned to France.

The monks then chose another William, known as William the Englishman, who is believed to have built the apse (Trinity Chapel) and ambulatory between 1179 and 1184. This William is also thought to have added the axial chapel (usually dedicated to Mary and therefore referred to as the Lady Chapel). Canterbury's axial chapel, however, is dedicated to St. Thomas Becket and is referred to as 'Becket's Crown' because his scalp or a portion of his skull was kept here as a venerated relic. The stained glass windows depict his miracles as well as pilgrims praying and making offerings at his shrine and tomb.

Thomas Becket, the most popular of all English saints, was murdered in Canterbury Cathedral in 1170. Born in 1118 in London into a comfortable family, the well-educated Becket moved swiftly up the religious hierarchy. In 1155, he was appointed Royal Chancellor by his close friend King Henry II. Extravagant, brilliant, and able, Becket served Henry II in many capacities. In 1162, he was appointed Archbishop of Canterbury. Curiously, he then changed his worldly ways and chose to live austerely and to champion the power of the Church against that of the State. This brought him into conflict with the king. They quarreled on many issues, especially on whether a member of the clergy accused of a crime should be tried in an ecclesiastical or secular court. Feelings grew bitter. Becket left for France in 1164 and remained absent from England until 1170 when he and Henry II had resolved their differences. But when Becket returned the arguments began again; Becket claimed that the king had set

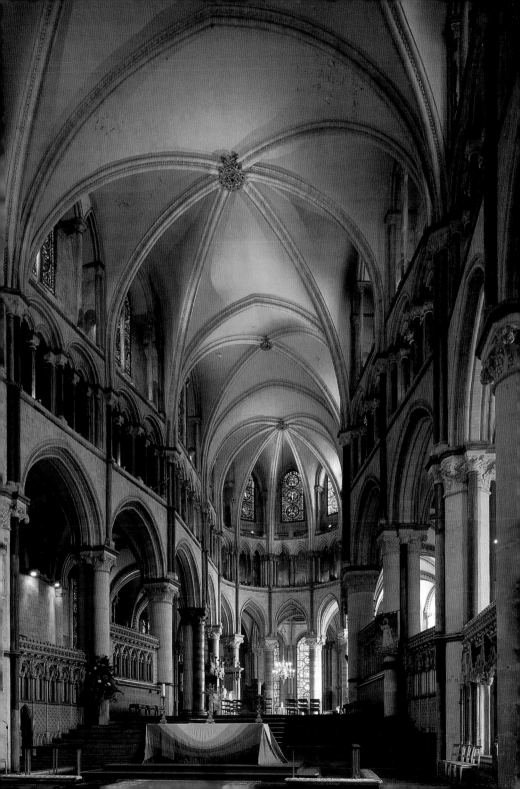

certain bishops to infringe on Canterbury's prerogatives. Henry was furious at this assertion and his angry words encouraged four of his knights to murder Becket in the north transept of Canterbury Cathedral. The people were horrified: Becket was considered a martyr and he was canonized three years later. His relics were cherished, and his tomb soon became a major goal for pilgrims.

Becket's relics were placed in reliquaries made of precious materials by the most skilled craftspeople, and were among the many highly valued objects kept in the cathedral's treasury. During the Reformation the treasury was looted and twenty-four carts were required to transport its vast holdings to the London Mint where, between 1536 and 1540, they were melted down. It is recorded that Becket's shrine alone filled two huge chests that required six men to lift them.

Wells Cathedral, in typical English fashion, has a sprawling angular plan with the effect of two transepts. Differing from French cathedrals, which were usually located in the city center, Wells, like many other English cathedrals, was also an abbey and therefore in a precinct of its own, surrounded by green lawn. The rebuilding of the cathedral began around 1175 and was virtually completed, except for parts of the west front, by the early fourteenth century.

Construction of the west facade began between *c.* 1225 and 1240 but was not finished until centuries later. The massive towers date to the late fourteenth and early fifteenth centuries. Enormous spires were planned but never built. The facade has a heavy base and broad proportions that emphasize width rather

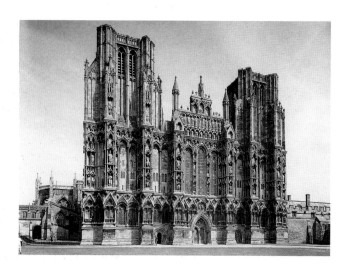

160. Facade, Wells Cathedral, started *c.* 1225–40

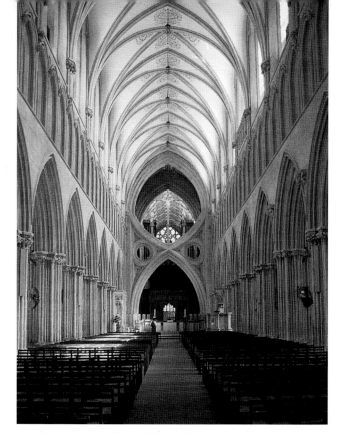

161. Nave looking toward crossing, Wells Cathedral: nave begun *c.* 1190, strainer arches *c.* 1338. English Gothic masons did not enter the French competition for ever greater height, as seen by comparison of the nave of Wells to that of the Cathedral of Notre-Dame, Chartres (Ill. 127), started within a few years. The most memorable features at Wells are the strainer arches added to solve a structural problem. The curves of the arches both mirror and echo those of the vault.

than height. The entire surface, made of variously colored stones, is abundantly decorated with statues of holy women and men as well as queens and kings; this facade is the first major display of sculpture in England and includes a total of 300 thirteenth-century figures. The array of various types of niches, in which these figures stand, creates a quality of fragility, as if the facade were a weightless screen. The facade of Wells Cathedral has affinities with many other English facades, but it is hardly to be mistaken for a contemporary French counterpart. Instead of the French stress on verticality, the English emphasis is on horizontality. Unlike the French preference for three huge portals flanked by sculpture, Wells has tiny entryways and the sculpture is high on the facade. However, individual elements at Wells are in the French Gothic style with statues in canopies, pointed arches, gables, and quatrefoils, and the sculpted figures are similar in style to those at Amiens and Reims.

The nave, begun around 1190, recalls the Norman Romanesque in the thickness and solidity of its walls. The unbroken

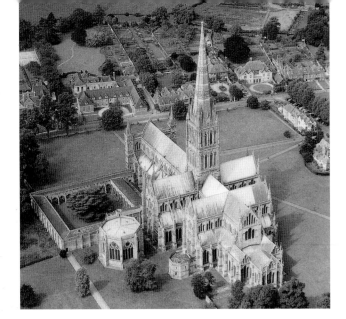

162. Salisbury Cathedral, begun 1220, spire early 14th century. The serenity of English Gothic cathedrals, such as Canterbury, Wells, and Salisbury, is enhanced by their sprawling plans and horizontal shapes that seem to relax in broad lawns. In contrast, French Gothic cathedrals are compact in plan, stress the vertical, and are seemingly squeezed by their surroundings, for they are typically located in the middle of cities, closely neighbored and even abutted by houses and shops.

horizontals between the stories differ from the French, as does the low springing of the vault that begins near the bottom of the clerestory. The vault of four-part bays rises only 20.4 meters (67 feet). Stiff-leaf capitals in the nave and transepts provide ornamentation, as do the complex architrave moldings and multiplicity of slender colonnettes surrounding the nave arcade piers.

Surely the most visually striking, even architecturally audacious, features of the interior are the strainer arches at the crossing. These were not constructed until *c.* 1338, shortly after the tower was completed, and were needed to redistribute the weight of the tower and to reinforce the west crossing piers. Hardly to everyone's taste, these strainer arches have been described as 'obtrusive,' even 'a grotesque intrusion' that 'mars' the otherwise laudable interior.

Also characteristic of Early English Gothic is picturesque Salisbury Cathedral, begun in 1220 and set in a green lawn. The choir, Lady Chapel, transepts, and nave, were built between 1220 and 1258 by Nicholas of Ely. Work was completed by 1266 or 1270. The cloister to the south of the cathedral and the chapter house off the cloister were built prior to 1266. Salisbury is typically English in its double transepts and spreading plan. The whole structure, measuring 144.2 by 70.1 meters (473 by 230 feet), has the typically English Gothic square east end rather than the typically French rounded apse, ambulatory, and radiating chapels. Salisbury's nave is long – ten bays instead of the seven usually used by the French.

The facade of Salisbury Cathedral, although begun in the same year as Amiens Cathedral, has very different proportions. Salisbury is low and wide, seemingly stretched left and right, with no great emphasis on height. The facade is wider than the church and is treated as a screen divided into horizontal bands with great emphasis on the sculpture. There is little emphasis on the portals: entry to English cathedrals is usually through a porch on the side of the nave or on the transepts. Flying buttresses, so characteristic of the French Gothic, were used sparingly in England.

The tall and massive crossing tower and spire at Salisbury were built in the early fourteenth century. Such impressive crossing towers are an English feature not found in France, where the greater height of the naves made construction of such heavy towers structurally ill-advised.

Salisbury is rare among English Gothic cathedrals in that its interior was built essentially in one campaign; Nicholas of Ely was in charge of the actual construction from the basic layout of the building to the templates for the profiles of the moldings. The interior has a three-story elevation in which the verticals are broken and the horizontals unbroken. Color contrast is created by the dark marble columns and arches on the pale nave wall. The effect is bare, the interior plain, cool and crisp, with

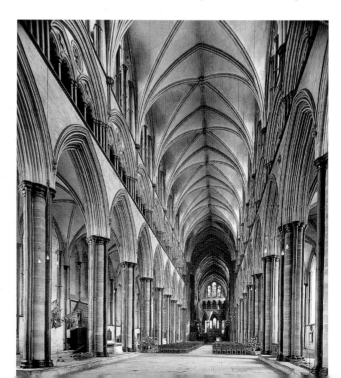

163. **Nicholas of Ely**, nave looking toward east end, Salisbury Cathedral, begun 1220–58 f.

strongly cut moldings and sharp points. The nave, 12.2 meters (40 feet) wide, is covered by four-part vault bays that rise 24.7 meters (81 feet). English vaults rarely rise higher than this, whereas some French vaults are significantly higher: Beauvais, soaring and spindly, reached almost 48.2 meters (158 feet). Salisbury's vaulting comes to a sharp point because the ribs begin to curve in at the bottom of the clerestory; in some English cathedrals the curve starts even lower. The clerestory windows are smaller and the walls are thicker than in a contemporary French Gothic cathedral.

An outstanding example of the Rayonnant phase of English Gothic is found at Westminster Abbey in London. Although originally built in Romanesque times, the abbey underwent rebuilding in the Gothic style, mostly between 1245 and 1269, due to King Henry III, who saw this as an assertion of Plantagenet power. Breaking with the English tradition of a single axial chapel, Westminster Abbey has a polygonal apse with a surrounding ambulatory and five radiating chapels – a plan derived from French models. The transepts, the eastern bays of the high three-story nave (liturgical choir), and the crossing, dated c. 1250–72, look French. The elevation begins with the sharply pointed arcade built with reinforcing iron bars; although probably intended to be removed when construction was completed, they are still in place today. As in French models, the springing of the vault begins well up into the clerestory and each bay of the clerestory consists of two lancet windows with a traceried rose above. Much of this is the work of the master mason Henry of Reyns/de Reynes, who appears to have been inspired by the French Rayonnant, exemplified by the Sainte-Chapelle in Paris, for the slender window tracery, interior ornament of floral patterns, and general delicacy.

Yet in other aspects Westminster Abbey is distinctly English. Typical thirteenth-century English construction methods are used, in which the vaults are treated as webs of masonry. Also characteristically English is the horizontal emphasis and the arcade made higher than the clerestory. The narrowness of the clerestory windows and the areas of solid wall around them also differ from the French examples. Although it has been suggested that Henry of Reyns may have come from the French city of Reims, he is generally believed to have been English and to have created a comfortable confluence of English and French influences.

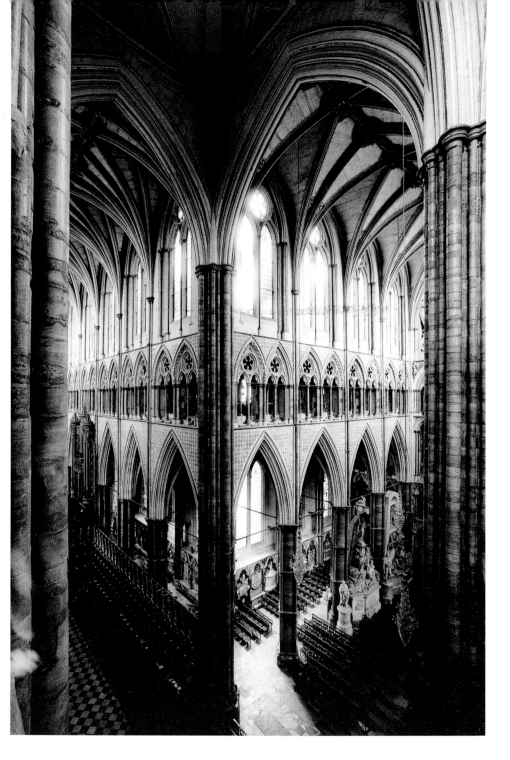

165. Stone leaves in chapter house of Southwell Minster, c. 1295. This celebrated indoor garden in stone indicates changes in architectural decoration and artists' approaches to Nature. Rather than repeating the standard column capitals, usually based upon debased descendants from antiquity, here the acanthus leaves of the Corinthian order and stylized unidentifiable plants are replaced by a variety of specific plants. These budding interests in botanical accuracy and direct observation will bloom in the Renaissance.

Architectural ornament in Gothic England, as in France, abandoned the Romanesque fascination with distortion and the grotesque for a gradual increase of interest in accurate depictions of Nature. This is most evident at Southwell Minster in the celebrated 'Leaves of Southwell,' carved c. 1295 in the chapter house and in the passage leading to it from the choir vestibule. Built in the Decorated Gothic style during the thirteenth century, the little chapter house is only 9.4 meters (31 feet) in diameter and therefore could be constructed without a central supporting pier.

The famous foliage seems to grow luxuriously over the forty-five capitals, twining up above the seats, along the gables, and still higher onto the roof boss. Unlike Early English Gothic foliage, such as the stiff-leaf capitals in the nave of Wells Cathedral, the notably realistic leaves of Southwell were inspired by the trees and plants of the English countryside. Emphasis is on variety rather than on repetition of only one or even a few types. Most can be identified, maple being the most common, followed by oak. Also present are hawthorn, ranunculus, potentilla, ivy, hop, rose, bryony, and perhaps mulberry vine; only a few entirely defy identification. Above a hawthorn capital is a human face sprouting foliage, the well-known motif of the Green Man or Jack-in-the-Green of medieval art.

A balance between art and science is achieved at Southwell. Wild Nature has been lovingly controlled and cultivated to grow in specific areas. Deep undercutting creates strong shadows that emphasize textures. The carving is accurate, sharp, and so lively that a gentle wind seems to rustle the leaves. The

166. Retro-choir, Wells Cathedral,
c. 1320–40

disregard for realistic relative scale between different types of plants may be explained by sculptors relying on drawings or pattern books rather than Nature's own examples. Although no two capitals are the same, reuse of the same design on two capitals, merely reversed, also suggests that sculptors may have worked from model books.

The leaves of Southwell are thought to be the work of more than one sculptor: two 'personalities' are evident in the carvings, yet the effect is homogeneous. Capitals similar to these are found in France at Reims Cathedral and the Sainte-Chapelle in Paris, both carved before the middle of the thirteenth century, raising a question that remains unanswered: were the masters of the Southwell leaves English or French?

The delicacy and refinement of the Decorated Gothic also appear in the retro-choir of Wells Cathedral, where the varied views – intricate and intriguing – seem to change constantly as the visitor walks between the presbytery and the Lady Chapel. The complexity of the Decorated Gothic is evident in the slender colonnettes of dark marble applied to the pale walls and in the multiplicity of delicate ribs in geometric patterns. The richly ornamented retro-choir was built to house a saint's relics but is still without a resident reliquary today.

From the late Decorated Gothic comes an example of extraordinary medieval engineering genius – the unique octagon topped by a lantern that is the glory of Ely Cathedral. The old Norman central crossing tower, built shortly before 1100, collapsed during a storm in 1322. Construction of the octagon began almost immediately and was completed in 1334. The Ely

167. Alan of Walsingham, octagon above crossing, Ely Cathedral, 1322–34. Visitors looking up into the Ely octagon might imagine themselves to be standing inside an enormous kaleidoscope. For those who wish to look in the opposite direction, it is possible to ascend a staircase and walk around the octagon from within; removal of a wooden panel permits one to look down into the crossing for a second spectacular view.

octagon is the masterpiece of Alan of Walsingham, referred to as sacrist and master mason. Rather than rebuilding on the same plan, he ingeniously enlarged the space of the crossing, expanding it into one bay on each of the four sides, and built eight enormous supports to create an irregular octagon of stone. The result is a crossing that measures approximately 23 meters (74 feet) in diameter. The great dimensions of the octagonal vault required its construction in wood rather than in stone. The visitor to Ely Cathedral, after passing through the heavy Norman nave, enters the open space of the crossing. The view up into the octagon is striking – if not dazzling – with its complex patterns of delicate ribs.

Above the octagon, the master carpenter William Hurley built the lantern of wood, faced externally with lead. Upon eight pillars rest timber triangles that support 200 tons of wood, lead, and glass. Among the carved portrait heads around the octagon are those of Alan of Walsingham and William Hurley. Approximately 45.7 meters (150 feet) above the floor, in the center of the octagon, is a lifesize carving of Jesus, the work of John of Burwell. The brilliant colors and much else seen today, however, are the result of restoration.

Vault ribbing became far more complex than that of the Ely octagon, as evidenced by the choir of Gloucester Cathedral, actually a modernization achieved by replacing the late eleventh-century Romanesque ashlar surfaces with an early Perpendicular Gothic style veneer, begun soon after 1330 and completed in 1357. Gothic and Romanesque alternate at Gloucester: the Gothic west facade contrasts with the Romanesque nave, which in turn contrasts with the Gothic choir. Certainly an English development, the Perpendicular Gothic first appeared at Gloucester and became dominant in England until approximately 1525 or 1530, when the Reformation and Henry VIII's dissolution of the monasteries brought an end to the construction of large churches.

As seen in Gloucester's choir, the Perpendicular is characterized by an extreme complexity of rib vaulting. Emphasis is on intricacy, with a multiplicity of small slender shapes repeated over and over in various ways. The many verticals running from floor to ceiling without interruption are much like the French Gothic, but the vault ribs differ from the French in that they proliferate to form a dense decorative screen. The vault is no longer divided into distinct bays but instead is unified by a continuous gauze, a spider web in stone. This incredible accumulation of

168

carefully carved and almost crystalline contours creates an illusion both light and lush.

The ribs in star patterns look Islamic and the multi-foils are also an Eastern motif. Contact between England and the East certainly occurred through the Crusades, through activity along the trade routes, and via other forms of extensive travel such as that undertaken by the emissary sent to Persia by King Edward I (d. 1307).

After English Gothic builders thoroughly mastered the structural problems of the style, they refined and enriched its decorative forms. Vaulting became progressively more adventurous as extra ribs were added, tracery became thinner, and decorative carving proliferated. The complexity of vault rib patterns seen in Gloucester's choir was carried still further in the cathedral's early Perpendicular Style cloister, constructed

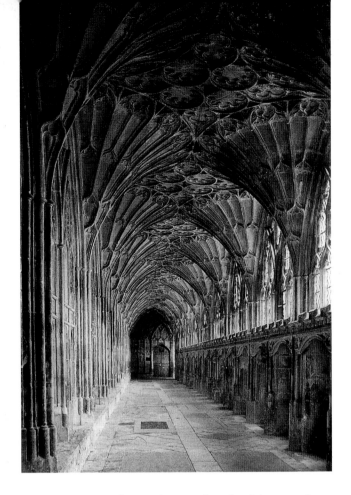

between *c.* 1351 and 1364. Surrounding the cloister garth are
four walkways, long and tunnel-like, only 3.7 meters (12 feet)
wide and 5.6 meters (18½ feet) high. Yet the interior surfaces
are treated to unprecedented elaboration. The fan vaulting,
thus named because the ribs radiating from the piers resemble
a fan, ranks among the most animated and complicated archi-
tectural achievements imaginable: it is idiosyncratically,
absolutely, and uniquely English. Although the ribs look like an
embroidered web applied to the ceiling, they are actually cut as
part of the vault stones. In this system of fan vaulting, the walls
provide the support, unlike the French Gothic system in which
the vaults are supported by the ribs. A series of flaring half-
cones constructed along the walls create an undulating surface,
yet the upper edges are joined together by vaulting that is
almost flat.

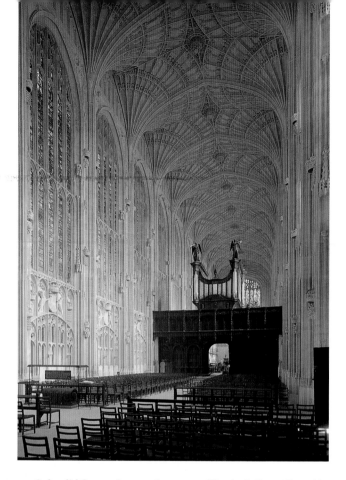

170. **Reginald Ely and John Wastell**, interior of nave with fan vaults, King's College Chapel, Cambridge, 14th–early 16th century

Splendid fan vaults are also seen at King's College Chapel in Cambridge. The nave was built in the fourteenth century by Reginald Ely, but it was John Wastell who completed the chapel between 1508 and 1515 by constructing the fan vaults. The springing begins high up in the clerestory, rising to pointed transverse ribs high above the nave. The underlying solid stone support structure is masked by a surface film of geo-metric faceted froth. In this lyrical environment, the interior is unified by covering the entire nave vault with stone lace.

The ultimate in fantastic English vaulting is found at Westminster Abbey in London where the enormous building culminates in a grande finale – the Chapel of Henry VII. Between 1503 and 1519 Robert and William Vertue, the king's architects, replaced the axial chapel, originally built in 1220 but later rebuilt as part of the new church of 1245, with this chapel. The tomb of Henry VII is located behind the altar.

The chapel is as big as a small church, fully equipped with aisles and a five-sided apse. Instead of a triforium there is a series of statues supported on corbels and under canopies that create a curving serpentine baseline for the clerestory. The remarkable vaulting is a variation on the fan vaults seen in the cloister at Gloucester and at King's College Chapel in Cambridge, for at Westminster the ribs also radiate in a fan-like shape. Half-cones line the walls and pairs of full cones hang between. At the ends of the hanging cones are bosses; fan vaults are carried to an extreme, to become pendant vaults. In fact, the vaults are supported by transverse arches from which the pendants are suspended, yet the Chapel of Henry VII seems to deny both logic and gravity. In this architectural extravaganza, the fundamental nature of stone as solid and heavy has been denied, transformed into delicacy and lightness. The entire ceiling surface is dissolved by intricate geometric patterns in a demonstration of the English fondness for architectural opulence.

Further examples of the English Gothic may be seen at the cathedrals of Exeter, Lichfield, Lincoln, Peterborough, and York.

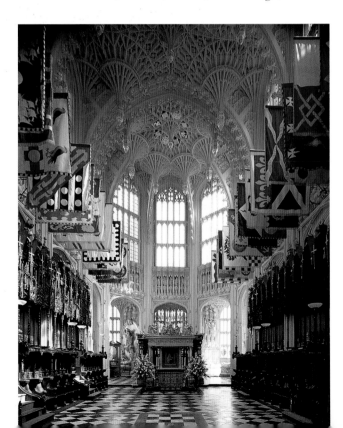

171. **Robert and William Vertue**, interior looking toward altar, Chapel of Henry VII, Westminster Abbey, London, 1503–19. This dramatic late English Gothic chapel contrasts vividly with reticent Early English Gothic. Surpassing the French in non-structural ornamentation, it is the ultimate in pendant vaulting, for the ceiling actually *hangs down* at regular intervals, in contradiction to the fundamental purpose of a ceiling. The solid surface is dissolved and faceted to become a crystalline canopy, the pattern recalling that of a honeycomb.

Germany

The city of Cologne achieved prominence during the Middle Ages, with its very large Gothic cathedral as the focus point. The first truly Gothic building in Germany, Cologne Cathedral demonstrates the spread and dominance of French architectural ideas. Indeed, given the degree of French influence, it has been suggested that the design of the cathedral was the work of a French architect: documents give his name as Gerhard, but it has been suggested that the name was originally the French Gérard.

Cologne Cathedral was begun on August 15, 1248, on the site of a Carolingian church, with the laying of the cornerstone by Archbishop Konrad von Hochstaden. The cathedral was built because of the desire of Archbishop Reinald von Dassel to erect an edifice to house the relics of the three wise men believed to have brought gifts to the infant Jesus. Although construction stretched over many centuries, the original plans for the cathedral were maintained. The west facade was designed between *c.* 1300 and 1310, and the two lowest stories of the south tower date *c.* 1310–1410. This first building campaign concluded in 1560, but the cathedral remained unfinished for centuries. The rest of the facade, including the spires that rise 157 meters (515 feet), as well as the nave, were not completed until the nineteenth century (1842–80). At this time, the many little houses, churches, and chapels that had been built around the cathedral were removed to provide a clear view of it from all sides.

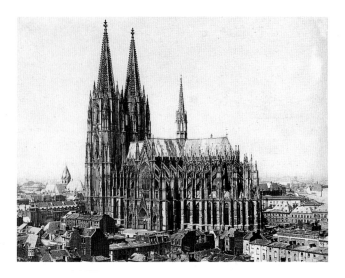

172. **Gerhard/Gérard**,
Cologne Cathedral, 1248 f.

The only portion of Cologne Cathedral completed during the Middle Ages was the choir, begun in 1248, the upper stories built c. 1280–1300. The exterior of the choir appears to redefine the nature of stone, for it seems to stretch elastically upward toward heaven. What was solid and heavy becomes lacy and light, apparently now weightless. In fact, the apse end is supported by slender buttresses, their verticals bracing and forming a visual foil for the diagonal accents of the many delicate flying buttresses that are covered with tracery and topped by a plethora of pointy pinnacles. Germany readily imported the forms of the French Rayonnant style while retaining a degree of mass. Cologne Cathedral's vault rises 46 meters (150 feet 11 inches): Beauvais, the tallest French Gothic cathedral, built shortly before Cologne, rises only slightly higher.

Cologne's choir combines elements from the Rayonnant choir of Amiens Cathedral, from the glazed triforium of the Rayonnant portions of Saint-Denis, as well as from the windows of the Rayonnant Sainte-Chapelle in Paris. In Cologne's choir, however, the proportions are extended so high as to create a dizzying effect. The design here is clear and rhythmic, unified and harmonious. Mathematically perfect dimensions combine with elegant ornament typical of the Rayonnant Gothic style.

140
139

Rayonnant Gothic ornament adorns the gables, balustrades, and buttresses of the large choir added between 1361 and 1372 to the thirteenth-century nave of Saint Sebald (Saint Sebalduskirche) in Nuremberg. This choir represents a type of construction popular in Germany, known as the hall church (Hallenkirche), in which the nave and aisles rise to the same height. The choir elevation is only one story: there is no triforium, gallery, or clerestory. Instead, the arcade supports the vault directly, uninterrupted even by capitals, creating the impression that the space flows upward. This building method was not an innovation, as evidenced by the Romanesque hall church of Notre-Dame-la-Grande in Poitiers, among other examples.

73

The popularity of the hall church construction in Gothic Nuremberg alone is demonstrated by the new choir added to Saint Lorenz (Saint Lorenzkirche) between 1439 and 1459 by Konrad Heinzelmann. Saint Lorenz, only a short walk across Nuremberg from Saint Sebald, is also built of a distinct reddish stone and has a single-story elevation that creates an open airy

173. Choir, Saint Sebald, Nuremberg, 1361–72

interior. Between 1459 and 1472 Konrad Roriczer constructed vaults here of great complexity with interweaving web-like ribs in the choir, in striking contrast to the simple four-part groin vaults in the late fourteenth-century nave. The choir of Saint Lorenz is surrounded by a two-story ambulatory, the stories divided by a walkway with a balustrade embellished with a variety of tracery patterns.

The late Gothic aesthetic in Germany is seen clearly in the parish church of Saint Anne (Saint Annenkirche) in Annaberg (Saxony). Despite its stark exterior of rough stone, this hall church, built between 1499 and 1522, has a colorful interior with a nave vault designed in 1515 by Jakob Heilmann of Schweinfurt (a pupil of Benedikt Ried/Benedict Rieth, the royal architect in Prague) and begun in 1517. The surfaces of the octagonal columns, rather than bulging with attached colonnettes,

175. **Jakob Heilmann of Schweinfurt**, nave vault, Saint Anne, Annaberg, designed 1515, begun 1517. Gothic Annaberg's prosperity derived from silver mining; the church is dedicated to St. Anne, the patron saint of mining. This single-story hall church is graceful and light in proportions, colors, and quantity of sunlight admitted through the aisle windows. The arcades barely divide the nave from the high aisles, their vault ribbing still more complicated and flower-like than that of the nave.

are a series of concavities that create a rippling effect. The ribs seem to grow from the tops of the columns, like delicate sapling branches swaying above tree trunks as the wind blows. The vault ribs, unlike the straight ribs of the net vaults of Saint Lorenz, actually curve in the Flamboyant style to form a canopy embellished with patterns resembling a series of flowers as their petals open. The overall effect is almost organic, a precursor of late nineteenth-century Art Nouveau – flowing fluid forms, slender and undulating.

Additional notable examples of German Gothic are the choir of Aachen Cathedral; the cathedrals of Freiburg-im-Breisgau, Magdeburg, Regensburg, and Ulm, as well as the Liebfrauenkirche, Trier, and the Elisabethkirche, Marburg an der Lahn.

176. **Peter Parler**, south transept porch vault, Cathedral of Saint Vitus, Prague, finished 1368. This may be seen as oppositional to the original use of ribs to support vaults, for here the vault surfaces are eliminated, taking the notion of a skeletal structure to its illogical extreme. Peter Parler's audacious display of his skill as a structural engineer pre-dates the pendant vaults in the Chapel of Henry VII in Westminster Abbey (Ill. 171) by a century and a half.

Bohemia

The city of Prague, the capital of Bohemia, became the artistic hub of central Europe in the second half of the fourteenth century due to John of Luxembourg, King of Bohemia (reigned 1310–46) and his highly educated son, Charles IV, King of Bohemia and Holy Roman Emperor (reigned 1346–78). Fine painting, sculpture, and architecture were produced for the royal court.

The focal point of Prague was to be the Cathedral of Saint Vitus. For its construction, Charles IV appointed Mathias/Matthew of Arras who began work on the choir, building portions of the east end in the French Rayonnant style, taking Narbonne Cathedral as his model (it seems worth noting that Charles IV married the sister of the French king Philip VI). Mathias of Arras died in 1352. In 1355, Charles IV acquired the relics of St. Vitus, the patron saint of the cathedral. Charles IV also copied the French fashion seen at Saint-Denis of filling the cathedral with precious items and royal tombs.

The significant place of Prague Cathedral in the history of late Gothic architecture is due to the work of Peter Parler, who was placed in charge of its construction in 1356 when he was only twenty-three years old. He worked here until his death in 1399. That he was given such an important job at so young an age surely had to do with the fact that he was a member of the highly regarded Parler family of architects who were active in Prague, Vienna, Freiburg-im-Breisgau, Basel, and Strasbourg. In fact, something of a Parler family style – a sort of Bohemian Gothic – was created, with Peter Parler playing a prominent role in its development. When he took over, Prague Cathedral was

being built in the French style, and although Parler was obliged to work in accord with Mathias of Arras's design, it was possible to redirect the style. And although the architecture of Peter Parler and his family was influenced by multiple sources (such as the cathedrals of Cologne and Strasbourg, the architecture of Prussia, and even of England), these sources were not merely copied; rather, they served as guides from which something personal was created.

Peter Parler completed the sacristy on the north side of the choir in 1362. In the west bay of the sacristy, he built a daring skeletal pendant vault with ribs forming a star: the ribs are suspended from the ceiling and supported by concealed ironwork. Soon after completing this pendant vault, Parler constructed most of the south transept, including the porch's extraordinary vault, which was finished in 1368. Here the ribs are partially detached from the vault, eliminating the stone web between them. This skeletal open work is essentially a net made of stone, for nothing fills in the spaces between the ribs. Similar vaults had been built previously at Strasbourg Cathedral (now gone), in several locations in Germany, and especially in England.

The arcade of the choir was finished by Peter Parler by 1370 and the upper levels of the choir by 1385 in a basically Rayonnant style, with emphasis on ornament and slender lines in the glazed triforium and large clerestory. The triforium's balustrade

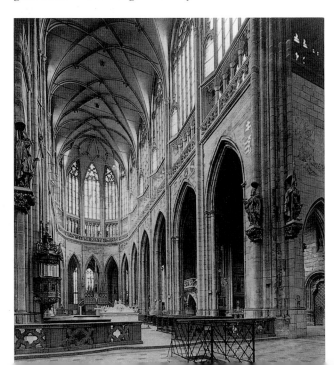

177. **Peter Parler**, interior of choir, Cathedral of Saint Vitus, Prague: arcade level finished by 1370, upper levels by 1385

interrupts the verticals and stresses the horizontal. The clerestory windows are recessed behind the wall of the arcade. The choir vault, like other elements of Prague Cathedral, is a synthesis of English and Germanic elements. The vault is a pointed tunnel with a complex decorative pattern of ribs: pairs of parallel ribs on diagonals form a geometric net with a pattern of large and small diamonds alternating along the apex of the vault. Rather than dividing the vault into a series of separate bays, this complex pattern unifies the space. Similar vaults at the Heiligkreutzkirche at Schwäbisch Gmünd are probably the work of Peter's father Heinrich.

The peak of pure Prague Gothic are the portions of the south transept and choir of Prague Cathedral built by Peter Parler. His net vault (*Netzgewölbe*) and his complicated tracery patterns were to be very influential; the pattern he used in Prague's choir was perpetuated during the following century and a half, as, for example, in the choir of Freiburg-im-Breisgau Minster, consecrated in 1513.

The choir of the collegiate church of Saint Barbara in Kutná Hora (Kuttenberg), also in Bohemia, was created either by Peter Parler or, more likely, his second son, Johann Parler IV. Building began in 1388, the choir continuing the Rayonnant style of Prague Cathedral. The net vault, designed in 1512 and constructed 1540–48, is the work of Benedikt Ried (Benedict Rieth), the teacher of Jakob Heilmann of Schweinfurt who made the net vaults in Annaberg. Because the nave has neither transverse ribs nor ribs running diagonally across the bays, it is not divided up into units; rather, it is united by curving, undulating ribs forming a series of six-petaled flowers along the center of the vault, as at Annaberg. These ornamental ribs, curving as if soft and elastic, are now distant descendants of their structural ancestors.

Also the work of Benedikt Ried is Vladislav Hall, built 1493–1502 at Hradcany Castle in Prague, which was constructed between 1487 and 1502. Slender ribbon-like ribs appear to grow up the walls of this tournament hall, undulating as if tossed by a breeze unfelt by the visitor, to form an open Flamboyant floral pattern on the vaulted ceiling. With its curving ribs, the vault of Vladislav Hall is similar to that at Saint Anne in Annaberg, but in Prague a rectangular space, unencumbered by columns or piers, is built on a grand scale. To construct a vault for so vast a hall – it measures 42.1 meters (138 feet) long, 15.8 meters (52 feet) wide, and 13.1 meters (43 feet) high – is an impressive engineering accomplishment in any age.

175

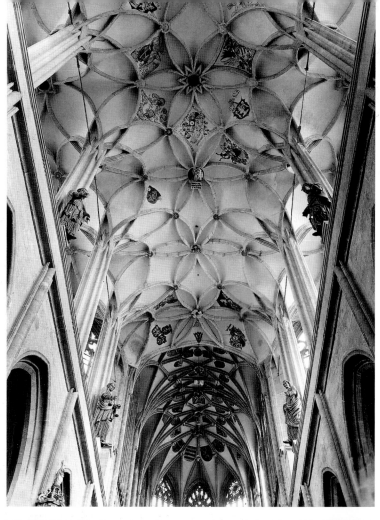

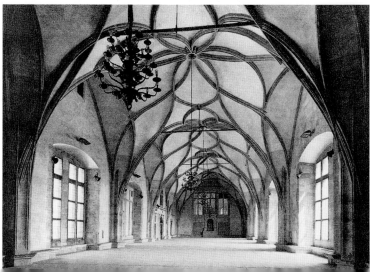

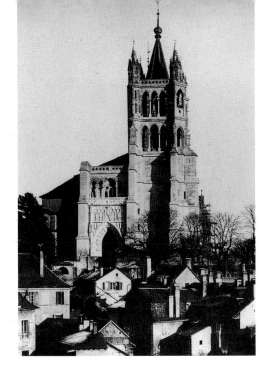

180. Cathedral of Notre-Dame, Lausanne, mid-12th to mid-13th century

Switzerland

Diffusion of the French Gothic architectural style is also seen at Lausanne Cathedral. Like French Gothic cathedrals, Lausanne is built in a Latin cross plan and the west facade was intended to be flanked by towers (but the north tower remains unfinished). Unlike the French Gothic, Lausanne's facade has neither a rose window nor a triple portal; instead, there is a single portal. Lausanne was built in three phases: first, the ambulatory, *c.* 1160–75, in a transitional Romanesque-Gothic style; second, the transept and nave, *c.* 1190–1210/20, in an early Gothic style; and third, the west porch, vestibule, and flanking towers, *c.* 1210/20–32 f., in a later Gothic style. For its relatively modest dimensions, Lausanne Cathedral has towers of impressive scale.

Although relatively small for a cathedral, Lausanne is larger than the buildings that previously occupied this site – the highest point in the city – necessitating the construction of supporting structures on the east and west. Sandstone was used for most of the cathedral, while tufa was used for the vaults and limestone for the foundations; there was also some re-use of ancient Roman materials. The original lead roofs were later replaced with tiles and stone.

The interior is replete with irregularities, surely due at least in part to the interruptions in the construction process. The visitor enters by a double-apsed vestibule that ends with a relatively small passageway. This creates a striking effect as the visitor enters the expanse of the nave, enhanced by making the first bay (the 'Great Bay') slightly narrower but longer than those that follow eastward. This effect results from an unusual history: today it is difficult to imagine what it was like when the main street of Lausanne ran through the 'Great Bay,' people and animals passing beneath the vaults. Thus it was until the early sixteenth century.

The supporting piers in the nave alternate large and small, and are of interesting variety. With the exception of the north transept, a three-story elevation is used throughout the interior. The pointed nave arcade is surmounted by a gallery, above which the clerestory level also includes a walkway. This elevation was influenced by Trinity Chapel at Canterbury Cathedral, which has a low three-story elevation with the gallery forming a distinct band. Lausanne's crossing is topped by an octagonal vault. Four of the nave vault bays are four-partite, one six-partite, and one seven-partite – more appealing irregularities. Yet an additional oddity is that the ambulatory, with its one axial chapel, is several steps below the sanctuary, and the choir is several steps above the level of the crossing.

Spain

Spain only began to build in the French Gothic style in the thirteenth century. The Spanish climate made exact imitation inappropriate: high-pitched roofs designed to facilitate run-off of snow and rain were not required in sunny Spain.

Burgos Cathedral, impressively located on the side of a hill, was the first major Spanish cathedral built in the Gothic style. Begun in 1221 or 1222, it is contemporary with Amiens Cathedral in France and Salisbury Cathedral in England. French influence may be connected with the fact that the Bishop of Burgos visited France in 1219, and the Spanish king Ferdinand III was a cousin of the French king Louis IX (St. Louis).

The first master mason at Burgos was probably Master Ricardo, who built the apse; the next was Master Enrique, responsible for the nave, built between 1243 and 1260, the year in which the cathedral was consecrated. The many interesting views of Burgos Cathedral result from a silhouette constantly interrupted by pinnacles, pointed shapes, and spiky forms. To some extent, Burgos is based on the French cathedral of

159

181. **Francisco de Colonia**,
interior of cupola (cimborio)
above crossing, Burgos Cathedral,
1540–68

Bourges, the influence of which is seen outside in the double fly-
ing buttresses and inside in the very high and heavily decorated
triforium. Differences from the French Gothic are the greater
thickness of the walls, the simplicity of the spaces, and mainte-
nance of horizontals. The contrasting use of ornamented and
plain areas is typically Spanish. Unity is enhanced by repeating
the motif of a multitude of quatrefoils in the west facade rose
window on a slightly larger scale in the story above and in each
triforium bay of the nave.

The arts in Spain were enriched by the mingling of cultures
that resulted from the conquest of the Muslims in southern
Spain. Arab artists who worked for Christian patrons developed
a part-Gothic, part-Islamic style of architecture known as
Mudéjar. Although Islamic aspects were intentionally minimized
in Christian religious architecture, they are evident in the cimbo-
rio, the impressive cupola/dome over the crossing of Burgos
Cathedral. After the previous cupola here collapsed, the piers
were strengthened and a new, heavily carved cupola was erected
between 1540 and 1568, the work of Francisco de Colonia. The
eight-pointed stars, one inside the other, and delicate geometric
webs filling all the sections are the spectacular result of combin-
ing Gothic and Islamic elements. Squinches make the transition
between the octagonal cupola and its four-sided base.

The first Spanish example of pure Rayonnant Gothic is León
Cathedral. More overtly French in style than Burgos, León has

long been thought to have been created by a Frenchman. Reconstruction began under Master Enrique, who worked here from 1255 until 1277, and based the plan of León upon that of Reims Cathedral. León's Master Enrique is almost certainly the same person who worked at Burgos. Construction of León proceeded until 1302 or 1303 and commenced again in 1439 when the upper parts were completed.

The striking facade has thirteenth-century triple portals in the French manner, a fourteenth-century north tower, and a fifteenth-century south tower by Master Jusquin of Utrecht. The upper central portion of the facade, however, is separated from the two massive towers, and the little flying buttresses in between create the impression that the central portion is trying to fend off the towers. The central gable is false, like a theater set with nothing behind it; in fact, the sky can be seen through the small rose window in the gable. The coarse stone used for construction of the cathedral eliminated the possibility of fine details.

The upper two stories of the thirteenth-century nave are glazed, much like the thirteenth-century Rayonnant nave of

182. Started by **Master Enrique**, facade from southwest, León Cathedral: triple portals 13th century, north tower 14th century, south tower 15th century

Saint-Denis. At León, unity is established by using a similar design for the windows in both stories: in each bay of the gallery level, lancets with a rose between are flanked by very slender lancets; the pattern is repeated in the clerestory, although the proportions are taller and a rose is added below the vault. The interior is further unified by the same elevation in the nave and first two bays of the choir: only the apse differs.

Later Gothic cathedrals of Spain are characterized by their vast dimensions. Seville became the biggest and richest of Spain's cities, and its cathedral was built on a deliberately colossal scale. In fact, Seville Cathedral is the biggest of all Gothic cathedrals in terms of floor area (it is especially wide) and volume (only Saint Peter's in Rome is bigger), although not height as the vaults rise 40.2 meters (132 feet). Often quoted is a canon's statement made at the commencement of the cathedral's construction: 'We shall build a church of such size that those who see it finished shall think us mad.' Work started in 1401 or 1402 on the site of a mosque. The design is probably by Alonso Martinez, mentioned in 1394. It is known that Master Carlin of France was master mason in 1439, and that his successor Juan Norman was responsible for the vaults. Later names are also recorded. The exterior, like the plan, is box-like. Unlike the French emphasis on verticals, Seville stresses the many horizontals – even the arches of the flying buttresses are almost horizontal.

183. Probably by **Alonso Martinez**, Seville Cathedral, begun 1401/02, largely finished by 1506: crossing tower rebuilt 1515–18, cathedral consecrated 1519

Rather than starting with the apse in the usual manner, Seville's nave was the first portion of the cathedral to be built.

This is flanked by large double aisles, the inner and outer aisles rising to the same height, the outer aisles flanked by chapels between the buttresses. Lacking a triforium or gallery, the elevation is only two stories – just the nave arcade and the clerestory – for Seville's builders were not overtly influenced by France. All bays have four-part vaults with the exception of the crossing and the four surrounding Flamboyant bays adorned with a proliferation of ribs forming a different pattern in each bay, the work of Juan Gil de Hontanon.

Spanish Gothic can also be seen at the cathedrals of Avila, Barcelona, Gerona, Toledo, the new cathedral in Salamanca, and Segovia, as well as the church of Santa Maria del Mar, Barcelona. In nearby Portugal, the convent of Santa Maria de Victória, Batalha, and the abbey of the Hieronymites, Belém, are worthy of note.

Italy

Italian Gothic architecture was the least Gothic – in the French sense – of the Gothic styles that arose in different geographic areas. There was a striking disparity in contemporary architectural styles north and south of the Alps. Instead of the verticality, flying buttresses, and large windows favored in Northern Europe, Italian builders preferred horizontality, large wall surfaces, and small windows. While the French Gothic is an emotional style intended to elevate the viewer's spirits, the Italian is more inclined to impress intellectually. As noted previously, sixteenth-century Italians favored the classical and

184. Abbey church of Fossanova, consecrated 1208

185. San Francesco, Assisi,
1228–53

therefore called this French style 'Gothic,' an insult implying that it resembled the Goths in its barbarism. Only superficially affected by the Gothic, Italy was soon to abandon the style: at the time France and England favored the Flamboyant Gothic, Italy had already moved on to the Early and High Renaissance based upon its own antique heritage. In contrast, France would largely bypass the Italian Renaissance style, moving directly to the Mannerist/Anti-Classical style.

Rather than using contemporary French models, Italian architecture of the Gothic era was based upon that of the Cistercian Order. The abbey church of the monastery of Fossanova, south of Rome, consecrated in 1208, is the oldest church of this order in Italy and served as the model for many churches. The Cistercians (see pp. 78–81), in connection with the monastery of Clairvaux, fostered a style based upon the ideas of Bernard of Clairvaux, who eloquently objected to sculpture and other ornament in the Church. Bernard favored severity and austerity – in architecture and in way of life for his monks.

As required by Bernard's Rule, Fossanova occupies a lonely site. Typical of Cistercian churches are Fossanova's minimal decoration and absence of facade towers, the octagonal crossing lantern, and the simplicity of the square choir instead of the

184

186. **Giovanni Pisano, et al,** facade, Siena Cathedral, mostly 1284–99. This cathedral demonstrates an Italian variant of the French Gothic, favoring a combination of a wider range of elements. These include the zebra-striped walls and colorful patterns of stone incrustation (which, unlike Northern European applied paint, have survived the years), areas of solid wall, and areas pierced with arches, mosaic, stained glass, and Giovanni Pisano's animated sculpted figures.

elaborate French semi-circular apse with radiating chapels. Although built in a Latin cross plan like contemporary French churches, the nave elevation is only two stories with pointed arches, large areas of flat unadorned wall, and simple moldings and capitals. The plain vault bays do not even have diagonal ribs. Rather than decoration, the Cistercians were concerned with perfect proportions and fine workmanship.

The hill town of Assisi, between Rome and Florence, has retained much of its late medieval atmosphere. The church of San Francesco here is the mother church of the Franciscan Order and was founded by St. Francis of Assisi in the early

thirteenth century. Francis died in 1226; the church of San Francesco was built between 1228 and 1253. Like the Cistercians, the Franciscans favored simplicity and at Assisi, as at Fossanova, there are no facade towers and the facade ornament consists of only large and small circular windows. Because the Franciscans stressed humility and poverty, towers – symbolic of power – were forbidden on Franciscan churches.

San Francesco is occidented – oriented with the entrance on the east and apse on the west. This reversal of the norm was necessary at Assisi so that the entrance would face the town. San Francesco is also unusual in that it is a double church consisting of upper and lower levels. The walls and ceilings are 217-18 entirely painted on both levels, whether this extensive decoration is in accordance with Francis' vow of poverty has been questioned. However, the fame of the paintings is unquestionably deserved.

Amid narrow curving streets and small abutting houses with irregular picturesque red-tiled roofs, stands Siena 186 Cathedral. Rebuilding began in 1245, most of the facade dates between 1284 and 1299, and work on the cathedral continued until the late fourteenth century. Differing from contemporary architecture in Northern Europe, the roof is low-pitched and there is more wall than window.

The design of the facade of Siena Cathedral, regarded as the most important artistic commission in Italy in its time, is the work of the sculptor Giovanni Pisano, son of the sculptor Nicola 214 Pisano, who had studios in Pisa and Siena. Giovanni built the 213 facade up to the top of the gables above the doors. This facade is actually a false front, unrelated to the interior. Structure is not stressed, but decoration is: the abundant ornament leaves no area plain. Siena Cathedral is the first Italian building to use a significant amount of large-scale figure sculpture on the facade, as in contemporary France. However, in France the figures flank the portals whereas at Siena the figures are placed higher up. Giovanni Pisano's figures are intentionally and overtly expressive in their twisted poses, their drama intended to be readily perceived from a distance, yet they are also simplified because tiny details would not be visible. The facade recalls the French Gothic also in its three portals and circular window above, but the arches are still in the Romanesque semi-circular shape and the buttresses are only thin pilaster strips.

The medieval Franciscan church of Santa Croce (Holy Cross) in Florence hides behind a nineteenth-century west facade by

187. **Arnolfo di Cambio (?)**, nave looking toward altar, Santa Croce, Florence, begun 1294

Niccolo Matas. Construction began in 1294, perhaps designed by Arnolfo di Cambio (*c.* 1245–*c.* 1310), a sculptor who worked and studied with Nicola Pisano. The church was completed in the later fourteenth century but not consecrated until 1443.

Although contemporary with the great Gothic cathedrals of France, the interior of Santa Croce does not copy the 'French style.' Characteristically Franciscan, Santa Croce is fairly simple in plan, with a rectangular east end like a Cistercian church. The interior is clear and rational, simple and sober. The walls are not dissolved as in the northern Gothic, yet the arcade is large and the effect fairly open and airy. The clerestory is small. While the wooden ceiling (this is the original wood, although the paint is gone) makes larger windows possible, the brilliant Italian sun makes it desirable to limit the window area. Most light enters from the east end; the lightest area is the altar, thereby focusing the visitor's attention here.

At the center of Florence is the famous cathedral group consisting of the baptistery, the bell tower (campanile), and the cathedral (duomo) itself. In 1334 Giotto was placed in charge of the construction of the cathedral. He received this appointment

93

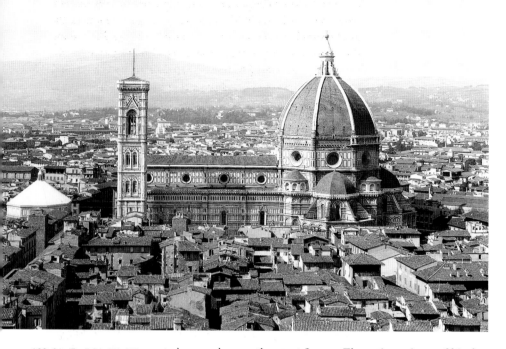

188. **Arnolfo di Cambio, Filippo Brunelleschi, et al**, Florence Cathedral, begun 1296. Visible throughout Florence, the duomo is a major accomplishment in the history of architecture. It grew gradually in size and importance, due, above all, to Brunelleschi's dome. Although built during the Early Renaissance, when architects were turning to the antique for inspiration, the dome retained the peaked Gothic form – which Brunelleschi constructed with a novel, lighter, double shell.

because he was the most famous Florentine painter of his day. 219-21 However, Giotto knew little about architectural structure and therefore designed only the campanile, which is known as 'Giotto's tower.' Although the free-standing campanile is typically Italian, it is not an invention of the Italian Gothic, as evidenced by the Romanesque campanile of Pisa. Florence's richly ornamented Gothic campanile, with its multi-colored marble incrustation and sculpture, served not only as the bell tower but also as a symbol of the sovereignty of the Florence commune. Giotto's original drawing survives: it shows that he intended the tower to be topped by a spire. When he died in 1337 only the first floor of the socle (the square base) was finished. Construction continued under Andrea Pisano, but he died of the plague in 1348. The tower was finished by Francesco Talenti in a somewhat different design in the 1350s or 1360. The interior of the tower consists of a series of rooms connected by staircases.

Florence Cathedral dominates the city. Due to the belief that Florence was built on a field of flowers, and in recognition of the lily on Florence's coat-of-arms, the cathedral is also known as Saint Mary of the Flower (Santa Maria del Fiore). The cathedral's unusually long and complicated history begins with an older church on the site dedicated to Sta. Reparata. In 1296

Arnolfo di Cambio began a new cathedral here, his commission requiring that he ~~build the~~ highest, the most sumptuous, the most magnificent church that the human brain could devise and that human strength could construct.' Work started at the entrance on the west (the present facade is nineteenth-century work by Emanuele de Fabris) and proceeded quickly until Arnolfo's death around 1310, after which work slowly stopped. Construction then resumed over a long period with various people in charge: Giotto, Andrea Pisano, Francesco Talenti, and Ghini. The three different treatments on the exterior of the nave are due to the different planners. The cathedral, like the bell tower and the baptistery, is covered with ~~a colorful~~ veneer of white, green, and pink marble incrustation applied in flat planes. The marble was brought from various parts of Italy, a country wonderfully rich in stone.

The long nave consists of only four square bays, flanked by single aisles: Arnolfo di Cambio's plan was probably similar to this simple version, although on a smaller scale. The elevation consists of only two stories: the arcade and a clerestory of oculi.

The dome was built between 1420 and 1436 during the Italian Early Renaissance and is the work of Filippo Brunelleschi (1377–1446). Arnolfo di Cambio had left the dome unfinished and his intentions unknown, obliging Brunelleschi to build onto the irregular octagonal plan he had established. Brunelleschi built an enormous and unusual double-shell dome in the pointed Gothic shape. Further, he did not use internal centering (a temporary wooden supporting structure), yet he managed to raise hundreds of tons of masonry up on the vaulting ribs to construct this extraordinary dome. In fact, Brunelleschi's dome is the largest after the Pantheon, larger than the sixteenth-century dome of Saint Peter's in Rome, and, in its time, the highest dome ever built. Brunelleschi's architectural triumph spans 42.2 meters (138 feet 6 inches) and rises 111.9 meters (367 feet); with the lantern, added after 1446 by Michelozzo, a height of 118.9 meters (390 feet) is achieved.

Among Italian cathedrals, that most akin to the French Gothic is Milan Cathedral. Founded in 1386 by the ruler of Milan, Gian Galeazzo Visconti, construction started the following year. The cathedral occupies an impressive setting in the center of Milan with an enormous piazza in front. Measuring 156.7 meters (514 feet) long and 92 meters (302 feet) wide, the nave flanked by double aisles, it is the largest Italian Gothic cathedral and, after Seville, the largest medieval cathedral. The

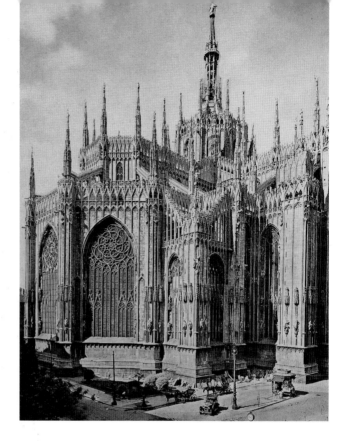

189. Milan Cathedral, begun 1386. Today, one is permitted to walk on the roof in the company of gargoyles and flying buttresses.

plan is akin to those of the cathedrals of Bourges and Le Mans, but the proportions more horizontal in this Italian adaption. Support for construction of Milan Cathedral was widespread: each guild tried to outdo the others in their tasks, different areas of the city vied in their contributions, and people of all social classes contributed funds.

Among Italian Gothic buildings, Milan Cathedral, with its polygonal ambulatory, most closely approximates the Northern fashion for complicated east ends. The incrustation of delicate, refined Flamboyant ornament is associated with the Northern architects who came to Milan with advice on the construction of the cathedral. With a proliferation of pinnacles and multiplicity of minute forms, Milan Cathedral may be considered overly ornamented, every element competing for the visitor's attention. Although consecrated in 1577, the apse and spire were unfinished at the time, and the facade is mid-nineteenth-century work.

Other than this importation of the French style to Milan, was Italy actively unreceptive to the Gothic? It has been said

that there was a conscious Italian resistance to the ideas of French architecture. Italian nationalism has been cited as an explanation and certainly Italy had strong longstanding traditions. It may be suggested, however, that the reason the French Gothic style never became very popular in Italy has less to do with politics and nationalism than with climate and comfort. A building with glass walls, such as the cathedrals of Chartres and Reims or the Sainte-Chapelle in Paris, would hardly be habitable in Florence or Rome on a summer day under the scorching Italian sun. Northern Gothic architecture may be seen as a prototype for today's solar heating, which would be received *too* warmly in Italy, frying the faithful. It seems worth noting in this regard that Milan Cathedral, the Italian cathedral that most closely resembles those of France, is in the north of the country.

The impact of the political environment on architecture is evident in certain secular structures. The Palazzo Vecchio (Old Palace), which functioned as the town hall of Florence, is an enormous stone block, the massive fortress-like construction necessary in a time of political and social strife. Attributed to Arnolfo di Cambio, noted to have worked in Florence at Santa Croce and the cathedral, the Palazzo Vecchio was begun in 1298.

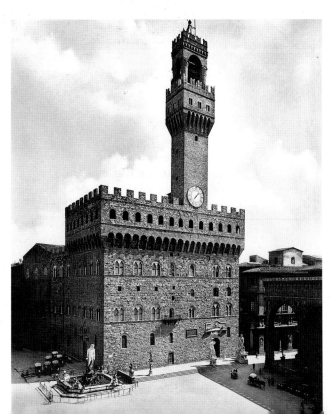

190. Attributed to **Arnolfo di Cambio**, Palazzo Vecchio, Florence, begun 1298

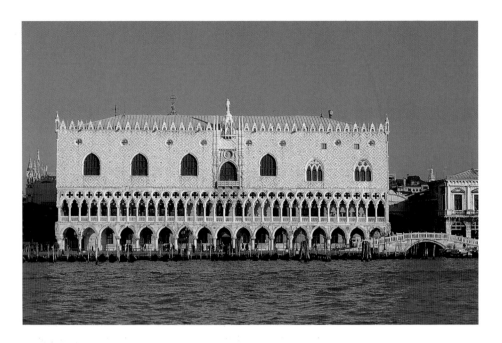

191. Palazzo Ducale, Venice,
mid-14th to mid-15th centuries

The rustication of the thick walls, their surface deliberately left rough to convey a sense of brute strength, is associated with military architecture. Little ornament adorns the severe exterior. For defensive purposes, the entrance and windows are small, and crenelations for archers edge the roof line. There is also a lookout tower: the solid mass of masonry needed to support the weight of the tower is masked by the blind windows below it. Originally there was a raised socle where speakers could address the public and where offenders were chained.

Roughly equivalent in function to the Palazzo Vecchio is the Palazzo Ducale (Ducal or Doges' Palace) in Venice, the seat of the city's government, originally built in the twelfth century but entirely remade between the mid-fourteenth and mid-fifteenth centuries. The security provided by the firm autocratic rule of a merchant aristocracy, as well as the island location, made fortifications less of a consideration in Venice than in Florence.

The walls of the Palazzo Ducale are richly decorated: pink and white marble patterned surfaces create a floating, shimmering quality. The superimposed open arcades are distinctly Venetian. Lavishly sculpted column capitals create a light, airy, animated effect, for Gothic delicacy combines with an Oriental quality. As the Byzantine church of San Marco beside the Ducal Palace demonstrates, Venice has long been influenced by the East.

20

Chapter 10: Gothic Sculpture, Decorative Arts, Manuscript Illumination, and Painting

The Gothic aesthetic preference for visual abundance is evident in the use of ornamentation. Church and cathedral as well as castle and court were generously embellished. Sculptures of stone and wood, objects of gold and silver with enamel and gems, ivory carvings, and manuscripts were created throughout Europe; tapestries were favored in Northern Europe, while murals and panel paintings were preferred in Italy.

Northern Europe

The cult of the Virgin, already strong during the Romanesque era (see p. 132), increased in popularity during the Gothic. Mary, often depicted as queen of heaven, crowned by her son, was especially venerated in the thirteenth century and by the fourteenth century was considered almost as important as Jesus. People in need of help appealed to the Madonna of Mercy. The hours (prayers recited at specific times) of Mary were recited daily. Writers extolled her virtues and explained her symbolic roles.

Among the most famous of the many images of Mary made during the Gothic era is the early fourteenth-century statue known as *Notre-Dame-de-Paris* (Our Lady of Paris) in the cathedral of the same name. This marble Mary stands in the transept crossing, much as if she were a medieval queen holding court before her faithful followers in the nave.

5
124

The deliberately emotional appeal exerted by images of Mary and Jesus as mother and child is an important aspect of Gothic aesthetics. Such figures are intended to touch the viewer's heart with their tenderness and to invite the viewer's contemplation. Jesus now behaves like an infant and may be shown playing with his mother's clothing or touching her face, rather than sitting up rigidly with one hand raised in blessing as in the Romanesque era.

The emotion elicited by Gothic art, however, is not always pleasant, as evidenced by the subject of the pietà. The word is Italian for 'pity' and refers to the portrayal of Mary with her adult son lying dead in her lap. Intentionally and overtly

Pity
↙

192. *Roettgen Pietà*. Wood and
polychromy, German, early 14th
century, height 87.5 (34½).
The emotional appeal of the pietà,
a new subject, is characteristic
of Gothic art (although the
emotion elicited by other subjects
is usually pleasant). The horrifying
aspects of Jesus' suffering at
the end of his earthly life were
emphasized in Germanic
countries, as seen earlier in
the Ottonian *Gero Crucifix*
(Ill. 41) and later in the images
of Jesus crucified painted by
the Renaissance artist Matthias
Grünewald.

moving, the viewer is to feel pity and to grieve with Mary.
This subject was popular during the Gothic era, especially in
Germanic areas, and is represented here by an example known
as the *Roettgen Pietà*, a German work of the early fourteenth
century, made of wood with polychromy. Jesus is gory and
grotesque, his body emaciated, the wounds emphasized. The
gruesome aspects of death are exaggerated: this is not meant to
be 'pretty' in the traditional artistic sense. Instead, expressive
emotional impact is maximized.

The relationship between architecture and sculpture
changed during the Gothic era. Initially column figures were
dominated by the building to which they were attached, but
gradually the figures were freed from their architectural
settings, as observed at Chartres and Reims. This tendency 129-31
continued in the work of Claus Sluter, a major sculptor in the
service of the dukes of Burgundy, as demonstrated by the so-
called *Well of Moses*, carved between *c.* 1395 and 1406, in the
Chartreuse de Champmol in Dijon. Surrounded by six lifesize
figures, the well serves only as their background; the slender
columns are barely noticeable.

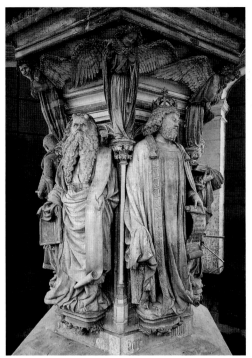

193. **Claus Sluter**, *Well of Moses*, Chartreuse de Champmol, Dijon. Stone with polychromy and gilding, Netherlandish, c. 1395–1406, figures lifesize

194. **Naumburg Master**, *Ekkehard and Uta*, Naumburg Cathedral. Stone with polychromy, German, c. 1240–50, figures lifesize

Although known as the *Well of Moses*, the well is only symbolic and originally served as a base for a crucifix. A dignified Moses is accompanied by other Old Testament prophets around the well. All the figures are massive in their proportions and are clothed in abundant drapery carved with deep undercutting to create a contrast of light and shade. The high level of realism, including details such as wrinkles in the skin, shows Claus Sluter to have had complete mastery of his medium, although the Old Testament prophet wearing eyeglasses shows that this concern for realism did not extend to historical accuracy.

The interest in making cold hard stone appear to come to life is seen also in the work of the Naumburg Master, thus called because he sculpted a number of works between *c.* 1240 and 1250 for Naumburg Cathedral in Germany. In the choir he carved depictions of people associated with the founding of the cathedral, such as Ekkehard and Uta. Although these people lived before the Naumburg Master and he could not have known them personally, he imbued them with such a sense of life that each one's personality is implied, as is the rather cool relationship between the two, for Uta turns up her collar seemingly to

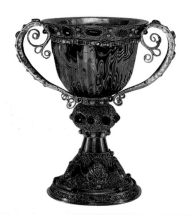

distance herself from Ekkehard. These sculptures have the abil-
ity to reach out to, and draw in, the spectator. Characteristic of
German art in general, and especially of that created during the
Gothic era, is the emphasis on emotion and powerful expressive
force conveyed through pose, gesture, and facial expression.
This may be related to the fact that German Gothic sculpture
tends to be less connected with the architecture than is French
Gothic sculpture; the finest German works adorn the interiors
rather than the exteriors of churches, their dramatic impact
unhampered by the architecture.

The medieval fascination with small objects fashioned from
precious materials reached a high point during the Gothic era,
and the level of technical skill and manual dexterity displayed
by these objects is unequaled in any other era. Objects embell-
ished with rich patterns and colors were felt to have spiritual
value as aids in aweing and edifying the faithful.

Abbot Suger's efforts to enrich the royal abbey church of 118-20
Saint-Denis included his famous sardonyx chalice, used for
wine during the mass to consecrate the new altar on June 11,
1144. Thereafter, the chalice was used as the sacramental cup at
the coronations of French queens for almost six centuries.
The stone was probably carved in Egypt during Roman times,
the fluting intended to emphasize the multi-colored veining.
The medieval metal mounting is exquisitely crafted of gold and
silver with gold wire filigree. The valuable stones smoothed as
cabochons are original, whereas those cut in facets are replace-
ments: faceting of stones was not fashionable prior to the
fifteenth century. The medallions on the base symbolize the
Eucharist with grain and grapes. The only original medallion is

196. Eucharistic dove. Champlevé enamel on copper gilt, made in Limoges, 13th century, 19 x 20.5 (7½ x 8)

that depicting Jesus flanked by the Greek letters Alpha and Omega, derived from John's Book of Revelation in which Jesus says, 'I am Alpha and Omega, the beginning and the ending...' (Rev 1:8). Jesus' pose with one hand raised in blessing originated in Byzantium; goldsmiths trained there may have made the mounting. Individually, each of the several materials used in crafting this chalice is valuable and, when combined, the impression of opulence is greatly increased.

In the Gothic era, as in the Romanesque, a variety of objects, often religious in purpose, were made of champlevé enamel on gilded copper plaques (see p. 135). The ateliers of Limoges continued to produce a larger number of enamels and a greater variety of items than any other city, the quality of its enamels ranging from magnificent to mediocre. Limoges was at its peak in the twelfth and thirteenth centuries. In the fourteenth and fifteenth centuries, 'Limoges style' enamels appeared in studios all over Europe, sometimes making it difficult to tell the origin of a piece.

Among the many types of items made of champlevé enamel in Limoges were eucharistic doves, the example illustrated here dating to the thirteenth century. This clever creature is actually a container for the host (the consecrated wafer used in communion), which was inserted through a hinged opening on the dove's back. The dove was suspended over the altar on chains; some models even flapped their wings as they were raised and lowered. The dove symbolizes the Holy Ghost or Holy Spirit due to John the Baptist's words: 'I saw the Spirit descending from heaven like a dove, and it abode upon him' (John 1:32).

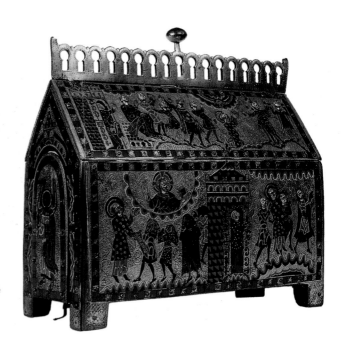

197. Reliquary châsse with *Stoning of St. Stephen*. Champlevé enamel on copper gilt, made in Limoges, 13th century, 25.4 x 28.8 x 11.9 (10 x 11⅜ x 4⅝)

198. Crozier with *St. Michael Slaying the Dragon*. Champlevé enamel on copper gilt, made in Limoges, c. 1220–30, 34 x 13 (13⅜ x 5⅛)

Many crozier heads were also made in the champlevé enamel technique in thirteenth-century Limoges, and were fitted into long, usually wooden, staffs. On several croziers, as illustrated here, St. Michael is shown spearing a small dragon, a symbol of the devil. On this example, the curling volute forms a bigger dragon, seemingly intent on avenging his smaller relative as he sneaks up on Michael from behind. On the knop are openwork dragons and further below on the shaft are more dragons flanking rinceau enamel bands. Among the great many fantastic animals depicted by medieval artists, the dragon appears with the greatest frequency, no doubt for its symbolic value, but also for the many decorative forms the serpentine body can assume. The two main decorative motifs used in thirteenth-century Limoges enamel work are the rosette and the flowering rinceau.

Reliquaries were one of the principal products of the Limoges studios. Most frequently reliquaries were made in the form of a châsse – a little casket or box made of wood to which plaques of champlevé enamel were attached, as represented by a thirteenth-century example on which the stoning of St. Stephen is depicted. The great importance attached to relics (see p. 133), combined with the medieval love of elegance, explains their encasement in sumptuous reliquaries, displaying

199. Reliquary shrine (open).
Silver gilt and translucent enamel.
French, c. 1345, height 25.4
(10). The fascination with and
veneration of relics persisted
throughout the Middle Ages,
as did the consequent creation of
splendid reliquaries. Architectural
forms originally conceived for
large-scale structures of stone
are recreated here for a minutely-
scaled reliquary of precious
materials. The twelfth- and
thirteenth-century reliquaries
seen in Ills. 105 and 197 appear
rudimentary by comparison.

unrivaled virtuosity of design and technique – often on a nearly microscopic scale.

Less frequent was the reliquary shrine: the exquisite example illustrated here was made c. 1345, perhaps in Paris, of silver gilt and translucent enamel. The simple box shape of the châsse has been elaborated to form a miniature building which, with its pointed arches, pinnacles, and crockets, looks like a tiny Sainte-Chapelle. This reliquary, however, opens much like a miniature altarpiece – an example of Gothic engineering genius on a minuscule scale, combined with elegance and opulence. In the center, Mary nurses Jesus, and is flanked by attendant angels holding little boxes that originally displayed relics. The enameled scenes depict Jesus' early life, making it likely that the relics were associated with the Nativity.

138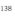

The enamels on this reliquary shrine are exquisite examples of the basse-taille technique using translucent enamel, a method invented in the fourteenth century; all earlier enamel was opaque. Basse-taille is done on a silver or gold ground into which a pattern is sculpted, engraved, or chiseled in low relief and is intended to show through the coat of translucent enamel applied to it. Because the colors appear deeper in the grooves and recesses, extremes of nuance and richness of effect are possible.

A charming example of enamel work is a cup with monkeys, dated *c.* 1425 to 1450, made in Flanders, only 20 centimeters (7⅞ inches) high. The subject portrayed on this cup was popular in the fifteenth and sixteenth centuries. On the outside, a sleeping pedlar is robbed by thirty-five monkeys. They take his clothing and other possessions and then cavort in the tendril-like trees with their ill-gotten gain. On the inside, the monkeys act like human hunters equipped with hounds, hunting horn, and bow and arrows, as two monkeys chase two stags, the favorite quarry of the aristocracy.

This cup is made with painted enamel, a technique usually done on copper, only rarely on gold or silver (the monkey cup is silver gilt). Painted enamel is unlike other enamel techniques in that the metal ground receives no special preparation – neither soldering of tiny fences as in cloisonné, nor gouging of depressions into the ground as in champlevé. Instead, this cup was created by painting gold, white, and dark blue enamel directly onto the surface. Because painted enamel is very brittle and can be used only to decorate objects that receive little physical use, few examples survive today. The monkey cup is probably the most famous medieval survival of the technique.

Precious objects continued to be carved from ivory during the Gothic period. Relatively few ivory carvings remain from the late twelfth through the mid-thirteenth century, the decline explained, presumably, by a lack of ivory: elephant ivory was difficult to obtain in Western Europe in this period and the native walrus population had been decimated. Further, as monumental sculpture increased in popularity, sculptors (and their

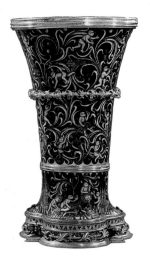

200. Cup with *Monkeys*. Silver gilt and painted enamel, French, c. 1425–50, height 20 (7⅞), diameter 11.7 (4⅝)

201. Polyptych with *Madonna and Child* and *Scenes of the Infancy of Jesus* (open). Elephant ivory with traces of polychromy and gilding, metal hinges, Northern French (probably from Paris), c. 1280–90, 29.4 x 28 (11⅝ x 11)

202. Polyptych with *Madonna and Child* and *Scenes of the Infancy of Jesus* (closed)

patrons) turned away from small-scale ivory work. In the late thirteenth century, however, there was enough of a return to ivory carving that it became a significant industry in the Ile-de-France. After reaching a peak in fourteenth-century France, there was a decline in production in the fifteenth century.

For the most part, Gothic ivories are small items for private devotion, as opposed to objects used in church ceremonies. Statuettes of Mary holding the infant Jesus and little diptychs and triptychs with scenes of Mary and Jesus became popular. For example, a small thirteenth-century French polyptych depicting Mary and Jesus with attendant angels, served a wealthy owner as a folding tabernacle to be used for prayer at home or when traveling. Young Mary, svelte and swaying, supports her infant son on her left hip and exchanges smiles with him. The shallow space in which they stand continues onto the wings where Jesus' early life is portrayed in charming vignettes.

A variety of secular objects, including mirror backs, were also carved from ivory. In antiquity and in the Middle Ages, mirrors were made of polished metal, for glass mirrors were as yet unknown. Small mirrors were worn suspended from a belt or were carried in a purse worn in the same manner. To protect the metal mirror, it could be encased in two disks of ivory; the

203. Mirror back with *A Game of Chess*. Ivory, first quarter of the 14th century, diameter 10.8 (4¼). Medieval mirrors were likely to be polished metal disks kept within ivory cases. This luxury item is carved with a depiction of one of the pastimes enjoyed by the upper class. Chess is known to have been played during the Carolingian era and its history can be traced back to early Islamic culture.

exterior one was likely to be sculpted with scenes of romance, court events, or daily life, such as a game of chess. Chess was a royal game played before the time of Charlemagne and chess pieces were carved of ivory throughout the Middle Ages. In the early fourteenth-century example illustrated here, a young couple plays chess under a tent – not without the advice of their friends. The ivory carver managed to convey the tension of the game through poses, gestures, and facial expressions.

Such elegance and attention to perfectly crafted detail appear also in manuscript illumination – an art that reached a peak during the Gothic period. The production of manuscripts was essentially the domain of monks until approximately 1100. However, by 1200, secular workshops produced books for the laity, and by 1250 there were book shops in the big universities and in commercial towns. By 1300 most monks bought their books in shops. Second-hand books might be traded. Scribes and manuscript illuminators were initially regarded as artisans – anonymous workers within the guild system who were paid as craftspeople and lived accordingly. Only at the end of the Middle Ages did manuscript illuminators cease to be anonymous, finally becoming known by name and even address. Those employed by nobility and royalty may have been highly remunerated for their skills.

France was the leader in manuscript illumination and Paris, with its new university and various ateliers, was the center that influenced all of Western Europe. This was especially true under the reign of Louis IX, and the quintessential mid-thirteenth-century French manuscript may well be the *Psalter of St. Louis*, made for him *c.* 1260, a luxurious book containing 78 scenes from the Old Testament. An exemplar of the tiny folios, measuring only 21 x 14.5 centimeters (8¼ x 5⅝ inches), portrays Joshua bidding the sun to stand still. The composition is similar in all the scenes, the background forming an important part of the design, the symmetry stressed by the division of the background into two halves. Contemporary Rayonnant architecture with pointed arches, pinnacles, tracery, and rose windows is depicted (it is worth noting that the Sainte-Chapelle in Paris, which the manuscript seems to reflect, was also commissioned by Louis IX). Not only contemporary architecture, but also stained glass influenced manuscript illumination. Thus, reds and blues dominate, the heavy black outlines are similar to the leading used in stained glass, and the effect is ornamental and flat with the background parallel to the picture plane. In turn, stained glass was

138-9, 147

204. *Joshua Bidding the Sun to Stand Still*. Manuscript illumination from the *Psalter of St. Louis*, French, *c.* 1253–70, 21 x 14.5 (8¼ x 5⅝). This is one of 78 full-page miniatures from the *Psalter*, which is the perfect embodiment of the Gothic in its sophisticated elegance. Interaction between the arts is evident: contemporary architecture in the background of this and other scenes is recorded with the bright colors and heavy dark outlines of stained glass.

influenced by manuscript illumination. The figures, in contrast to the two-dimensional background, are modeled to appear three-dimensional. With their long thin bodies, dainty extremities, and tiny heads, the figures assume swaying elegant poses, graceful yet active.

Attributed to the French manuscript illuminator known as Master Honoré, a layman working in a city atelier, is the *Prayer Book (Breviary) of Philip the Fair*, dated to 1295, which includes a depiction of David and Goliath. The style is similar to that of the *Psalter of St. Louis*, in that the flat patterned background contrasts with the subtly modeled figures, but Master Honoré's figures, with their typically slender French Gothic proportions, seem to take advantage of their greater three-dimensionality by stepping over the picture frame. The story is told in condensed, compact, continuous narrative: in the lower register, the shepherd boy David is seen with the stone in his sling; the giant Goliath is struck in the forehead with the stone; and David beheads the giant with his own sword.

205

205. **Master Honoré** (attributed),
David and Goliath. Manuscript
illumination from the *Prayer Book
(Breviary) of Philip the Fair*,
French, 1295, 20.3 x 13.3
(8 x 5¼)

In the fourteenth century the most elegant manuscripts
continued to be made in Paris. The arts became centralized in
this city which was the seat of a powerful monarchy. Here, the
most splendid manuscripts were made in the studio of Jean
Pucelle; the *Hours of Jeanne d'Evreux*, dated 1325–8, is consid-
ered to be Pucelle's masterpiece. This book of hours (personal
prayer book) was made for the queen of France, Jeanne d'Evreux,
as a gift from her husband, Charles IV. French Gothic manu-
scripts were written in finer lettering and were smaller in size
than those produced previously or anywhere else: this tiny book
measures only 9.2 x 6.1 centimeters (3⅝ x 2⅜ inches). Included

206. **Jean Pucelle**, *Crucifixion and Adoration of the Magi*. Manuscript illumination from the *Hours of Jeanne d'Evreux*, French, 1325–8, each page 9.2 x 6.1 (3⅝ x 2⅜). Printed approximately actual size.

are depictions of the Crucifixion and the Adoration of the Magi: the sequence of the scenes is not chronological.

The *Hours of Jeanne d'Evreux* is executed in grisaille – a painting technique in which the palette is largely limited to shades of gray. This was to become especially popular in manuscript illumination of the second half of the fourteenth century. A comparable vogue for grisaille windows has already been noted (see p. 190). So delicately drawn and modeled are the lithe and lively little figures in this minute work that a magnifying glass would be useful. Poses and gestures are dramatic and emphatic. Scenes are crowded and compact. The full-page unframed scene here is a rarity. Margins are filled with plant forms, insects, animals, hybrid creatures, playful oddities, cavorting figures, and genre scenes – perhaps symbolic. The influence of stained glass seen in manuscript illumination of the preceding century is gone.

The years on either side of 1400 were dominated by the International Style: the term is literally descriptive as the style was found throughout Western Europe. The prime example of the International Style in Northern European manuscript

207. **Limbourg brothers**, *May.*
Manuscript illumination from
*Les Très Riches Heures du Duc
de Berry*, French, 1413–16,
29.2 x 21 (11½ x 8¼)

[handwritten note: LIFE enjoyed by the upclass]

illumination is *Les Très Riches Heures du Duc de Berry* (*The Very Rich Hours of the Duke of Berry*), dated 1413–16. It is the last and greatest work of the Limbourg brothers, Pol (Paul), Herman, and Jean (Jannequin), who were probably German or Flemish, and was made for Jean, Duke of Berry (1340–1416), one of the brothers of King Charles V. Jean de Berry spent much of his fortune on art and was a compulsive collector and patron on a grand scale – at least in part because the display of personal possessions was a method of establishing and maintaining prestige. The effluence of his affluence can be seen in this book of hours which includes one folio portraying the activities, attire, and weather characteristic of each month of the year. The idea of

208. **Limbourg brothers**,
February. Manuscript illumination from *Les Très Riches Heures du Duc de Berry*, French, 1413–16, 29.2 x 21 (11½ x 8¼).

This manuscript is of great importance for, in addition to the beauty of the painting, it documents the life enjoyed by royalty and endured by peasantry – the disparity depicted in detail. Also chronicled is the emerging interest in observation of natural phenomena, such as the seasonal changes in the color of the sky and the foliage of the trees.

representing the labors of the months is not new (cycles were carved in relief on the facades of the cathedrals of Paris, Amiens, and elsewhere), but never before had each month received such detailed attention. Nor had the way of life of the aristocracy and the peasantry been so clearly documented – and contrasted. The illumination for the month of January includes a portrait of Jean de Berry, while most of the other figures in the manuscript are not individualized.

The illustration for the month of May – one of several scenes of aristocratic life – is characteristic of the International Style in its use of bright contrasting colors, decorative flowing lines, elongated figures, crowded composition, decorative surface

pattern, and quality of opulent elegance. The splendid outing that is depicted records the tradition of young women and men, many wearing green, riding into the countryside on the first of May and returning with branches and garlands of leaves – just as the Duke of Berry had done in his youth. Here the riders are accompanied by the sounds of trumpet, trombone, and flute, as well perhaps as the barking of small dogs. The ladies ride side-saddle, as was customary; the flirtatious behavior was equally as expected. The Limbourg brothers recorded many details both of custom and costume in this scene of the luxurious life enjoyed by those at the peak of the social pyramid.

In contrast, the folio for the month of February depicts peasant life in winter. Removal of a wall of the farmhouse permits the viewer to peer inside where people warm themselves by the fire: they lift their garments to do so, causing the woman sitting closest to the viewer to avert her gaze from her companions who wear no undergarments. Indicative of a new interest in Nature at the end of the Middle Ages, this is one of the earliest known snow scenes. Within the illusion of a deep space, careful observation and recording of details from farm life in winter are evident: sheep huddle together inside their wattle fence, birds look for food in the snow, the trees are leafless, and the sky a winter gray. The Limbourg brothers even paint the temporary and momentary: the smoke from the chimney and the breath of the woman as she blows on her hands to warm them while running toward the house through the cold air. In depictions for other months in this manuscript, some figures even cast shadows for the first time since Roman antiquity.

✳ Increased realism and observation of natural phenomena are also seen in the convincing depiction of the dead body of an older emaciated man on a folio by the so-called Rohan Master in the *Grandes Heures de Rohan* (*Rohan Hours*), a French book of hours dated *c.* 1420–30. At the moment of judgement, the archangel Michael grabs the devil by the hair in an effort to take claim of the dead man's soul, typically represented by a tiny nude youth. An enormous figure of God looks down sympathetically on the man, lying in a graveyard scattered with bones. God holds a sword and a globe – symbols of his power. A banner issues from the dead man's mouth on which is written in Latin, 'Into thine hand I commit my spirit; thou hast redeemed me, O Lord God of truth' (Psalm 31:5). Modifying the words of the repentant thief to Jesus when both are crucified (Luke 23:41-43), God answers the dead man in French,

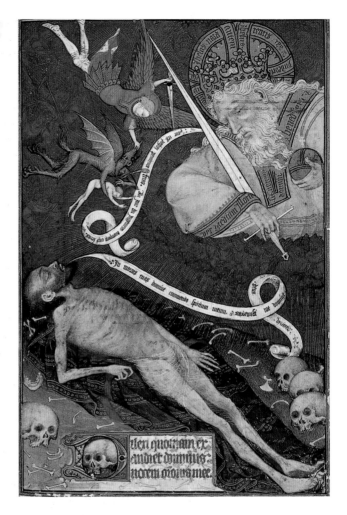

209. **Rohan Master**, *Office of the Dead*. Manuscript illumination from the *Grandes Heures de Rohan* (*Rohan Hours*), French, c. 1420–30, 29 x 20.8 (11 x 8)

'For your sins you shall do penance. On Judgement Day you shall be with me.'

The painstaking care with which medieval manuscripts were created is paralleled by the time-intensive production of medieval tapestries. These and certain other textiles were of great importance during the Middle Ages. The earliest extant tapestries date to the twelfth century. Their popularity gradually increased and in the fourteenth century tapestry production achieved a peak as a major and well-organized industry. Important cities for early manufacture were Arras, Tournai, and Paris; later Paris, as well as Aubusson and Brussels, took the lead. Tapestry weaving focused in Northern Europe because,

resistant to cold and damp, tapestries are especially suitable for insulating dank medieval castles, minimizing drafts through stone walls. Further, tapestries provide decoration for Northern buildings where the climate is unreceptive to frescoes, such as those painted on walls in Southern Europe. Owners routinely took their tapestries with them as they moved among their various castles. Because tapestries were luxury items to be collected and coveted, their acquisition was regarded as an investment of significant economic importance and their possession considered a sign of rank, power, and prestige. For example, in the later fourteenth and early fifteenth century, four royal brothers competed with one another in tapestry collecting: Charles V, King of France; Jean, Duke of Berry; Louis, Duke of Anjou; and Philip the Bold, Duke of Burgundy.

The manufacture of a tapestry is a long process, requiring several different skills. The division of labor was established by custom and maintained by law. First, the artist makes a small-scale color drawing. To re-use someone else's design, or a part of it, or to reverse it and call it one's own, was common practice. Re-use sometimes resulted in figures and objects taken out of context and is the explanation for some otherwise baffling iconography. Second, the cartoon-maker enlarges the artist's image to the dimensions intended for the tapestry. This is done on linen or paper and is called the cartoon. No medieval cartoons survive today; the oldest extant examples date to the early sixteenth century. Third, the cartoon is translated into a tapestry by weavers. The tapestry is woven on a loom that is worked by several people sitting side by side. If a set of tapestries was to be produced, as was often the case, several looms were employed simultaneously.

To begin the actual weaving, the loom is strung with evenly spaced warp threads of tightly twisted undyed wool: the number of warp threads per inch determines how fine the tapestry will be. The warp threads will be hidden by the weft threads which are most often of wool, although silk was also used. The wool and silk threads were colored with vegetable dyes: weld, woad, and madder were used to make the primary colors yellow, blue, and red. These could be mixed to create many more colors. The palette of medieval weavers was limited to about thirty tones, whereas later a great many more colors were used. Medieval tapestries also include silver and gold threads made by winding strips of silver or gilded silver around silk strands. Every change of color requires the weaver to tie off one thread and begin with another. The weaver works from the back of the tapestry, the finished

image therefore being a reversal of the artist's original design. Weaving a tapestry is a tedious and exceedingly slow process, at times requiring several years to produce a single finished product. On average, one weaver produced approximately one square meter (approximately 9 square feet) of tapestry per year.

Tapestry was the medium used to create one of the most complete representations of the Apocalypse, a subject popular in Gothic art. The last book of the New Testament, the Book of Revelation (Apocalypse) – a prediction of the catastrophic events at the end of the world – was written by St. John (see p. 58). Known as the *Angers Apocalypse*, this tapestry series once hung in the cathedral of Angers. The tapestries were commissioned in 1373 by Louis, Duke of Anjou. The weaving was done in Paris by Nicholas Bataille, based on cartoons by Jean Bondol (Hennequin de Bruges), court painter to Charles V, whose work was in turn based on an illuminated Apocalypse manuscript. Representative of the series is the tapestry in which St. Michael and his angels triumph over the dragon, derived from Apocalyptic texts: 'And there was war in heaven: Michael and his angels fought against the dragon; and the dragon fought and his angels' (Rev 12:7), and ' ... the great dragon was cast out, that old serpent, called the Devil, and Satan, which deceiveth the whole world...' (Rev 12:9). On one side St. John is seen in a little building. The angels descend from the clouds and attack the beast, piercing him with their long lances and swords. The dragon, with his bat wings, seven heads, and notable teeth, has fallen to the ground and makes his final fruitless effort.

210. **Nicholas Bataille**, *St. Michael and his Angels Triumph over the Dragon* (Revelation 12:17). Tapestry from the *Angers Apocalypse* series, commissioned 1373, 4.3 m (14' 1")

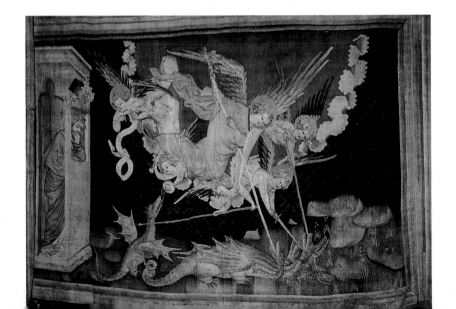

Perhaps from the studio of Nicholas Bataille are the *Nine
Heroes* tapestries, made *c.* 1385, originally a set of three tapestries
with three heroes on each, although portions are now lost. The
Nine Heroes encompass three pagans – Alexander, Hector, and
Julius Caesar; three Hebrews – Judas Maccabeus, Joshua, and
David; and three Christians – King Arthur, Charlemagne, and
Godfrey of Bouillon, leader of the First Crusade. All are shown
dressed in late fourteenth-century courtly fashion. The arms of
the great art patron, Jean, Duke of Berry – the fleur-de-lys on a
blue background with a red border – are included in these tapes-
tries.

Another celebrated set, famous for their charm, richness of
design, and fine quality of weaving, are known as the *Hunt of
the Unicorn* tapestries. These are Franco-Flemish work of
c. 1499–1500 from a Brussels atelier. They tell the story of
the hunt, capture, and murder of the unicorn – a mythological
creature sought for its single horn which was thought to bring

211. **Workshop of Nicholas
Bataille (?)**, *King Arthur*.
Tapestry from the *Nine Heroes*
series, made in Paris, *c.* 1385

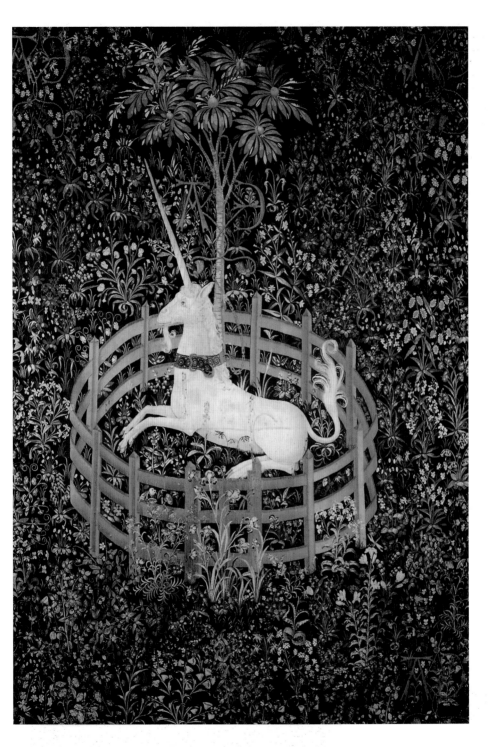

good luck and to provide protection from poisoning. The first and last tapestries in this series are of a type known as *mille-fleurs* (thousands of flowers), characterized by a background filled with many plants that have been meticulously observed and recorded. Yet in spite of their individual botanical accuracy, they create an unreal realm, an impossible environment in which a variety of plants from different geographic areas, climates, and seasons all bloom simultaneously.

pic
217

In these tapestries, as is often true elsewhere in medieval art, the iconography is intricate and the context crucial to its interpretation. Throughout the narrative, the unicorn may be regarded as a religious symbol of Jesus or as a secular symbol of a bridegroom. The former interpretation derives from the story of the unicorn who is made vulnerable and is killed when he comes to a virgin woman – comparable to Jesus. The latter interpretation (the tapestries may have been made as a wedding gift) derives from the medieval stories of the lover who endures various hardships to win his lady's love – comparable to the unicorn's suffering. In the final tapestry, illustrated here, the dual symbolism is combined. According to the religious interpretation, this is Jesus resurrected in a heavenly garden. According to the secular interpretation, this is the lover, now wearing the *chaîne d'amour* (chain of love) around his neck and surrounded by a fence, perhaps tamed and domesticated by his lady's affection. The red juice that falls on the unicorn's white coat from the pomegranates above, like the unicorn, is interpreted according to both religious and secular iconography. The former holds

Religious

that the many seeds of the pomegranate represent the unity of the Church and hope for the Resurrection, whereas in the latter the crown-like finial represents royalty and the many seeds represent fertility and the children to be produced by the marriage.

Secular

Italy

Just as Italian Gothic architecture differed stylistically and remained somewhat separate from that of the rest of Europe, the same is true of Italian Gothic sculpture. Italian sculptors treated their work as distinct from the architecture, showing a preference for carving in marble no matter what material was used to construct the building.

Nicola Pisano (*c.* 1220/25–84) reintroduced a classical style in sculpture, as demonstrated by the marble hexagonal pulpit supported on classical Corinthian columns which he made between 1259 and 1260 for the Baptistery in Pisa. He may have

studied ancient Roman sarcophagi preserved in Pisa, for he carved classical figures and faces in the panel that portrays the Nativity. Deeply undercut, solid and massive, the forms bulge outward from the background, but the emotional feeling of this composition, into which several subjects are crowded, is characteristically Gothic.

Nicola Pisano and his son Giovanni (1240/45–after 1314) each carved two marble pulpits. Giovanni's pulpit in Pisa Cathedral also includes the Nativity but, carved between 1302 and 1310, it departs from his father's classical style, and instead reflects the elegance favored in Paris at the end of the thirteenth century. Giovanni's figures are slimmer than his father's, the drapery more flowing, the composition not as crowded, the

213. **Nicola Pisano**, *Nativity*.
Marble panel on pulpit,
Baptistery, Pisa, 1259–60

214. **Giovanni Pisano**, *Nativity*.
Marble panel on pulpit, Pisa
Cathedral, 1302–10

215. **Duccio**, *Madonna and Child in Majesty*, main panel of the *Maestà* altarpiece. Egg tempera and gold on panel, 1308–11, 213.4 x 412.1 (84 x 162¼)

effect somewhat agitated rather than serene. The figures are carved as if seen from above and each figure now takes up a logical amount of space, thereby making the composition clearer. Giovanni includes more landscape and setting than his father; he also creates a greater sense of recession, and uses still deeper undercutting for an increased play of light and shade.

Important changes also occurred in Italian painting at the end of the thirteenth and beginning of the fourteenth century. Two different trends, in some respects opposed, are evident in the painting found at this time in the rival cities of Siena and Florence. Conservative Siena, represented by the artist Duccio, perpetuated earlier medieval and Byzantine traditions, favoring decorative patterns, gold backgrounds, and emphasis on line. Progressive Florence, however, represented by the artist Giotto, preferred greater illusions of reality, three-dimensional space, and emphasis on mass. Europe would follow the Florentine trend for the next several centuries.

Duccio (*c.* 1255–before 1319) was mentioned frequently in the Sienese archives for his art – as well as for disturbing the peace, accumulating many wine bills, and borrowing money

several times. Yet he was a great religious painter, his most famous work being the *Maestà* altarpiece, painted between 1308 and 1311. *Maestà* means 'majesty of the Madonna' and the front of the altarpiece depicts the Madonna and Child in Majesty. This altarpiece was made for the high altar of Siena Cathedral and was painted entirely by Duccio (the contract survives), even though the usual practice at this time was to employ assistants. When the altarpiece was finished, it was carried through the street in procession and a feast day was proclaimed in Siena.

The panel is splendid and sumptuous, though not innovative. Arranged in a rigidly symmetrical composition, Mary and the infant Jesus are enthroned and surrounded by tiers of saints and angels. Mary, extremely elongated, ethereal and immaterial, is significantly larger than any other figure. Her soft drapery falls to a flowing hemline, the linear quality emphasized by the gold border – a characteristic of Duccio. Outline and silhouette play a major role; the effect of shading is minor. In accord with the Gothic interest in emotion, the gentle faces are wistful and melancholy, and the angels look tenderly at Mary. The throne is shown to be inlaid with multi-colored marbles, much like contemporary architecture, and is splayed and flattened rather than rendered with scientific perspective to suggest depth.

The *Maestà* altarpiece consisted of this large panel, predella panels (small panels attached below the main panel of an altarpiece), and small scenes painted on separate panels on the back of the altarpiece. These were intended to be read like a story. The predella panels include the Nativity with the prophets Isaiah and Ezekiel. The arrangement is traditional, with Mary in red and blue, larger than everyone else, aloof and queenly. The stable is unstable: contrary to optical logic, both the ceiling and the roof are seen. Angels cluster in this golden realm landscaped

216. **Duccio**, *Nativity with the Prophets Isaiah and Ezekiel*, predella panel from the *Maestà* altarpiece. Egg tempera and gold on panel, 1308–11, middle panel 43.8 x 44.4 (17¼ x 17½), each side panel 43.8 x 16.5 (17¼ x 6½). Duccio's painting is the culmination of Sienese medieval art. Of highest importance were narrative clarity and visual splendor; visual reality was of less interest. Therefore the sky is gold, scale is used for emphasis, and maximum information is included (ceiling and roof are both shown). Giotto's interior (Ill. 220), although hardly scientific, is more realistic.

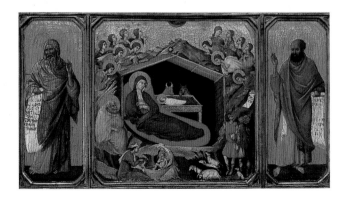

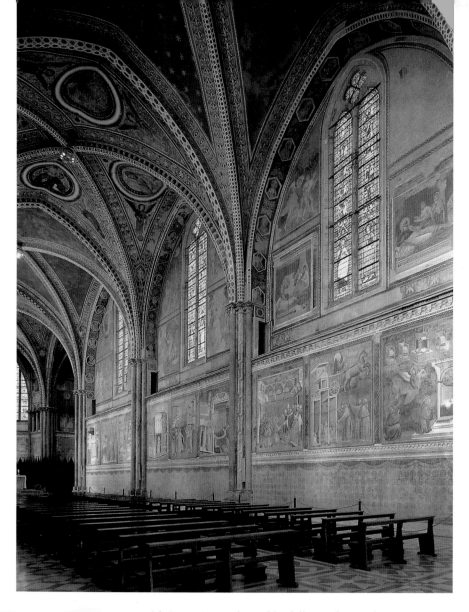

217. Nave of upper church looking toward apse, Church of San Francesco, Assisi, painted late 13th century

with Byzantine-style crinkly cliffs. Further working against any illusion of reality is the use of 'continuous narration' – the simultaneous representation of two or more events that occurred sequentially – for baby Jesus is shown twice. Gothic characteristics include the emphasis on emotion and the attempt to humanize a religious subject, as seen in the foreground vignette in which two midwives attempt to bathe the newborn as he recoils from the water. The importance attached to clarity of

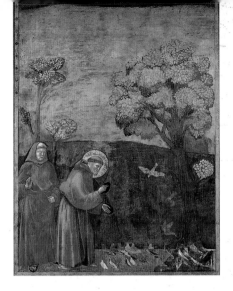

218. **Saint Francis Master (?)**,
St. Francis Preaching to the Birds.
Fresco, upper church of San
Francesco, Assisi, late 13th
century

narrative is made apparent on the right, for the shepherds, presumably illiterate, appear appropriately awed as they receive news of the birth of Jesus in writing. Joseph sits on the left.

Duccio focuses on story-telling, composition, and richness of effect. The colors are bright and the lines are sharp; nothing is fuzzy or implied. The scale is illogical and the sky is golden but such digressions from Nature only add to the desired effect. Duccio's *Maestà* represents the final flourish of earlier trends.

The *Maestà* is painted in the egg tempera technique. Around 1390 or shortly thereafter, a Florentine craftsman named Cennino Cennini wrote *Il Libro dell'Arte* (*The Craftsman's Handbook*), a treatise on various artistic techniques, including painting with egg tempera on a wooden panel. The process is as follows: the wooden panel must first be shaped and allowed to age to minimize future warping. A coat of rabbit skin glue is applied to seal the panel and make it non-absorbent. Several coats of gesso (a thick white paint made from any one of several white powders mixed with glue) are applied to form a smooth white surface. The picture is then drawn on the panel. A mixture of red gilder's clay and glair (essentially egg white) is brushed on the panel in the areas to be gilded to serve as the glue for the gold leaf. This is made by placing a small piece of soft gold between two layers of leather and pounding on it until the gold is paper-thin. The gold leaf is then applied to the panel, rubbed to make it adhere, and polished to make it shine. Using a wooden implement with a design cut into the end, areas of the gold leaf may be tooled by repeatedly pressing this design

219. **Giotto**, *Jesus Entering Jerusalem*. Fresco, Arena (Scrovegni) Chapel, Padua, 1305–6

220. **Giotto**, *Last Supper*. Fresco, Arena (Scrovegni) Chapel, Padua, 1305–6. Giotto's work broke from the medieval style, enabling Florence to lead the way to the Renaissance. For Giotto, as for Duccio, the narrative was paramount, but here told through a style unprecedented in the three-dimensionality both of the figures and of the space they inhabit. By eliminating two walls, Giotto permitted the viewer to look inside this cubic space.

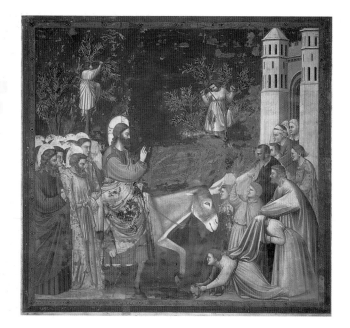

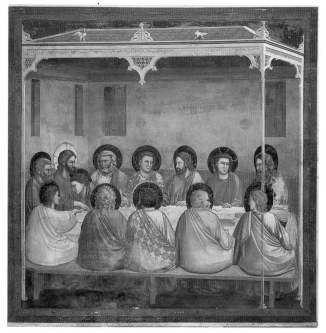

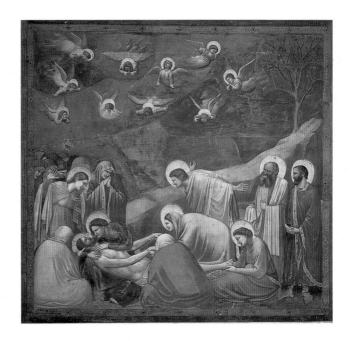

221. **Giotto**, *Lamentation over the Body of Jesus.* Fresco, Arena (Scrovegni) Chapel, Padua, 1305–6

into the gold leaf; the gesso beneath gives slightly. Haloes and borders are often tooled to increase the richness of effect. The actual painting is done next, using ground pigment plus egg yolk or whole egg. The yellow of the yolk bleaches out in about two weeks and has no effect on the color.

Egg tempera has many desirable properties: the colors are bright, the images clear, and the painted surface has an enamel-like quality that is extremely tough and durable. However, egg tempera also has disadvantages. Because the paint dries very quickly, the artist is restricted to using small brushstrokes, blending of colors is difficult, and the uniformly matte surface makes textural illusions almost impossible. Furthermore, certain pigments cannot be used because the albumen of the egg contains sulfur, which causes darkening.

Even more important to the history of thirteenth- and four-teenth-century painting in Italy is the technique of fresco. One of the key sites to see early fresco painting is the church of San Francesco at Assisi. (Unhappily many were seriously damaged in an earthquake in 1997.) A significant number of the best Italian artists of the time painted here in the lower and especially the upper church, providing a document of Italian painting at a crucial time of transition between the Middle Ages and the Renaissance. Innumerable debates have been devoted to

217

identifying the painter or painters of the famous cycle of twenty-eight scenes portraying the life of Francis of Assisi. Above all, the issue is whether Giotto was the master. Since no documents prove either side, the arguments rest on style. The St. Francis scenes, probably painted in the late thirteenth century, are framed by illusionistic painted architecture – an idea that derives from ancient Roman wall painting.

The most famous scene in the cycle is· *St. Francis Preaching to the Birds*, showing the love and respect Francis had for all Nature. The relative realism of the landscape and the identifiable species of birds are indicative of a new interest in direct observation of the natural world and a fresh appreciation of Nature's beauty. 218

An extremely influential innovator, Giotto (1267?–1336/37) is pivotal in the history of art. Known primarily as a muralist, his most famous work is the extensive fresco cycle portraying the lives of Mary and Jesus in the Arena (Scrovegni) Chapel in Padua, dated 1305–6.

In the scene of Jesus entering Jerusalem, Giotto's ability to express mass and weight is evident. His large figures appear three-dimensional, solid, tangible, and sculpturesque. The figures and composition are reduced to essentials: no details distract from the story being told. As if on a shallow stage, the actors move in a limited foreground space, very close to the viewer, parallel to the picture plane. Giotto uses a clever compo- 219

222. **Simone Martini**, *Guidoriccio da Fogliano*. Fresco, Palazzo Pubblico, Siena, 1328

223. Matteo Giovannetti (?),
Fishing in a Pool. Detail of fresco,
Room of the Stags, Papal Palace,
Avignon, *c.* 1343–5. The
extensive murals that cover
all the walls in this room with
scenes of country life provide
documentation of contemporary
fishing and hunting methods.
They are among the best-known
secular paintings of the epoch,
yet, curiously, they are in the
private rooms of the Pope's
residence.

sitional device in this scene: the next step the donkey takes will
bring Jesus into the very center of the composition. Because this
is where the viewer intuitively expects the most important per-
son in the scene to be located, we tend to imply, to mentally
supply, this movement.

The figures in Giotto's depiction of Jesus' Last Supper
achieve a sense of monumentality from the strong modeling that
emphasizes their roundness. All is simplified: there are no por-
traits, no textures, no shadows, no atmosphere, no single light
source. Giotto's solution to the problem of portraying an event
indoors is to allow the viewer visual access simply by removing
walls. However, Giotto dealt some of the apostles a significant
difficulty: they must eat while wearing opaque haloes in front of
their faces.

In the *Lamentation over the Body of Jesus*, the poses of the
figures as well as the composition of the scene are used to con-
vey profound emotional grief. Several figures bend down in
mourning toward the dead Jesus. The position of the body,
referred to today as 'body language,' can be used to convey
mood. The center of the composition is empty; the diagonal of

220

221

224. **Ambrogio Lorenzetti,**
*Good Government in the City
and Country.* Fresco, Palazzo
Pubblico, Siena, 1338–40.
This record of life and politics
in medieval Siena is painted,
appropriately, in the town hall.
Good government is shown to
be due to the commune of Siena,
guided by Faith, Hope, and
Charity, whereas Bad Government
is ruled by Tyranny, advised
by Avarice, Pride, and Vainglory.
These murals are the first
reappearance of large-scale
landscapes and cityscapes
since Roman antiquity.

the hill leads the viewer's eyes down to the heads of Mary and
Jesus where, atypically, the center of attention is located low and
off-center. Here the figures form a circle around Jesus, leaving a
space for one more person – the viewer is thereby invited to join
in their mourning.

In each of the paintings in the Arena Chapel illustrated here,
Giotto employed a different method to encourage the viewer's
sense of participation in the event portrayed. The enhanced
emotional impact thus achieved in these scenes is characteristic
of Gothic art.

Simone Martini of Siena (*c.* 1284–1344) painted a wall
fresco of Guidoriccio da Fogliano, dated 1328, in the Palazzo
Pubblico (city hall) of Siena. This painting commemorates
Guidoriccio's successful campaign against Florence and his
capture of the towns of Montemassi and Sassoforte, both shown
in the mural. The military leader is shown lifesize, graceful and
elegant, rendered with the same fine details and beautiful lines
used by Simone Martini's fellow Sienese artist Duccio. The
lines are simultaneously decorative, expressive, and represen-
tational. The fluttering edges of the garments indicate both the
forward movement of the horse as well as the wind. Simone
Martini creates a surface design of organized silhouettes, with
the horse and Guidoriccio moving parallel to the picture plane.

Genuine portraiture, as that of Guidoriccio da Fogliano,
which accurately records the features of a specific face, went out

222

of vogue after the ancient Roman era and is not characteristic of medieval art. When portraiture began to reappear in the late Middle Ages, the preference was for profile presentation. The genre grew rapidly in popularity, an aspect of the new interest in looking carefully at one's surroundings and documenting the visible world. This interest was to be characteristic of the coming Renaissance. Here, for example, Simone Martini recorded a fourteenth-century military camp with tents, huts, and banners. A vast landscape is also portrayed. Like portraiture, landscape painting disappeared with ancient Roman wall-painting and reappeared only now.

A notable example of forested landscape painting by an Italian follower of Simone Martini can be found in the Room of the Stags in the Papal Palace in Avignon, painted *c.* 1343–5. Although other rooms in the palace are decorated with sacred subjects, the walls of this small room are frescoed with a secular subject popular at the time – the hunt. A variety of hunting methods are depicted, including use of a falcon, a ferret, and hunting hounds. The detail reproduced here depicts *Fishing in a Pool*, in which four men, wearing four different costumes, use four different angling techniques. The pool, an irregular rectangle stocked with fish, is probably the *piscarium* formerly at Avignon – the pool where fish were kept prior to being served at the pope's dinner table. The pool is surrounded by a landscape lush with trees, plants, birds, and game. Several painters worked

223

in this room; the portion with the pool was painted by Matteo Giovannetti, court painter to Pope Clement VI, or by Italians supervised by this artist.

Simone Martini's competition in Siena came from two brothers, Pietro and Ambrogio Lorenzetti, who combined the rich decorative surfaces and linear elegance of the Sienese artists Duccio and Simone Martini with the naturalistic three-dimensional volumetric figures and human emotion of the Florentine artist Giotto. Pietro is thought to have been the older sibling, born around 1290; Ambrogio's date of birth remains unknown. Both brothers are believed to have died in 1348.

The interest in landscape that can be seen in Simone Martini's portrait of Guidoriccio da Fogliano is carried to an extreme in Ambrogio Lorenzetti's frescoes of 1338–40, *Good Government in the City and Country*, also in the Palazzo Pubblico, Siena. The portion of the mural illustrated here portrays the effects of Siena's good government (other portions portray the effects of bad government). This cityscape includes various monuments of Siena, not all of which are actually visible from a single location. The city is shown to be full of busy, productive, and happy people: some literally dance in the street. The country around Siena is depicted as a vast rolling landscape with convincing depth. The fields are under cultivation and the crops plentiful as people bring their produce into the city. Ambrogio Lorenzetti has provided a superb document of life in four-teenth-century Siena and its surroundings. 224

Most medieval murals were painted on dry plaster in the *fresco secco* technique (see p. 92). Some murals, however, like Giotto's in the Arena Chapel in Padua and Ambrogio Lorenzetti's in the Palazzo Pubblico in Siena, were painted in the true fresco technique on wet lime plaster, known as *fresco buono* – literally 'good fresco.'

Cennino Cennini, in his *Il Libro dell'Arte*, provides information on the *fresco buono* technique, which is appropriate for large-scale work on ceilings and walls. After waterproofing the surface, layers of plaster are applied to make it smooth and even. On the *arriccio* (rough plaster), the underpainting is made in *sinopia* (a red pigment). Around 1400, the sinopia underpainting was replaced by use of pounced cartoons: the design is drawn full-scale on heavy pieces of paper (the cartoons), and trans-ferred to the wall by pouncing, whereby a small spiked wheel is used to make a series of tiny holes along the lines of the cartoon, after which a cloth sack filled with charcoal is tapped along the

holes, the charcoal dust penetrating them and transferring the design to the wall. The portion of wall to be painted in one day – the *giornàta* ('day's work') – is covered with a layer of wet lime plaster, the *intonaco*. The actual paint consists only of pigment and water. Painting must be done rapidly because the artist races against the drying time of the plaster.

The true fresco technique has significant advantages and disadvantages. Favorable qualities include its permanence, the result of the fact that the painting dries as part of the wall, and the crystalline glitter of the plaster surface. The medium lends itself to a style like Giotto's with broad forms and few details. On the other hand, if the *giornàta* dries before it is completely painted, the unpainted portion must be chipped away. The seams between one day's work and the next are visible. Some colors are chemically incompatible with the lime and are adversely affected by its caustic action: this prohibits the use of almost all colors of vegetable origin. A true fresco cannot be touched up or changed after the plaster dries. Because the colors dry lighter, it is difficult to match the colors used on one day to those used the next.

Important for the development of pictorial space is a large panel painting, *The Birth of Mary*, by Pietro Lorenzetti, signed and dated 1342. The actual frame is treated as part of the architecture of the painting. The interior of a room is depicted on the center and right panels, the frame serving as a pier behind which the action continues. Thus the frame establishes the foreground plane and all action takes place behind this plane; the frame is treated as a window through which the viewer looks. The linear perspective is intuitive rather than systematic or scientific, for if all the oblique lines of recession were extended they would not converge to a single vanishing point but, instead, to several. Nevertheless, this is a major accomplishment. The squares of the patterns on the floor and blanket emphasize the spatial recession. The left panel, in which Joachim learns that his wife Anna has given birth to a daughter, shows a second room with a distant architectural view.

Italian prosperity, documented by Ambrogio Lorenzetti's scenes of the good life in and around Siena, soon ended. In the 1340s there were crop failures and banking disasters. But most devastating was the Black Death (bubonic plague) which was at its worst during the summer of 1348 (see p. 13). Understandably, major artistic accomplishments decreased in the following years. Certainly there were gifted artists, such as

225

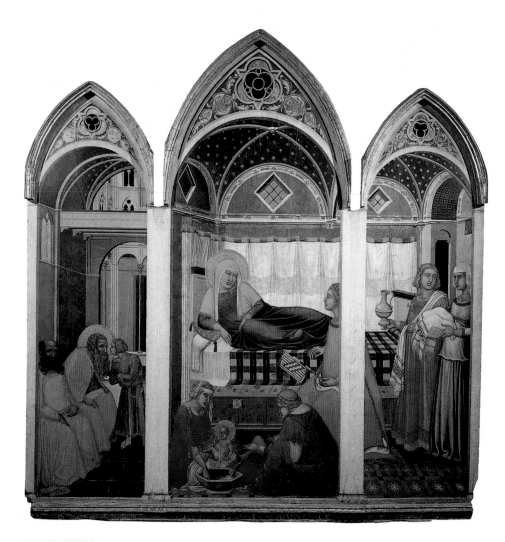

225. **Pietro Lorenzetti**,
Birth of Mary. Egg tempera on
panel, 1342, 185.4 x 180.3
(73 x 71). This clever investigation
of three-dimensional interior
spaces on a two-dimensional
panel makes innovative use of
the traditional triptych format.
Pictorial space was a new artistic
interest in the late Middle Ages
that was to develop further in
the Renaissance.

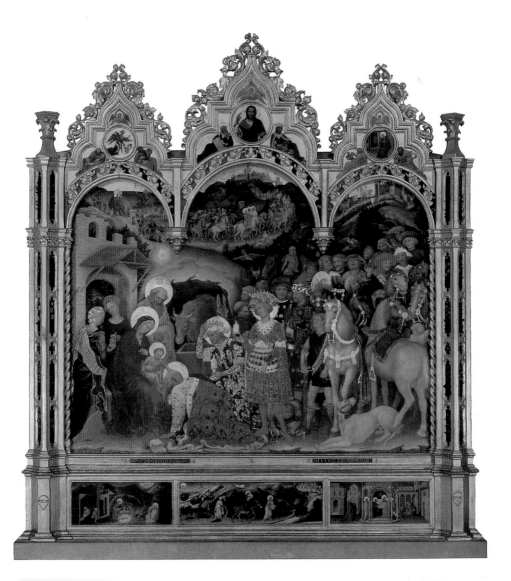

226. **Gentile da Fabriano**,
Adoration of the Magi.
Egg tempera on panel, 1423,
300 x 281.9 (118⅛ x 111).
This similarly triple-arched panel
is separated from Ill. 225 by 81
years, and especially by the impact
of bubonic plague. The return
of prosperity is suggested by an
increase in scale and splendor –
the influence of elegant, opulent
Northern European painting.

Francesco Traini and Andrea Orcagna, but there was no Duccio, and certainly no Giotto.

By the early fifteenth century Italy had regained artistic strength. The International Style, represented in Northern Europe by the Limbourg brothers, had its greatest Italian counterpart in Gentile da Fabriano (*c.* 1370–1427), evidenced by his *Adoration of the Magi* of 1423. As in the work of his Northern contemporaries, Gentile da Fabriano's scene is rich and colorful. Rhythmic flowing lines form a pleasing decorative pattern, the beautiful fabrics are soft and abundant, and the garments are varied and edged with rich embroidery. Unusual details, such as notable facial types and exotic animals (the monkeys, camel, and leopard), are combined with glimpses of ordinary life, for example the man who unfastens the spurs of the standing Magus. So crowded is this scene that even if something more could be imagined to add, no space would be available for it.

Medieval painting had come to a glorious conclusion. The International Style would be left behind as Italy moved into the Early Renaissance.

Chapter 11: Art in Daily Life During the Middle Ages

Medieval church rituals were an art form in themselves, complete with elaborate ecclesiastical vestments worn by members of the Church hierarchy. Because these garments were intended to dress the wearer for God's presence, they were perhaps the most sumptuous of the opulent arts during the Middle Ages. Adding to their historical importance is the fact that ecclesiastical vestments are the only significant medieval textiles extant today. They survived because they were used only for ritual functions and were otherwise kept in special chests and cupboards with the liturgical vessels in the church sacristy.

Ecclesiastical vestments remained quite consistent in type and form over many centuries; by the end of the twelfth century they were largely standardized. From the thirteenth to the sixteenth century no new items were added, although the old ones were refined. The importance attached to them is made clear by the fact that a member of the clergy might be demoted and publicly disgraced by the removal of his religious attire.

The most magnificent of all vestments is the cope, also called a pluvial. It began as a hooded cloak, semi-circular in shape and open down the front, used for protection against rain and cold by the laity and clergy. In the eighth or ninth century it became a liturgical vestment, and in the twelfth century became purely processional in use. As the outermost garment, the cope is worn for ceremonies by high-ranking clergy and the pope. It represents purity, dignity, innocence, chastity, temperance, and

227. Cope. Silk twill embroidered with silk, gold, and silver-gilt, English, c. 1280–1300, height 137.2 (54), width 309.9 (122)

228. Miter, embroidered with the martyrdom of Thomas Becket on the front and the stoning of St. Stephen on the back, English, c. 1200

self-restraint. No restraint, however, is seen in the display of richness and luxury lavished on copes. The English example shown here, dated between *c.* 1280 and 1300, is made of silk twill and embroidered with silk, gold, and silver-gilt threads to depict Jesus, his crucifixion, his mother Mary, and seraphim.

The chasuble derives its form from a cape used when traveling, and its name from the Latin *casula*, meaning 'little house.' In 636 the council of Toledo proclaimed the chasuble a liturgical garment to be worn by members of the clergy. In the Carolingian era it was already worn exclusively by priests, although later by bishops and archbishops. The splendid Chichester-Constable chasuble shown opposite is named for the Yorkshire family who once owned it. On the back are depicted, from the bottom up, the annunciation of the birth of Jesus; the three kings adoring the infant Jesus; and Mary and Jesus enthroned. The chasuble was reshaped sometime after the early sixteenth century when fashion changed.

The Chichester-Constable chasuble is presumed to have been made in London, the center for *opus anglicanum* from the mid-thirteenth century onward. This type of embroidery is done on velvet and includes pearls and jewels. The technique involves placing a thin piece of fabric over the velvet to provide a smooth working surface onto which the pattern is traced. The embroidery is done through the thin fabric and the velvet. The gold thread (actually gilded tin wound on yellow silk thread) is applied using a technique popular during the Middle Ages known as underside couching. To do this, the gold thread is placed on the fabric surface. Then, working from the underside, a loop of linen thread is brought up to encircle the gold thread

229. Chichester-Constable chasuble. *Opus anglicanum* on velvet, English, 1330–50, max. width 76.2 (30). The Church – the major source of medieval patronage – adorned its buildings with rich furnishings and its clergy with lavish garments. Over the years, an entire vocabulary of ecclesiastical vestments developed, each item having a specific form, meaning, and history. The type of embroidery used – *opus anglicanum* – was famous for the level of artistry and for the gold threads, pearls, and jewels incorporated into the designs.

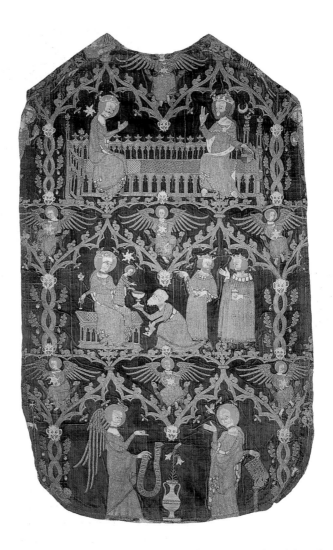

and returned through the same hole, pulling a loop of gold thread down with it; thus, the linen couching thread is unseen from the front. The final step is to cut away the portions of thin fabric not covered by the embroidery. At its peak in the thirteenth and fourteenth centuries, English embroidery was commissioned by the highest members of the Church, including the pope.

The repertoire of ecclesiastical vestments includes several additional garments. The dalmatic is a shin-length, sleeved tunic, usually with orphreys – bands of decoration. The alb, worn under the dalmatic, is a long linen tunic, also with bands of embroidery, which are referred to as apparel when on an alb.

A major exception to the general consistency of ecclesiastical vestments after the twelfth century is the miter – the two-horned hat worn by bishops as a symbol of authority and status. The miter began in the eleventh century as a round pointed cap; in the twelfth century it had two horns on the sides; and then the horns were relocated to the front and back. An embroidered English miter of *c.* 1200 demonstrates this type. 228 The martyrdom of Thomas Becket, Archbishop of Canterbury, is portrayed on the front, and the stoning of St. Stephen on the back. Becket wore this kind of miter.

Members of the various religious orders established during the Middle Ages also had recognized costumes, the main garment being the habit – a long loose gown with wide sleeves and a cowl that could be pulled up to form a hood. Augustinians wore a black habit and leather belt. Benedictines wore a black habit (reformed Benedictines wore white habits, as did Carthusians, another reformed order of Benedictines). Carmelites wore brown habits with white cloaks and therefore were known as the White Friars. Celestines wore white gowns with long black cloaks and hoods. Cistercians wore white habits. Franciscans wore a brown habit and a rope belt with three knots to recall Jesus' flagellation and as a symbol of chastity. Dominicans wore white habits with long black cloaks and hoods; in Andrea da Firenze's *Allegory of the Church and the Dominican Order*, a mural dating from *c.* 1366–8 in Santa Maria Novella in Florence, the Dominicans are portrayed as 'dominicanes' – 'dogs of the lord' with black and white fur. Additionally, nuns covered their heads with veils.

Although very few secular garments survive from the Middle Ages, this attire is well-documented. Medieval artists used the styles current in their own time, thereby providing an accurate record whatever the period they were portraying. Costume was much more than merely a means of protection from the elements: it was used to make social status and affiliation visually apparent.

During the Romanesque era, costume was much the same for women and men, the wearer's position in society distinguished by garment length, fabric, and ornament. For the upper class, the perfectly pressed plethora of pleats and wide sleeves seen on twelfth-century depictions of Mary were the vogue. She wears 4 the bell-sleeved bliaud, a voluminous garment that hung from the shoulders and was cut without a seam at the waist. The human body, regarded as a potential enticement to the sin of lust,

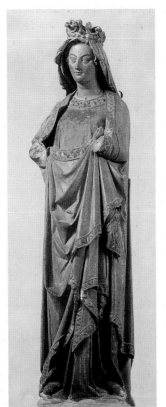

230. *Mary*, from Strasbourg Cathedral. Sandstone and polychromy, French, mid-13th century, height 148.6 (58½)

231. *Clovis*, from the monastery church of Moutiers-Saint-Jean in Burgundy. Stone, French, mid-13th century

was hidden by garments made to hang and conceal, rather than to cling and reveal. Only gradually, as ideas of physical beauty changed, did costume come to conform to the body's contours.

During the thirteenth century the elaborate pleating that characterized costume of the previous century disappeared: garments became softer and simpler, more practical, and presumably more comfortable. Evidence is offered by a portrayal from Strasbourg Cathedral of Mary, dressed as a young French queen, carved in sandstone and polychromed in the mid-thirteenth century; also a mid-thirteenth-century figure of Clovis, the first Christian king of France, from the monastery church of Moutiers-Saint-Jean in Burgundy.

The bell-sleeved bliaud was superseded by the tight-sleeved cote. For warmth, women and men wore a cloak or cape, fastened across the chest with a brooch or cord. The popularity of the 'layered look' during the Middle Ages was based upon practical necessity prior to efficient heating. Because multiple garments

were a sign of status, the outer garment was cut shorter than the undergarment to guarantee its visibility. A belt might be worn to mark the waistline and to provide a practical place to hang a pouch purse, as seen on the figure of Clovis.

Personal attire, especially during the Gothic era in Northern Europe, developed into a splendid and sumptuous art. So heavily embroidered and bejeweled were hems and borders that when the fabric of the garment wore out they were removed and reused on a new garment. Sumptuary laws were passed by the nobility in an effort to maintain a visual distinction between social classes. The width of trimmings on garments, the amount of fabric a person could own, and much more were stipulated. Some sumptuary laws targeted specific segments of society. For example, England passed a law in 1355 governing the garb of prostitutes so they could be readily distinguished: fur was prohibited, only striped hoods were allowed, and clothing had to be worn inside out. Whether this was censure or publicity must remain outside the scope of this book.

France was the leader in fashion during the fourteenth century. French dolls, wearing the latest modes, were sent as gifts to English queens. Elegant gowns were treated like spoils of war, for a conquered town was looted not only of its gold and silver, but also of its fancy garments – and the best booty was the gown of a fine French lady.

The French dominance of fashion is seen in the statues of Charles V Valois and his queen Jeanne de Bourbon, sculpted between 1365 and 1370. Known as Charles le Sage (the Wise), he is said to have lived without excess or extravagance. But such things are relative for kings of France, for it is recorded that his sleeves flared from the elbow to such an extent 'that they trailed on the ground.' Of fragile health and often cold, Charles V wore his cote covered by an ample surcote rather than the newly introduced short costume for men.

The queen wears contemporary French fashion, her hair caught up in ribbons, her neckline wide, waistline marked, and hemline long. Buttons became popular only in the fourteenth century, making Jeanne de Bourbon's fitted gown possible. The queen's attire includes the sideless gown, a sort of open surcote or sleeveless tunic for women that reveals a tight-fitting undergarment through the openings on the sides. The clergy denounced this style from the pulpit; the openings, because they contained views of the female form, were called 'windows of hell.' The sleeves of the cote underneath were made so tight

232. *Charles V*, from the portal of the Church of the Celestines, Paris. Marble, French, 1365–70, height 195.6 (77)

233. *Jeanne de Bourbon*, from the portal of the Church of the Celestines, Paris. Marble, French, 1365–70, height 193 (76)

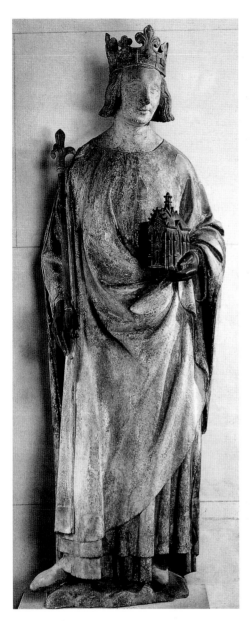
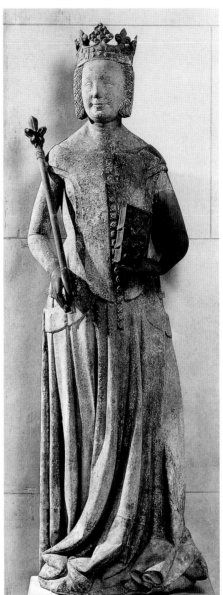

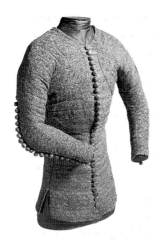

234. Pourpoint of Charles of Blois. Silk with gold threads, French, before 1364, height 87 (34¼). This jacket is a rare extant example of medieval secular attire: historians of medieval costume are almost entirely dependent on depictions in other media. The mid-14th-century preference for garments that modified the shape of the human body through the use of tightly fitted areas and padded areas is seen here.

that they had to be unstitched to be taken off and restitched at the wrist when put back on: dressing and disrobing required some time and trouble. When a woman went out she might carry scissors in her purse, depending upon the occasion.

In the second half of the fourteenth century clothing was made not merely prettier in a decorative way but more blatantly seductive and alluring. Women used hairpieces more freely. Make-up colored the skin very white, a sickly look carefully cultivated and coveted. A tiny waistline was the vogue, and necklines were cut as low as they could go and still be called necklines.

Men's jackets became very short, falling only slightly past the waist. Known as the pourpoint, this garment fit close to the body and was perhaps fur-lined or thickly quilted with cotton padding. A rare medieval survival is the pourpoint of Charles of Blois, worn before 1364, and made of silk with gold threads. The tight fit is achieved by a multitude of small separate pieces of fabric (this pourpoint consists of 32 pieces) and the rows of buttons down the front and on the sleeves. Such a garment sculpts and shapes the body, producing men with bulging chests and tiny waists. The brevity of the pourpoint was considered scandalous, for the legs were covered only by tight-fitting, intentionally revealing hose cut for the individual wearer and stitched to conform to the shape of the legs. The immodesty of this fashion was due, in part, to the fact that there were two separate legs. In the later fourteenth century, the two legs were sewn together with a triangular insert in the front over the opening. Sumptuary laws, in this case, were inverted for they stipulated what one was permitted *not* to wear: less of the body of a noble was required to be covered than of a peasant.

The ultimate extravagances in personal attire during the fifteenth century in Northern Europe – an era and area replete with excesses – were found in the court of Burgundy. The dukes of Burgundy freely spent large sums on luxury items, especially costume, as a display of their wealth. Their fabrics were the richest, their embroidery the most abundant, the cut of their clothing the most extreme. The account books make clear why their costumes were so costly: they consisted not only of fabric and fur but also of feathers, pearls, precious and semi-precious stones, and gold.

The calendar page for the month of May in the Limbourg 207 brothers' *Les Très Riches Heures du Duc de Berry* shows aristocrats celebrating May Day festivities. Luxury is evident in the splendid costumes of brightly colored and richly patterned

fabrics, soft and fluid, falling in graceful loops and curves. During the Gothic era artful artificiality was appreciated and physical beauty was an ideal consciously sought, in contrast to the earlier medieval conception of beauty as an incentive to sin and the human body as something to be concealed.

The late medieval ideal physical type was long and slender with delicate extremities for both women and men. The body was manipulated by the tailor, the milliner, and the cobbler into shapes unknown to Nature. In particular, it was artificially extended, especially at the head for women and at the toes for men. Thus, women's heads might acquire two horns – truffeaux – a fifteenth-century style seen in the Limbourg brothers' manuscript. This grew into the 'horned headdress,' an extreme style that received corresponding criticism: indulgences were offered by the Bishop of Paris to people who insulted the wearers. The greatest height in headdresses was achieved by hennins, developed in the mid-fifteenth century as a great cone, pointed or truncated. The higher the hennin, the higher the social status of the woman: lower classes wore hoods. Hennins were preached against from the pulpit but without effect.

Men's feet were increased in length by shoes with long toes, known as poulaines ('ship's prow' in French), pigaches, or crackowes (suggesting a Polish origin for the fashion). These reached their greatest extreme in the third quarter of the fifteenth century. Here, too, social class was the controlling factor: king, prince, and duke could add two-and-a-half times the length of their feet to the toes of their shoes, whereas common people could add only half the length of their feet.

The history of medieval secular attire, from relatively simple and standardized to intentionally eyecatching and exaggerated, is much the same as that of armor. The later Middle Ages was the era of chivalry – the days of knights. The word chivalry comes from the French chevalier, meaning 'knight' or 'horseman.' Knighthood usually required noble status as well as adequate financial resources to own and maintain a horse. The ideal knight was valiant and courteous, a dignified gentleman of gallant deeds, a man of honor who served the Church and worthy causes, aided the weak and oppressed, and was generous even to his foes. Yet he was also a warrior and his special skill was proficiency in arms. To become a knight, a boy began to train as early as the age of seven, at which time he was known as a page. When a teenager, he became a squire. Around the age of twenty-one, he was initiated into knighthood.

When William of Normandy invaded England in 1066, his soldiers wore suits of mail, also referred to as chain, made of a multitude of tiny metal rings linked together. The shirt of mail was the hauberk, a relatively comfortable garment because of the flexibility of mail. It provides good defense against injury from a sword but, because it is not rigid, does not protect against blunt trauma, a blow from a lance, an arrow from a long bow, or a bolt from a cross bow. To protect his skin from abrasion, the soldier wore a quilted, padded, or stuffed gambeson, aketon, or pourpoint under the mail. The importance of a fabric surcote worn over the metal armor is readily understood simply by imagining oneself encased in armor on the battlefield at noon on a cloudless August day: the surcote prevented the soldier from slowly baking inside his armor.

In the twelfth century the mail hauberk continued to be the main method of protecting the body, although its construction was improved by making the mail more flexible, stronger, and lighter. By the mid-thirteenth century, the bag mittens at the ends of the sleeves were given fingers and became gloves. The coif covering the head was now integral to the hauberk, and was made with a cord at the edge to fit it firmly to the face. Over this was worn a helmet. Hose were now made of mail, fastened up the backs of the legs, with the soles sewn in.

The broigne, a jacket of leather or strong linen reinforced by a metal framework found in the twelfth, thirteenth, and fourteenth centuries, developed into the coat of plates which had many small metal plates riveted in place and was worn over the hauberk. In the late fourteenth century, possibly earlier, the brigandine (the name is associated with 'brigand' or bandit) developed from the coat of plates. The brigandine was more refined, the plates smaller, and the garment more flexible due to the overlapping little metal scales attached to leather or strong canvas. The entire structure was covered with an attractive fabric, the result being an ornate, fitted, defensive vest.

Progressively more use of metal plate was made during the fourteenth century. The chest area of the brigandine was protected by larger metal plates fitted close to the body. During the transitional period from mail to plate armor, a metal breast plate was worn over a coat of plates or over mail. Later the breast plate came to be worn independently of the coat of plates, over a gambeson or pourpoint of quilted cloth or leather. Still later, a back plate was added. By the close of the fourteenth century the harness of steel plate had arrived.

Defensive dress eventually became so heavy that it was difficult if not impossible for a soldier who fell from his horse to remount. Chronicles of the Battle of Agincourt (1415) claim that the French lost because their knights persisted in wearing old-fashioned mail down to their knees under their plate armor and thus were too weighted down by the metal to move. Indeed, the hauberk was worn under plate armor until the end of the fifteenth century.

Joan of Arc was another victim of medieval military fashion. Her capture in 1430 was the result of her inability to escape a Burgundian soldier who pulled on her sleeveless surcote until she nearly strangled. She was wearing this surcote over a complete suit of plate armor.

Italy and Germany were the centers of armor production. From the thirteenth century on, Italy exported armor throughout Europe. Milan exported not only armor but also armorers to cities in Italy, France, England, and elsewhere. The styles of Italian and German armor differed, the former preferring rounded smooth forms and simple lines, the latter favoring spiky broken silhouettes and surfaces. Italian armorers placed more emphasis on a robust appearance, whereas German armorers emphasized a slender silhouette and long lines.

An Italian example is the armor of a governor of Matsch, 235 made in Milan, *c.* 1450, by the workshop of the Corio brothers (Giovanni, Ambrogio, and Bellino), Giovanni da Garavalle, and Dionisio Corio (a cousin). Greaves protect the lower leg. Poleyns protect the knees. Cuisses protect the thighs. The cuirass protects the chest and back. Vambraces protect the arms. Cowters/couters protect the elbows. Pauldrons protect the shoulders. Gauntlets protect the hands. And a helmet protects the head. The weight of the armor required a knight to dress for battle with the aid of a squire.

A German example from Augsburg, one of the important armor-producing cities in Germany, is the armor of Archduke 236 Siegmund of Tyrol (1427–96) by Lorenz Helmschmid, *c.* 1480. This demonstrates the characteristically Late Gothic use of decorative narrow gilded bands of metal riveted in place. Metal workers followed fabric fashions and the pointy toes of the sabatons mimic the shape of the long-toed poulaines fashionable in secular attire. The helmet seen here is a sallet, with only a slit for the eyes and a rounded skull with a central ridge. The fluting, an aspect of the Germanic emphasis on slender forms, is simultaneously decorative and able to deflect the blow of a sword or lance.

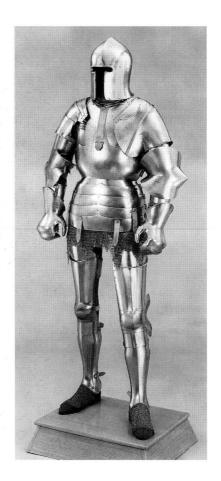

235. **Workshop of the Corio brothers (Giovanni, Ambrogio, and Bellino), Giovanni da Garavalle, and Dionisio Corio**, armor of a governor of Matsch from Churburg, made in Milan, c. 1450. Knights in armor, literally dressed to kill, are among the most enduring images of the Middle Ages. The development of armor from mail (chain), to the coat of plates, to plate armor is well documented. Combat armor, heavy and plain, differed from parade armor, lightweight and decorated.

Armor could be made to order or bought ready made, but was invariably costly. Plate was made of forged billets of metal, hammered flat by muscle or water-powered tilt hammers, hammered hot or cold. A polisher or millman shined the pieces using rotating water-driven wheels. A finisher made the strappings and lined each piece. Etchers and gilders might decorate the armor.

The decline of the armorer's art was a result of changes in weaponry and the appearance of guns and cannons. Use of gunpowder is documented in Europe as early as 1260. A recipe for an explosive from the second half of the fourteenth century calls for four parts saltpeter, one part carbon, and one part sulfur. Although armor could be made heavy enough to withstand a bullet, it was then too heavy to wear: troops refused to put on their armor or had to be paid extra to do so. In the mid-sixteenth century, armor for equestrian or foot soldiers became history, although parade armor

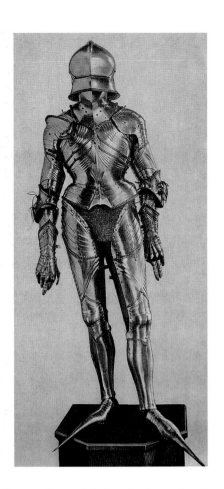

236. **Lorenz Helmschmid**, armor of Archduke Siegmund of Tyrol (1427–96), made in Augsburg, c. 1480

continued to be manufactured during the sixteenth century. This was made of thin light wrought iron, easily formed into fantastic shapes, unlike the heavy hardened steel used for defensive armor.

Heraldry was introduced at the time of the Crusades, gradually becoming a complex system of visual identification for aristocratic families and their retinues. Geoffrey Plantagenet, Count of Anjou, seen in a champlevé enamel plaque of *c.* 1152, is said to have introduced the first medieval heraldic crest – the rampant lion depicted on his shield and hat. Images of animals and objects as well as patterns and colors were used. A family's coat-of-arms could be displayed on a member's surcote worn over his armor, on a shield, mantle, banner, or elsewhere. At first, heraldic devices were used only during battles – a useful system of identification when a helmet covered the combatant's face – although they were later used also in tournaments.

109

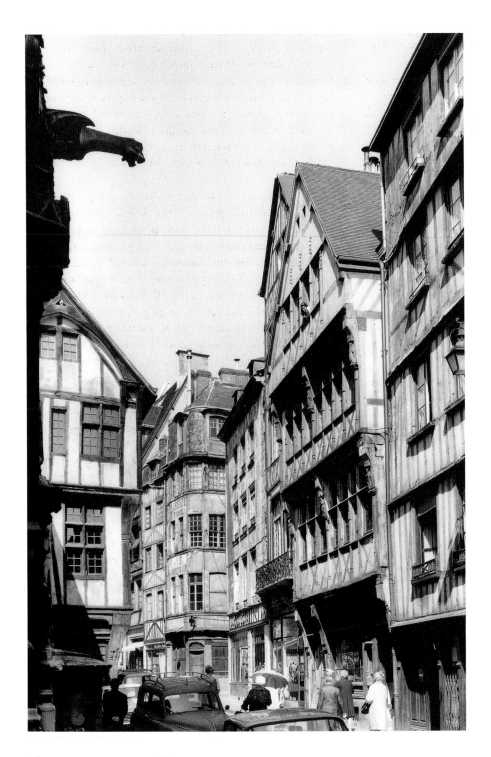

237. Half-timbered houses, Rouen, Gothic era. Charming, picturesque, irregular, some leaning precariously, half-timbered houses were the norm in cities and towns throughout medieval Europe. Those in the city center were built on narrow plots of land, each sharing its neighbors' walls. Construction began at the street: there was no front yard, although there could be a garden behind. One's home was also likely to be one's place of work: a shop or workroom might occupy much of the ground floor.

Aesthetic interests are seen not only in medieval secular attire but also in medieval secular architecture, though, in general, this changed less rapidly and less radically than religious architecture. The wealth of the Church and its desire to attract and retain the attention of the populace combined to foster the most innovative ideas in architectural construction. A private home, however, required to satisfy living, eating, sleeping, and other requirements, built for and by a smaller number of people, offered less incentive or opportunity to innovate.

Private homes constructed during the Middle Ages survive in various cities and towns throughout Western Europe, but represent only a very small percentage of the secular architecture that once existed. Although some homes were constructed of stone, the basic medieval dwelling was the half-timbered house. The many examples at Rouen were built with a lattice-work of wooden beams filled in with different kinds of materials. Depending on the geographic area, the filling could be plaster, brick, mud, straw, stone, or a combination of materials. The system was used for expensive abodes and for humble homes, for free-standing houses and for row houses (town houses). In an effort to maximize living space when building on a small plot of land, each story overhangs the one below: this progressive overhang of the upper stories occasionally resulted in houses on opposite sides of the street nearly touching. Little sunlight reached the pavement in some of the very narrow streets, such as one appropriately called La Ruelle des Chats (the little street of the cats) in Troyes.

Other examples of half-timber construction survive in France, for example, at Auch, Chinon, Conques, Chartres, Saint-Bertrand-de-Comminges, Sens, and Troyes. In England examples are found in Wells, Winchester, York, Great Coggeshall (the especially ornately carved House of Thomas Paycocke), and elsewhere.

A few medieval towns with half-timbered homes and irregular narrow winding streets remain remarkably intact. In France, tiny Saint-Cirq-Lapopie, just east of Cahors, is claimed to be the oldest town in France. In England, the medieval town of Lavenham in Suffolk retains numerous examples of intricate and irregular half-timbered construction. Such dwellings continued to be constructed after the Middle Ages with little change in method or materials.

A type of half-timber construction known as 'black-and-white' is an English specialty, the most famous example being Little Moreton Hall in Cheshire, owned for centuries by the Moreton family. Construction of this moated manor house began in the 1440s, with additions made in the sixteenth century. The house was built with a framework of oak beams, the spaces between filled with a mixture of clay, twigs, and straw or hair. This and many other houses are referred to as Tudor (the Tudor dynasty ruled from 1485 to 1603), but the style goes back at least to the fourteenth century in England and it continued into the seventeenth century.

Little Moreton Hall is an appealing and irregular building. The facade is asymmetrical and there are no true verticals or horizontals to be found here. Instead, a delight in designs is evident in the abundance of picturesque patterns created by the intricate and ornamental woodwork, the effect complicated yet casual. Each story overhangs the one below. Since the manor sits in an open green lawn, this is hardly the result of a need to maximize floor space but is instead a characteristic of the half-timber method of construction.

Other important examples of the black-and-white style are found at Bramall Hall in Bramhall, Stockport, Cheshire, and at Rufford Old Hall, near Ormskirk, Lancashire.

238. Little Moreton Hall, Cheshire, mid-15th century with 16th-century additions

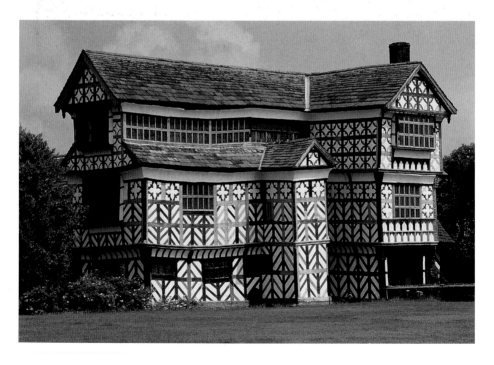

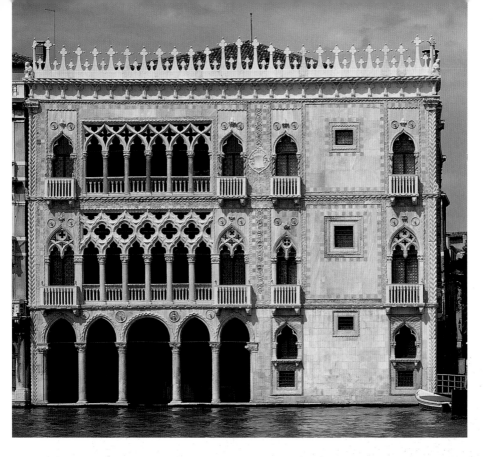

239. Ca' d'Oro (House of Gold), Venice, 1422–c. 1440

Notable early English manor houses not built in the black-and-white style include Stokesay Castle in Craven Arms, Shropshire (called a castle although really a fortified manor house) and the moated Ightham Mote in Ivy Hatch, Sevenoaks, Kent.

A striking contrast in domestic architecture is offered by the exotic and eclectic Ca' d'Oro (House of Gold) in Venice, thus named because of its former gilding, and built between 1422 and *c.* 1440. The ornate facade of lacy open screens enriched by contrasting textures is reflected in the water of one of Venice's many canals. The various types of arches also reflect Venice's many cultural contacts and influences, including Oriental and Islamic. Located off the east coast of Italy and a maritime trade power, Venice long had contacts with the East, as evidenced earlier by the domed church of San Marco.

An extraordinary example of early military architecture, Caerphilly Castle dominates the town of Caerphilly in Mid-Glamorgan, Wales. The castle was built very quickly between

20-1

1268 and 1271, additions were made in the later 1270s and the 1280s under the direction of Master James of Saint George, and the castle was essentially completed in 1295. The result is visually impressive, striking in its strength, and beautiful in the boldness of its tremendous towers.

Rather than deriving its defenses from a hilltop site, the castle is located in a valley between two streams that were dammed to form two lakes, thereby surrounding the building on all sides with a wet moat. Even a fairly shallow wet moat was effective in preventing the enemy from digging tunnels and undermining the castle. The surrounding water also eliminated the possibility of a sudden mass assault, for it kept the enemy at a distance and protected the walls from the force of a catapult or other weapon.

Caerphilly is considered the finest of the true regular concentric fortifications in Great Britain, and the first to be built from the start on a regular concentric plan. Rather than being laid out around a massive rectangular stone keep, as at Rochester or the Tower of London, a concentric castle is built around an open bailey (ward) that contains the well and the Great Hall. Caerphilly is constructed of local stone, with two rectangular surrounding curtain walls, the inner higher than the outer. The outer has two two-towered gateways; the inner has two gateways plus four drum towers at the corners. The curtain walls create open areas – an inner bailey and a middle bailey. The ground level of the inner and middle baileys is raised artificially.

240. Caerphilly Castle, Wales, 1268 f.

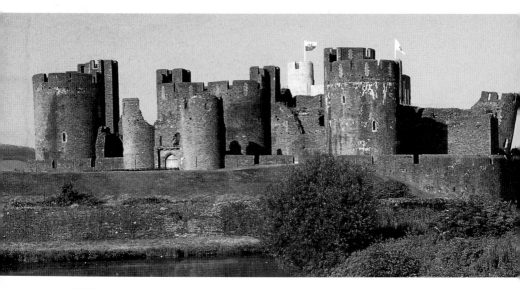

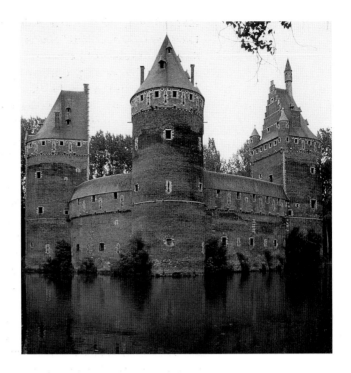

241. Beersel Castle, near Brussels, early 14th century–1310. The powerful and the wealthy lived in fortified castles, such dwellings indicative of the political instability of the times. Beersel is characteristic, with its central courtyard, massive towers and walls with crenelations, machicolations, and loop holes, a drawbridge, a portcullis, and a surrounding moat. A fortified castle can, however, also be designed with an eye to aesthetic appeal – as demonstrated by Beersel.

At the top of the walls is a sentry walk. The roofline is crenelated; once there were swinging wooden shutters in the open crenels between the merlons. If an assailant managed to make his way through the outer wall, he then found himself in the middle bailey, where there was no place to hide from the defenders on the inner walls. Additional defenses included draw-bridges and portcullises to prevent entry, murder holes for dropping things on uninvited visitors, and loop holes used by archers. Caerphilly served as the model for the concentric castles built soon thereafter by Edward I in northern Wales.

Other medieval fortresses in Wales at Chepstow, Conwy, Caernarfon, and Harlech remain quite intact. Excellent examples of early castles in England (of various types) are the Tower of London, Dover, Rochester, Hedingham, Bodiam, Skipton, and the earlier portions of Windsor.

A quintessential towered medieval moated fortress is Beersel Castle outside Brussels. Beersel was built as part of a belt of fortified castles around Brussels to protect the city and the province of Brabant from attacks coming from neighboring Flanders or Hainaut. Construction of the fortress is believed to have begun shortly after 1300, work proceeding so rapidly

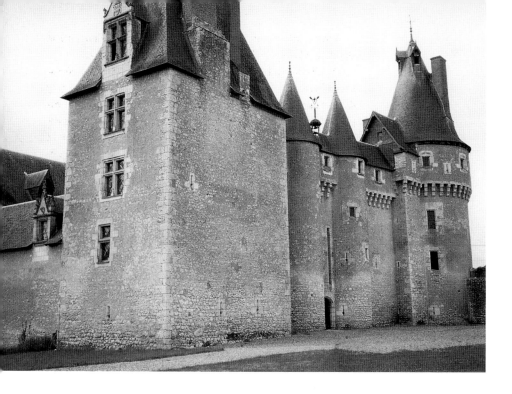

242. Castle, Fougères-sur-Bièvre, France: keep built 1030, rest of castle largely c. 1470

that the castle was completed in 1310. Beersel is practically impregnable due to the width of the moat and the thickness of the brick walls reinforced at the corners with stone. In plan, the castle is an ellipse including three massive towers. A wall walk links the towers. The battlements are pierced with machicolations – openings through which soldiers dropped defensive materials: stones, pieces of iron, hot oil (although probably more often in literature than in fact), or more offensive defensive materials (such as the contents of chamber pots) on assailants.

A visitor to Beersel must cross the moat via a fixed bridge, which could readily be destroyed in time of siege. At the end of this bridge is a drawbridge that can be raised to prevent entry. After an iron-bound gate there was a wooden portcullis that could be dropped to block the entrance. Archers stood guard in the long corridor. The windows were originally filled with oiled paper rather than expensive glass. At the end of the fifteenth century, the narrow arrow slits on the outside of the fortress were replaced by windows. At the beginning of the seventeenth century, the three towers were given pointed roofs and their courtyard facades surmounted by high stepped gables, an architectural feature characteristic of the Low Countries.

Other important early castles in today's Belgium are at Bouillon, Corroy-le-Château, Ghent, Spontin, and Vêves.

Medieval castles of France are represented by Fougères-sur-Bièvre. A castle built here in 1030 by Fraugal was largely destroyed in 1356 by English forces, leaving the powerfully proportioned square keep as the only remnant of the original castle. Today's building, incorporating the keep (the original form of its roof is unknown), was built of rough beige and tan stone in 1470 by Pierre de Refuge, treasurer of Louis XI. The massive tower at the opposite end of the facade is equipped with machicolations. The pair of towers flanking the entry are far from perfect cylinders, instead narrowing noticeably toward the top. Each of the many round towers contains a spiral staircase, providing easy access to the floors of the castle. The basic plan of Fougères is an irregular squarish courtyard surrounded by long buildings and including a chapel. During the Middle Ages, when a fortified castle needed to be self-sufficient and independent of the outside world, a chapel was part of the plan; during the Renaissance, with increasing security, the chapel was often an independent structure outside the castle. Now gone are Fougères' drawbridge and moat, which was once fed by the Bièvre River.

Additional examples of medieval French castles are the Palace of the Popes in Avignon; Angers; parts of Blois; Châteaudun; Langeais; Loches; Saumur; Sully; and Vincennes at the edge of Paris.

Medieval art includes some perhaps surprisingly witty subjects unrelated to traditional iconography – unexpected instances of medieval mischief. A special fondness for visual puns is evident, even on churches and cathedrals. For example, the heads that have replaced the customary capitals and seem

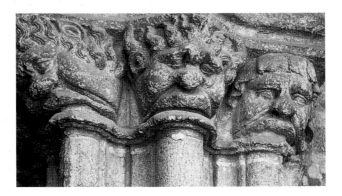

243. Monstrous heads consume columns, cloister of León Cathedral, Gothic

244. Stone figure leaning out of window, street facade of the House of Jacques Coeur, Bourges, 1443–51

245. Hand holding up column, back porch of Cathedral of Notre-Dame, Le Puy, 12th century

246. Stone figures standing guard, west facade of Exeter Cathedral, 1346–75. The ability to amuse depends upon the context and the unexpected substitution of stone figures for live ones. Other examples of stone guardians are those atop the gateways to York known as Monks Bar and Bootham Bar.

determined to consume the columns below in the cloister of the Cathedral of León, Spain, are among several examples of people or animals who bite buildings.

Stone figures may act as if they are real, like the carved figures who lean out of the windows on the street facade of the House of Jacques Coeur in Bourges, built between 1443 and 1451. These were certainly still more startling before they lost their paint. Even today they seem to try to engage the people who pass by in conversation. Similarly, figures created between 1346 and 1375 stand guard at all hours in even the worst weather, without a complaint and without requesting a raise in salary, in the crenelations on Exeter Cathedral.

247. Stone rope reinforcing window tracery, cloister of Domkerk, Utrecht, after 1396

Stone figures, or even parts thereof, may serve as architectural supports, as on the back porch of the Cathedral of Le Puy where below the vault rib an abbreviated column ends abruptly. Fortunately, there is no need to worry because support is supplied by a stone hand that holds up the column from below – the sculptor lending a helping hand, so to speak, to the mason.

A change in medium provides a humorous element at the cloister of the Domkerk in Utrecht, begun in 1396, where one arch seems to be reinforced by a stone rope that ties the delicate tracery together. During the time Jacob van den Borgh was master builder, the bishop remarked that the arch looked 'rather unstable,' so van den Borgh strengthened it in the manner seen here.

Such carvings are clever because of the context in which they appear: placed in a different environment, the joke would be lost. There is an element of amusement in these unanticipated interplays between sculpture and architecture – and perhaps, originally, also between sculptor and mason, thereby lessening the traditional medieval division between the two arts.

It is testimony to the ability and accomplishment of medieval artists that even today – so very many years later – they are still providing visitors with pleasure.

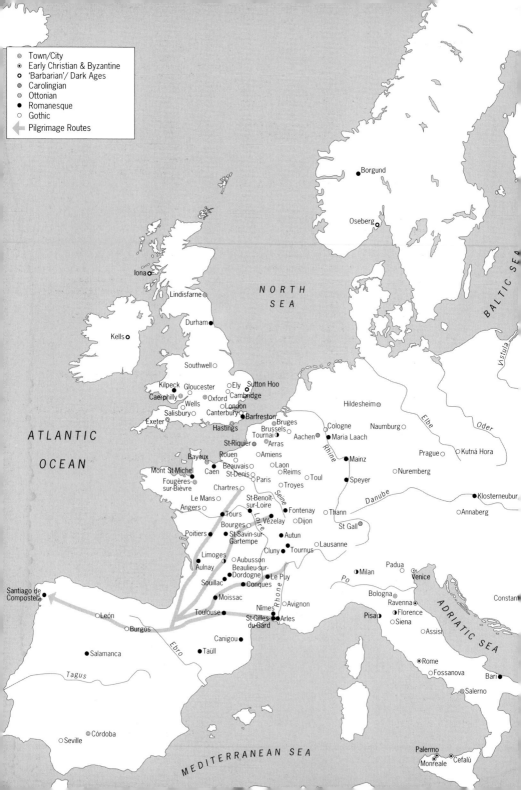

Town/City
Early Christian & Byzantine
'Barbarian'/ Dark Ages
Carolingian
Ottonian
Romanesque
Gothic
Pilgrimage Routes

NORTH SEA

BALTIC SEA

ATLANTIC OCEAN

ADRIATIC SEA

MEDITERRANEAN SEA

Borgund
Oseberg
Iona
Lindisfarne
Durham
Kells
Southwell
Kilpeck
Gloucester
Ely
Sutton Hoo
Cambridge
Caerphilly
Oxford
Wells
London
Salisbury
Canterbury
Barfreston
Exeter
Hastings
Bayeux
Rouen
Bruges
Tournai
Brussels
St-Riquier
Arras
Amiens
Aachen
Cologne
Maria Laach
Naumburg
Hildesheim
Prague
Kutná Hora
Beauvais
Laon
Reims
Mainz
Nuremberg
Mont St-Michel
Caen
St-Denis
Paris
Troyes
Toul
Speyer
Fougères-sur-Bièvre
Chartres
Le Mans
Angers
St-Benoît-sur-Loire
Fontenay
Thann
Klosterneuburg
Annaberg
Tours
Bourges
Vézelay
Dijon
St Gall
Poitiers
St-Savin-sur-Gartempe
Autun
Lausanne
Cluny
Tournus
Limoges
Aubusson
Beaulieu-sur-Dordogne
Le Puy
Milan
Padua
Venice
Aulnay
Po
Souillac
Conques
Rhône
Avignon
Bologna
Ravenna
Constan
Moissac
Nîmes
Pisa
Florence
Santiago de Compostela
León
Toulouse
Arles
St-Gilles-du-Gard
Siena
Assisi
Burgos
Ebro
Canigou
Salamanca
Taüll
Tagus
Rome
Fossanova
Bari
Salerno
Seville
Córdoba
Palermo
Monreale
Cefalù

Rhine
Elbe
Oder
Vistula
Danube
Seine
Loire

Chronology

Date	Historical Event	Art Historical Event
313	Edict of Milan; Constantine legalizes Christianity	
330	In addition to Rome, a second capital is established in Constantinople	
c. 333 f.		Old Saint Peter's, Rome
c. 350		Santa Costanza, Rome
c. 359		Sarcophagus of Junius Bassus
410	Alaric, King of the Visigoths, captures and sacks Rome	
c. 430 f.		Santa Maria Maggiore, Rome
440–461	Pope Leo I 'the Great'	
481–511	Clovis, King of the Franks; Merovingian dynasty	
526–547		San Vitale, Ravenna
527–565	Justinian, Emperor of Byzantium	
532–537		Anthemius of Tralles and Isidorus of Miletus, Hagia Sophia, Constantinople
c. 547		*Justinian and Theodora* mosaics
625–633		Purse cover, Sutton Hoo, England
751	Pepin deposes the Merovingian monarch and becomes King of the Franks; Carolingian dynasty begins	
768–814	Charlemagne, King of the Franks	
799		Saint-Riquier, Abbeville, consecrated
c. 800		*Book of Kells*
800–814	Charlemagne, Emperor	
c. 800–810		*Gospel Book of Charlemagne* (*Coronation Gospels*)
814–840	Louis the Pious, Emperor	
816–835		*Utrecht Psalter*
820–830		Saint Gall plan
c. 825		Animal head, Oseberg, Norway
840–855	Lothair I, Emperor	
843	Treaty of Verdun divides Charlemagne's empire	
855–875	Louis II, Emperor	
c. 870		Cover of the *Lindau Gospels*
875–877	Charles the Bald, Emperor	
881–887	Charles the Fat, Emperor	
896–899	Arnulf, Emperor	
899–922	Charles IV the Simple (minded), Emperor	
?927–942	Odo, Abbot of Cluny	
960–1022	Bernward, Bishop of Hildesheim	
c. 975–1000		*Gero Crucifix*
987–96	Hugh Capet, King of France; Capetian dynasty begins	
996–1031	Robert II the Pious, King of France	
late 10th century		*Harbaville Triptych*
late 10th century–c. 1000		*Gospel Book of Otto III*
c. 1000		Romanesque era begins
early 11th century		*Grimbald Gospels*
first quarter of 11th century f.		Mont Saint-Michel, church; interior 1060s
first half of 11th century		Porch tower, Saint-Benoît-de-Fleury
1001–31		Saint Michael's, Hildesheim

Date	Historical Event	Art Historical Event
1001–1126		Monastery of Saint-Martin, Canigou
1010		Reliquary image of Sainte Foy first recorded
1011–15		Doors of Saint Michael's, Hildesheim
1031–60	Henry I, King of France	
1042–66	Edward the Confessor, King of England	
1049–1109	Hugh of Semur, Abbot of Cluny	
1060s f.		Nave vaulting, Saint-Philibert, Tournus
1060–1108	Philip I, King of France	
1062–1150		San Miniato al Monte, Florence
1063 f.		San Marco, Venice
1063 f.		Cathedral group, Pisa: cathedral; baptistery 1153 f.; campanile 1174 f.
1064–77 f.		Saint-Etienne, Caen, nave; vaulted early 12th century
1066	Harold Godwinson seizes throne and becomes King of England	
1066	William, Duke of Normandy, invades England and defeats Harold at the Battle of Hastings	
1066–87	William I the Conqueror, King of England	
c. 1070–80		*Bayeux Tapestry*
c. 1070/75–1120f.		Santiago de Compostela
c. 1070 or 1077f.		Saint-Sernin, Toulouse
1085	William of England orders compilation of Domesday Book	
1085	Alfonso VI, King of Castile, takes the great Muslim city of Toledo	
1087–1100	William II Rufus, King of England	
1089–after 1132		San Nicola, Bari
1090–1153	Bernard of Clairvaux	
1093–1133		Durham Cathedral
1096 f.		Sainte-Madeleine, Vézelay
11th and early 12th centuries		Speyer Cathedral
late 11th century f.		*Pala d'Oro* (Golden Altarpiece)
later 11th and early 12th century		San Ambrogio, Milan
12th century		*Last Judgement* tympanum, Sainte-Foy, Conques
early 12th to 13th century		Tournai Cathedral
c. 1100		Frescoes, nave vault of Saint-Savin-sur-Gartempe
c. 1100 or early 12th century		Theophilus writes *De diversis artibus*
1100–35	Henry I, King of England	
1108–37	Louis VI the Fat, King of France	
1118–70	Thomas Becket	
1120–32		*Mission of the Apostles* tympanum, Sainte-Madeleine, Vézelay
c. 1120/25–35		Gislebertus, *Last Judgement* tympanum, Autun Cathedral
c. 1123		*David Beheading Goliath*, Santa Maria, Taüll
c. 1125–30		*Jesus of the Apocalypse* tympanum, Saint-Pierre, Moissac
c. 1130–45		Notre-Dame-la-Grande, Poitiers
1130/39–47		Monastery of Fontenay
mostly after 1130		Abbey church of Maria Laach
1135–54	Stephen, King of England	
1137–80	Louis VII, King of France	

Date	Historical Event	Art Historical Event
1140–44		Early Gothic begins at Saint-Denis under Abbot Suger
1145–1220		Chartres Cathedral; Royal Portals 1145–55
before mid-12ᵗʰ century–early 13ᵗʰ century		Old Cathedral, Salamanca
mid-12ᵗʰ century		Master Hugo, Bury Saint Edmunds Cross
soon after 1151		Funeral effigy of Geoffrey Plantagenet
1152	Eleanor of Aquitaine divorces Louis VII of France and marries Henry II of England; her lands go to the English throne	
1154–89	Henry II, King of England	
1163 f.		Notre-Dame, Paris
c. 1170		*Notre-Dame de la Belle-Verrière*, Chartres Cathedral
1174 f.		Guillaume de Sens and William the Englishman, Canterbury Cathedral
late 12ᵗʰ century		*Saints Andrew and Paul*, Saint-Trophîme, Arles
1180		Saint Nicholas Crozier
1180 f.	Eleanor of Aquitaine sponsors courtly love and literature; contributes to the beginning of chivalry for knights	
1180–1223	Philip II Augustus, King of France	
1181		Nicholas of Verdun, Klosterneuburg Abbey altarpiece
1181–1226	St. Francis of Assisi	
1187	Islamic leader Saladin begins to recapture the Holy Land lost to the Crusaders	
1189–99	Richard I Lionheart, King of England	
c. 1190		Master of the Grandmont Altar, *Crucifix*
c. 1190 f.		Nave, Wells Cathedral; facade c. 1225–40 f.; strainer arches c. 1338
1193	Saladin dies; Islamic Empire is split by his descendants	
c. 1195 f.		Cathedral of Saint-Etienne, Bourges; facade late 13th century
1199–1216	John Lackland, King of England	
c. 1200		*Creation Dome* mosaic, San Marco, Venice
1200	Innocent III grants a charter to the University of Paris	
1212	Crusaders push the Muslims out of northern Spain	
1215	King John signs the Magna Carta	
1216–72	Henry III, King of England	
1220–92	Roger Bacon	
1220 f.		Nicholas of Ely, Salisbury Cathedral
1223–26	Louis VIII, King of France	
1225 f.		Cathedral of Saint-Pierre, Beauvais
1226–70	Louis IX (St. Louis), King of France	
1228–53		San Francesco, Assisi
1230s		*Annunciation and Visitation*, Reims Cathedral
c. 1240–50		Naumburg Master, *Ekkehard and Uta*
1241/43–48		Pierre de Montreuil (?), Sainte-Chapelle, Paris
1248 f.		Gerhard/Gérard (?), Cologne Cathedral
13ᵗʰ century		Master Enrique, facade of León Cathedral
13ᵗʰ century f.		Siena Cathedral
first half of 13ᵗʰ century		*Beau Dieu*, Amiens Cathedral
1259–60		Nicola Pisano, pulpit of Baptistery, Pisa

Date	Historical Event	Art Historical Event
c. 1260		*Psalter of St. Louis*
c. 1262–c. 1286		Facade, Saint-Urbain, Troyes
1268 f.		Caerphilly Castle, Wales
1270–85	Philip III, King of France	
1272–1307	Edward I, King of England	
1285–1314	Philip IV the Fair, King of France	
1294 f.		Arnolfo di Cambio (?), Santa Croce, Florence
1295		Master Honoré (attributed), *Prayer Book (Breviary) of Philip the Fair*
c. 1295		*Leaves*, Southwell Minster
1296 f.		Arnolfo di Cambio, Filippo Brunelleschi, et al, Florence Cathedral
1298 f.		Arnolfo di Cambio (?), Palazzo Vecchio, Florence
		Giovanni Pisano, pulpit of Pisa Cathedral
1302–10		
1305–6		Giotto, Arena (Scrovegni) Chapel, Padua
1307–27	Edward II, King of England	
1308–11		Duccio, *Maestà*
1314–16	Louis X, King of France	
1316–22	Philip V, King of France	
1318 f.		Choir, Saint-Ouen, Rouen; nave 15th and 16th centuries
1322–28	Charles IV, King of France	
1322–34		Alan of Walsingham, octagon of Ely Cathedral
1325–28		Jean Pucelle, *Hours of Jeanne d'Evreux*
1327–77	Edward III, King of England	
1328		Simone Martini, *Guidoriccio da Fogliano*
1328–50	Philip VI Valois, King of France	
early 14th century		Beersel Castle, near Brussels
early 14th century		*Roettgen Pietà*
1330–50		Chichester-Constable chasuble
1334 f.		Giotto, campanile, Florence
1337–1453	Hundred Years' War	
1338–40		Ambrogio Lorenzetti, *Good Government in the City and Country*
1348	Black Death (bubonic plague)	
mid-14th century f.		Palazzo Ducale, Venice
1350–64	John II the Good, King of France	
c. 1351–64		Cloister, Gloucester Cathedral
1361–72		Choir, Saint Sebald, Nuremberg
before 1364		Pourpoint of Charles of Blois
1364–80	Charles V the Wise, King of France	
1368		Peter Parler, south transept porch vault completed, Prague Cathedral
commissioned 1373		Nicholas Bataille, *Angers Apocalypse* tapestries
1377–99	Richard II, King of England	
1378	Popes return to Avignon; beginning of the Great Schism with one pope in Rome, another in Avignon	
1380–1422	Charles VI, King of France	
1381	Peasants' Revolt in England	
1386 f.		Milan Cathedral
c. 1395–1406		Claus Sluter, *Well of Moses*
1399–1413	Henry IV, King of England	
1412–31	Joan of Arc	
1413–16		Limbourg brothers, *Les Très Riches Heures du Duc de Berry*

Date	Historical Event	Art Historical Event
1413–22	Henry V, King of England	
1415	Council of Constance meets to determine the supreme head of the Church	
1415	Execution of Jan Huss	
1415	Battle of Agincourt	
c. 1420–30		Rohan Master, *Grandes Heures de Rohan (Rohan Hours)*
1422–c. 1440		Ca' d'Oro (House of Gold), Venice
1422–61	Charles VII, King of France	
1422–61	Henry VI, King of England	
1423		Gentile da Fabriano, *Adoration of the Magi*
mid-15th century		Little Moreton Hall, Cheshire, England, with 16th-century additions
1453	Ottoman Turks capture Constantinople; end of Byzantine Empire	
1455–85	Wars of the Roses in England	
1461–83	Louis XI, King of France	
1461–83	Edward IV, King of England	
c. 1470		Castle of Fougères-sur-Bièvre; keep built 1030
1470–90	Matthias Corvinus, King of Bohemia	
1471–84	Sixtus IV, pope, art patron	
1479–1516	Ferdinand and Isabella reign in Spain	
c. 1480		Lorenz Helmschmid, armor of Archduke Siegmund of Tyrol
1483	Edward V, King of England	
1483–85	Richard III, King of England	
1483–98	Henry VII, King of England; first Tudor king	
1485–1509	Charles VIII, King of France	
1492	Combined Aragonese and Castilian armies of Ferdinand and Isabella conquer the Muslim kingdom of Granada	
1493–1502		Benedikt Ried (Benedict Rieth), Vladislav Hall, Hradcany Castle, Prague
1498	Girolamo Savonarola, Dominican monk, burned at the stake in Florence	
1498–1515	Louis XII, King of France	
c. 1499–1500		*Hunt of the Unicorn* tapestries
1499–1522		Jakob Heilmann of Schweinfurt, nave vault of Saint Anne, Annaberg
1500–14		Ambroise Havel (?), facade of Saint-Maclou, Rouen
1503–19		Robert and William Vertue, Chapel of Henry VII, Westminster Abbey, London
1503–13	Julius II, pope, patron of Michelangelo and Raphael	
1509–47	Henry VIII, King of England	
1515–47	François I, King of France	
1517	Protestant Reformation begins in Germany; Martin Luther in Wittenberg	
1519–56	Charles V, Emperor of Germany; as Charles I Habsburg, King of Spain, Spanish America, Austria, the Netherlands, and additional territories	
1527	Sack of Rome by Charles V	
1540–68		Francisco de Colonia, cimborio of Burgos Cathedral

Glossary

abbey community of men or women living under religious vows

aisle passage flanking and running parallel to the nave

ambulatory passage around the apse in a basilican church

apse semi-circular or polygonal recess, especially at the east end of a church

aquamanile water pitcher, often in the shape of an animal

archivolt arch-shaped ornamental molding around an arch

atrium open courtyard (in front of a church)

bailey open courtyard in a castle

barrel vault/tunnel vault a continuous arched masonry vault

basilica church consisting of a central nave defined by arcades, flanked by aisles, and lit by clerestory windows

bay in architecture, a compartment or division that recurs, as the space between adjacent columns or piers, or between the transverse ribs of a vault

bestiary encyclopedic illustrated compendium of animal lore and symbolism

blind arcade series of arches against a solid wall

book of hours private prayer book containing devotions, liturgies, litanies, and, usually, a calendar, intended for lay use

boss decorative projection covering the intersection of the ribs in a vault

buttress mass of masonry used to strengthen a wall and to counter the thrust of an arch, vault, etc.

cabochon round or oval, unfaceted, polished stone or gem

campanile Ital. 'bell tower'

cartoon full-scale drawing made as a guide for painters or weavers

catacomb subterranean burial place

cathedral church containing the bishop's throne (cathedra)

chancel easternmost part of a church, reserved for the clergy, where the altar is situated

choir part of church reserved for clergy and singers, usually part of the chancel

cimborio raised structure above a roof to admit light

clerestory (clearstory) upper part of wall with row of windows

cloister courtyard in a monastery enclosed by covered walkways

collegiate church church which has a chapter, or college, of canons but is not a cathedral

crenelation fortification technique: alternating crenels (notches) and merlons (raised sections) provide defensive shields in upper wall of building

crocket stylized decoration, usually leaves, along angles of spires, pinnacles, gables, and around capitals

cross vault/groin vault vault formed by the intersection at right angles of two identical barrel vaults

crossing intersection of nave and transepts

crypt vaulted chamber, usually beneath the apse and choir, housing tombs or a chapel

diaphragm arch transverse arch, supporting the ceiling, and dividing the longitudinal space into bays

diptych two hinged wooden panels or ivory plaques

duomo Ital. 'cathedral'

enamel powdered colored glass fused to a metal surface and then polished: **champlevé** (Fr. 'raised ground') recesses cut in the metal surface for enamel; **cloisonné** (Fr. 'partitioned') strips of metal fused to the surface form compartments for enamel

engaged column column that is attached to a structure rather than freestanding

facade face of a building, usually the front

fan vault vault shaped into inverted cones and half-cones

flying buttress masonry that transmits the thrust of a vault or arch by means of a half-arch leaning against the wall down to a massive buttress

folio page or leaf of a book

fresco literally, 'fresh'; a painting applied to a wall so that it becomes part of the surface: **fresco buono** (Ital. 'good fresco') paint applied directly to wet lime plaster; **fresco secco** (Ital. 'dry fresco') paint applied after plaster has dried

gallery enclosed upper space; in a church, the story above the arcade

gargoyle waterspout often carved as a monster or animal

garth open garden space within a cloister

grisaille monochromatic painting in shades of gray

groin vault, see **cross vault**

hall church church in which the aisles are as high as the nave

icon a picture or image which is the object of veneration

iconography the study of the meaning of images

keep innermost or most fortified part of a castle, commonly a massive tower

lancet tall sharply pointed window

lintel horizontal element spanning an opening

Lombard bands rows of small decorative blind arches

lunette semi-circular window or recess

machicolation opening in castle battlements through which missiles can be dropped

maestà (Ital. 'majesty') altarpiece with representation of Mary and Jesus enthroned, adored by saints and angels

mandorla almond-shaped light surrounding a figure, indicating sanctity

minster often applied to a cathedral or other great church without any monastic connection, especially in England and Germany; obsolete term for any monastery or its church

misericord a 'mercy seat' in the form of a bracket on the underside of a hinged choir-stall seat, allowing clergy to appear to stand when actually sitting during long services

moat defensive ditch around a castle

monastery community of monks

narthex vestibule or entrance hall in front of the nave of a church

nave the main body of a church, accommodating the congregation

oculus circular opening in a wall or dome

Order fraternity, esp. religious or knightly

parchment animal skin on which manuscripts are written and illuminated

parish subdivision of a diocese under the care of a priest

pendentive spherical triangular section of masonry enabling a circular structure to sit on a square base

pietà (Ital. 'pity') depiction of Mary with Jesus lying dead in her lap

pilgrimage journey to a holy place as an act of piety or penance

polyptych a painting or sculpture, usually an altarpiece, in several sections, often hinged so that the sections can be opened and closed

predella the base of an altarpiece, often painted or carved

priory monastic community dependent on an abbey

quatrefoil a shape with four lobes

recto front of a manuscript page

refectory dining hall

relic venerated remains or object usually associated with a saint

reliquary container for a relic

retro-choir extension of church behind the high altar

rib arched, molded band dividing and supporting the cells of a vault

rinceau ornament composed of scrolls of foliage

rose window/wheel window circular window, esp. one filled with tracery or divided into compartments by mullions radiating from the center

roundel circular window

Rule regulations drawn up by the founder of a religious order to govern the life and observances of its members

sacristy room in a church near the altar where liturgical objects are kept

spandrel triangular space formed by the curve of arches in an arcade

springing point at which an arch or vault leaves the wall or vertical support

squinch corbeled arch or niche enabling an octagonal structure to sit on a square base

stave church wooden church built using staves (massive vertical posts); esp. Norway

tessera small colored cube used to make a mosaic

transept part of a church at right angles to the nave

trefoil a shape with three lobes

triforium wall-passage above an arcade; sometimes used to mean the same as gallery

triptych three hinged wooden panels or ivory plaques

trumeau central post supporting the lintel and tympanum

tunnel vault, see **barrel vault**

tympanum semi-circular area above a doorway between the lintel and the arch

vault arched masonry ceiling

vellum calfskin; see also parchment

verso back of a manuscript page

voussoir wedge-shaped stone used to construct an arch

ward guarded court of a castle

westwork massive tower-like structure at the west end of a church

wheel window, see **rose window**

Bibliography

1. General

Adams, Henry, *Mont-Saint-Michel and Chartres*, Princeton, 1989 (first pub. 1905)

Alexander, Jonathan J. G. (gen. ed.), *A Survey of Manuscripts Illuminated in the British Isles*, 6 vols.: vol. 1. *Insular Manuscripts, Sixth to Ninth Century*; vol. 2. *Anglo Saxon Manuscripts, 900–1066*; vol. 3. *Romanesque Manuscripts, 1066–1190*; vol. 4. *Early Gothic Manuscripts, 1190–1250 and 1250–1285*; vol. 5. *Gothic Manuscripts, 1285–1385*; vol. 6. *Later Gothic Manuscripts, 1390–1490*, London, 1978–96

Ariès, Philippe, and Georges Duby, *A History of Private Life, II. Revelations of the Medieval World*, Cambridge, 1988

Backhouse, Janet, *The Illuminated Page: Ten Centuries of Manuscript Painting in the British Library*, Toronto, 1997

Beckwith, John, *Early Medieval Art: Carolingian, Ottonian, Romanesque*, London, 1994

Benton, Janetta Rebold, *Holy Terrors: Gargoyles on Medieval Buildings*, New York, 1997

——, *The Medieval Menagerie: Animals in the Art of the Middle Ages*, New York, 1992

——, *Medieval Monsters: Dragons and Fantastic Creatures*, Katonah, 1994

Calkins, Robert G., *Medieval Architecture in Western Europe, from AD 300 to 1500*, New York, 1998

——, *Monuments of Medieval Art*, Ithaca, 1985

Caviness, Madeline Harrison, *Paintings on Glass: Studies in Romanesque and Gothic Monumental Art*, Brookfield, 1997

Christe, Yves, *Art of the Christian World, AD 200–1500: A Handbook of Styles and Forms*, New York, 1982

Clifton-Taylor, Alec, *The Cathedrals of England*, London, 1989

Conant, Kenneth John, *Carolingian and Romanesque Architecture, 800–1200*, New Haven, 1993

Cutler, Anthony, *The Craft of Ivory: Sources, Techniques, and Uses in the Mediterranean World: AD 200–1400*, Washington, DC, 1985

Dodds, Jerrilyn D., et al, *The Art of Medieval Spain: AD 500–1200*, New York, 1994

Dodwell, C. R., *The Pictorial Arts of the West, 800–1200*, New Haven, 1993

Duby, Georges, *The Age of the Cathedrals: Art and Society, 980–1420*, Chicago, 1981

——, *France in the Middle Ages, 987–1460: From Hugh Capet to Joan of Arc*, Oxford, 1991

——, *Medieval Art*, 3 vols.: vol. 1. *The Making of the Christian West, 980–1140*; vol. 2. *Europe of the Cathedrals, 1140–1280*; vol. 3. *Medieval Art: Foundations of a New Humanism, 1280–1440*, Geneva, 1995

——, *Sculpture: The Great Art of the Middle Ages from the Fifth to the Fifteenth Century*, New York, 1990

Eco, Umberto, *Art and Beauty in the Middle Ages*, New Haven, 1986

——, and Costantino Marmo (eds.), *On the Medieval Theory of Signs*, Amsterdam, 1989

Fitchen, John, *Building Construction before Mechanization*, Cambridge, MA, 1994

Ford, Boris, *The Cambridge Guide to the Arts in Britain: The Middle Ages*, Cambridge, 1988

Holt, Elizabeth Gilmore (ed.), *A Documentary History of Art: I. The Middle Ages and the Renaissance*, Princeton, 1981

Kessler, Herbert, *Spiritual Seeing: Picturing God's Invisibility in Medieval Art*, Philadelphia, 2000

Lasko, Peter, *Ars Sacra, 800–1200*, New Haven, 1994

Mickenburg, David, et al, *Songs of Glory: Medieval Art from 900 to 1500*, Oklahoma City, 1985

Midmer, Roy, *English Medieval Monasteries: 1066–1540*, London, 1979

Minne-Sève, Viviane, and Hervé Kergall, *Romanesque and Gothic France: Architecture and Sculpture*, New York, 2000

Oakeshott, Walter Fraser, *The Mosaics of Rome: From the Third to the Fourteenth Centuries*, London, 1967

Platt, Colin, *Architecture of Medieval Britain*, New Haven, 1990

Radding, Charles M., and William W. Clark, *Medieval Architecture, Medieval Learning: Builders and Masters in the Age of Romanesque and Gothic*, New Haven, 1994

Saalman, Howard, *Medieval Architecture: European Architecture, 600–1200*, New York, 1962

Schapiro, Meyer, *Late Antique, Early Christian, and Medieval Art*, selected papers, New York, 1979

Smeyers, Maurits, *Flemish Miniatures from the Eighth to the Mid-Sixteenth-Century*, Turnhout, 1999

Snyder, James, *Medieval Art: Painting, Sculpture, Architecture, 4th–14th Century*, New York, 1989

Stoddard, Whitney S., *Art and Architecture in Medieval France*, New York, 1972

Stokstad, Marilyn, *Medieval Art*, New York, 1986

Zarnecki, George, *Art of the Medieval World: Architecture, Sculpture, Painting, the Sacred Arts*, Englewood Cliffs, 1975

2. Early Christian and Byzantine Art

Beckwith, John, *Early Christian and Byzantine Art*, New Haven, 1979

Boyd, Susan A., *Byzantine Art*, Chicago, 1979

Cormack, Robin, *Byzantine Art*, Oxford, 2000

Cutler, Anthony, *The Hand of the Master: Craftsmanship, Ivory, and Society in Byzantium (9th–11th Centuries)*, Princeton, 1994

——, *Late Antique and Byzantine Ivory Carving*, Brookfield, 1998

Demus, Otto, *Byzantine Art and the West*, New York, 1970

Durand, Jannic, *Byzantine Art*, Paris, 1999

Galavaris, George, *Colours, Symbols, Worship: The Mission of the Byzantine Artist*, London, 2002

Gerstel, Sharon, E. J., *Beholding the Sacred Mysteries: Programs of the Byzantine Sanctuary*, Seattle, 1999

Kitzinger, Ernst, *Byzantine Art in the Making: Main Lines of Stylistic Development in Mediterranean Art, 3rd–7th Century*, Cambridge, MA, 1995

Kleinbauer, W. Eugene, *Early Christian and Byzantine Architecture: An Annotated Bibliography and Historiography*, Boston, 1993

Krautheimer, Richard, and S. Curcic, *Early Christian and Byzantine Architecture*, New Haven, 1992

Lowden, John, *Early Christian and Byzantine Art*, London, 1997

Maguire, Henry, *Art and Eloquence in Byzantium*, Princeton, 1981

——, *The Icons of their Bodies: Saints and their Images in Byzantium*, Princeton, 2000

Mainstone, Rowland J., *Hagia Sophia: Architecture, Structure and Liturgy of Justinian's Great Church*, London, 1988

Mango, Cyril, *The Art of the Byzantine Empire, 312–1453: Sources and Documents*, Toronto, 1986

——, *Byzantine Architecture*, New York, 1985

Mark, Robert, and A. S. Cakmak (eds.), *Hagia Sophia from the Age of Justinian to the Present*, New York, 1992

Mathew, Gervase, *Byzantine Aesthetics*, London, 1963

Mathews, Thomas F., *Byzantium: From Antiquity to the Renaissance*, New York, 1998

——, *The Clash of the Gods: A Reinterpretation of Early Christian Art*, Princeton, 1993

Milburn, Robert L. P., *Early Christian Art and Architecture*, Berkeley, 1988

Obolensky, Dimitri, *The Byzantine Commonwealth: Eastern Europe 500–1453*, London, 1971

Onasch, Konrad, and Annemarie Schnieper, *Icons: The Fascination and the Reality*, New York, 1995

Ousterhout, Robert, *Master Builders of Byzantium*, Princeton, 1999

Rice, David Talbot, *Art of the Byzantine Era*, London, 1985

Rodley, Lyn, *Byzantine Art and Architecture: An Introduction*, New York, 1994

Runciman, Steven, *Byzantine Style and Civilization*, Harmondsworth, 1975

Stevenson, James, *The Catacombs: Rediscovered Monuments of Early Christianity*, London, 1978

Vassilaki, Maria (ed.), *Mother of God: Representations of the Virgin in Byzantine Art*, Milan, 2000

von Simson, Otto G., *Sacred Fortress: Byzantine Art and Statecraft in Ravenna*, Princeton, 1987

Weitzmann, Kurt, *Late Antique and Early Christian Book Illumination*, New York, 1977

——, *The Place of Book Illumination in Byzantine Art*, Princeton, 1975

3. Art of the Early Middle Ages

Backes, Magnus, and Regine Dölling, *Art of the Dark Ages*, New York, 1971

Backhouse, Janet, *The Lindisfarne Gospels: A Masterpiece of Book Painting*, San Francisco, 1995

——, et al, *The Golden Age of Anglo-Saxon Art, 966–1066*, Bloomington, IN, 1984

Borst, Arno, *Medieval Worlds: Barbarians, Heretics and Artists*, Chicago, 1992

Carver, Martin, *Sutton Hoo: Burial Ground of Kings?*, Philadelphia, 1998

Cirker, Blanche (ed.), *The Book of Kells*, New York, 1982

Davis-Weyer, Cecilia, *Early Medieval Art, 300–1150, Sources and Documents*, Toronto, 1986

Deshman, Robert, *Anglo-Saxon and Anglo-Scandinavian Art: An Annotated Bibliography*, Boston, 1984

Dodwell, C. R., *Anglo-Saxon Art: A New Perspective*, Ithaca, 1982

Evans, Angela Care, *The Sutton Hoo Ship Burial*, London, 1986

Farr, Carol, *The Book of Kells: Its Function and Audience*, Toronto, 1997

Henderson, George, *From Durrow to Kells: The Insular Gospel Books, 650–800*, London, 1987

Horn, Walter, and E. Born, *The Plan of Saint Gall*, 3 vols., Berkeley, 1979

Hubert, Jean, et al, *The Carolingian Renaissance*, New York, 1970

Kennedy, Brian, et al, *The Book of Kells and the Art of Illumination*, Seattle, 2000

Kitzinger, Ernst, *Early Medieval Art, with Illustrations from the British Museum*, Bloomington, IN, 1983

Laing, Lloyd, and Jennifer Laing, *Art of the Celts*, London, 1992

Mayr-Harting, Henry, *Ottonian Book Illumination: An Historical Study*, 2 vols., London, 1999

Meehan, Bernard, *The Book of Kells*, London, 1994

Megaw, Ruth, and Vincent Megaw, *Celtic Art: From Its Beginnings to the Book of Kells*, London, 1989

Mütherich, Florentine, and Joachim E. Gaehde, *Carolingian Painting*, New York, 1976

Nees, Lawrence, *From Justinian to Charlemagne: European Art, 567–787: An Annotated Bibliography*, Boston, 1985

Nordenfalk, Carl A. J., *Early Medieval Book Illumination*, New York, 1988

O'Mahony, Felicity (ed.), *The Book of Kells*, Aldershot, Hants, 1994

Smalley, Roger, *Early Medieval Architecture*, Oxford, 1999

Werner, Martin, *Insular Art: An Annotated Bibliography*, Boston, 1984

Williams, John, *Imaging the Early Medieval Bible*, University Park, PA, 1999

Wilson, David M., *Anglo-Saxon Art: From the Seventh Century to the Norman Conquest*, Woodstock, NY, 1984

4. Romanesque Art

Anthony, Edgar W., *Romanesque Frescoes*, Princeton, 1951

Armi, C. Edson, *Masons and Sculptors in Romanesque Burgundy: The New Aesthetic of Cluny III*, University Park, PA, 1983

Bizzarro, Tina, *Romanesque Architectural Criticism: A Prehistory*, New York, 1992

Borg, Alan, *Architectural Sculpture in Romanesque Provence*, Oxford, 1972

Cahn, Walter, *Corpus of Romanesque Sculpture in American Collections*, New York, 1999

Davies, Martin, *Romanesque Architecture: A Bibliography*, Boston, 1993

Demus, Otto, *Romanesque Mural Painting*, New York, 1970

Fergusson, Peter, *Architecture of Solitude: Cistercian Abbeys in Twelfth-Century Europe*, Princeton, 1984

Fernie, Eric, *The Architecture of Norman England*, Oxford, 2000

Focillon, Henri, *The Art of the West in the Middle Ages, Part One: Romanesque Art*, London, 1980

Forsyth, Ilene H., *The Throne of Wisdom: Wood Sculptures of the Madonna in Romanesque France*, Princeton, 1972

Gitlitz, David M., and Linda Kay Davidson, *The Pilgrimage Road to Santiago: The Complete Cultural Handbook*, New York, 2000

Glass, Dorothy, *Italian Romanesque Sculpture: An Annotated Bibliography*, Boston, 1983

——, *Romanesque Sculpture in Campania: Patrons, Programs, and Style*, University Park, PA, 1992

Grabar, Andre, and Carl Nordenfalk, *Romanesque Painting from the Eleventh to the Thirteenth Century*, New York, 1958

Grivot, Denis, and George Zarnecki, *Gislebertus, Sculptor of Autun*, New York, 1961

Haskins, Charles H., *The Renaissance of the Twelfth Century*, Cambridge, MA, 1993

Hearn, Millard F., *Romanesque Sculpture: The Revival of Monumental Stone Sculpture in the Eleventh and Twelfth Centuries*, Ithaca, 1981

Jacobs, Michael, *Northern Spain: The Road to Santiago de Compostela*, San Francisco, 1991

Kahn, Deborah, *Canterbury Cathedral and Its Romanesque Sculpture*, Austin, 1991

——(ed.), *The Romanesque Frieze and its Spectator*, London, 1992

Kennedy, Hugh, *Crusader Castles*, Cambridge, 1994

Kinder, Terryl N., *Architecture of Silence: Cistercian Abbeys of France*, New York, 2000

Kubach, Hans Erich, *Romanesque Architecture*, New York, 1988

Künstler, Gustave, *Romanesque Art in Europe*, Greenwich, CT, 1969

Kupfer, Marcia, *Romanesque Wall Painting in Central France*, New Haven, 1993

Leroux-Dhuys, Jean-Francois, *Cistercian Abbeys: History and Architecture*, Cologne, 1998

Little, Bryan D. G., *Architecture in Norman Britain*, London, 1985

Lyman, Thomas W., *French Romanesque Sculpture: An Annotated Bibliography*, Boston, 1987

Mâle, Emile, *Religious Art in France, the Twelfth Century: A Study of the Origins of Medieval Iconography*, Princeton, 1978

Mouilleron, Veronique Rouchon, *Vézelay: The Great Romanesque Church*, New York, 1999

Nichols, Stephen G., Jr., *Romanesque Signs: Early Medieval Narrative and Iconography*, New Haven, 1983

Norton, Christopher, and David Park, *Cistercian Art and Architecture in the British Isles*, Cambridge, 1986

Petzold, Andreas, *Romanesque Art, 1050– 1200*, New York, 1995

Porter, Arthur Kingsley, *Romanesque Sculpture of the Pilgrimage Roads*, 10 vols., New York, 1985 (first pub. 1926)

Rollason, David, et al (eds.), *Anglo-Norman Durham: 1093–1193*, Woodbridge, Suffolk, 1994

Schapiro, Meyer, *Romanesque Art*, New York, 1993

——, *The Romanesque Sculpture of Moissac*, New York, 1985

Seidel, Linda, *Legends in Limestone: Lazarus, Gislebertus, and the Cathedral of Autun*, Chicago, 1999

Shaver-Crandell, Annie, and Paula Gerson, *The Pilgrim's Guide to Santiago de Compostela*, London, 1995

Stratford, Neil, *Studies in Burgundian Romanesque Sculpture*, London, 1998

Tate, Robert Brian, and Marcus Tate, *The Pilgrim Route to Santiago*, Oxford, 1987

Tobin, Stephen, *The Cistercians: Monks and Monasteries of Europe*, New York, 1996

Toman, Rolf (ed.), *Romanesque Architecture, Sculpture, Painting*, Cologne, 1997

Zarnecki, George, *Further Studies in Romanesque Sculpture*, London, 1992

——, *Romanesque Art*, New York, 1971

——, *Romanesque Lincoln: The Sculpture of the Cathedral*, Lincoln, 1994

——, *Studies in Romanesque Sculpture*, London, 1979

——, et al, *English Romanesque Art, 1066–1200*, London, 1984

5. Gothic Art (including stained glass)

Alexander, Jonathan, and Paul Binski (eds.), *Age of Chivalry: Art in Plantagenet England, 1200–1400*, London, 1987

Anderson, William, and Clive Hicks, *The Rise of the Gothic*, London, 1988

Andrews, Francis B., *The Medieval Builder and His Methods*, New York, 1999

Armi, C. Edson, *The "Headmaster" of Chartres and the Origins of "Gothic" Sculpture*, University Park, PA, 1994

Basford, Kathleen, *The Green Man*, Woodbridge, Suffolk, 1999

Basile, Guiseppe, *Giotto: The Arena Chapel Frescoes*, New York, 1993

Bellosi, Luciano, *Giotto: Complete Works*, New York, 1981

——, *The Maestà*, London, 1999

Binney, Marcus, *The Châteaux of France*, London, 1994

Binski, Paul, *Westminster Abbey and the Plantagenets: Kingship and the Representation of Power, 1200–1400*, New Haven, 1995

Blum, Pamela Z., *Early Gothic Saint-Denis: Restorations and Survivals*, Berkeley, 1992

Bonsanti, Giorgio, *The Basilica of St. Francis of Assisi: Glory and Destruction*, New York, 1997

Bony, Jean, *The English Decorated Style: Gothic Architecture Transformed, 1250–1350*, Ithaca, 1979

——, *French Gothic Architecture of the Twelfth and Thirteenth Centuries*, Berkeley, 1983

Branner, Robert (ed.), *Chartres Cathedral*, New York, 1996

——, *Gothic Architecture*, New York, 1991

Braunfels, Wolfgang, *Monasteries of Western Europe*, Princeton and London, 1972

Brisac, Catherine, *A Thousand Years of Stained Glass*, Edison, 2000

Bromford, David, et al, *Art in the Making: Italian Painting before 1400*, London, 1990

Brown, Sarah, *Stained Glass: An Illustrated History*, London, 1994

Butts, Barbara, and Lee Hendrix, *Painting on Light: Drawings for Stained Glass in the Age of Dürer and Holbein*, Los Angeles, 2000

Camille, Michael, *Gothic Art: Glorious Visions*, New York, 1997

——, *The Gothic Idol: Ideology and Image-Making in Medieval Art*, Cambridge, 1989

Caviness, Madeline Harrison, *Paintings on Glass: Studies in Romanesque and Gothic Monumental Art*, Brookfield, 1997

——, *Stained Glass Before 1540: An Annotated Bibliography*, Boston, 1983

——, *Sumptuous Arts at the Royal Abbeys of Reims and Braine*, Princeton, 1990

Coe, Brian, *Stained Glass in England, 1150–1550*, London, 1981

Cole, Bruce, *Giotto and Florentine Painting, 1280–1375*, New York, 1976

——, *Giotto: The Scrovegni Chapel, Padua*, New York, 1993

Collinson, Patrick, et al, *A History of Canterbury Cathedral*, Oxford, 1995

Courtenay, Lynn T., *The Engineering of Medieval Cathedrals*, Brookfield, 1997

Cowan Painton, *Rose Windows*, London, 1992

Crosby, Sumner McKnight, *The Royal Abbey of Saint-Denis from its Beginnings to the Death of Suger, 475–1151*, New Haven, 1987

——, et al, *The Royal Abbey of Saint-Denis in the Time of Abbot Suger (1122–1151)*, New York, 1981

d'Arcais, Francesca Flores, *Giotto*, New York, 1995

Deuchler, Florens, *Gothic*, New York, 1989

Droste, Thorston, and Axel M. Mosler, *Châteaux of the Loire*, New York, 1997

Dumont, Georges-Henri, *Châteaux en Belgique, Kastelen in België, Castles of Belgium, Schlösser in Belgien*, 2 vols., Brussels, 1994–6

Emery, Anthony, *Greater Medieval Houses of England and Wales, 1300–1500*: vol. 2. *East Anglia, Central England, and Wales*, Cambridge, 2000

Erlande-Brandenburg, Alain, *The Cathedral Builders of the Middle Ages*, London, 1995

——, *Gothic Art*, New York, 1989

——, *Notre-Dame de Paris*, New York, 1998

Evans, Joan (ed.), *The Flowering of the Middle Ages*, New York, 1985

Favier, Jean, *The World of Chartres*, New York, 1997

Fenwick, Hubert, *The Châteaux of France*, London, 1975

Fitchen, John, *The Construction of Gothic Cathedrals: A Study of Medieval Vault Erection*, Chicago, 1961

Focillon, Henri, *The Art of the West in the Middle Ages, Part Two: Gothic Art*, London, 1980

Frankl, Paul, *Gothic Architecture*, New Haven, 2000

Frisch, Teresa G., *Gothic Art 1140–c. 1450: Sources and Documents*, Toronto, 1987

Fry, Plantagenet Somerset, *Castles of Britain and Ireland*, New York, 1997

Gascoigne, Christina, and Bamber Gascoigne, *Castles of Britain*, London, 1980

Gerson, Paula Lieber (ed.), *Abbot Suger and Saint-Denis: A Symposium*, New York, 1987

Gies, Joseph, and Frances Gies, *Life in a Medieval City*, New York, 1969

Gillerman, Dorothy, *Corpus of Gothic Sculpture in American Collections*, New York and Turnhout, 2001

Gimpel, Jean, *The Cathedral Builders*, New York, 1961

Gouvion, Colette, *Châteaux of the Loire*, New York, 1986

Grodecki, Louis, *Gothic Architecture*, New York, 1985

——, and Catherine Brisac, *Gothic Stained Glass, 1200–1300*, Ithaca, 1985

Huizinga, Johan, *The Autumn of the Middle Ages*, Chicago, 1996

Icher, Francois, *Building the Great Cathedrals*, New York, 1998

James, Thomas Beaumont, *The Palaces of Medieval England, c. 1050–1500*, London, 1990

Jannella, Cecilia, *Duccio di Buoninsegna*, New York, 1991

——, *Simone Martini*, New York, 1989

Jantzen, Hans, *High Gothic: The Classic Cathedrals of Chartres, Reims, and Amiens*, Princeton, 1984

Jenner, Michael, *Journeys into Medieval England*, London, 1991

Johnson, Paul, *Castles of England, Scotland, and Wales*, New York, 1992

——, *Cathedrals of England, Scotland and Wales*, New York, 1990

Kerr, Nigel, and Mary Kerr, *A Guide to Medieval Sites in Britain*, London, 1989

King, D. J. Cathcart, *The Castle in England and Wales: An Interpretive History*, London, 1991

Ladis, Andrew (ed.), *Giotto and the World of Early Italian Art: An Anthology of Literature*, 4 vols., New York, 1998

Levron, Jacques, *Châteaux of the Loire*, Paris, 1973

Lillich, Meredith Parsons, *The Armor of Light: Stained Glass in Western France, 1250–1325*, Berkeley, 1994

——, *Rainbow like an Emerald: Stained Glass in Lorraine in the Thirteenth and Early Fourteenth Centuries*, University Park, PA, 1991

——, *Studies in Medieval Stained Glass and Monasticism*, London, 2001

Lord, Carla, *Royal French Patronage of Art in the Fourteenth Century: An Annotated Bibliography*, Boston, 1985

Lunghi, Elvio, *The Basilica of Saint Francis in Assisi*, New York, 1997

Lushington, Laura, *The Bible in Stained Glass*, Ridgefield, 1990

Maginnis, Hayden B. J., *Painting in the Age of Giotto: An Historical Re-evaluation*, University Park, PA, 1997

Mâle, Emile, *Chartres*, New York, 1983

——, *Religious Art in France of the Thirteenth Century*, New York, 2000

Marks, Richard, *Stained Glass in England During the Middle Ages*, Toronto, 1993

Martindale, Andrew, *Gothic Art*, London, 1979

——, *Simone Martini: Complete Edition*, New York, 1988

McIntyre, Anthony, *Medieval Tuscany and Umbria*, San Francisco, 1992

McNeill, Tom E., *Book of Castles*, London, 1992

Meiss, Millard, *French Painting in the Time of Jean de Berry*: vol. I.1-2 *The Late Fourteenth Century and the Patronage of the Duke*; vol. II. 1-2 *The Limbourgs and Their Contemporaries*, New York, 1969–74

Miller, Malcolm, *Chartres Cathedral*, New York, 1997

Miquel, Pierre, and Jean-Baptiste Leroux, *The Châteaux of the Loire*, New York, 1999

Montgomery-Massingberd, Hugh, *Great Houses of England and Wales*, New York, 2000

Moskowitz, Anita Fiderer, *Italian Gothic Sculpture, c. 1250–c. 1400*, Cambridge, 2000

Mullins, Edwin, *The Pilgrimage to Santiago*, New York, 2001

Murray, Stephen, *Beauvais Cathedral: Architecture of Transcendence*, Princeton, 1989

——, *Building Troyes Cathedral: The Late Gothic Campaigns*, Bloomington, IN, 1987

——, *Notre-Dame, Cathedral of Amiens: The Power of Change in Gothic*, Cambridge, 1996

Neagley, Linda Elaine, *Disciplined Exuberance: The Parish Church of Saint-Maclou and Late Gothic Architecture in Rouen*, University Park, PA, 1998

Nussbaum, Norbert, *German Gothic Church Architecture*, New Haven, 2000

Owen, Dorothy (ed.), *A History of Lincoln Minster*, Cambridge, 1994

Panofsky, Erwin, *Gothic Architecture and Scholasticism*, New York, 1985

—— (ed. and trans.), *Abbot Suger on the Abbey Church of Saint-Denis and its Art Treasures*, Princeton, 1979

Parry, Stan, *Great Gothic Cathedrals of France: A Visitor's Guide*, New York, 2001

Pérouse de Montclos, Jean-Marie, *Châteaux of the Loire Valley*, Cologne, 1997

Pettifer, Adrian, *English Castles*, Woodbridge, Suffolk, 2000

——, *Welsh Castles*, Woodbridge, Suffolk, 2000

Pevsner, Nikolas, and Priscilla Metcalf, *The Cathedrals of England*, 2 vols., Harmondsworth, 1985

Pirenne, Henri, *Medieval Cities, their Origins and the Revival of Trade*, Princeton, 1974

Platt, Colin, *The Castle in Medieval England and Wales*, London, 1995

Pope-Hennessy, John, *Italian Gothic Sculpture*, Oxford and New York, 1986

Prache, Anne, *Cathedrals of Europe*, Ithaca, 1999

Raguin, Virginia Chieffo, *Stained Glass in Thirteenth-Century Burgundy*, Princeton, 1982

Rudolph, Conrad, *Artistic Change at St-Denis: Abbot Suger's Program and the Early Twelfth-Century Controversy over Art*, Princeton, 1990

Sampson, Jerry, *Wells Cathedral West Front: Construction, Sculpture, and Conservation*, Phoenix Mill, Glos., 1998

Sauerländer, Willibald, *Gothic Sculpture in France, 1140–1270*, London, 1972

Smart, Alastair, *The Dawn of Italian Painting, 1250–1400*, Ithaca, 1978

Stoddard, Whitney S., *The Sculptors of the West Portals of Chartres Cathedral*, New York, 1992

Stone, Lawrence, *Sculpture in Britain: The Middle Ages*, Harmondsworth, 1972

Stubblebine, James, *Assisi and the Rise of Vernacular Art*, New York, 1985

——, *Dugento Painting: An Annotated Bibliography*, Boston, 1985

Swaan, Wim, *Art and Architecture of the Late Middle Ages, 1350 to the Advent of the Renaissance*, New York, 1982

——, *The Gothic Cathedral*, New York, 1984

Sweetman, David, *The Medieval Castles of Ireland*, Woodbridge, Suffolk, 2000

Toman, Rolf (ed.), *Gothic: Architecture, Sculpture, Painting*, Cologne, 1998

Tummers, H. A., *Early Secular Effigies in England: The Thirteenth Century*, Leiden, 1980

van der Meulen, Jan, *Chartres: Sources and Literary Interpretation: A Critical Bibliography*, Boston, 1989

von Simson, Otto Georg, *The Gothic Cathedral: Origins of Gothic Architecture and the Medieval Concept of Order*, Princeton, 1994

Weber, Andrea, *Duccio di Buoninsegna*, Cologne, 1997

Welch, Evelyn, *Art and Society in Italy, 1350–1500*, Oxford, 1997

White, John, *Art and Architecture in Italy, 1250–1400*, New Haven, 1993

——, *Duccio: Tuscan Art and the Medieval Workshop*, New York, 1979

Williamson, Paul, *Gothic Sculpture, 1140–1300*, New Haven, 1999

——, *Northern Gothic Sculpture, 1200–1450*, London, 1988

Wilson, Christopher, *The Gothic Cathedral: The Architecture of the Great Church*, London, 1990

——, et al, *Westminster Abbey*, London, 1986

Wilson, Jean C., *Painting in Bruges at the Close of the Middle Ages: Studies in Society and Visual Culture*, University Park, PA, 1998

Woodman, Francis, *The Architectural History of Canterbury Cathedral*, London, 1981

Zarnecki, George, *Later English Romanesque Sculpture, 1140–1210*, London, 1953

6. Decorative Arts: Romanesque and Gothic (including manuscript illumination, ivory, enamel, metalwork, tapestry, costume, armor, ecclesiastical vestments)

Alexander, Jonathan J. G., *The Decorated Letter*, New York, 1978

——, *Medieval Illuminators and their Methods of Work*, New Haven, 1993

Arnold, Janet, *Queen Elizabeth's Wardrobe Unlock'd*, Leeds, 1997

Ashdown, Charles Henry, *European Arms and Armor*, New York, 1995

Avril, Francois, *Manuscript Painting at the Court of France: The Fourteenth Century*, New York, 1978

Barnet, Peter (ed.), *Images in Ivory: Precious Objects of the Gothic Age*, Princeton, 1997

Barsali, Isa Belli, *European Enamels*, London, 1988

Basing, Patricia, *Trades and Crafts in Medieval Manuscripts*, New York, 1990

Beckwith, John, *Ivory Carvings in Early Medieval England*, London, 1990

Bennett, Anna Gray, *Five Centuries of Tapestry from The Fine Arts Museums of San Francisco*, San Francisco, 1992

Bernstein, David J., *The Mystery of the Bayeux Tapestry*, Chicago, 1986

Blair, Claude, *Arms, Armour and Base-Metalwork: The James A. de Rothschild Collection at Waddesdon Manor*, London, 1974

Boehm, Barbara Drake, and Elizabeth Taburet-Delahaye, *Enamels of Limoges, 1100–1350*, New York, 1996

Bowie, Theodore (ed.), *The Sketchbook of Villard de Honnecourt*, Westport, 1982

Boyer, Marie-France, *The Cult of the Virgin: Offerings, Ornaments, and Festivals*, New York, 2000

Bradley, John, *Illuminated Manuscripts*, London, 1996

Branner, Robert, *Manuscript Painting in Paris During the Reign of Saint Louis: A Study of Styles*, Berkeley, 1977

Brooke, Iris, *English Costume of the Early Middle Ages: The Tenth to the Thirteenth Centuries*, London, 1936

——, *English Costume of the Later Middle Ages: The Fourteenth and Fifteenth Centuries*, London, 1935

——, *A History of English Costume*, London, 1961

——, and William-Alan Landes, *Western European Costume: Thirteenth to Seventeenth Centuries*, New York, 1993 (first pub. 1939)

Brown, Michelle P., *Understanding Illuminated Manuscripts: A Guide to Technical Terms*, Los Angeles, 1994

Cahn, Walter, *Romanesque Bible Illumination*, Ithaca, 1982

——, *Romanesque Manuscripts of the Twelfth Century*, 2 vols., London, 1996

Calkins, Robert G., *Illuminated Books of the Middle Ages*, Ithaca, 1983

Camille, Michael, *Image on the Edge: The Margins of Medieval Art*, Cambridge, MA, 1992

——, *The Medieval Art of Love: Objects and Subjects of Desire*, New York, 1998

——, *Mirror in Parchment: The Luttrell Psalter and the Making of Medieval England*, Chicago, 1998

Campbell, Marian, *Medieval Enamels*, London, 1983

Caroselli, Susan L., *The Painted Enamels of Limoges*, London, 1993

Carr, Dawson, and Mark Leonard, *Looking at Paintings: A Guide to Technical Terms*, Santa Monica, 1992

Cavallo, Adolfo Salvatore, *Medieval Tapestries in The Metropolitan Museum of Art*, New Haven, 1993

——, *The Unicorn Tapestries*, New York, 1998

Caviness, Madeline Harrison, *Sumptuous Arts at the Royal Abbeys in Reims and Braine*, Princeton, 1990

Cazelles, Raymond, and Johannes Rathofer, *Illuminations of Heaven and Earth: The Glories of the Très Riches Heures du Duc de Berry*, New York, 1988

Cennini, Cennino d'Andrea, *Il Libro dell'Arte* (The Craftsman's Handbook), trans. Daniel V. Thompson, Jr., New York, 1960

Chapman, Gretel, *Mosan Art: An Annotated Bibliography*, Boston, 1988

Cherry, John, *Medieval Decorative Art*, London, 1991

Cole, Bruce, *The Renaissance Artist at Work: From Pisano to Titian*, Boulder, 1990

Cunnington, C. Willett, and Phyllis Cunnington, *Handbook of English Medieval Costume*, Philadelphia, 1952

de Hamel, Christopher, *A History of Illuminated Manuscripts*, London, 1997

Delmarcel, Guy, *Flemish Tapestry*, New York, 2000

Digby, George Wingfield, *The Tapestry Collection: Medieval and Renaissance*, London, 1980

Evans, Joan, *Dress in Medieval France*, Oxford, 1952

Feller, Robert, et al (eds.), *Artists' Pigments: A Handbook of their History and Characteristics*, 3 vols., New York, 1994–7

Flores, Nona C. (ed.), *Animals in the Middle Ages*, New York, 1996

Gameson, Richard (ed.), *The Study of the Bayeux Tapestry*, Woodbridge, Suffolk, 1997

Gauthier, Marie-Madeleine S., and M. Marcheix, *Limoges Enamels*, London, 1962

Golob, Natasa, *Twelfth-Century Cistercian Manuscripts: The Sitticum Collection*, London, 1996

Gordon, Stewart (ed.), *Robes of Honor: The Medieval World of Investiture*, New York, 2001

Grape, Wolfgang, *The Bayeux Tapestry: Monument to a Norman Triumph*, Munich, 1994

Harte N. B., and K. G. Ponting (eds.), *Cloth and Clothing in Medieval Europe*, London, 1983

Hayward, John Forrest, *European Armour*, London, 1965

Hodges, Laura F., *Chaucer and Costume: The Secular Pilgrims in the General Prologue*, Woodbridge, Suffolk, 2000

Houston, Mary G., *Medieval Costume in England and France: The 13th, 14th and 15th centuries*, New York, 1996

Kren, Thomas (ed.), *Margaret of York, Simon Marmion, and The Visions of Tondal*, Los Angeles, 1992

Lewis, Suzanne, *The Rhetoric of Power in the Bayeux Tapestry*, Cambridge, 1999

Lightbown, R. W., *Secular Goldsmiths' Work in Medieval France: A History*, London, 1978

Longnon, Jean, and Raymond Cazelles, *The Très Riches Heures of Jean, Duke de Berry*, New York, 1989

Lyall, Sutherland, *The Lady and the Unicorn*, London, 2000

Mann, James, *Wallace Collection Catalogues: European Arms and Armour, I. Armour*, London, 1962

Marks, Richard, and Nigel Morgan, *The Golden Age of English Manuscript Painting, 1200–1500*, London, 1981

Martin, Rebecca, *Textiles in Daily Life in the Middle Ages*, Cleveland, 1985

Medieval Craftsman series, University of Toronto Press:
Binski, Paul, *Painters*, 1991
Brown, Sarah, and David O'Connor, *Glass-Painters*, 1991
Cherry, John, *Goldsmiths*, 1992
Coldstream, Nicola, *Masons and Sculptors*, 1991
de Hamel, Christopher, *Scribes and Illuminators*, 1992
Eames, Elizabeth, *English Tilers*, 1992
Pfaffenbichler, Matthias, *Armourers*, 1992
Staniland, Kay, *Embroiderers*, 1991

Meiss, Millard, *French Painting in the Time of Jean de Berry: The Limbourgs and their Contemporaries*, New York, 1982

——, and Edith W. Kirsch, *The Visconti Hours*, New York, 1972

Mentre, Mireille, *Illuminated Manuscripts of Medieval Spain*, London, 1996

Metropolitan Museum of Art, *Bulletin*, March, 1971, articles on ecclesiastical vestments:
Hayward, Jane, "Sacred Vestments as They Developed in the Middle Ages"
Husband, Timothy, "Ecclesiastical Vestments of the Middle Ages"
Schimansky, Dobrila-Donya, "The Study of Medieval Ecclesiastical Costumes: A Bibliography"
Young, Bonnie, "Opus Anglicanum"

Metropolitan Museum of Art, *Masterpieces of Tapestry from the Fourteenth to the Sixteenth Century*, New York, 1973

Morand, Kathleen, *Claus Sluter: Artist at the Court of Burgundy*, Austin, 1991

Morgan, Nigel, *Early Gothic Manuscripts: Survey of Manuscripts Illuminated in the British Isles*, 2 vols., London, 1982–8

Newton, Stella Mary, *Fashion in the Age of the Black Prince*, Woodbridge, Suffolk, 1999

Noad, Timothy, and Patricia Seligman, *The Art of Illuminated Letters*, London, 1994

Norman, A. V. B., *Wallace Collection Catalogues: European Arms and Armour Supplement*, London, 1986

Oakeshott, Walter Fraser, *European Weapons and Armour*, Woodbridge, Suffolk, 2000

Pächt, Otto, *Book Illumination in the Middle Ages*, London, 1994

Parker, Elizabeth C., and Charles T. Little, *The Cloisters Cross: Its Art and Meaning*, New York, 1994

Pelikan, Jaroslav, *Mary Through the Centuries: Her Place in the History of Culture*, New Haven, 1996

Penny, Nicholas, *The Materials of Sculpture*, New Haven, 1993

Pierpont Morgan Library, *The Stavelot Triptych: Mosan Art and the Legend of the True Cross*, New York, 1980

Piponnier, Françoise, and Perrine Mane, *Dress in the Middle Ages*, New Haven, 1997

Porcher, Jean, *Medieval French Miniatures*, New York, 1960

Pyhrr, Stuart W., and José-A. Godoy, *Heroic Armor of the Italian Renaissance: Filippo Negroli and his Contemporaries*, New York, 1998

Randall, Lilian M. C., *Images in the Margins of Gothic Manuscripts*, Berkeley, 1966

Randall, Richard H., Jr., *The Golden Age of Ivory: Gothic Carvings in North American Collections*, New York, 1993

——, *Masterpieces of Ivory from the Walters Art Gallery*, New York, 1985

Schacherl, Lillian, *Très Riches Heures: Behind the Gothic Masterpiece*, Munich, 1997

Scott, Margaret, *The History of Dress: Late Gothic Europe, 1400–1500*, London, c.1980

——, *Visual History of Costume: The Fourteenth and Fifteenth Centuries*, London, 1986

Seeler, Margarete, *The Art of Enameling*, New York, 1983

Swarzenski, Hanns, *Monuments of Romanesque Art: The Art of Church Treasures in Northwestern Europe*, Chicago, 1974

Theophilus, *On Divers Arts: The Foremost Medieval Treatise on Painting, Glassmaking and Metalwork*, trans. from the Latin with introduction and notes by John G. Hawthorne and Cyril Stanley Smith, New York, 1979

Thomas, Marcel, *The Golden Age: Manuscript Painting in the Time of Jean, Duke of Berry*, New York, 1999

Thompson, Daniel V., *The Materials and Techniques of Medieval Painting*, New York, 1956

Victoria and Albert Museum, *Opus Anglicanum, English Medieval Embroidery*, London, 1963

Walters Art Gallery, *Liturgical Objects in the Walters Art Gallery: Medieval Ivories*, Baltimore, 1984

Wieck, Roger S., *Painted Prayers: The Book of Hours in Medieval and Renaissance Art*, New York, 1997

——, *Time Sanctified: The Book of Hours in Medieval Art and Life*, New York, 1988

Williams, John, *Early Spanish Manuscript Illumination*, New York, 1977

——, *The Illustrated Beatus: A Corpus of the Illustrations of the Commentary on the Apocalypse, the Tenth and Eleventh Centuries*, 4 vols., London and Turnhout, 1998–2001

Williamson, Paul, *Medieval Ivory Carving*, London, 1982

—— (ed.), *The Medieval Treasury: The Art of the Middle Ages in the Victoria and Albert Museum*, London, 1996

Wilson, David M., *The Bayeux Tapestry: The Complete Tapestry in Color*, New York, 1985

Wormald, Francis, *The Winchester Psalter*, Greenwich, CT, 1973

Young, Bonnie, "Needlework by Nuns: A Medieval Religious Embroidery," *Bulletin*, Metropolitan Museum of Art, New York, vol. XVIII, Feb. 1970, 263–77

Zijlstra-Zweens, H. M., *Of His Array Telle I No Lenger Tale: Aspects of Costume, Arms and Armour in Western Europe, 1200–1400*, Amsterdam, 1988

List of Illustrations

Measurements are given in centimeters followed by inches: H. = height, W. = width, L. = length, D. = diameter or depth

Index